DIGITAL ART MASTERS

: VOLUME 2

3DTOTAL.COM LTD.

 Routledge
Taylor & Francis Group

LONDON AND NEW YORK

First published 2014 by Focal Press

Published 2016 by Routledge
2 Park Square, Milton Park, Abingdon, Oxon OX14 4RN
711 Third Avenue, New York, NY 10017

First issued in hardback 2017

Routledge is an imprint of the Taylor & Francis Group, an informa business

British Library Cataloguing in Publication Data
A catalogue record for this book is available from the British Library

Library of Congress Cataloging-in-Publication Data
A catalog record for this book is available from the Library of Congress

ISBN 13: 978-1-138-41782-3 (hbk)
ISBN 13: 978-0-240-52085-8 (pbk)

DIGITAL ART MASTERS

: VOLUME 2

'With truly the best collection of digital artists, this book stands out from the masses with its elegant layout and explanatory content fit for any artists of any genre or level. This beautiful art book jump-started my inspiration and muse, and I found myself doodling along after reading through it.'

HENNING LUDVIGSEN

WWW.HENNINGLUDVIGSEN.COM

'3D Total's second instalment of "Digital Art Masters" gives you once again the opportunity to take a look over today's most popular digital artists' shoulders. You are not only getting a beautifully treated and presented art book but also interesting insights on how the artists create their stunning visions. You wouldn't want to miss that opportunity!'

NATASCHA ROEOESLI

WWW.TASCHA.CH

'Definitely one of my favorite art books of the year. It contains an incredible source of inspiration from amazing digital artists all around the world. The high quality of this book is outstanding to say the least; it will become a part of my personal collection for sure.'

FREDERIC ST-ARNAUD

WWW.STARNO.NET

'When inspiration meets technique... Inside these pages, the best digital artists reveal and share their techniques through detailed step by step tutorials of their most beautiful pieces. DAM Vol. 2 offers a unique chance to discover all the "secrets" from the pros in both 2D and 3D, but also stunning digital masterpieces from worldwide renowned artists.'

MÉLANIE DELON

WWW.ESKARINA-CIRCUS.COM

DIGITAL ART MASTERS
:VOLUME 2
FEATURED ARTISTS

Andrzej Sykut
Alessandro Baldasseroni
Alessandro Pacciani
Alexandru Popescu
André Holzmeister
André Kutscherauer
Andrea Bertaccini
Andrey Yamkovoy
Antonio José González Benítez
Benita Winckler
Bingo-Digital
Brian Recktenwald
Daarken
Daniel Moreno Diaz
Daniela Uhlig
Emrah ELMASLI
Fran Ferriz Blanquer
Fred Bastide
Gerhard Mozsi
Glen Angus
Hao Ai Qiang
Hoang Nguyen
Hrvoje Rafael
Hyung-Jun Kim
James Busby
Jian Guo
Jonathan Simard
Jonny Duddle
Khalid Abdulla Al Muharraqi
Kornél Ravadits
Kosta Atanasov
Marcel Baumann
Marcin Klicki
Marco Menco
Marek Denko
Massimo Righi
Maurício Santos
Michael Engstrom
Michael Smith
Mikko Kinnunen
Neil Maccormack
Olga Antonenko
Patrick Beaulieu
Pawel Hynek
Philip Straub
Raymond Yang
ROLANDO Cyril
Rose Frith
Sebastien Sonet
SIKU
Stefan Morrell
Tae young Choi
Torsten J. Postolka
Vincent Guibert
Vitaly S Alexius
Wen-Xi Chen
Wiek Luijken
Yang Zhang

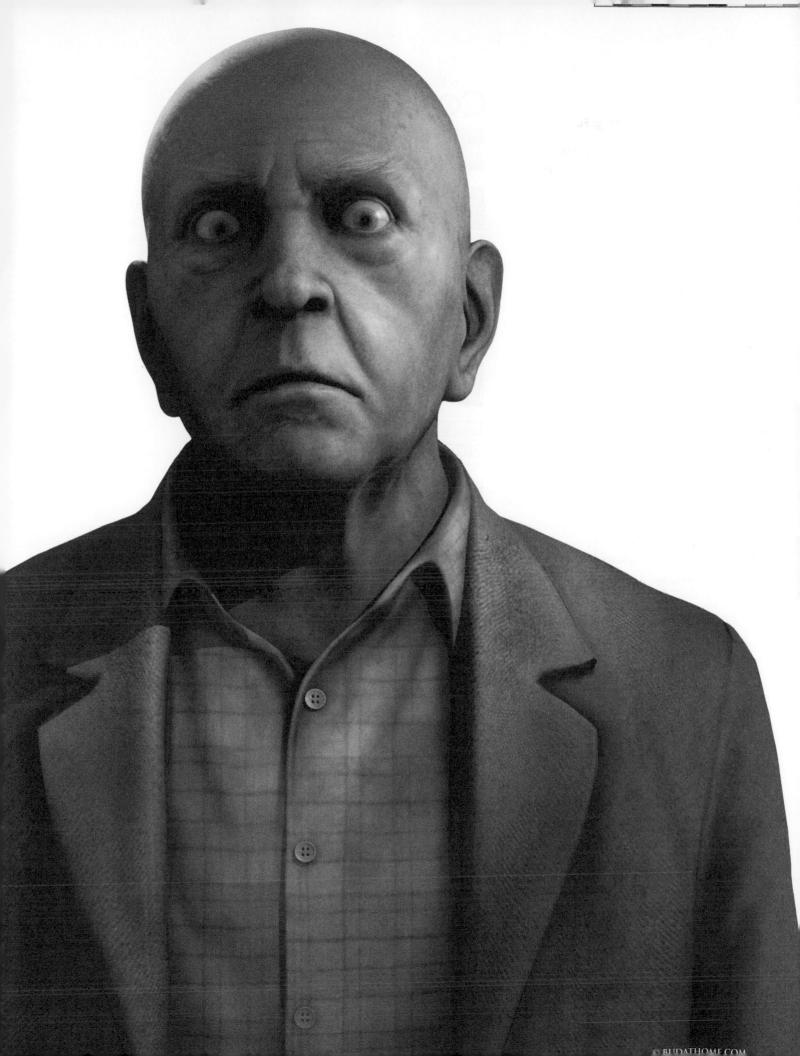

CONTENTS

 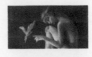 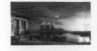 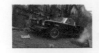

CONTENTS

 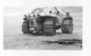

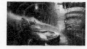
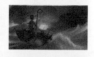 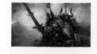
 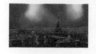
 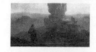

 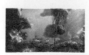

DIGITAL ART MASTERS
: VOLUME 2

COMPILED BY THE 3DTOTAL TEAM

CHRIS PERRINS LYNETTE CLEE RICH TILBURY WARIN GREENWAY BEN BARNES TOM GREENWAY

INTRODUCTION

Digital art is moving at such a pace and the ever emerging artistic talent is proving to be more than enough to harness the continual software and hardware advances. With such a wealth of digital imagery available the aim of *Digital Art Masters: Volume 2* is to provide an annual record of some of the greatest digital art works achieved to date and to give these artists an opportunity to inspire others with an insight into their creations.

Following the success of our first book, we announced a call out for entries for this second volume and the response was overwhelming; even after filtering out the most appropriate submissions the panel of judges were still faced with the daunting task of reducing 500 excellent images down to a final selection of just sixty. This response is yet another sign of the incredible growth of the digital art industry as it is fueled by the many Internet communities, such as 3DTotal.com, which allow artists to meet, share and learn from each other.

For this volume we have joined forces with publishers Focal Press, an imprint of Elsevier. We are confident that, with their experience and worldwide networks combined with the leading talent of the digital art community, this book series will strengthen further and will be accessible to a much wider audience.

Final thanks must of course go the 58 digital art masters featured on the forthcoming pages, who represent five continents and thirty countries. The combination of their cutting edge skills, talents and mastery of both traditional art techniques and software knowledge provide us with this volume that is sure to educate and inspire artists everywhere.

TOM GREENWAY

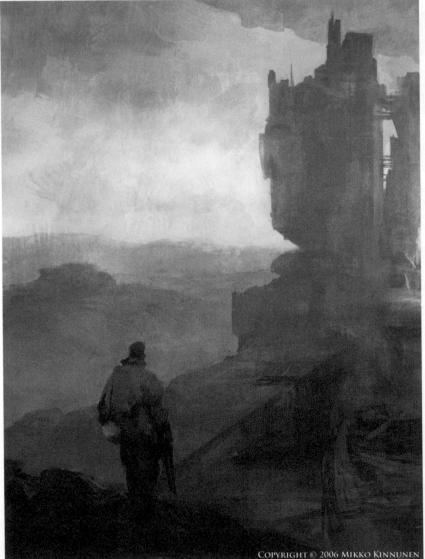

COPYRIGHT © 2006 MIKKO KINNUNEN

FOREWORD

Digital Art Masters: Volume 2 has succeeded in bringing together some of the finest talent from across the globe. As a digital artist, it gives me great pleasure to be given the chance of participating in this celebration of artistic achievement. Together, we share a common passion, and the digital revolution has allowed us to explore our creativity in ways that were once impossible.

In recent years, digital art has taken huge strides. The continued hard work and accomplishments of those at every level within the community have launched it into mainstream consciousness as a valid medium for artists of all backgrounds, finally earning the recognition and respect it deserves.

Like any art form, talent must be coupled with a degree of technical skill and ability before true self-expression can flourish. Therein lies the beauty of the *Digital Art Masters series*. The flair and imagination on display in this book is paired with an insight into the creative process behind it. The variety of subject matter and diversity of styles result in an eclectic mix that is testament to the evolution of the medium. The art exhibits more than just personal talent, it represents the greater community and shows the world that digital art has matured in a way that allows artists to achieve their visions without limitation.

All of the artists featured in this book have poured their heart and soul into the work that so elegantly graces its pages. I applaud the efforts of 3DTotal and Focal Press for supporting them, and providing an outlet through which they are able to share their hard-earned knowledge and talents for the education and enjoyment of artists everywhere.

I believe that we are entering a renaissance period for digital art, and I feel that this volume can influence a new generation by encouraging creative exploration. For those that have already embarked on a journey towards artistic enlightenment, may your voyage through this book provide a continued source of inspiration and fulfilment.

BY JOHN KEARNEY

www.Brushsize.com
Contact@Brushsize.com

© JOHN KEARNEY

© JOHN KEARNEY

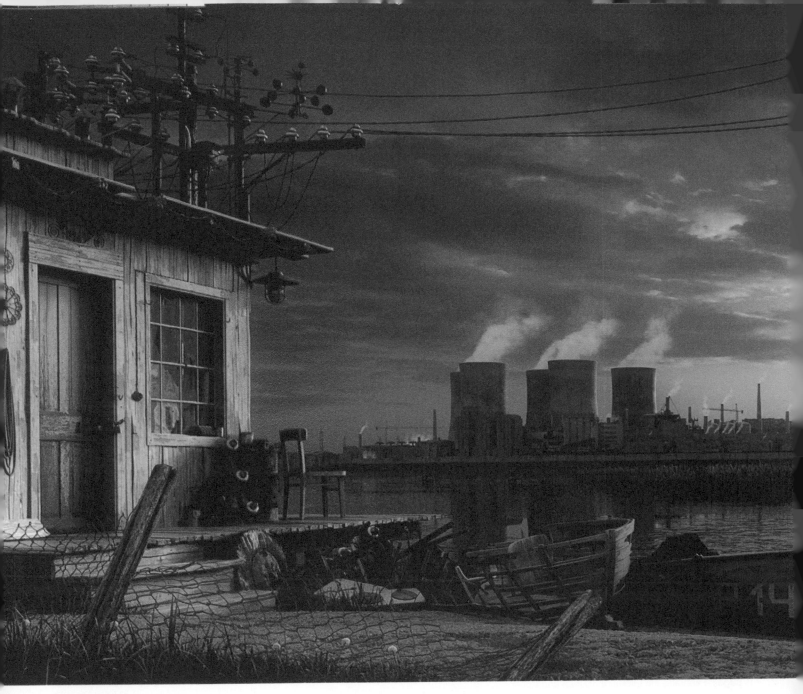

HERITAGE

BY MAREK DENKO

INTRODUCTION

In the beginning there was an idea, which came to me whilst I was watching the movie, *Stalker*. It is a movie from 1979, directed by Andrej Tarkovskij, and I really enjoyed it. The movie is one of those films that is quite hard to understand. The environments in this movie are just awesome. At the end of the film there is a nice scene where the whole family is walking on the shore of a lake with a nuclear power plant in the background. The scene is a bit foggy and has dirty, old snow on the shores, and it is so gray and depressing, just as eastern Europe and Russia once was. This was my initial inspiration and the reason behind the creation of my work, *Heritage*. Although, in the end, my image was quite different to the

picture painted by the film, *Stalker*, but it did remain as my starting point throughout. Another important element in the picture is the presence of the transmission towers, which are so romantic during the sunset, and I really like these kinds of structures. So my first inspiration was the nuclear power plant from *Stalker*, followed by the transmission towers.

I spent more or less two months of my free time on this piece, with gaps when I was traveling. I enjoyed all parts of the image, step by step, during the hot summer nights whilst I was working in Italy. So, over the following pages, I'd like to write about how I created *Heritage* in a step by step format, from searching for references through to modeling, texturing, shading, lighting, rendering and, finally, post-production.

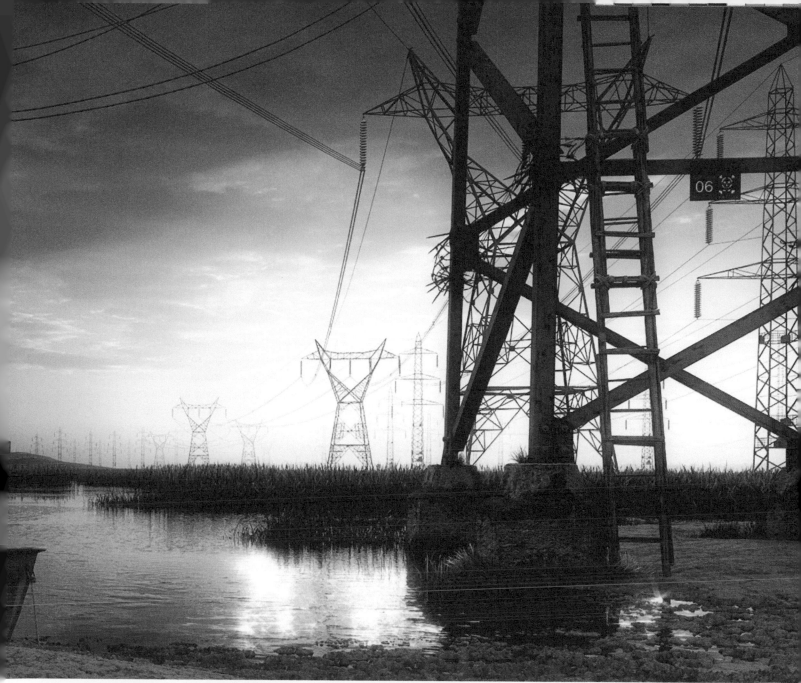

References

For me personally references are one of the most important parts when I'm creating my images. Usually I spend several hours searching the Internet and my photo library trying to find the best references. Very often I just go outside to take new pictures if need be. You should never underestimate this part of work. In your references you can find a lot of interesting things and details which are very hard to represent if you don't see them directly. They are very helpful for modeling, texturing and shading (Fig.01a–f).

Fig.01a

Fig.01b

PHOTOGRAPHS COURTESY OF THE ARTIST

Fig.01c

Fig.01d

Fig.01e

Fig.01f

MODELING

For me, modeling is really quite relaxing. I added so many more details in my models than I have done before, and really enjoyed the task. I agree that it was definitely not necessary to model all of these details, but in my personal works, where I'm not pressured by deadlines, I'm free to spend more time on these areas. All geometry was modeled in 3D Studio Max as editable polygons. In most cases I started from primitives, such as a plane, box, cylinder, sphere or line, and after few deformations I usually converted them to Editable polys. Then I applied extrusions, bevels, chamfers, cutting and all those modeling tools which are available in your 3D package (in this case 3D Studio Max). I usually use several types of modifiers to deform or change the geometry. For example Symmetry, Bend, Twist,

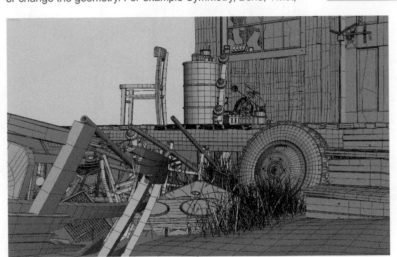

Fig.02b

Fig.02c

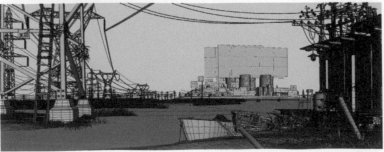

Fig.02d

Taper, Free Form Deformation, Noise, Displace, Turbosmooth, Wave, Ripple, Path Follow, and so on. If you are a beginner in 3D you should read the accompanying manual and try to understand how everything works but, trust me, the modeling of static objects is one of the easier parts of 3D. I essentially used an Editable poly with functions such as connect, slice, weld, cut, extrude, bevel, chamfer, and so on. Again, I'm sure that all of these functions are described in your user reference. If you want to be a swift and precise modeler you need to know your tools as best as you can, so take the time to study them and try them out. Don't avoid solving things for yourself as opposed to posting questions in forums, as there is no substitute for learning through experience. I'd like to mention that, for the grass modeling, I used a script called *Advanced Painter*, by Herman Saksono, later upgraded by my friend Federico Ghirardini. This script allows you to do something similar to Maya's PaintFX, but in 3D Studio Max. Another useful plug-in I used was Greeble, which allows you to create "Death Star" like surfaces with a few clicks. I used it to create certain parts of the power plant (Fig.02a–d).

UV MAPPING, TEXTURING & SHADING

If there is something I find boring in CG it is definitely making UV maps. For these I used basic planar, box and cylindrical mapping almost everywhere. I always unwrap only those parts which really require it. In this case it was only the concrete part of the transmission tower in the foreground. This is mainly because this part is displaced with a V-Ray displacement modifier, and to have a continuous displacement you need to have continuous UVs. There is a lot of displacement which is just great in V-Ray, but I was very careful about where to use it. It's hungry for memory and slows down the render times, but the end result is much better. For texturing I used textures from my personal library, pictures I had taken, and also from www.environment-textures.com. This is the biggest reference library of environment textures that I know. I also used a lot of dirt textures from the 3DTotal Textures collection. These are some of the most used textures in my personal, as well as professional, work. I used a V-Ray material as a base shader

SCENES

Fig.02a

for all geometry. Very often I use low intensity, fresnel, glossy reflections. In general, raytraced reflections also increase rendertimes but they help to create a more natural and believable looking image. For smoke on the power plant I used pre-rendered images. I made them with ParticleFlow and Afterburn and then I projected them onto planes (Fig.03).

LIGHTING AND RENDERING

For the lighting I used a V-Ray dome light as a skylight and one directional light for sunlight and didn't use Global Illumination this time. I wanted a high contrast in the image and therefore the bounced light was not that necessary. The image was rendered to a 2000 pixel width resolution with the Mitchell-Netravali anti-aliasing filter to make it a bit sharper. It was quite a nightmare to render it too, and took something like sixty hours on my laptop (Centrino duo processor with 2 GB of Ram). Of course there are many options to optimize the render time; more than half of the image could be a matte painting. Despite this I still think that I spent the time wisely while working on it and finishing it in 3D. Computer graphics is my job but it is also my great passion and I really like to play with the details in my work. Actually I'd like to point out that I've already optimized this scene for animation reducing render times to about 10–15 minutes in HD resolution on the same hardware. So in the near future it is quite possible that you will see it somewhere online.

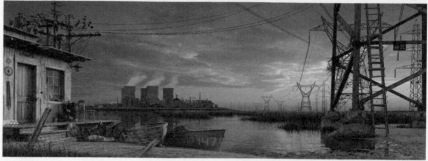

Fig.03

Fig.05a

Fig.05b

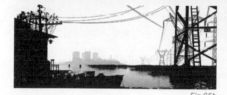

Fig.05c

POST-PRODUCTION

For the post-production I used Fusion 5. It is great compositing software and in Fig.04 you can see a short and simple flow. In Fig.05a–c you can see the passes that I've used. There are two rectangle masks for masking the area of highlights and area of fog. Note that in the fog pass there is still reflection on the water. For this pass I used a black material for all objects except the water which has the same material as in the render pass. From the coloring point of view I decided to use a green/yellow tinting which usually represents sickness, illness and depressiveness, just like the scene suggests.

CONCLUSION

I believe that, if you have read this, then you understand some of my techniques and how I work. I'm not saying that my way is the only way, and indeed the right way, but I'll be happy if you accept this making of my artwork as me sharing with you, my "Heritage".

Fig.04

ARTIST PORTFOLIO

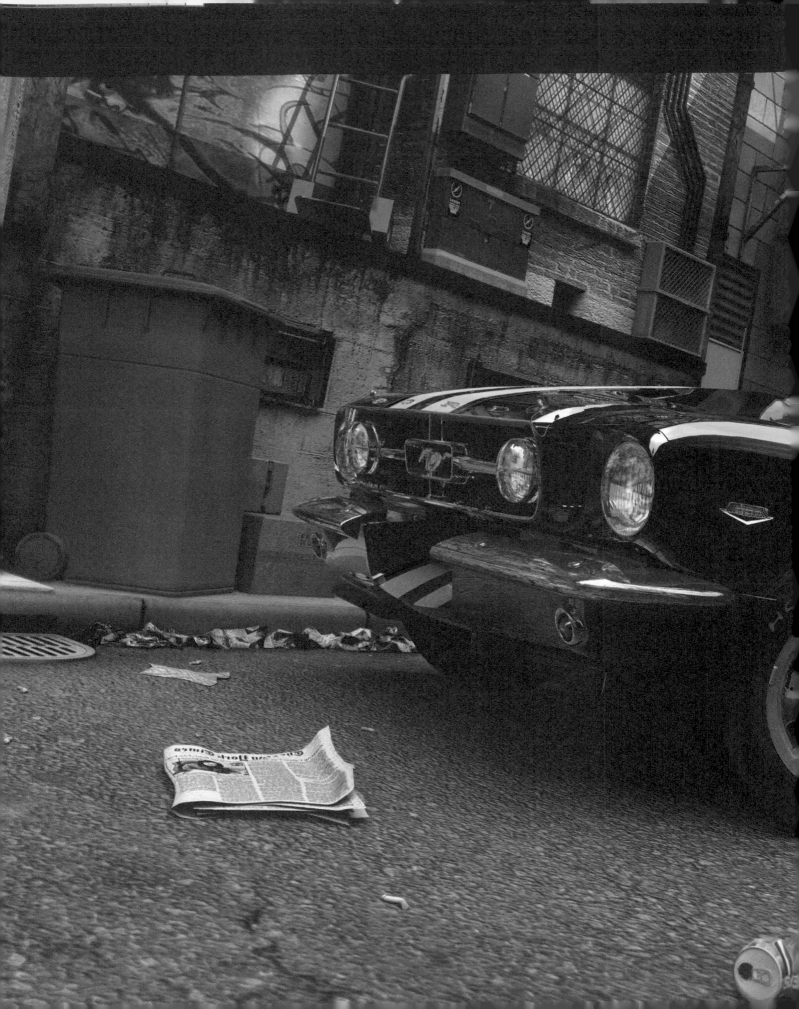

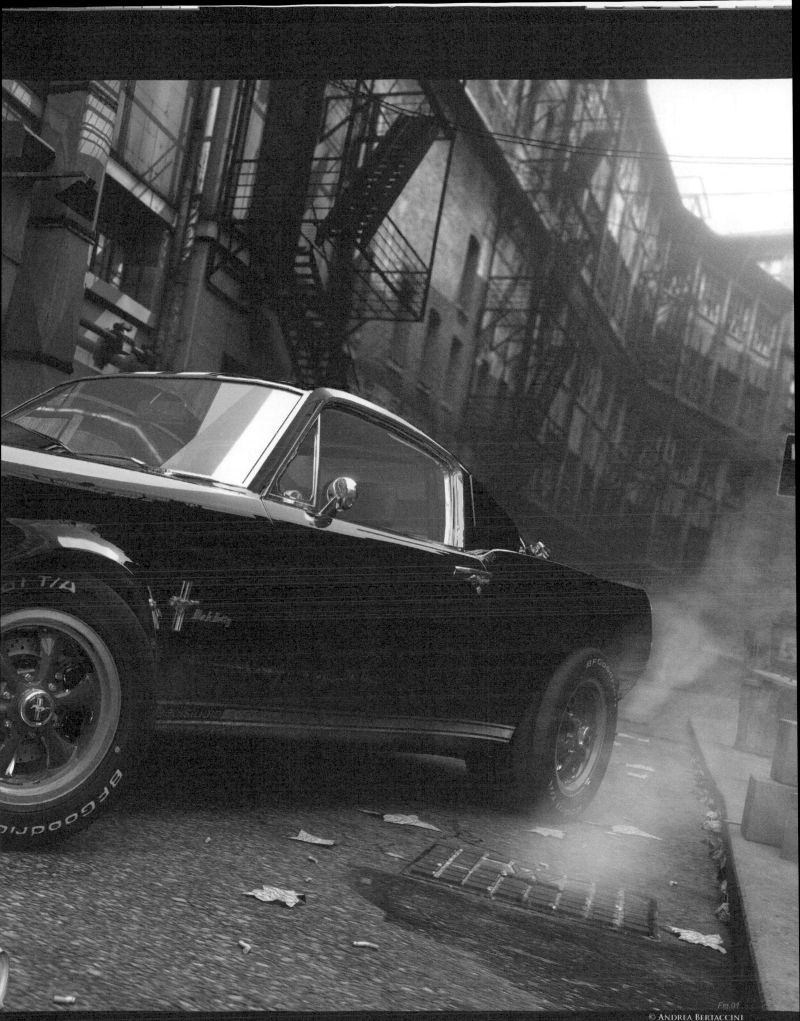

Dark Alley
By Andrea Bertaccini

Concept

I have always loved the Ford Mustang ever since I was a little boy and I saw it for the first time in the movie, *Bullitt*. I consider it myself to be an icon, as is its driver, Steve McQueen. I wanted to create an image which was not just a reproduction of a car, but I also wanted to give it a look that identifies my own idea of the car. I spent time looking for an environment which would give the car a dark and "bad" aspect, which is how I imagine this "muscle car". I considered an alley of a nondescript American city, where the light could not reach the ground, so the illumination was soft and low, even during the sunniest of days. The alley had to be dirty, with lots of garbage, pieces of paper at the side of the road, cigarette butts on the ground (typical of the sixties and seventies), abandoned newspapers, trash cans and floating smoke escaping from the drains. The pencil sketch helped me to visualize what I had in mind (Fig.01).

When I have an idea, I try hard to focus it in my mind, and then I sketch it down using a pencil, further developing the details. I don't think this is necessary, but I do feel that it is the best way, because it helps you to visualize the final project and gives you the ability to better understand it – the scene, the vehicle, and so on. In past times we always used pencil and paper, and today we have the computer, but the ability to take an idea to the drawing board has never changed.

Modeling

I started modeling the car using a blueprint image, found on the Internet, along with several images of the Ford Mustang, on dedicated sites, such as http://bradbarnett.net/mustangs. I created all of the models in 3D Studio Max 8 beginning from a plane, and used Edit Poly to optimize the number of polygons used (Fig.02). I usually avoid modeling in Nurbs because it immediately seems intuitive and fast, but it creates very complicated and heavy

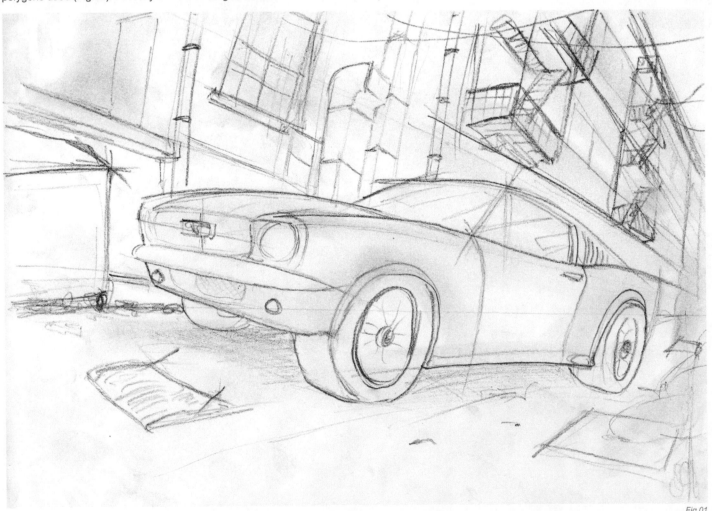

Fig.01

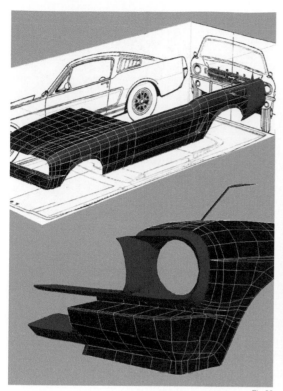

Fig.02

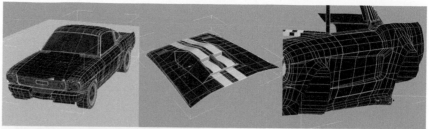

Fig.03

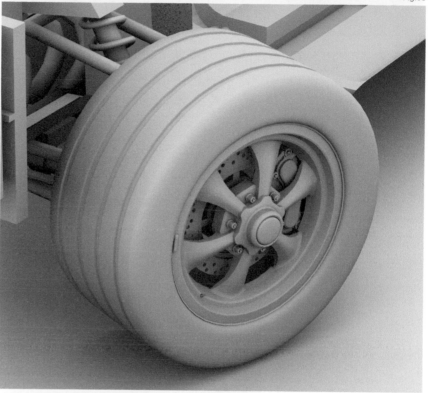

Fig.04a

models. You can have a little control over them, and if you have to do animation then you'd better have a renderfarm, or it can be very difficult.

I started to model in low poly and only worked on half of the car, so that I could better manage the polygon detail. I was then able to use the Symmetry modifier and Meshsmooth modifiers to achieve a smooth result.

After making a silhouette of the car, I started work on the details until I had obtained a standard version of the Ford Mustang Fastback 65. Then I worked on the tuning of the car and, in fact, the final car is a "tuned" version of the Mustang, I added larger sides to it, as well as a back aileron, a bumped cowling and side tail pipes (Fig.03). Once the fine tuning was finished, I added all the final details, like the logos, the cowling cable (detail from the Shelby version of the Mustang) etc. Afterwards I turned my attention onto the wheel (Fig.04a–c), which was a very detailed part of the car, because it is seen in close-up detail in the final image.

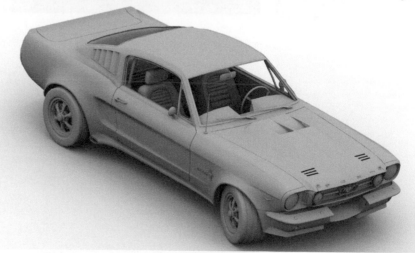

Fig.04c

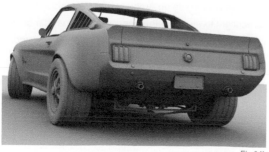

Fig.04b

The alley had to be narrow with high buildings, with back doors on the ground floor and a depository security exit. I added some details, like the electrical cables, an air conditioning tube, street signs and the fire escape staircase, which is typical of an American back alley. The final part of the modeling was all the ground details, like the garbage, pieces of paper at the side of the road, fag butts on the ground, paper boxed and everything else which adds to the sensation of a realistic, dark alley (Fig.05a–c).

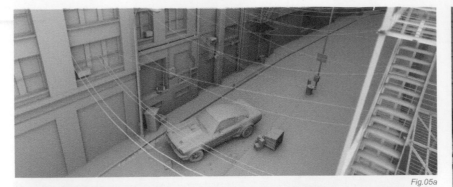

Fig.05a

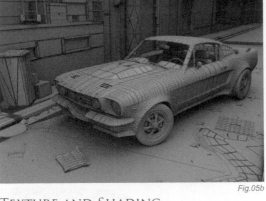

Fig.05b

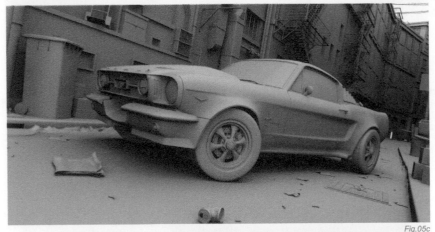

Fig.05c

Texture and Shading

The textures were created in Photoshop, using photographs taken in the United States. The most complex part was the creation of the textures of the ground and buildings. In fact, the ground was only one high definition, large texture (3000x1048 pixels) from which I made all of the masks: diffuse, specular, and so on (Fig.06). For the buildings, I used real photographs of windows, and the bricks were pasted together to build up a dirty façade. I then applied the texture to a flat surface in 3D Studio Max and made some cuts and extrusions to give a three-dimensional effect.

I paid particular attention to the car shader. Because the setting is a dirty alley, the car also needed to be dirty on its surface – it just could not be a clean car. The definition of the car shader was based on the HDR maps. I mixed the real Ray tracing reflection with the HDR maps, emphasizing it on the side with a falloff mask, giving more reflection to the surfaces perpendicular to the point of view, as in reality. The dirty effect were done with some mask maps applied at the color, the reflection, the glossiness and specular level, so that I could have less shine and reflection on the dirty surfaces (Fig.07a–c).

Lighting

The illumination was quite simple: I used the Brazil rendering system and the global illumination render engine, to give the whole scene a soft illumination, without marked shadows. I put an HDR map (the same as the reflection) as an Ambient map, and also used a Direct light to simulate the sun, which was visible only on the highest part of the buildings, not on the ground. Towards the end I added some Omni lights with Area shadows to increase the specular light.

COLOR TEXTURE

Fig.07a

REFLECTION MASK

Fig.07b

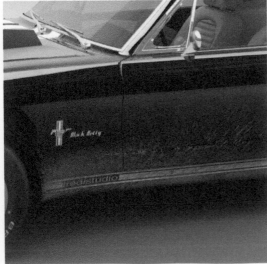

Fig.06

Fig.07c

Rendering and Post processing

Before starting the render I gave a different Object ID to the scene objects to use later in Combustion. I rendered all of the images in different sections, with the files bigger than 2500 pixels, and then I joined them together.

As mentioned earlier, I used Brazil from Splutterfish to render the scene. The rendering took eight hours for a 4442x2800 pixel (about two hours for each section). I rendered everything using the RPF output format, so that I could open it in Combustion, for the post-processing effect. The RPF file contains a lot of information about the depth of field, alpha mask, render ID, as well as other things. Inside Combustion it's possible to work on the effects in real time. This effect could take a long time if using 3D Studio Max, but with this you have a preview control for the fine adjustments.

First of all I made the glow and the fog effects using the RPF file, and the Z-buffer information inside it. For the smoke coming out of the drains, I used the particle system inside Combustion to create a realistic smoke effect. To obtain a real effect I used the Z-Buffer operator to achieve a depth of field effect (Fig.08a–d). Finally, I added a final touch, with some color corrections, to create the dark look that I was aiming towards.

Conclusion

The final image has something different about it when compared to any "normal" image of a car, but people will inevitably have to decide upon this for themselves. What I do know is that I really enjoyed creating this image, and so to conclude as Bugs Bunny would, "that's all folks...".

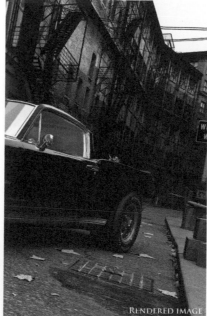
RENDERED IMAGE
Fig.08a

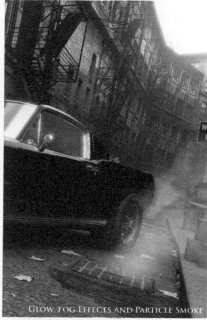
GLOW, FOG EFFECTS AND PARTICLE SMOKE
Fig.08b

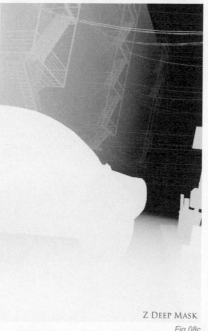
Z DEEP MASK
Fig.08c

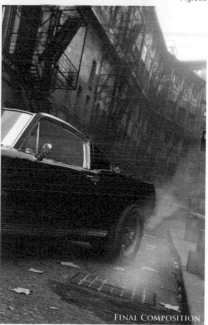
FINAL COMPOSITION
Fig.08d

ARTIST PORTFOLIO

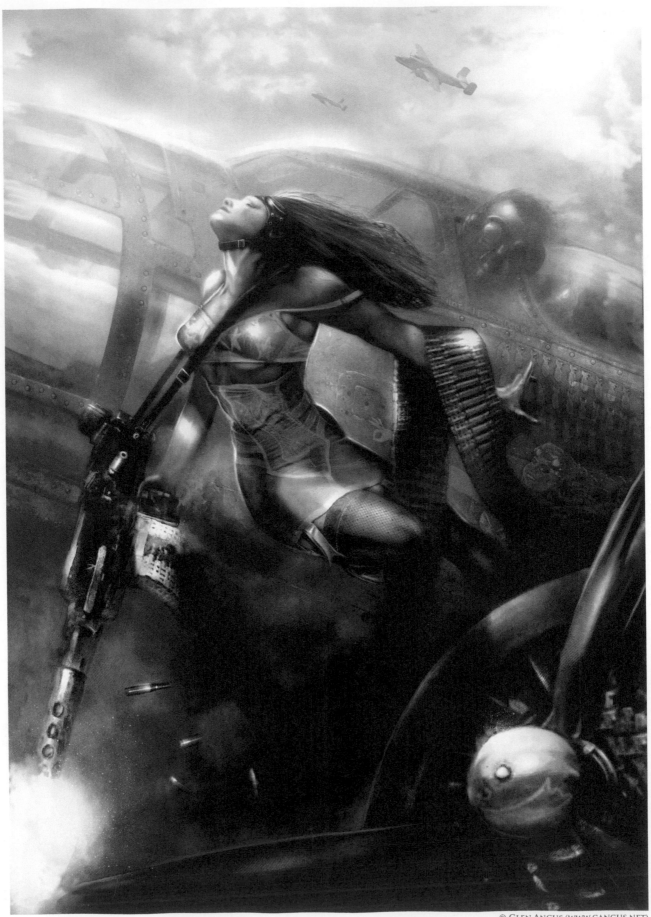

VICTORY GAL

BY GLEN ANGUS

INITIAL CONCEPT

This piece was one of those great inspirational moments where you find yourself just drowsing off in bed for the night, and then – in a flash – an image just appears in your mind. For a long time I've been mulling over what type of signature series I should paint for myself. I have recently turned my efforts inward and away from freelancing to try to better my artistic skills. Why not paint something that I love to do?

I have always had a passion for history, especially that tumultuous time in the 1940s during the war, when fascinating technological advancements were born out of pure survival and necessity – specifically aircraft and submarines. In this case it was my love of World War II aeroplanes that surfaced. I have also been a huge admirer of pin-up art. One must of course acknowledge influences like Elvegreen and Vargas here. My thought was, "how can I marry all of these elements into a cohesive and moving subject matter?"

The answer was to "angel-ify" these beautiful women painted on the front of the planes, coming to life into some type of a protective spirit, or totem.

What followed after this initial piece was a series of follow-up images that have gathered a small, but extremely generous and appreciative, group of followers on sites such as ConceptArt and CGSociety. One of my favorite patrons of this series better described my passion in this endeavor, which is much better in his own words than I could ever do:

"…as I see it the women nose art on the planes is more of a ritual between the warriors… It was like putting a woman on the plane was like giving your plane an actual spirit, and identity, as the pilots were trusting their lives to their planes…the symbolism of protection and guidance through hardships and sometimes guidance and protection to the afterlife… I see it more like their guardian angels, they took care of their plane and the plane took care of them in return…just like old sailors did when putting woman figures in their front of their ships…it was the feeling of protection and becoming a group and raise morale before going to the unknown…" – Carlos Arellano

Armed with so much inspiration, this image quickly took shape from the concept in my mind, down to a flowing composition, right from the start (Fig.01).

Being that the first concept was down on the page I had obvious anatomy issues to work out. Some points did not get fully resolved until the final touches and personal revisions of the painting were made. This is an example of one of the early preliminary pose studies that I was working through along the way – in this state there were still concerns about her arm and leg positions in comparison with the turn of her upper torso. I am always trying to get to a state where my figures appear natural, even if they are stylized in their anatomy or free in their pose (Fig.02).

The most difficult challenge for me with this painting was to capture that moment and set the tone in a tasteful manner so that the image wasn't just a painting of a girl in her lingerie. For me, it was all about setting the right mood and ethereal feel for the painting.

Fig.01

Right away I wanted her to have an "other – worldly", transcendent carelessness to what she was doing – focusing her attentions on the pure act of soaring above. As you can see in Fig.02, I worked with several poses and subtle cropped angles of the piece until I got it just right.

The next priority for me, before indulging in the details, was to make sure I could lead the viewer's eye casually through the composition and then back to the main focal point, without any major leaps or breaks in visual progression. I always start with the main focal point, which is usually the main figure's gaze. The eye naturally follows up the direction she is looking and then slides back over the shape of the plane to one of the secondary focal points that stands out in contrast to the plane – the pilot's awkwardly jutting out head. He is looking down at her hand that precariously holds up the chain of ammo that snakes around to the balancing element in the bottom left-hand corner of the piece. The firing machine gun adds balance because of its stark contrast, tone and color compared with the rest of the piece. From there it is an easy walk up the prop of the plane to the engine, which points and leads the viewer's eye up her legs and back to the initial focal point. I have also added some basic overlay tones to help illustrate how I used various levels of lighter to darker areas in the painting to achieve an overall asymmetrical

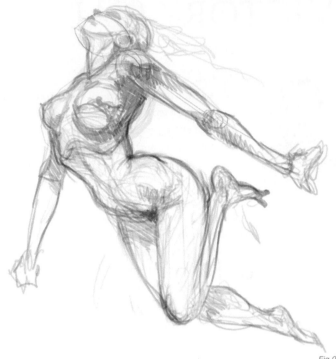

Fig.02

balance of values vertically. The area at the top has the largest areas of brightness, the center contains the majority of middle and dark tones, and then a small strip near the bottom balances the larger area at the top by contrasting light and darks together (Fig.03).

The yellow arrows represent the levels of intended eye movement. Even though there may be separate paths to break off, they always meet back at the beginning of the painting. The circles represent the initial eye-catching areas of the composition.

A great tip for illustrators who want to add that extra element of control and thought to their compositions: go out and buy a basic advertisement layout graphic design book. Apply all the basic design elements as pieces in your illustration. Things like focal points, flow, asymmetrical and symmetrical balance achieved with contrast, unity of shapes, color and values.

Lighting was key for this image to work as well. It had to come from above to give her that saintly persona. The difficulty in choosing such a strong light source is when it hits translucent (especially pale in this case) skin. I wanted to have it glow – but not to be mistaken for over dodging. Which if this piece precariously dances the edge on it is this one point. For me, it was trying to illustrate that delicate glow and use the strong shadows cast by her body to create interesting shapes on the gun and ammo string. The other solution that I had to solve with this dramatic lighting was to balance the

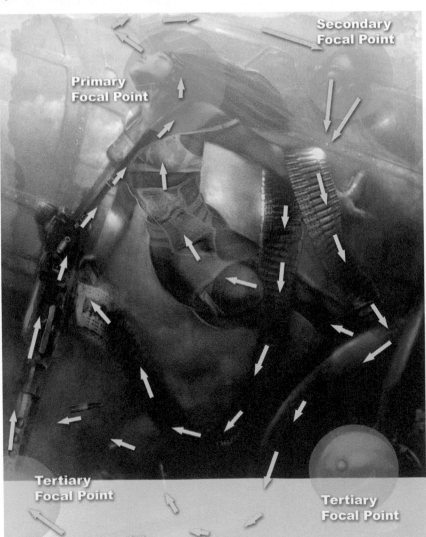

Secondary Focal Point

Primary Focal Point

Tertiary Focal Point

Tertiary Focal Point

Fig.03

SCENES

image so that it wasn't top heavy. I did this by using lighter elements, like the reflective tip of the propeller and the hot burst of color from the nozzle of the machine gun.

The rest for me was about balancing the colors and then using and finding good reference material for the historical pieces, like the plane and the gun. I especially went out and researched vintage lingerie and used elements of them and had fun designing my own corset for her to wear. A great place to find references for vintage lingerie – oddly enough – is eBay. I thought I would have been forced to lurk through vintage porn sites, but luckily came across some fairly thorough and tasteful dealers with tonnes of pics to get some great starts for fashion design ideas (which I have continued to use as starting points for following *Victory Gal* pieces). The last, and fun, parts to do were the little details, like the effect of the gunfire; a splatter of black ink scanned and then put on a hard light layer – inversed – and then toyed with the levels to take out the black background (Fig.04).

What I ended up with is one of the most influential pieces that I have accomplished personally in a long time. I feel that it works well as a composition but more so in indemnifying the art, machines and, more importantly, young pilots who fought in the greatest air battle in our world's history, in a tasteful fashion that still has a fun, fantastical flair. This image also inspired and set up several more images to come in a series of *Victory Gals* (as seen in my Artist Portfolio) and can be seen in a *Victory Gal* thread on ConceptArt.org and in my CG portfolio on CGtalk.com. I hope to continue doing more of these pieces, exploring the subject matter from different angles, emotions and representing all sides involved. Perhaps I will have enough *Victory Gals* in the near future to make a fun, but thought provoking, calendar for which I sincerely hope artists, war buffs and aircraft afficionados alike can appreciate and enjoy.

Fig.04

ARTIST PORTFOLIO

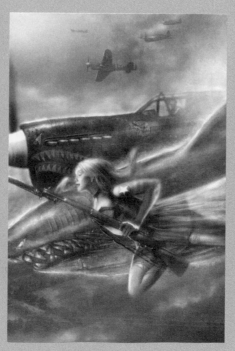

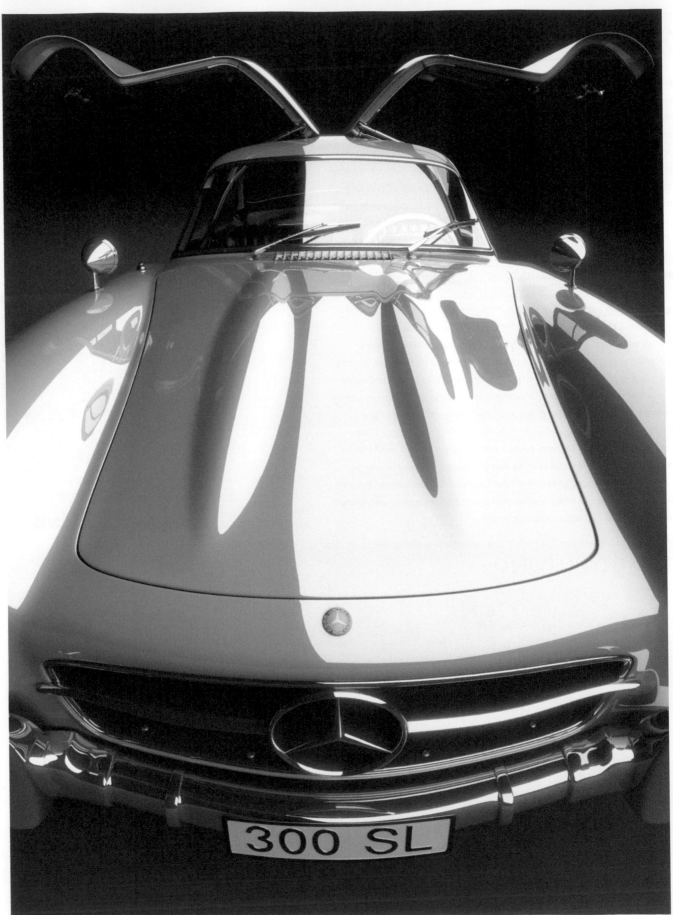

WINGS UP
BY HRVOJE RAFAEL

INTRODUCTION

The model of Gullwing, seen in this image, was my first, highly detailed model in 3D. It is actually my pet project that will probably never be finished. There is always something to add or improve.

The whole project started as a means to improve my modeling skills. At the time I already had a couple of years of experience with CAD software but little with "ordinary" 3D packages. Moving on from one to another is actually harder than it might sound at first. Both are used to create and render 3D models, but require different approaches. Parametric modeling that CAD packages offer is a very effective modeling tool but their greatest strength, which is precision and full geometric definition of shapes, proves to be their weakness as soon as you have to make any organic shapes. As soon as I learned something about polygon based modeling and subdivision it was clear to me that there is a lot of potential in it; I just didn't know how much. The best way to learn something is by doing it, so I decided to do something. Being somewhat of a vintage car lover, the decision was made to do a Gullwing. It is not just a car. Its unique design makes it stand out in the crowd and it is bound to be instantly recognized by both car enthusiasts and people who are interested in design of any kind. This proved to be a good choice because there is less chance of this kind of work being dismissed by a viewer as just another car (and there really are a lot of cars in the world of CG).

PREPARATIONS AND MODELING

There is little place for artistic freedom when making a model of something that exists, so it is not necessary to start with concept sketches unless no usable blueprints are available. However, it is essential to conduct proper research on the subject, gathering as much reference material as possible. Basically there is no such thing as too much reference. It can include any picture of the selected subject – photographs, sketches, blueprints, diagrams etc. Photos are usually the most reliable and they should be used to check if there are any mistakes in blueprints or other pictures. They are also used to cover all the fine details that blueprints do not show. Gathering all this material can take up a lot of time but it can also save a lot, later in the process. There is always some angle that is not covered in any individual photo (Murphy's law, I guess) but it is good to keep it at a minimum.

One last step before moving on to the modeling phase is the blueprints setup. It's not a difficult process but it shouldn't be rushed. I was lucky enough to find blueprints which were pretty accurate and I only had to cut out individual views. There was no need to squeeze or skew them in order to make the views align better, which can sometimes be the case. Different views were assigned to corresponding planes which were the same proportion as the real car in real world units. It is good to work in real world units because it enables you to merge objects into scenes without having to worry about relative sizes and it simplifies use of some lighting techniques which are unit based.

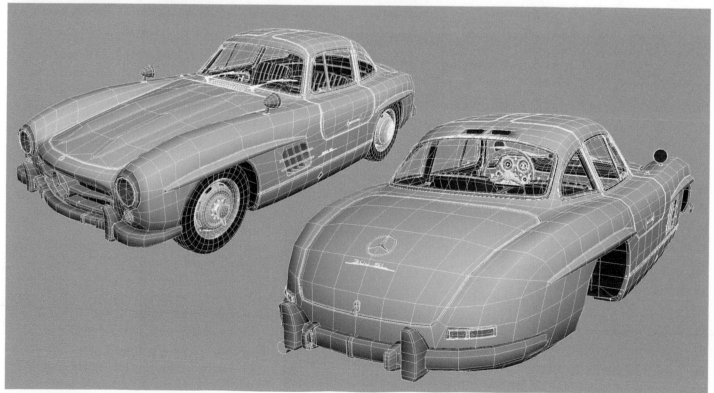

Fig.01

The model itself is polymodeled completely. Starting with simple geometry and then cut, extruded, etc. to its final shape (Fig.01). Nothing too smart, it just requires a lot of work. It is a slow and tedious process which can undoubtedly give you a headache but in return you get full control over your mesh. Most of the parts are subdivided except the smallest details, which are only box modeled to avoid unnecessary increases in the polycount.

MATERIALS AND TEXTURING

This model has seen a lot of different materials applied to it during its evolution. In a way, it has been my shader testbed. For this image I decided to go with all raytraced materials. Fresnel based falloff maps were used in reflective slots to give a touch of realism to the reflective surfaces. It also creates very nice gradient effects on curved reflective surfaces (Fig.02). Even glossy specular highlights were replaced with glossy reflections, since specularity really is just a fast approximation of blurred reflections of very bright objects. I don't have to say that it seriously increased render times, especially when the leather interior had to be rendered (Fig.03).

As far as textures are concerned, there are few of them. Only maps for the front badge, dashboard instruments and tires were hand-made and all others are procedural. Mainly, falloff maps were used for reflections, with cellular types for leather on the interior. That helped to keep unwrapping to the minimum!

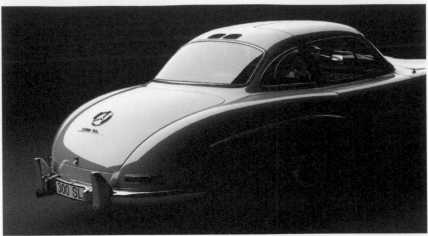

Fig.02

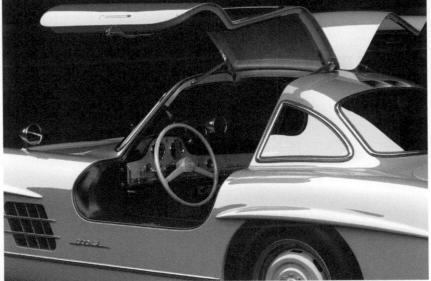

Fig.03

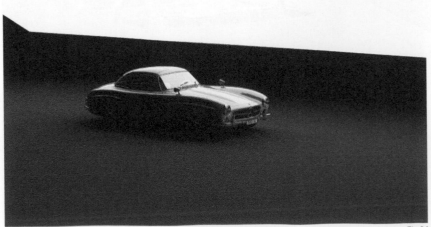

Fig.04

LIGHTING AND RENDERING

I had been trying to create a good studio environment scene for this car for some time when, one day, I saw a picture of one photo studio setup. It was used by a professional photographer to take pictures of vintage and concept cars. The pictures looked fantastic and it was clear to me that something similar would suit Gullwing perfectly. After some experimenting, this setup looked the best and was actually the simplest (Fig.04). There is only one area light and floor plane big enough such that its edges are outside the influence of light. That area light is rather big. It looks unbelievable but it is about the same size as the real thing. Implementing a smaller light plane doesn't provide reflections that cover the whole length of the car and expose the full curvature of the bodywork. There are no other fill lights or skylight; no indirect lighting or radiosity were used either. Once the studio scene was finished it was all about establishing the right angle for the image. This model was never intended to be used in a single image. Too much work has been put into it and I wasn't going

to let it go so easily. It is fun to have your own virtual photo studio and freely take pictures. I tried a number of different color schemes and angles but this one seems to represent this car the best. Revealing "spread wings" which reflect the cool, sky blue bonnet, with their distinctive bulges, shows that Gullwing is a truly well deserved nickname.

The final image was rendered in one pass, so little post work had to be done in Photoshop. The only thing that was added was a glow from the light and one duplicated base layer was slightly blurred and set to 50% opacity to soften some hard edges a little. To add glow I rendered one image without any light. The only thing that was visible was the self-illuminating light plane (Fig.05). That image was blurred with Gaussian Blur and used as a "lighten" layer on top of everything. And that is it. Difference between the raw render and edited image is quiet subtle but, in my opinion, it improves the overall mood of the image.

CONCLUSION

At the beginning of this project I had no idea where it would take me. During the process I learned almost everything I know about polygonal modeling and it enabled me to start exploring raytrace materials. Of course all of this was made easier for me by way of forum communities and all those people who share their knowledge by writing tutorials. So I hope that I was also able to help someone, even if just a little.

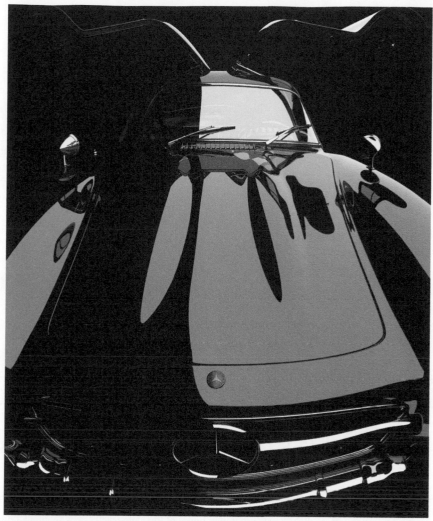

Fig.05

ARTIST PORTFOLIO

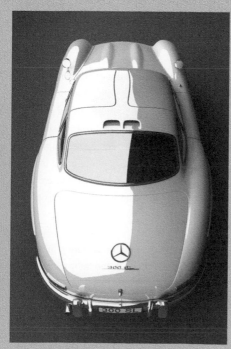

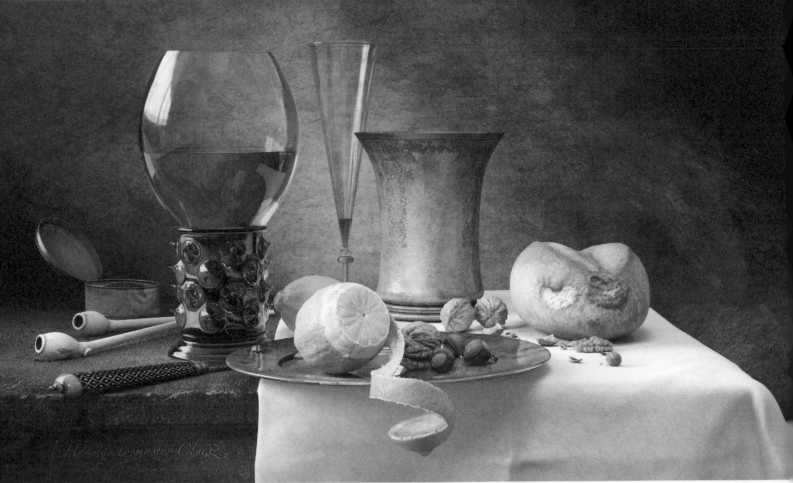

HOMAGE TO MASTER CLAESZ

BY KORNÉL RAVADITS

INTRODUCTION

This picture was created in honor of the Dutch still-life painter, Pieter Claesz (1596/97–1660), who, in my eyes, was the greatest of all the Dutch still-life painters. My goal was to recreate the particularly special atmosphere that shines through his pictures with the use of modern technology – peace and beauty in a little place, of simple means, where the eye can relax and the mind can meditate over the forms, lighting and details. I think this notion has proven itself to be a consistent ideal which hasn't changed among artists over the past four centuries. I didn't wish to simply recreate an already existent Claesz picture in 3D, not even out of simple respect. Instead, I aimed at creating a still-life with a new composition using elements of the Master's work as reference. The legendary objects which Claesz created in his works were a great challenge and inspiration for me in this piece.

MODELING

I used two different methods during the modeling stage: the simple forms were created with the lathe tool and a little polygon filling, and the organic forms were firstly created as low poly models, then subdivided and further sculpted in ZBrush. The process was finished in BodyPaint with the painting of the remaining textures. This last step was the most tedious, but was unavoidable, in creating the natural forms (Fig.01).

ROUND OBJECTS AND SIMPLE POLYGON MODELS

First of all, I drew the contour of the object using a bezier line to form the curve for the cup (Fig.02), I then applied a Lathe Modifier to create the volume of the cup. I next added tiny irregularities with the help of the Noise modifier to avoid the synthetic look of a perfectly curved model. The more difficult details were made from an Editable Poly, with further subdivisions, to achieve a continuous surface. The final stage was to create the UV map.

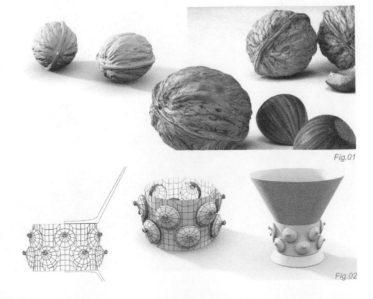

Fig.01

Fig.02

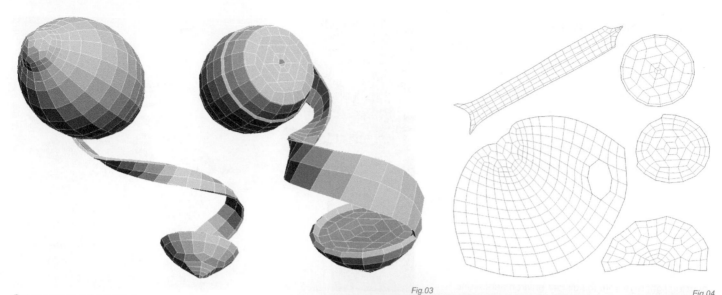

Fig.03

Fig.04

ORGANIC MODELS

I used the following steps. In order to build the model of the lemon I made a low poly object making sure to maintain similar sized quads across the surface (Fig.03). I then unwrapped the low poly model to prepare for texturing as it is far easier in this simpler state and the UV coordinates are preserved when further subdivisions are added later on (Fig.04). The next phase involves subdividing the low poly model and sculpting the details in ZBrush in order to generate the displacement map. The practical way of working is to start with the overall form and gradually work towards the minute details (Fig.05). I also generated a "cavity" map to help the texturing process. This can be a good starting point for painting the textures because it contains information on the smallest details (Fig.06). The intermediate-level model is then exported for texturing in BodyPaint. The definition on this model will not provide the final details, but we can work quicker and smoother in BodyPaint later on as a result. The next step was to paint the diffuse, bump and specular maps in BodyPaint (Fig.07–09) followed by a few test renders...or many as is often the case. During this testing phase it is possible to make continuous adjustments to both the models and the textures if need be in order to find a satisfactory result (Fig.10).

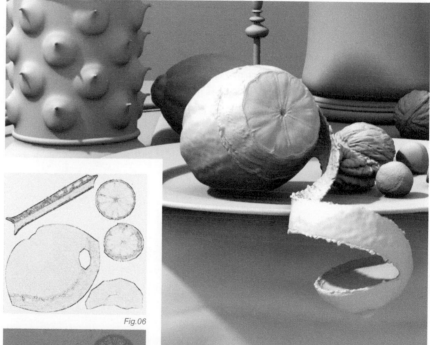

Fig.05

Fig.06

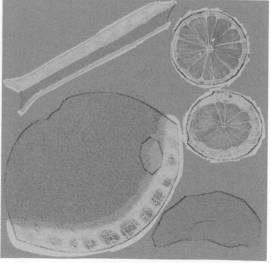

Fig.07

Fig.08

Fig.09

TEXTURES AND SHADERS

I used only two different shaders for the different objects, both of which originated from the base V-Ray material shader. The simpler one was created for the glass and metal objects and, apart from the reflect/refract, color and opacity settings, I used only one additional dirt layer. For the metals I also used one extra grayscale map to control the specular and bump properties. For the more organic surfaces I hand-painted the following maps: diffuse, bump, opacity, specular, reflection and SSS-mask, alongside using a general occlusion map in some cases (Fig.11a –e).

LIGHTING

I used the classic three-lamp setup: one key light and two fill lights. The two fill lights were used to simulate the bouncing light rays from the distant environment – one from the bottom and another from the side (for example the floor and wall). For the subtle reflections between the objects I turned on the calculations. Coupled with this I also used an HDRI map for the reflective objects. Thanks to Global Illumination, we can now achieve nice lighting results that mimic a real photograph. This does however rely upon us placing our virtual lights in the 3D space in similar positions where a photographer would set up his/her physical lamps. I used V-Ray targeted spots with area shadows, which enabled me to control the shadow spreading nicely (Fig.12).

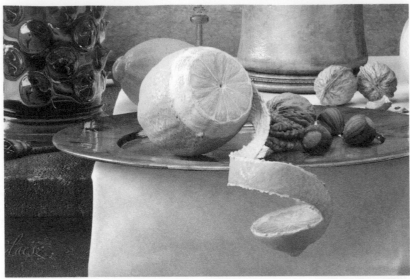

Fig.10

Fig.11a Fig.11b Fig.11c Fig.11d

Fig.11e

RENDERING AND COMPOSITING

The most difficult process is always the rendering; rendering high definition pictures of detailed objects with large textures slows down today's computers considerably, which is problematic when doing test renders. To achieve acceptable render times I used the scene partition technique and proxy models. I separated the scene into three different sections and later composited the three renders into one final result. Of course, with this technique, I had to pay particular attention to the lighting and reflections between the separated scene parts.

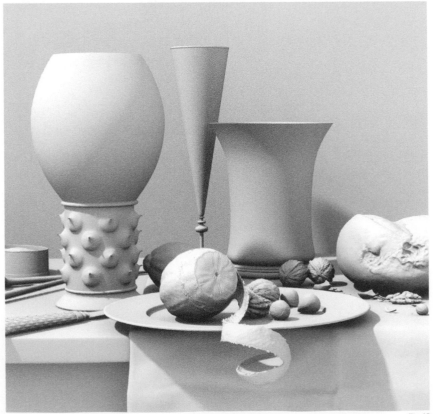

Fig.12

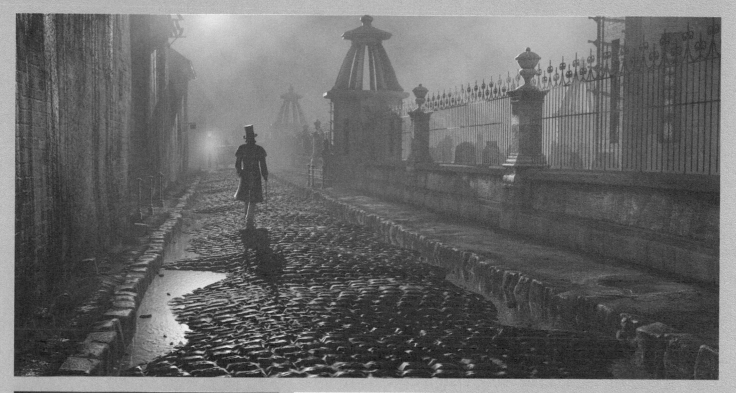

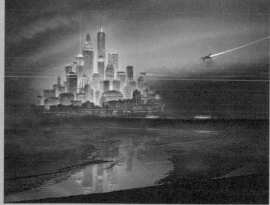

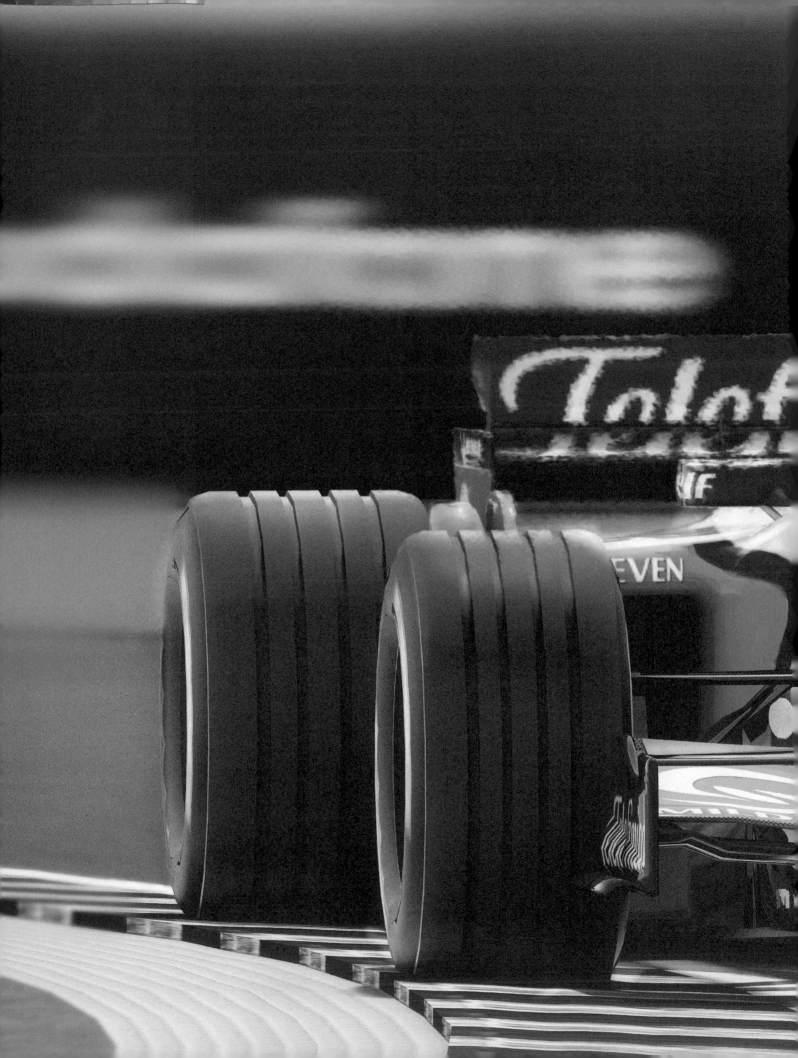

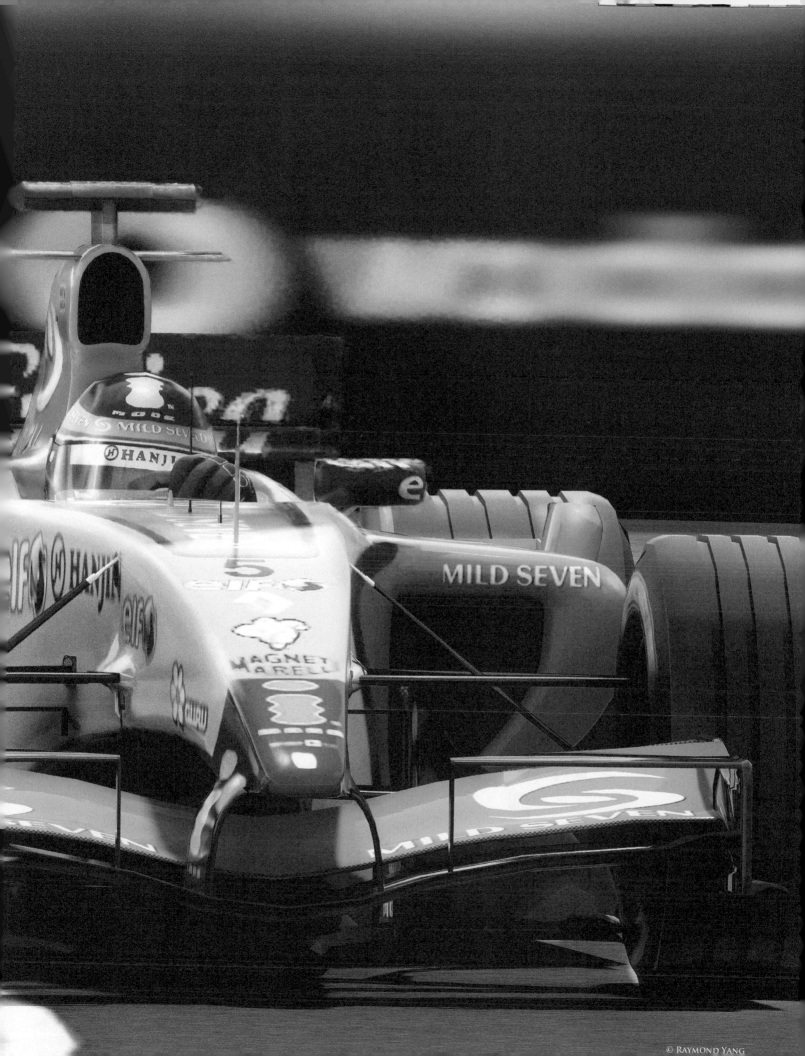

Fernando Alonso R25 Renault F1 Team

By Raymond Yang

Introduction

I have been a Formula 1 fan for almost a decade now, and I've seen a lot of great moments and classic action on the track by some legendary drivers. These great moments have been captured by photographers whose jobs are to record every single moment of the motor sport through their cameras.

I remember the moment when a TV commentator was yelling that Fernando Alonso was just one corner away from becoming the youngest world champion in Formula 1 history, and I was so excited that I couldn't wait to see the historical moment happen. Fernando Alonso did an amazing job throughout 2005 and achieved both driver and construction titles for the Renault F1 team. Being a Formula 1 fan myself, it was definitely a great moment to remember and enjoy. This image has been created using 3D Studio MAX with V-Ray rendering system, and Photoshop CS2 was used to create textures and to do the final image touch-up work.

I did as much research as I could by reading magazines and Formula 1 year books, searching through tonnes of images on the Internet, and looking at photos of miniature models. To get the accurate data blueprints for modern Formula 1 cars has always been a difficult process since the teams have to be very proactive about their design data and specifications. In order to create this image for it to look like an actual action shot, I also had to study a lot of motor racing photography, captured by famous photographers such as Bernard Cahier and his son Paul-Henri Cahier. Their images truly capture the greatest moments

of Formula 1 history and there is no doubt that it was great reference material for me in creating this image.

Modeling

To begin with, I collected a lot of reference images such as car profiles, shots from all angles, close-up shots, sponsorship logos and background elements (road, curbs, grass, crowds). One of the hardest things during the modeling process was that there were no actual mechanical data for me to base it on; hence my eyes became the best measuring tool to judge it if was too wide, too high, not smooth enough, etc.

I prefer to set up basic lighting in the scene during the modeling process, the reason being that it is easier for me to work on the model, e.g. if the curve looks correct based on the photographs, or if the smoothing group is set up correctly on each surface. In order to perfectly depict the unique design of the Renault F1 R25, I constantly rendered the model from each new angle, and I always had a lot of reference images available to cross reference with the model itself (Fig.01–03).

Fig.02

Fig.01

Fig.03

The entire modeling process went smoothly, but was also very time consuming. Apart from constantly hitting the render button and checking the shape of the car body, I needed to make sure every part of the body had been modeled correctly. The best way to make sure if the model looks correct is to work for an hour and then stop for a while, have a cup of tea and refresh your mind. Personally I don't prefer working on one particular model for ten hours a day; a good thing takes time, so I need to make sure I don't rush it (Fig.04).

The background elements were fairly simple, most of them being done with simple low polygons; the only thing you need to be careful of is making sure you don't overdo it, by which I mean making sure you spend time on the right things. We all know that action photographs are shot at a distance from the actual subject, and therefore whatever is behind the main subject is completely blurred, so there is no need for you to make everything in the scene in high detail.

TEXTURING

After the modeling process was done, then came the fun part, and the hardest part: the texture mapping. Formula 1 involves big money and sponsorships; therefore the entire car has been covered with logos and color schemes based on the title sponsors. Blue and yellow are the dominant colors of recent Renault F1 cars. Even though I had tonnes of images available for me to pick the color, it was impossible for me to pick the correct one from the photo references, because colors may differ between different times of the day, countries and weather. With this in mind, I referred to the colored modeling paints from *Tamiya*, and received many helpful suggestions from scale modelers (since they are very picky about the colors they use on their models). Another important thing was the logos that had been used on the car. A lot of logos that we see every day, on the road or in the stores, are a different form of the version that they use on sports cars, so most of the time I draw the logos by myself, if I cannot find the correct version that they used on the F1

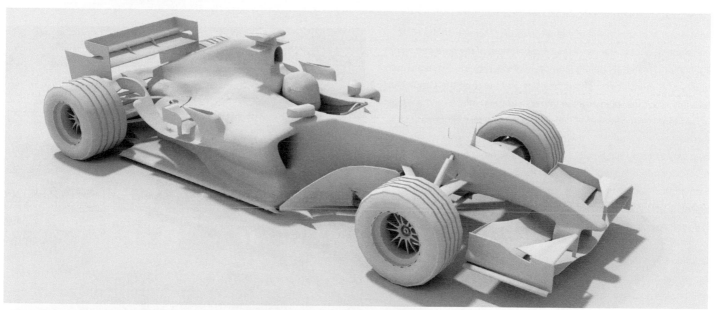

Fig.04

car. Most of this can be found through the Internet, but my only concern is that the resolution is sometimes too low for a large texture map size.

A lot of the textures in the scene have been based on the actual photos taken around the race track, and have then been taken into Photoshop to add detail and color corrections. My goal was to make this image look like an actual action shot, so instead of animating the tires and the whole scene, I chose to apply motion blur to the textures, which made them look like they are in motion. The mapping process went smoothly, but was also time consuming, and, again, it was a fun learning exercise and it's always fun to explore new techniques.

RENDERING AND LIGHTING

The reason why I chose V-Ray rendering system was because the rendering speed is unbelievably fast. The

Fig.05

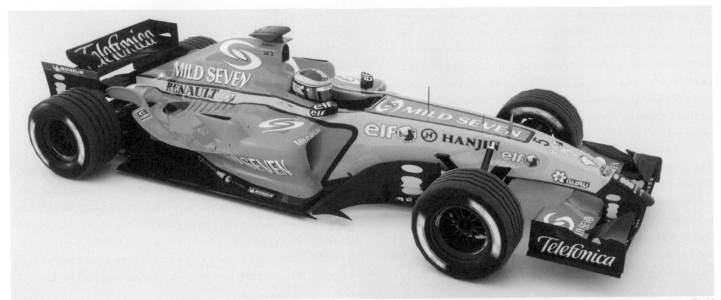

Fig.06

final result is amazing within a short amount of time, with the HDR contributing a lot to the rendering. I spent most of my time setting up lighting and materials during later parts of the project. There are many artists who are willing to share their tips and tricks on the Internet, in tutorials, such as setting up the current car paint effects and setting up exterior lighting scenes. These are available in abundance, but the best way to learn is to try to experiment and to come up with your own way of doing each task. Rendering is another time consuming process, and I often woke up during the night to check if the result was good. There was much frustration and happiness during this process, and you can easily spend a day just trying to figure out why the reflection doesn't look quite right (Fig.05–06)!

Lighting the scene also played a major part in this project. The entire rendering and lighting was all done within V-Ray rendering system, and post-production work was all done in Photoshop. The first thing I started with was correcting the contrast and color balance. I then also added motion blur and Gaussian blur onto the foreground and background to simulate the depth of field. My main goal for this project was to create a photorealistic image, and therefore the colors and contrast were all vital elements; the Renault blue and yellow was adjusted, based on real photo references, and I also applied a slight Film Grain effect onto the image to give it more realism (Fig.07).

CONCLUSION

Throughout the entire process of creating this image, there were quite a few tasks that cropped up which I wasn't quite prepared for before starting the project. It has been a fun project to work on, and most of time I was researching many techniques to make the image look real and attractive, although there are always things that you can find to fix to make the artwork look even better. As an artist, the process of creating an artwork is always enjoyable; watching the art work improve with every moment is simply a great feeling in itself for you to enjoy.

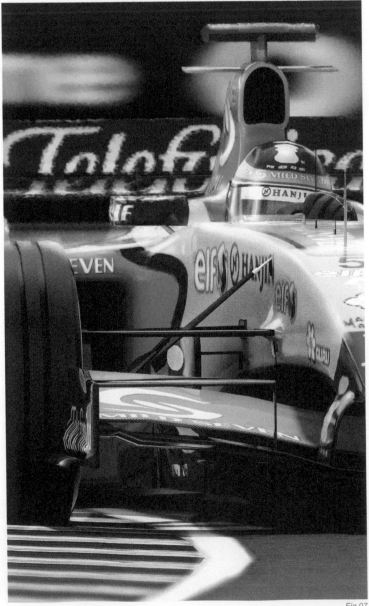

Fig.07

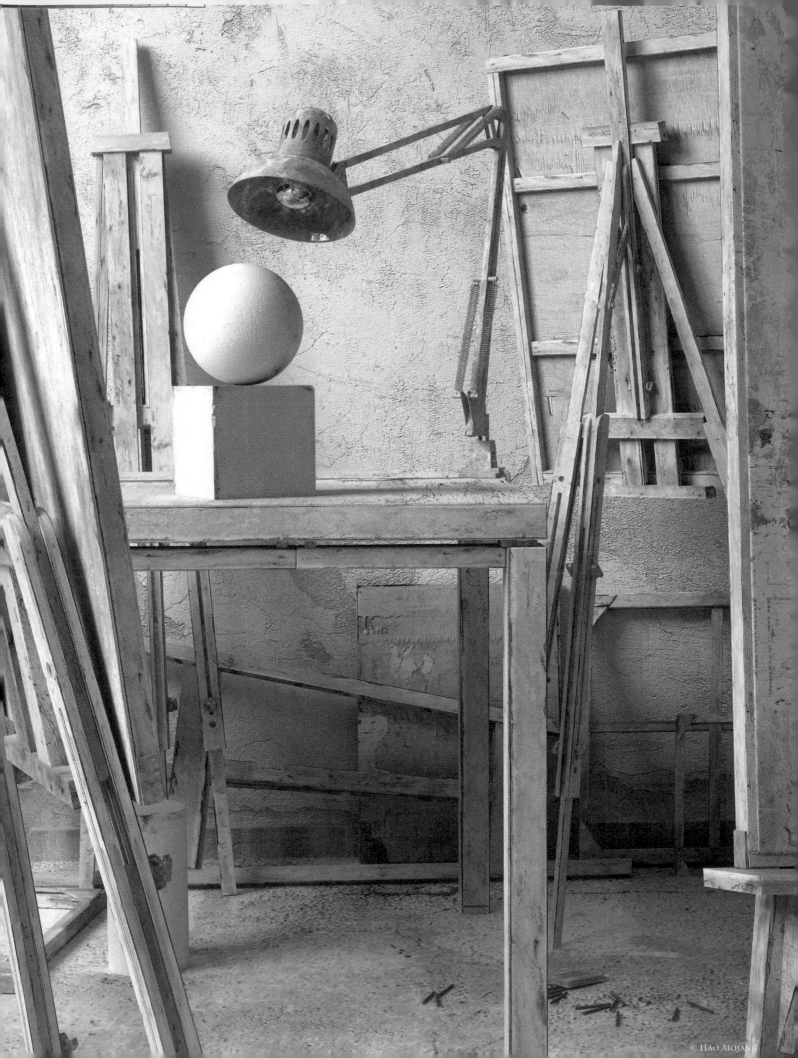

SKETCH LESSON

BY HAO AI QIANG

CONCEPT

The original intention of producing this piece, titled *Sketch Lesson*, was to cherish the memory of my childhood. I used to learn to paint pictures in an old house full of sunshine, and the scene has left a deep impression on me. It has been almost ten years since I have painted on paper, so I made up my mind to produce something to remember the life I once led...

The plaster geometry figures play the lead role in my composition, because they were the homework from my very first sketch lesson. I like the lamp very much, although I doubt that there were many like that in the studio before. And there are also many drawing boards and stands featuring in this work, which were not so old when I first used them, but I think that in order to make the piece work as a whole, the older objects work great in achieving the overall feel of the scene. The unused drawing stands, the broken drawing boards and the charcoal lying on the floor were the tools that I often used before, and I used them to enrich the general appearance of my pictures. All that I have mentioned above are the basic elements of my artwork, *Sketch Lesson* (Fig.01).

I was always the one person who got to the studio first before everyone else arrived, so that I could see what the studio was like when there was no one else in it – the sunshine, the shadows of the drawing stands and so on. How could I possibly forget all of these impressionable things? So, I therefore decided to express my feelings for this time and place through the use of CG (Fig.02).

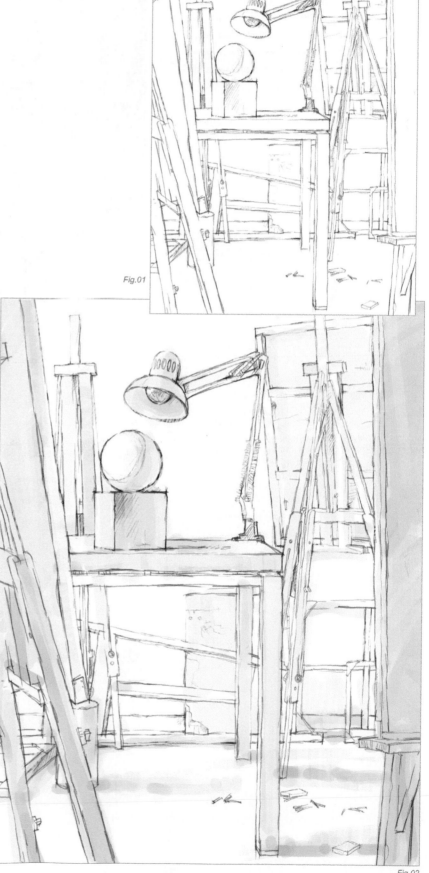

Fig.01

Fig.02

Modeling and Texturing

Some of the modeling was created by referring to photographic references (Fig.03a and b). Perhaps these references are a little different to my memory, but I decided to make the textures a little fantasy-esque. I used lots of resource materials on the layers, which were photographed mostly by myself and were also partly hand-painted (Fig.04a–d).

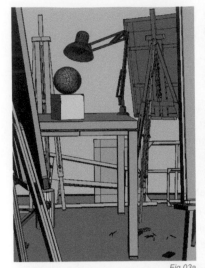

Fig.03a

Fig.03b

Fig.04a

Fig.04c

Fig.04d

Fig.04a

SCENES

LIGHTING

The Global Illumination helped me to use less lights, and therefore relieved a lot of work, but in turn it also forced me to have to spend much more time on rendering. The lighting setup was simple: the main light source was a V-Ray Light, and I used the Area Shadow to move the shadows to create the desired effect (Fig.05). There was no point in adding other lights, so what I needed to do was just to add in the Sky Light in the GI setup (Fig.06a and b). When rendering the lighting preview, I always made sure the map was turned off.

RENDERING

I used V-Ray for the rendering of this piece, because of its speed. V-Ray is used by many artists and companies in China. It seems that there can be some trouble in using different editions, but it's not really a big problem. V-Ray had many influences on the Global Illumination that had already been set up, but many choices were available within the Preview and Final render stages. Daylight was also needed in setting up the environment, which was a mixture of blues and grays with a high value because the interior was not easy to fully illuminate. After setting up, I made many test renders with alternate settings before achieving the required results.

POST-PRODUCTION

After finishing the final rendering of a piece, I then always go on to use Photoshop to tweak my images. I used the stamp and healing brushes to fix any errors with the modeling, and overlapping of textures. I then went on to use an adjustment layer to add any final improvements (Fig.07a and b).

CONCLUSION

The color tones of the work looked a little sad, which was not as I had originally intended. In fact, the days had simply slipped away from me, and I also only had a vague idea of the studio when I started on the piece.

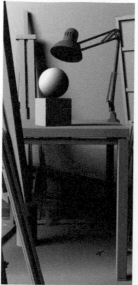
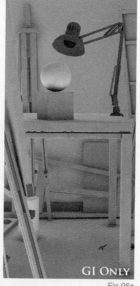
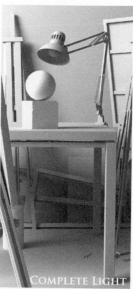

GI ONLY

COMPLETE LIGHT

Fig.05 Fig.06a Fig.06b

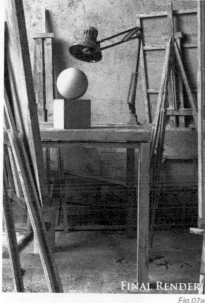
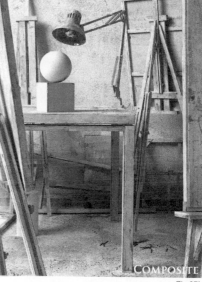

FINAL RENDER

COMPOSITE

Fig.07a Fig.07b

So, perhaps this work actually expressed my real feelings about the time and place? Maybe, subconsciously, sad elements came through whilst I was working on the image, which were perhaps underlying feelings of a previous time? This was the first time that I had used GI to produce artwork. For me, the work is not "perfect", but I think it has helped in giving me valuable experience in producing artwork using this technique, which I will of course carry into my future projects.

ARTIST PORTFOLIO

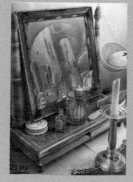

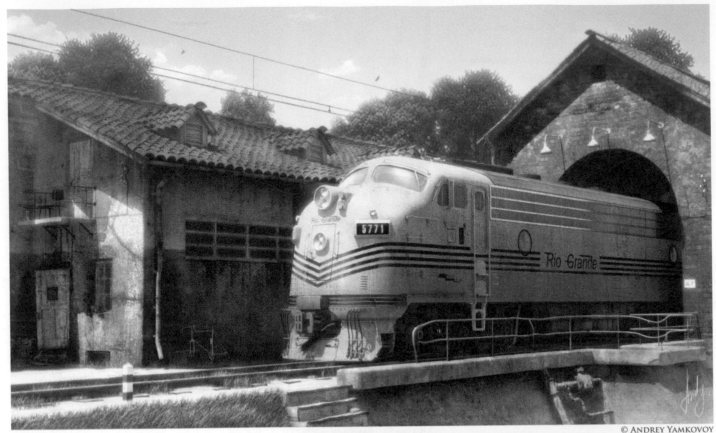

© ANDREY YAMKOVOY

RIO GRANDE
BY ANDREY YAMKOVOY

INTRODUCTION

I'm a huge fan of different mechanical devices, electronics and vehicles – particularly sci-fi. But this time, I decided not to do a sci-fi scene. Ideas and inspiration for this image came to me when I was watching small model locomotives in a local shop. I was so impressed that, after a few days, I decided to make one of these machines with a high level of detail and place it in an atmospheric scene. To begin with, I wanted to create an indoor scene, but after a few days I changed my mind and finally decided upon creating a quiet, sunny environment near a train depot, based on the huge Rio Grande train (Fig.01). Let's have a look at how it was made…

MODELING

In wanting to build an impressive model, I needed some good references and/or blueprints before I began, and so I searched the Internet for images of the specific train. Polygonal and box modeling were used as the main techniques, dependent upon what object I was

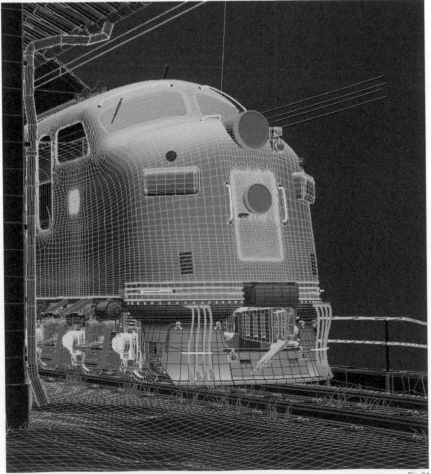

Fig.01

working on. The final mesh can be seen in Fig.02. Some primitives were used as a starting point to create some of the objects, such as barrels, tubes, lamps and wheels (Fig.03). All of the wires and cables in the scene were just renderable splines. To achieve a more realistic look I rotated, scaled and moved some details of the scene and arranged them in a more natural way. The scatter tool was used whilst working on the grass. Four different types of grass were made and scattered on the ground. The ground plane was modified with the help of paint deformation to add some randomness.

Tools that enable grouping items can be very useful, and with their help I added a deformation to the roof, as if it were a single object. I included all the details that I had hoped to place in the scene, and the polygon count was far from small by the end of modeling phase. This however didn't matter to me too much as I was making a static image that excluded any animation. I'm sure the methods that I used are not too different to how most modelers work.

TEXTURING

Mapping and texturing was more of a difficult stage because of the high number of objects in the scene. It took a lot of time to get the UVs that I needed. During this procedure I used mapping types including planar, cylindrical, spherical and unwrapping. Some of the objects were mapped before they got their final shape,

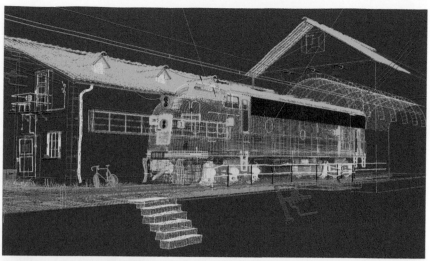

Fig.02

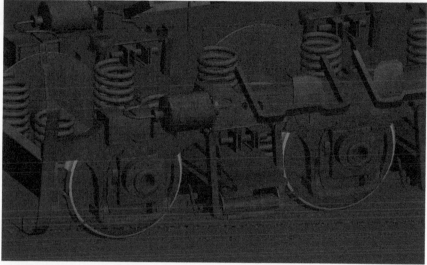

Fig.03

Fig.04

like the roof tiles, because it was much easier to map a straight shape. I didn't find the mapping to be a particularly interesting process, but it played a major role in creating the correct UVs. I used the checker to control and check the UVs after mapping and unwrapping objects. The checker map also helps in showing any stretches and tensions in the texture across the surface of the mesh. I also chose to create some UVs using morph maps for certain objects. This method manually unbends the object to make a flat version of it. The second stage in this process was using simple planar mapping to create UVs for the object. The last step was to delete all of the morph maps to return the object to its initial shape. When all of the UVs were done and were satisfactory, they were all exported as EPS files for further work in Photoshop, without making any UV screenshots. This helps in creating more accurate textures, especially if you need to do them bigger than your monitor's resolution. The best way to make real-looking textures is to look around you and analyse how things look, or simply take photographs for reference. Dirt, dust, scratches and other "marks of time" are very important in obtaining a natural quality in your works (Fig.04–07).

Fig.05 Fig.06

Fig.07

Do try to resist overdoing it with all that dirt though. Another thing to look out for is the saturation of your textures, because they can make your image look cartoon-like and unnatural if you're not careful. Also be mindful not to forget to create bump or displacement, reflection and specular maps for better results and more realistic-looking materials.

LIGHTING

The lighting setup was very important, for me. With the help of light you can recreate the specific mood that you are aiming for, and it can also help to "hide" something, or, alternatively, to highlight something that is important. But for "sunny day", the lighting setup was actually very simple...just the sun, or in other words, one direct light in 3D Studio Max (or other similar software) (Fig.08). To simulate the sun I adjusted only a few settings. The most important one of all was that the multiplier had to be set to 1.5 in order to create the flow of light akin to a sunny, summer's day. The color of the light was turned to pale yellow to recreate the summer sun. To add more volume, and to create a feeling of Global Illumination, I decided not to use photons and instead rendered an ambient occlusion pass (Fig.09) – it took less time to render and to adjust it this way. The result was not physically correct, but I don't think it looks too bad.

RENDERING

Rendering the scene was the most complex part of the work for me, due to the limitations of my hardware (Athlon XP 2400+, 1 Gig of RAM). As a result, I was

Fig.08

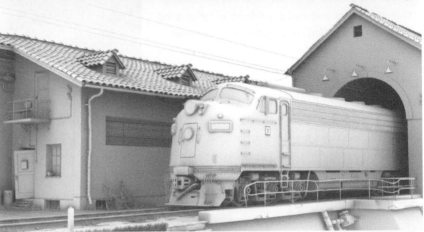

Fig.09

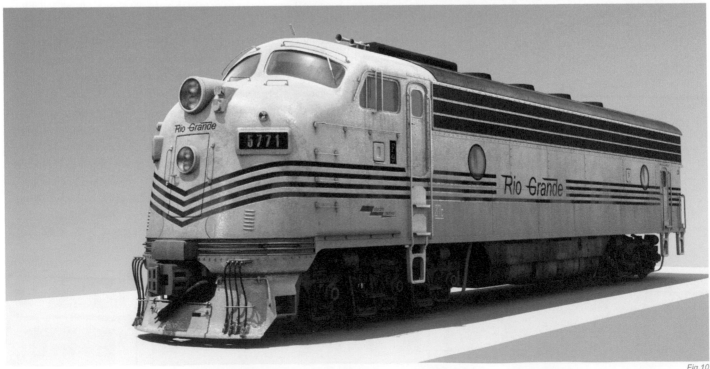

Fig.10

SCENES

compelled to render my "masterpiece" in layers. With the help of Brazil r/s I rendered out an ambient occlusion, direct light, diffuse pass, specular, z-depth and reflection layer for the train (Fig.10). Working with layers is a real pleasure for me because of the afforded control of every element, such as shadows, light, specularity and reflection. To render images with similar results in one pass would require numerous hours adjusting the lights, materials, rendering settings, and even then there is no guarantee that you'll get the image that you first imagined.

POST-PRODUCTION

This part is my favorite because it's final, and you get to see all your work in just one piece. I began by opening Photoshop and putting all the render passes (Fig.11a–g) together. You need to know the sequence of the layers in order to achieve the correct result. Another important thing was the "blending mode" of each pass. You may also opt to add some noise, bloom, fog, and depth of field if you wish, to make your "masterpiece" appear even more "real". After you assemble all of your image layers, it's then time to make some final touches: Levels, Brightness/Contrast, Color Balance, Hue/Saturation, and any other color corrections.

CONCLUSION

Because I was working on *Rio Grande* for a long time, I had a lot of time to think about every detail and aspect of the scene. I think time is very important with this type of work, because you can try out different approaches to certain problems that appear in the creation of something. You also have time to consider things that may have been overlooked during the process. With time, I have learnt many new features in each stage of the work flow. This knowledge has been integrated into the piece and I have achieved the level of detail in the models, and created that atmosphere, that I wished for. In retrospect, I can see things that I would approach differently, but I do not wish to change anything, because the work on *Rio Grande* is now complete.

Fig.11a

Fig.11b

Fig 11c

Fig.11d

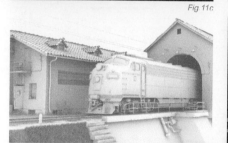

Fig.11e

Fig.11f

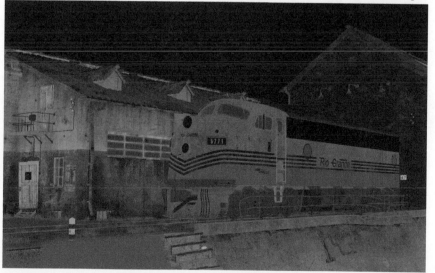

Fig.11g

ARTIST PORTFOLIO

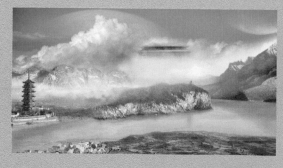

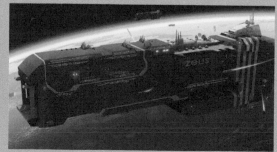

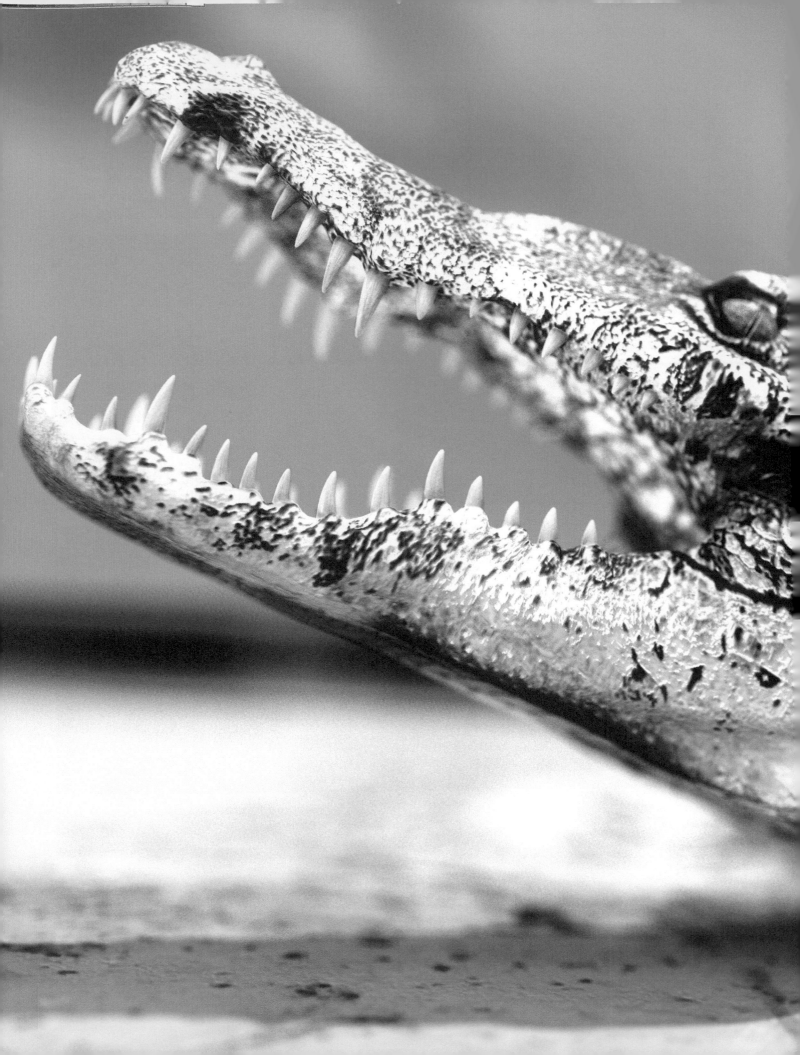

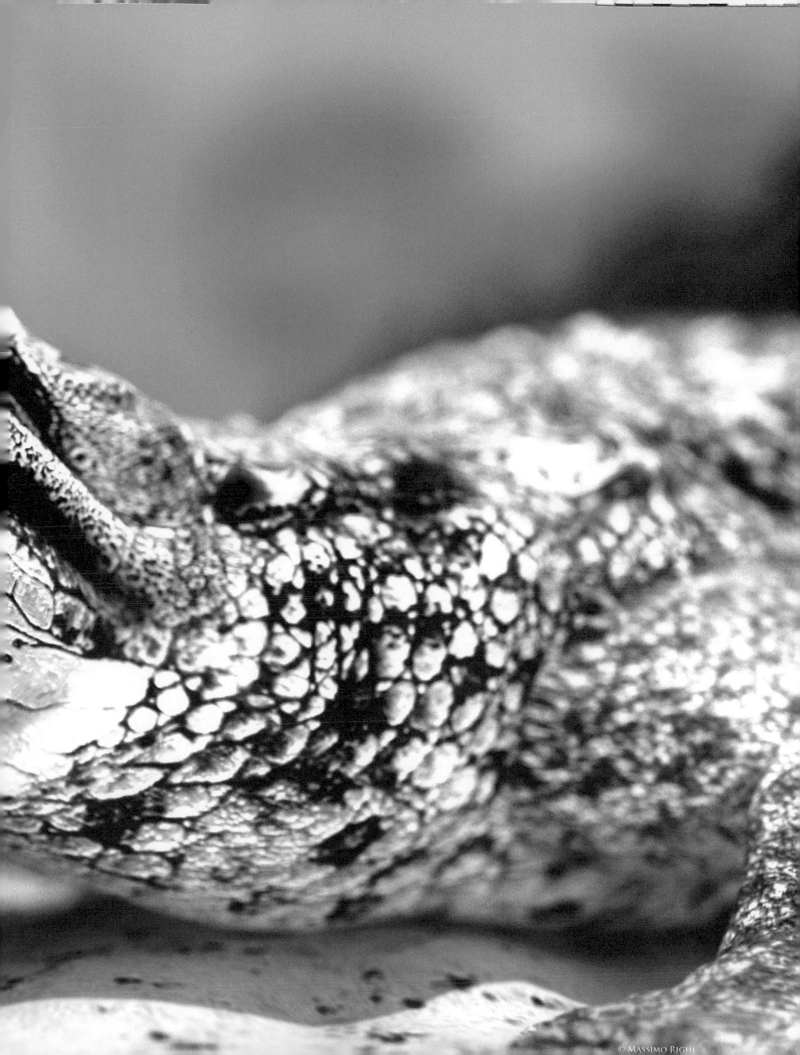

SUNBATHING

BY MASSIMO RIGHI

INTRODUCTION

Photography has always inspired me, especially shots of nature and wildlife from the *National Geographic* magazines. I decided to use the American alligator as the subject for my project, perhaps because I've been always fascinated by reptiles (this species in particular has truly brilliant colors) and I wanted to really enjoy the modeling process.

I thought the title *Sunbathing* for my artwork would be nicely identified with the cold-blooded creature. What I wanted to achieve with my *Sunbathing* image, was to not only create a photo-realistic render, but also a 3D model for animation purposes, without the use of ZBrush (or similar software) and without adding any kind of post-production work to the final render.

I spent many hours doing research to find some good reference material and to get an idea about camera angles and the kind of feeling I wanted to recreate in my piece. Finally I found a couple of shots that really inspired me, where the alligator had bright colors and teeth on show, that seemed to demonstrate the perfect model for my portrait.

To realize the ideas in my mind, I made a sketch of the alligator (Fig.01), posing it in a couple of ways. The idea was to have a typical still shot of the predator relaxing in the sun, but at the same time to show him with his mouth open, displaying teeth, and perhaps some aggressiveness.

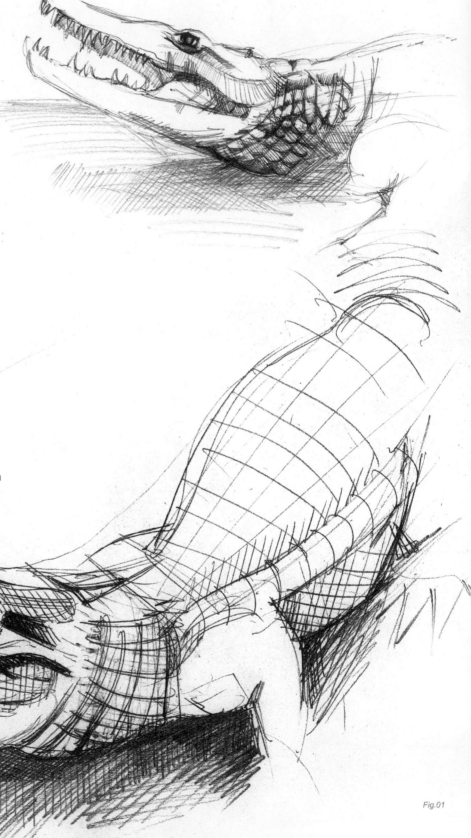

Fig.01

SCENES

MODELING

To start the modeling process in Maya, firstly I needed to create a low poly model of the alligator. I did this by following the reference images, starting with the head of the beast. Using a simple polygon plane and extruding the edges according to the global shape, I created the head first, then moved on to the rest of the body, leaving holes where the legs were to be connected and where the the eyeballs were to be placed (Fig.02).

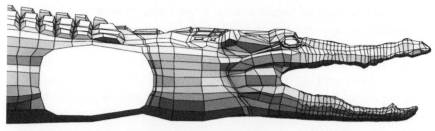

Fig.02

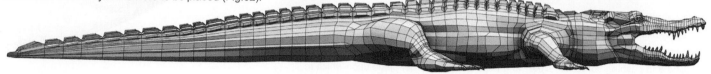

Fig.03

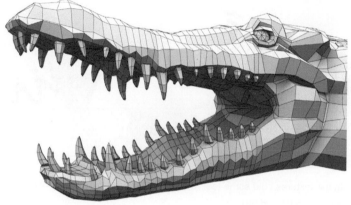

Fig.04

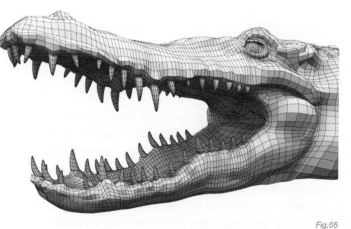

Fig.05

This is my preferred kind of polygon modeling technique, and, switching between all the four views, I had the feeling of good control over the step-by-step process. Once happy, I went on to model the legs and the eyeball in the same way, and joined them to the main body geometry. I modeled only one tooth, then duplicated it and distorted it – pulling vertices – and, with the use of lattice deformer, created smaller and bigger teeth, according to the reference photos. I only made half of the alligator so that I had only half of the UV map to deal with.

When the low poly model was complete (Fig.03), I then had to start the (boring) UV mapping process, before duplicating the model and adding details using the sculpting tool. For the main (half) body and the leg I made two cylindrical maps; for the feet I used two planar maps, one from the top view and one from the underside; and for the teeth I projected two planar maps. Then I used a simple checker, applied to a Lambert shader, to check the overall process whilst tweaking the UVs.

The laying out of the UVs is one of the most important steps, in terms of the final result, so my advice to anyone is to spend a little more time on it, until you're completely satisfied with the results. The UV tools that I use most often are; Cut UV, Move and Sew and Unfold. After finally finishing with the UVs, I duplicated the other half of the model, did a combine command (I also merged all the vertices) and moved on to the sculpting part.

I usually do 3 levels of detail for my models so that I can use at least 3 different resolution models for my projects (Fig.04–06).

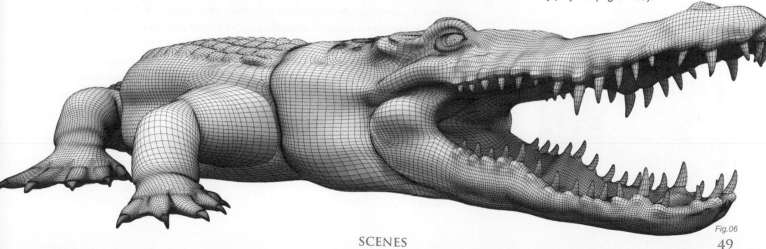

Fig.06

When necessary, I used the low poly model as a cage (using the Maya Wrap deformer) for the rigging and animation steps, but I hid it in another layer at all other times. For the sculpting process I used a higher resolution version obtained by doing two smooth operations. The mesh ended up with about 100 000 polygons (the low poly was just 8500 and the medium around 30 000). Using the Maya sculpting tool I added some details to the alligator, playing with push, pull and smooth tools, and the brush size. For this operation I used a Wacom tablet so that I had complete control over the pen pressure for the brush opacity and size.

Once happy with the results I then created a simple rig, just to change the position to the one in my sketch. For the scene I only needed to have a simple ground upon which to place the alligator. I modeled the terrain from a polygon plane and used the sculpting tool – pulling and pushing some vertexes – and then created another plane upon which to place the background photo.

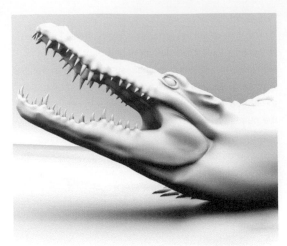

Fig.07

COLOR

SPECULAR

BUMP

DIFFUSE

Fig.09

Before starting with the textures I did some test renders just to see how the model looked in the various positions (Fig.07 and 08)

TEXTURING

I believe that the texturing part is extremely important, as the majority of the final effect is created by the textures. I decided to go for a 2K resolution map, which I think was enough considering that I had to deal with the Maya 3D paint tool, and the bigger the textures are the slower the process of the 3D painting is.

In Photoshop I started creating the textures using a Wacom tablet. The textures resulted in a mixture of photographs and freehand painting. I used the clone tool as well as custom brushes, always switching beween Maya and Photoshop and doing test renders to check how the textures behaved on the model. Once happy with the Photoshop work, it was then time to adjust the seams that were created by the edges where the UVs were cut during the mapping process. I used the built-in Maya 3D paint tool for this process, using the clone tool. When the color texture was made I went back to Photoshop and created the specular, reflectivity, bump and diffuse maps, all from the main color texture. I then edited them one-by-one in Maya 3D paint and made any last adjustments.

For the ground and background I used two photos which I took myself (approximately 3000x2000): I cropped the parts that I needed, enhanced the color saturation and made bump, reflective and specular maps from the color ones. I also did a planar projection map for both.

For the alligator, I used three different blinn shaders: one for the main body, one for the eyeballs and one for the teeth. Also, for the ground and background shaders, I decided to use blinn shaders. All the textures were applied to the materials using the Mipmap filter (Fig.09).

Camera setting and Lighting

To set up the scene I created a camera and enabled the depth of field. To further explain how I managed the depth of field: I made a distance tool, placing one locator in the point of focus on the model and the other locator in the camera lens. I then parented the locator to the camera so that when I moved the camera, the dimensional value also changed. The last thing I had to do was put the value in the Focus Distance field and give the desired F Stop (Fig.10a and b).

Before working on lighting, I tweaked the shader networks, tried different specular/reflectivity settings and played with the translucence value. I used an HRDI probe, made by myself, a directional light, and a point light with Ray Trace shadow enabled.

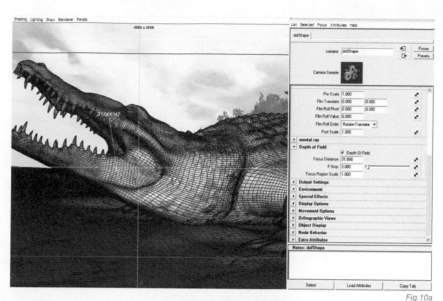

Fig.10a

Fig.10b

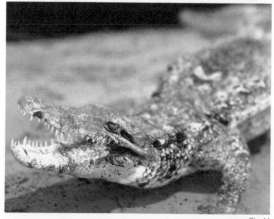

Fig.11

Rendering

For the Mental Ray render settings, I used a Mitchell filter (which I believe is the best for achieving high definition and contrast) with a sample level, min=1 max=3, Ray tracing and Final Gather.

I didn't do any additional post-production work on the scene, only different angle renders. In the main image, I used more saturated and contrasted colors for the background and the alligator itself. In the other render (Fig.11) I tried more depth of field and less saturated colors for achieving, in my opinion, a more photo-realistic look.

Conclusion

I learned a lot throughout the making of this image, and loved playing with the depth of field, much like when I take photographs with a reflex camera. As always, after the making of an image, I tend to feel like it could all be improved further. For example, knowing beforehand that I would need to eventually do larger renders for printing purposes, I probably would have made higher resolution textures, perhaps around 4K. I plan in the future to work more with this alligator, playing with more renders and camera settings, and I would also like to animate him…so, we will see! Hopefully I have given an insight into the idea behind the creation of this image, and I hope it will prove helpful in some ways to all who are reading.

Artist Portfolio

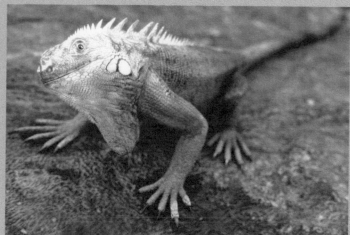

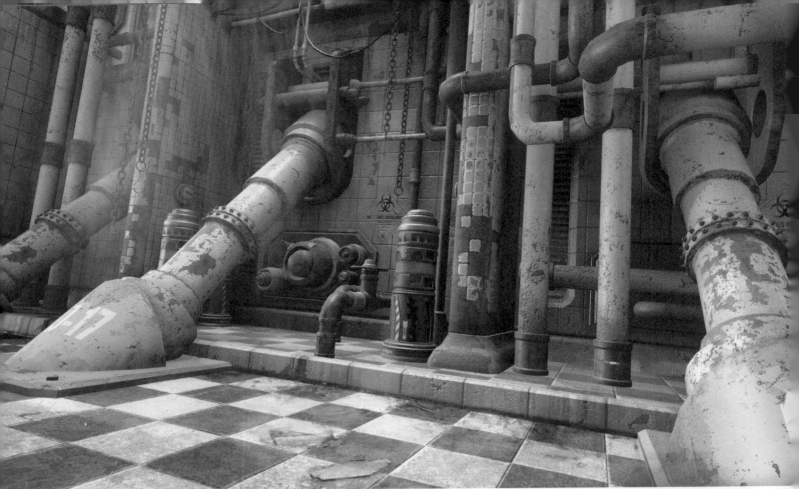

INDUSTRIAL

BY STEFAN MORRELL

INTRODUCTION

This image came to me while working on another sci-fi project. I had just finished texturing a chequer-board floor (Fig.01) which wasn't all that relevant to the sci-fi scene it was intended for, but the texture itself led me to think of other scenes it could be incorporated into.

Fig.01

I've always been interested in the darker environments of everyday life: buildings in decay and disrepair, aged and abandoned dwellings that have a great sense of character and can inject emotion into an image. Buildings of this kind in a computer can often produce something looking more sterile than intended, but hopefully I've made an environment that looks like it's had a past. From the initial idea it was just a case of building a scene literally from the ground up, the chequer-board floor texture being a focal point in the image. The composition would play a large part early on, as the environment would be devoid of any figure and so the shapes, lines and lighting had to carry the image.

Composing the image around two large angled pipes was the initial step in modeling the scene. I nestled each pipe between some buttress walls so I could play around some more with the idea of tiles on the walls. The camera setup was also established at an early stage, keeping it very low to the ground and using these large pipes to "pull" the viewer in. I used a low focal length of 25 to further accentuate the sense of depth these pipes had as well as tilting the angle to help create a dynamic looking image. When working with environments a good camera angle as well as careful use of perspective and focal length can make all the difference in creating an image that invites the viewer

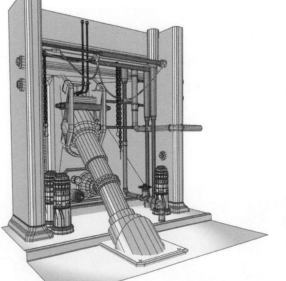

Fig.02

in. The modeling (Fig.02) is very much freestyle polygon modeling; the snaking pipes are splines converted to editable polys, which are further detailed with extrusions and bevels. Some smaller props were made (Fig.03) to place around the scene and whilst barely seen in the final render these small details really help sell an environment.

TEXTURES AND RENDERING

The texturing process on this image was great fun, with the only rule being that everything had to be filthy and riddled with character. Too often in computer graphics surfaces are left clean and devoid of life, but in this image I've strayed away from this look (Fig.04). I made a couple of generic chipped, paint materials that could be used across multiple objects as well as several template based textures for some larger elements in the scene, namely the walls and large pipes. Taking the time to carefully UV map these objects really helped in the texturing process. I also rendered ambient occlusion maps (dirt maps) which were set to multiply blending mode above the color textures.

The texture maps were made in Photoshop, each being built from literally dozens of different layers of varying

Fig.03

Fig.04

opacity (Fig.05). A layer can be anything from a couple of brush strokes to a photo of rusted metal with a heavy use of blending modes used to build up the texture. The color map is complemented by a bump map, a specular map and a reflection mask (Fig. 06). Off camera I placed several large self-illuminated white boxes to control what was being reflected/highlighted, as this creates the illusion that there is a large window letting light into the scene. For the lighting and rendering things are simple: there are two spotlights placed above the angled pipes which have a wide fall-off field and cast soft shadows from above. A Global Illumination (GI) solution was used to further illuminate the scene and a separate direct light was placed to the side of the scene and set to cast specular highlights only which were further tweaked in the post-production stages.

For rendering I used the FinalRender engine from Cebas. I've found this engine to be very user friendly and reasonably quick at rendering large detailed scenes at print-resolution. Knowing the image would be further altered in the post-production stage I made sure to keep open as many options as possible for the final rendering. Thus, rendering in passes (3D Studio Max Render Elements) was essential, each pass representing a different element of the image such as Shadows, Global Illumination, Beauty (Fig.07), Lighting, Specular, Reflection, Diffuse (color), Z-Depth (Z-Buffer) and object masks. All are separate from the "beauty" pass and can be saved as separate images, enabling the building of a master file within Adobe Photoshop during post-production.

POST-PRODUCTION

So now I have my render broken into several images to work with in Photoshop. Everything is layered into a master file and the blending modes and opacity of each layer are adjusted until all the elements are working in harmony with one another. Specular and reflection are set to screen with shadows and occlusion set to multiply.

COLOR

BUMP

REFLECTION

SPECULAR

Fig.06

54 SCENES

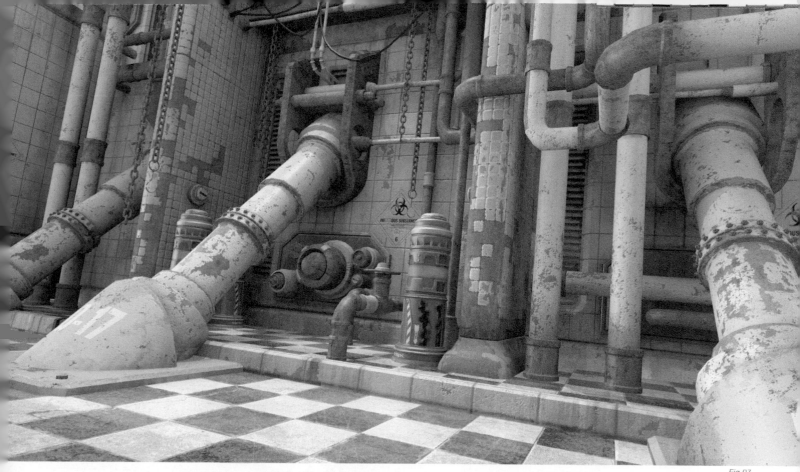

Fig.07

If the specular highlights in the final image are too dull I can brighten them by working with the specular layer only, and respectively if the shadows are too dark I have them on a separate layer, so again it's an easy fix. This kind of image control can make post-production go much smoother and offers many more options in how an image is created.

The Z-Depth layer is great for adding atmospheric effects and focus blurs; it stores information about the depth of a scene so selections of background or foreground elements are much easier. The Z-Depth can also be used with Photoshop's Lens blur tool, which is of great benefit in order to create Depth of Field (DoF) effects in real time, potentially shaving hours of tedious work adjusting DoF in 3D Studio Max.

In keeping with the industrial theme I wanted an overall color tint that was somewhat earthy and grungy. Initially the spotlights in 3D Studio Max were tinted with a hint of yellow while the Global Illumination was tinted light blue. This looked OK in the final render (Fig.07) but using

color adjustments in Photoshop allowed me to push the overall color tone even more. The final layered .psd file is composed of several color correction adjustment layers, mostly subtle orange and green shades, each with very low opacity (10% or less). Some volumetric effects were painted in using a large soft brush on a layer set to screen as I wanted a hint of some light falling from above and doing this in post-production offered more control than working with volumetrics in 3D Studio Max. In thinking of what else may be in this room I imagined an old glass ceiling that was filtering diffuse light throughout the scene and with that in mind I tried to avoid any harsh shadows.

CONCLUSION

For an image that was inspired by a floor texture I'm pleased with the outcome. These spur of the moment ideas invariably lead to something special and a relatively boring scene has been given some life with heavy use of grungy textures and atmospherics.

ARTIST PORTFOLIO

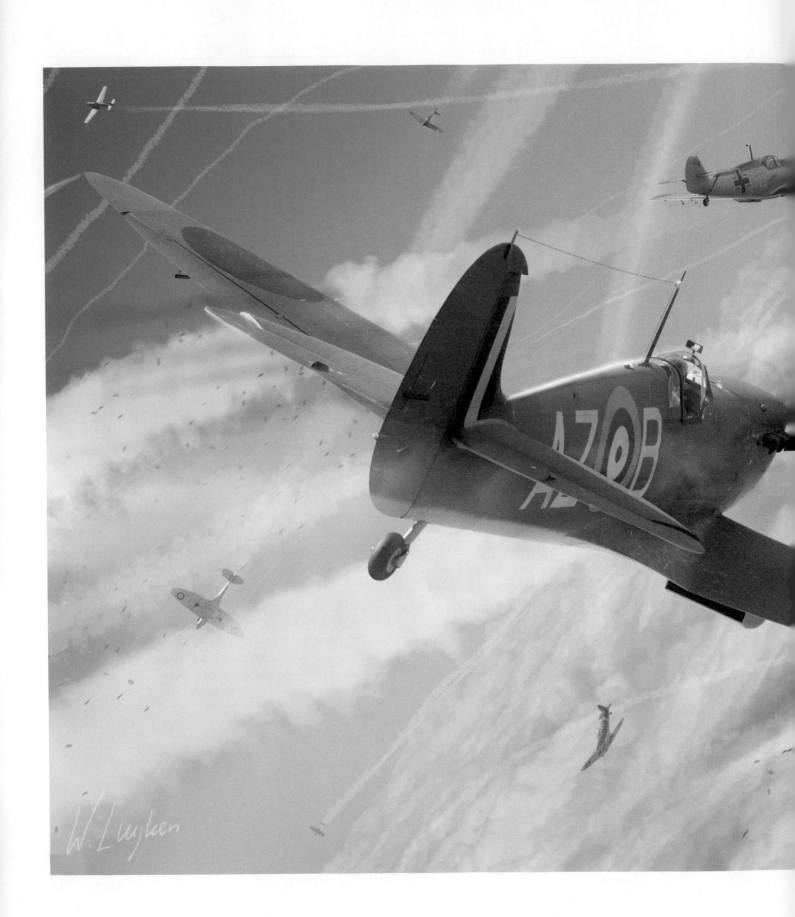

W. Luijken

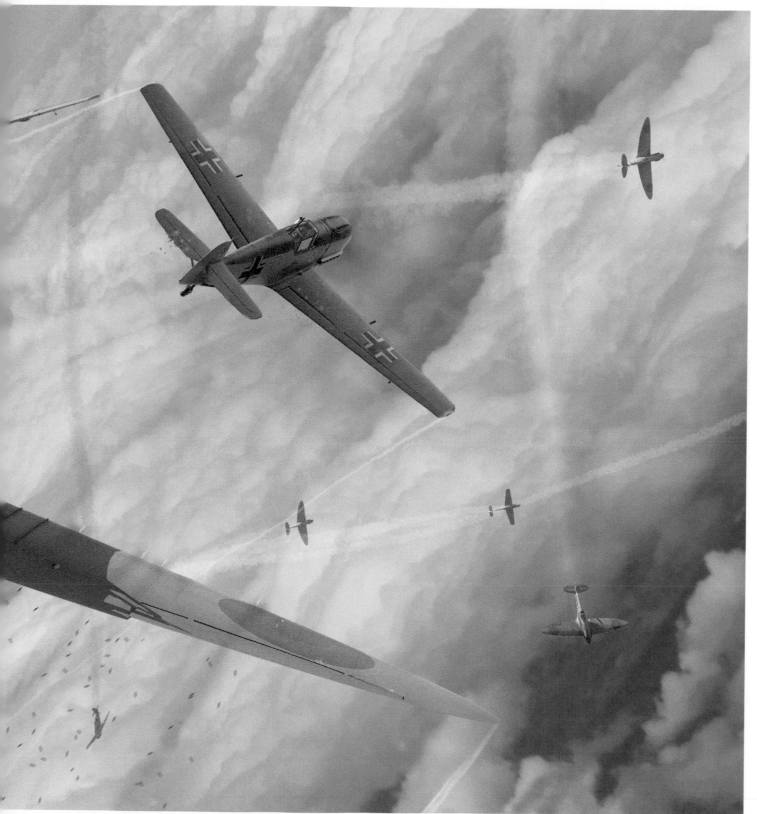

FURBALL
By Wiek Luijken

INTRODUCTION

Like any traditional aviation artist, I start with inspiration to do a certain image. However, by the time the detailed models are done, you are a couple of months or more down the line. Most ideas either dilute or are added onto a big pile of ideas. In this case the combined modeling time for the Spitfire and Messerschmitts has been almost two years, with other models in between (see Fig.01a–h). One of the things I've always wanted to do was to create a big dogfight scene. The Battle of Britain is an obvious moment in history to depict such an image. Furthermore, I just love the Spitfire; it is a beautiful design with graceful lines that looks great from any angle.

When I started the model of the Spit, I had several goals. I wanted the model to be very accurate and a true homage to Mitchell's design. Another goal was to make various types from the early model Spit (Mk. I) all the way to the end of the war (Mk. IX), so I had flexibility with my renders. Then, as images go, a few needed to be done: a big dogfight with Messerschmitts during the Battle of Britain, a take off from a desert airstrip, a dogfight over Malta, Spits attacking an ME109 bomber escort while the Hurricanes below deal with the bombers, shooting down a V-1, escorting B-17s, fighting with FW190s over Dieppe, attacking shipping at low level, landing on a carrier, and the list goes on and on. So, first things first, I had to create a good enough model and create a dogfight render...

Fig.01a

Fig.01b

Fig.01c

Fig.01e

Fig.01d

Fig.01f

Fig.01g

Fig.01h

SCENES

THE SPITFIRE MODEL

The model of the Spitfire was done using Luxology's Modo completely. Details include the pin that holds the wheels in place, the knot in the rope to close the canopy, various rivets, separate engine plates, the holes in the machine guns, and so on (see Fig.02). Almost all of it is still in subdivisions, as I hate freezing meshes, plus it makes your UV process less painful. The final model comes in at around a hundred thousand polygons, plus another forty thousand polygons for things like the cockpit dials. At render time this usually weighs in at around one million polygons or more.

As reference, I have used factory drawings, very detailed drawings based on factory drawings and lots of photographs. As usual, drawings don't always line up from various sides, so you have to base the shapes on what mostly resembles the photographs. As always, the most challenging problem is to get the overall shape just right and after that it is a breeze – just add in the details. The biggest advantage of using subdivisions without freezing the mesh is that you maintain better control over your shape in case of changes. The fun bits were the complex organic shapes like the wheel hub. Fig.03 shows a wireframe of the model after subdivision in the renderer.

Fig.02

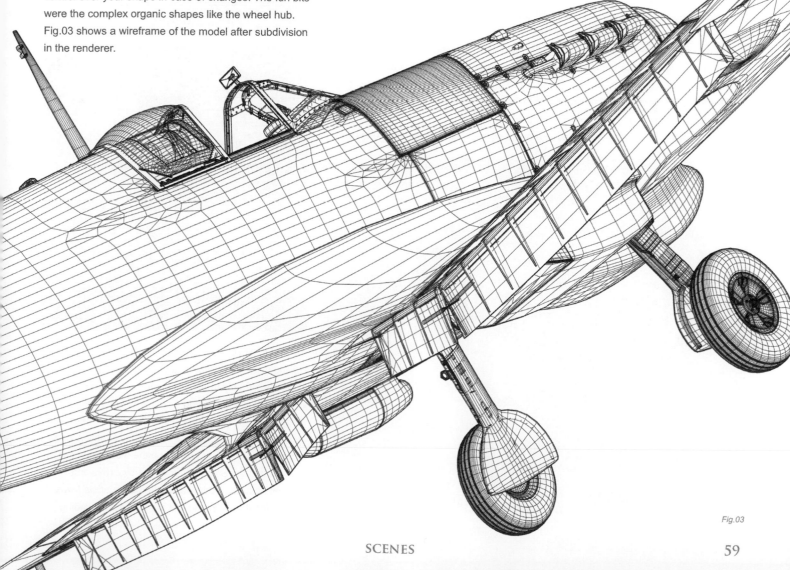

Fig.03

THE SPITFIRE UV-MAPPING AND TEXTURING

For the UVs the route was slightly different from my usual approach. Instead of doing bits with planar maps or multiple UV sets, I wanted to end up with only one map that would work for all sub variants. This made it easier to make a new set of colors/markings for new renders and allows the model to be used in different renderer software with ease. To achieve this, the goal was to make a UV-map with every single object including rivets and unfolded without any stretching. Then to make texturing feasible on a more detailed level, I needed specialist maps for each part. So I ended up creating the specialist unfolded map per part first, later combining all of those in one big, new UV-map with space to spare for new parts to be added later for different versions of the Spitfire (Fig.04).

After having done the model and unfolding all the UVs, it was time for texturing. This was the first time I used 3D painting to do the texturing of an aircraft. All the texture painting was done in Modo, with final touchup in Photoshop. This worked very well in view of the separate panels (Fig.05) as you can just take one panel at a time. The first thing to do was to paint the overall

Fig.04

camouflage pattern, as standard on the Spitfire, and after that came the dirt and stains map, scratch map. All were done in 3D on individual panels, then baked onto the one big UV-set for manipulation in Photoshop (Fig.04). The different painted maps were used for the specular, reflection, diffuse, bump and color maps in different ways, combined with good old brushing in Photoshop and resulted in the final texture set which is easily adjusted for individual aircraft with an even amount of detail across the model (Fig.06).

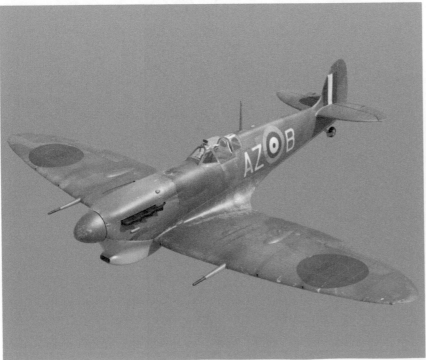

Fig.06

Fig.05

THE IMAGE

Having finished the model, textures and shading, it was now time for a big render. The center of attention should be a lone Spitfire, chasing a couple of Messerschmitts away from a buddy in distress. Action should be visible all around, showing it was a very hectic situation for all of them. First thing was to set up the most important four aircraft: the Spitfire in front, the two 109s and the Spitfire in the back. Having found the angle I was looking for, it was time to find a suitable surrounding.

For a render with a lot of things going on, it is useful to start with a background that is not too distracting, but at the same time interesting and suitable for the historic background. Having a sizeable collection of photographs that I took on various flights over the UK, I chose one that mostly shows thick cloud and blue sky, a common sight in British skies (Fig.07). This being too dull, even with a lot of action depicted, the background was rotated to fit my composition to help give the feel that you are up there with the boys and not flying "easyJet".

Fig.07

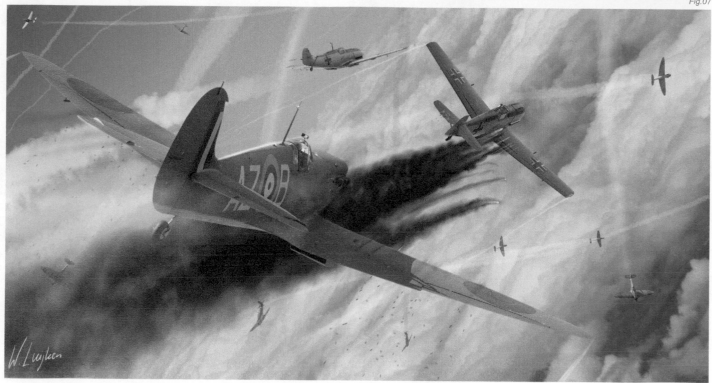

Fig.08

Added to all this was the furball around the main aircraft in 3D; then the long process of post-processing began. Markings were altered after consultation with historical experts and lots of cross-referencing with books, and vapour trails were painted in, machine gun shells rendered, and so on. The trickiest bit with this image was whether to show battle damage. It started off with the far Spitfire trailing smoke, showing it was under attack. That was then changed to the main 109 going up in flames, which in turn destroyed the profile of the close Spitfire (Fig.08) and became the instant focus of attention. In the end I chose to go without any smoke at all to prevent distraction.

Conclusion

After having done this render (along with a few more of the Spitfire), this one still stands out as one of the better ones I did. Not because it shows off the Spitfire so well, or because of all the work that went into creating it, but rather because of the action it depicts. For me it shows the chaos and inevitable mortal danger that must have caused so much fear, stress and sorrow for the guys battling it out in the skies above England. They gained the respect and gratitude of many and live on in the imagination of some, including myself.

Artist Portfolio

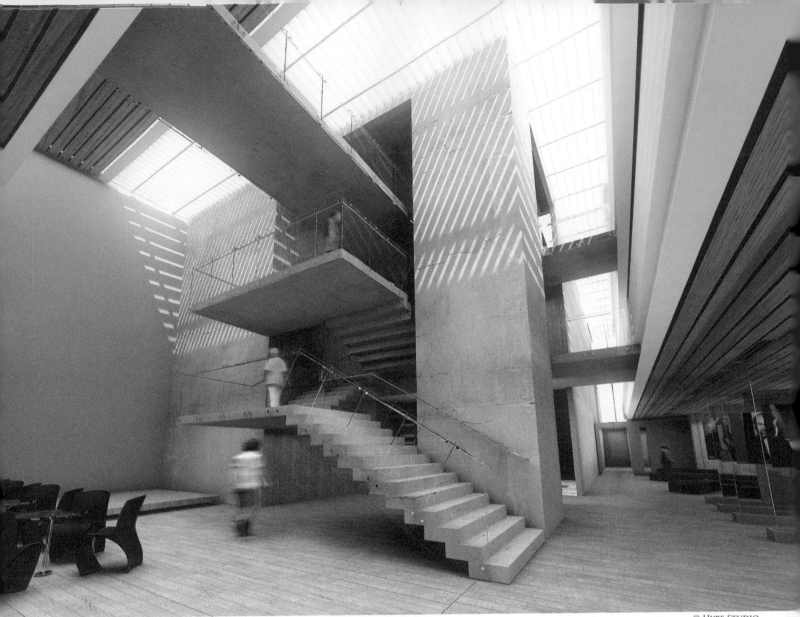

MUSIC INSTITUTE

BY MAURÍCIO SANTOS

INTRODUCTION

This image is part of my graduation project at the Architecture School of Universidade Federal do Rio Grande do Sul, southern Brazil. I believe the strength of this image is also the strength of the project itself. It relies on the original design concept. The building is a public institute focused on the development of music in Rio Grande do Sul State. The intention here was to create a public space that would fulfill professional musicians' needs, and also be friendly and open enough to bring new people into music, as well as to provide a good atmosphere where young and professional musicians could gather to socialize among themselves, and also with the general public. The design concept (Fig.01), divides the building in two main parts, one being the solid center and the other being the light exterior. The center accommodates the most technical spaces and its closed look also makes the acoustic and the ambient treatment much easier. The exterior part, on the other hand, is the interface with the street and should be responsible for bringing more people in – it's where the social activities should take place. Exploring the contrast between these two parts and playing with the touching elements, such as the walkways, the skylights and the holes in the solid concrete box, were some of the goals in the project, and this is the image that best represents them. This particular image is also significant to me as I believe I was able to show not only the project as it would probably be if it was built, but also emphasize the design values.

Fig.01

Modeling

As the main target throughout the development of this work was the design itself, the modeling step had a key role during the entire process. To manage all the complexity of the architectural project, and yet following the early concept and trying to reach interesting visuals, I made many alternatives and changes from the initial sketches. You can see some of the shapes I reached during the project development in Fig.02a–d. For those who also have the desire to enhance their design skills on the computer, I must say that speed in modeling is really important, as it gives you the possibility of innumerable tests and the option for making changes until you can be completely satisfied with the result. Lots of practice is still the best way to obtain the speed that you need. In this project, I wanted to portray a perception of the whole space and also the relationship between the parts, so I made the whole 3D model of the building in a single 3D Studio Max file, including all the furniture. This also helped in making the animation, but it resulted in a really heavy file and it became impossible to work with everything switched on, hence making the modeling a little harder in the end.

Texturing

The fact that this project was developed during a whole academic semester ended up helping me a lot with the textures too. I had the chance to test the look of several different arrangements of materials (Fig.02a and d). It may sound a little too obvious, but some of the materials I first thought would look great on the project didn't achieve the effect I was aiming for. These tests made me not only change the project itself but also re-affirmed the importance of the three-dimensional visualization tools. One of the decisions taken during this testing stage was to use a rough, concrete texture on the box. The concrete had much to do with the project requirements but at first I thought that some warmer material, like wood, would look better. After testing the concrete though, I liked the effect the light had on it. This particular concrete texture map, with all its cracks, added some realism to the scene and also helped achieve the contrast I was looking for, since the other materials in the scene were pretty clean.

Fig.02a

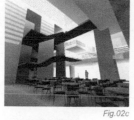

Fig.02b

Fig.02c Fig.02d

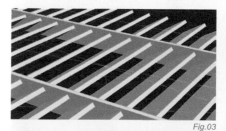

Fig.03 Fig.04

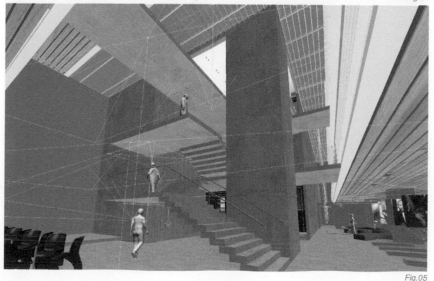

Fig.05

Lighting

What I was looking for in this image, in terms of lighting, was to emphasize the light coming from the top and its shadow effects on the concrete box due to the brise soleil. The skylight was thought to make the separation between the solid interior block and the light steel structure of the exterior part. The fixed brise soleil was developed to let the sunlight into the building during the winter, and block it during summer. Since the light passing through it produces a nice looking effect, the image simulates a winter's day. To create the feeling that the light is actually coming from above, I used a very high V-Ray environment (5.0) and a number of V-Ray lights pointing down (Fig.03). To create a vivid light effect on the top, I also positioned some V-Ray lights pointing up right below the brise soleil (Fig.04). Apart from the light from the top, I positioned some V-Ray lights in different places around the building in order to create an ambient light (Fig.05). I've got to say though, that as I was constantly changing the model, I didn't get to spend much time setting up the lights properly, and that the real gain in terms of lighting effects was obtained with Photoshop in the post-production stage.

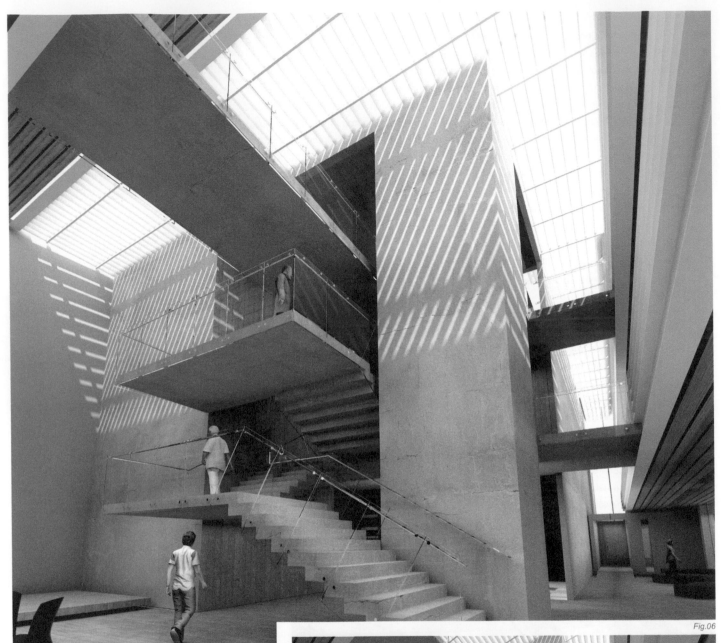

Fig.06

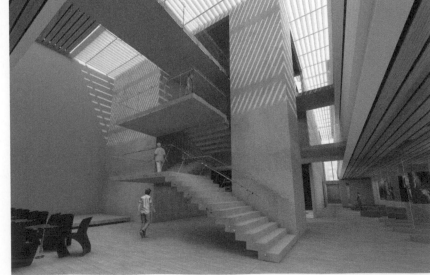

Fig.07

POST-PRODUCTION

Much of the visual effect and atmosphere in this scene was reached only at the post-production stage, through the use of some Photoshop tools. The first one I used was the Levels (Fig.06), which always comes in handy when you need to acquire some good contrast on the image. In this case, I not only gave more contrast to the scene but also lightened it, since the original render was a bit too dark (Fig.07). The other tool I used in this case, which I believe worked quite well and was responsible for the atmosphere in the scene, was the Photo Filter (Fig.08). It gave some unity to the colors in

the scene by making everything a bit warmer, through the use of the orange color. The Hue/Saturation tool, which in many cases can make the colors more vivid and create interesting results, in this image was used to remove the saturation to make the image appear more realistic. There are also some pre-sets of glowing effects that people can use from Photoshop that work quite well. In this particular scene though, I wanted to have a specific glow coming from the skylights, so I created the glowing effect using the regular brush, with hardness set to zero, in a separated layer, and started to fade out the layer opacity until I reached the desired effect. The 3D people in the scene looked a little fake after the image just came out from the 3D Studio Max, so I selected them manually and applied a motion blur effect as a test. I'm not sure if this effect would actually happen if the image was a real photograph, since the people are just walking and the space is pretty light, but I liked the effect and thought it created a better composition, starting to look more natural in the scene; so I decided to keep the motion blur effect (Fig.09).

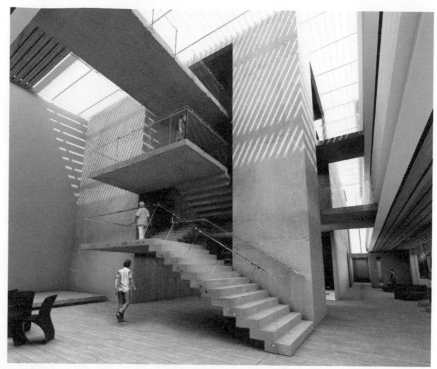

Fig.08

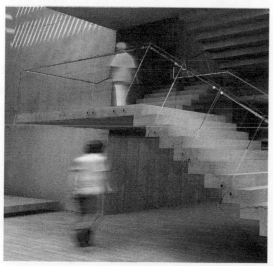

Fig.09

CONCLUSION

The design technique has always influenced the design result, and a more effective working method will certainly produce a better design. The power of the 3D computer tool is already making the difference in built environments and will definitely make even more impact in the future. The possibility to predict many different aspects of the building prior to its construction, from the visual appearance to the environmental impact, will result in less waste and better results for the whole construction industry.

This work was, for me, a great opportunity to test some of the ways in which architecture can be helped by the use of 3D computer technologies. The computer has been a part of the design process from the launching of the first concept to the demonstration of the final project, going through the testing of different alternatives and even through to the detailing stages. I hope that from this overview, some of you will become interested in this subject, as I believe the development of the computer as a tool will become better and faster if more people are using one and contributing to the process.

ARTIST PORTFOLIO

SCENES

OFF ROADER
BY TORSTEN J. POSTOLKA

INTRODUCTION

Do you know anyone who does not like Lego? Well, I don't. When I saw the *Lego Off Roader* for the first time, I knew it was going to be my next little project and an excellent opportunity for an exercise in modeling and rendering.

Almost all of my personal projects start for more or less the same reason. Either I want to try something out and experiment a little, or I feel the need for an exercise. I get the most motivation for my personal projects less by reaching the point of their completion, but more by the whole process leading me there. In my eyes the journey is the reward. Maybe that is the reason why many of my projects never exceed the state of work in progress. But since the definition of "completion" is a question of interpretation, it does not bother me too much in this respect. Since this project did not contain much concept work, I will focus on the technical part of its creation to give you a better insight…

MODELING

I think the right measurement is the most important thing when modeling something like Lego. It is not simply a question of parts fitting together, but of the overall look. If you do not get it right it will look odd, even when you cannot put your finger on it. To avoid this, I decided to use a tool called MLCad. Thanks to the community at www.ldraw.org you can get every

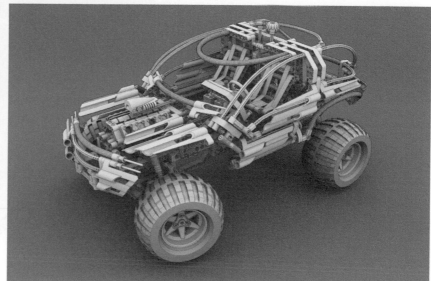

© TORSTEN J POSTOLKA

part from Lego for MLCad. Since it is CAD-based and the parts are very precise, you do not have to worry about their accuracy at all. But this fact is also a handicap from a modeler's point of view, as exporting parts into a usable 3D format can become a problem. I solved this problem by exporting all needed parts to Lightwave lwo-files. Then I used Right Hemisphere's Polytrans to convert these files to 3D Studio Max compatible 3ds-files. Through this method I got all the parts into 3D Studio Max; however, this Export-Import-Convert process did carry a drawback – all parts now had a low resolution and plenty of flipped faces. Since I needed them just for accuracy and measurement, it did not become a problem – getting everything into 3D Studio Max just took a little longer to prepare before I actually started modeling (Fig.01).

After that I had to decide how many slices the tubes and cylinders should have, since that determined the level of detail. It's important to know from the beginning which resolution – slices in this case – all rounded surfaces should have, especially with regard to Lego parts with all their holes and round surfaces as this can become a determining factor. It is very disappointing to find out that your hardware cannot handle the poly-count when you are almost finished with your model. Trust me, I know what I am talking about. I decided to go with 48 slices (Fig.02).

My chosen modeling technique was poly-modeling. Since all parts from Lego are modular, everything repeats itself at one point or another. This comes in quite handy when modeling hundreds of parts. I must admit I'm a big fan of symmetry and even numbers – modeling Lego was like heaven. For assembly I simply used the Lego manual which I already owned because I had already bought the *Off Roader* on eBay. Modeling and assembling everything was at least as fun as building the real thing. Looking at the finished technical details alone was worth all the effort (Fig.03).

Fig.01

Fig.02

Fig.03

SCENES

Fig.04

MODELING IN DETAIL

I think the parts worth going into detail about are the cables and tubes. They are made of rubber and flexible plastic and I wanted them to look as believable as possible (Fig.04).

I started by drawing splines with the final diameter to get a rough idea and to produce the paths. The basic object for the tubes was a ring. I deleted the inner faces of the ring, which left two open circles, and then used the 3D Studio Max Spacing Tool and the option to space objects along a predefined path. I raised the amount of rings until the space between each ring equalled the width of the rings themselves. After that I attached all rings into a single object. Next, I selected all open borders and used the Bridge option to connect all open edges with their corresponding edges on the rings to their left and right. Because both rings at the end of each side did not have a corresponding ring on one side, I had to cap them first (Fig.05). For the

Fig.05

Fig.06

cables I used a different technique. First I modeled the cable's end pieces, which represent the rigid tips. Then I used the drawn spline to extrude the cable's profile along that path. I did this by using Loft from the Compound Objects Rollout. To give it a more flexible look, I twisted the profile a little along the path as well. I think it came along nicely (Fig.06).

At the end, the model consisted of 1148 objects and 3.3 million polygons

.

RENDERING

For the final look of the image I tried to achieve something between a blueprint and the Lego manual. The image is composed of basically three layers: one rendering with only the skylight turned on (FinalRender), one rendering for the lines (FinalToon), and one layer for coloring the gray base rendering (Adobe Photoshop) (Fig.07).

Fig.07

The base rendering includes the model, a backdrop and the FinalRender Skylight – no Global Illumination. This way of rendering an image does not differ much from an ambient occlusion rendering. Everything I had to do to get the lines right was to apply proper smoothing groups to all objects and let FinalToon draw lines on all edges between the smoothing groups. So getting them right was no problem, but rendering these lines was an entirely different matter. Due to the high poly-count it was impossible to render the lines in one single pass – at least on my computer! Every attempt took ages and resulted in 3D Studio Max crashing. That is why I had to divide the image into slices and render each slice separately. This way it took longer and more effort was involved, but it worked out in the end. After that I could assemble the slices back together.

All necessary alpha masks were rendered by applying a 100% white material to all objects to be masked, and a 100% black material to all other objects to include the overlapping of objects in the alpha mask. You get a 100% single-colored material by applying that color to the self-illumination slot in the material editor.

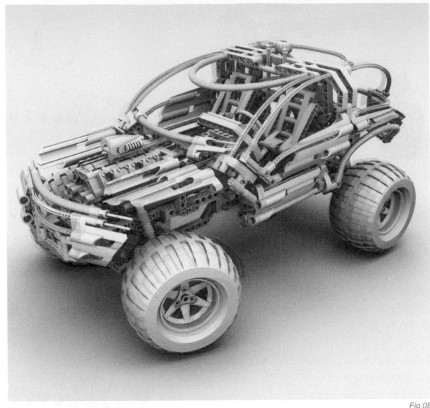

Fig.08

POST-PRODUCTION

The rendering received its final touches in Photoshop. I combined all layers via different bending options and added some new adjustment layers for refinement. That is basically all I did for post-production.

EXPERIMENTS

As I said in the introduction, I like to experiment. That is why this project did not end with rendering the images you can find in this book. I also wanted to try something you can see on many car companies' websites. They present their cars via QuickTime where you can rotate the model 360 degrees, as you want. I liked this idea and with the help of VR ObjectWorx it was no problem to reproduce. It turned out very nice and I think it is a very interesting way to present a model. The last thing I did with the model was a stereoscopic image. I like this kind of 3D a lot. You can create such an image very easily, and the result is something you always like to look at – provided that you own stereoscopic glasses. Even if you find someone who is immune to the appeal of digital art, they are definitely going to like this (Fig.08).

All you need are two renderings from slightly different angles. You start by setting up your camera the way you want it. When you are pleased with its position, you clone camera one and name it camera two. Then you move or rotate camera two a little to the right. To achieve the best results, the center of your model, should be the center of your camera rotation as well. This way you get an even offset in the front and in the back. Now you can render image one and two. All that is left to do now is to copy the red channel from image one and overwrite the red channel in image two. By doing so, image two becomes your stereoscopic image. After that put on your glasses and enjoy. Little effort – big result (Fig.09).

Fig.09

SCENES

CONCLUSION

I hope you have enjoyed this little insight and maybe found some parts of it useful for your own work. I loved the whole process and everything related to this project.

Am I pleased with how it turned out? Yes and no. I think you are pleased with your own work just for a short time. With a little distance, you will most likely find something that might have been done differently, or perhaps even better. But that is OK. It seems to be the slower version of what happens while you are working on a project. You change things until they seem right. So, finding things to change some time later is just another part of the process. As you might have guessed already, I could not resist trying something out while working on the article for this book (Fig.10).

Was this the last Lego project? Definitely not! It was way too much fun to let it be the last of its kind. I think there will be something that has to be tested or experimented with in the future, and for that I am going to need an adequate model.

Fig.10

ARTIST PORTFOLIO

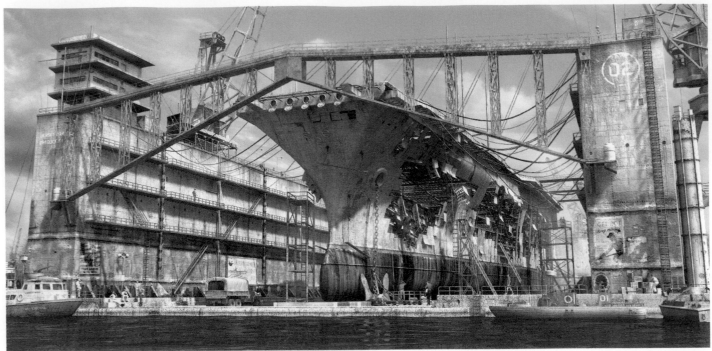

© ALESSANDRO BALDASSERONI

FLOATING DRYDOCK 1943

BY ALESSANDRO BALDASSERONI

INTRODUCTION

This *Floating Drydock 1943* is a scenario for Code Guardian`s animation short, by Marco Spitoni, for which, basically, the author's idea was to make a scene where P51 airplanes could perform some acrobatic, evasive maneuvers. Marco made a (very) quick sketch of what he wanted to represent: a rusty and decadent environment focused on a hull with a breached and dismantled carrier inside it (Fig.01).

Then came the research for drydock reference images on the Internet. Later I made quick sketches based on the source material; Fig.02 is pretty close to the final still, except for the camera angle. For the carrier

Fig.01 © 2007 Marco Spitoni, http://www.cee-gee.net

in particular, since I couldn't find any online pictures quite satisfying, I bought a plastic scale model of a Second World War carrier. There's nothing better than something 3-dimensional when trying to realize something in 3D.

MODELING

The modeling part was quite basic, where most of the structures are elaborated primitives. The water in front of the drydock is a flat plane displaced with a noise map. The carrier itself was quite challenging, and was made by boxmodeling and subdivision surfaces, with all the detaching panels carefully placed over it. The cranes and trucks are previous models that I had made for this project, whilst the people are a mix of pictures mapped onto flat polygons, and real-time

Fig.02

Fig.03 © Giovanni Bianchin

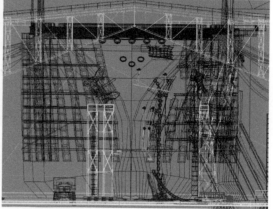

Fig.04

Fig.06

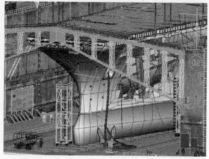

Fig.07

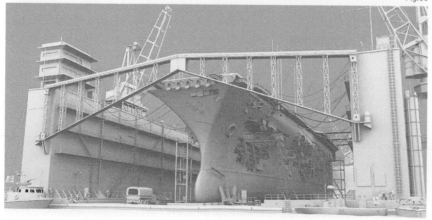

Fig.05

models made for the project by another Code Guardian artist, Giovanni Bianchin (Fig.03). The detail for all the elements were finalized and I then focused only on the camera shots. Some elements were invented for the scene and are probably not quite historically accurate (Fig.04 – 07).

The real challenge was dealing with the polycount, optimizing here and there with the aim of preventing the scene from collapsing in viewport. I tried to make all sorts of nasty little details with the minor number of polygons, but in spite of this the whole scene took almost six million polygons when rendering (Fig.08 and 09).

TEXTURING

Texturing was the most challenging and time consuming task, because it took a lot of trial and error, which I'm used to, to achieve the correct mood for the textures, due to the sheer size of them (the larger ones reached 4096x4096 pixels in size). Most of the textures made for this project were made by photo-retouching and painting over existing photo-realistic textures (thanks to 3DTotal for the nice 3DTotal Textures, largely used in this project). I organized my .psd files into cataloged folders: one for the rust layers, one for the diffused dirt, one for the hue and saturation color corrections, and so on. I was then able to easily experiment with them – turning them on and off – and could play with the layer fusion modes of entire folders, and of course I could also drag and drop them from one .psd file to another

Fig.08

Fig.09

Fig.10

Fig.11

in a swift and practical way. Just think how useful it can be to drag entire rust layer folders to achieve the same rusty mood from two different metal textures files...or the importance of building a folder containing color adjustment layers for specular and glossiness maps, and then being able to drag it from one .psd file to another for them to share the same shinyness map settings. Most of the materials were standard 3D Studio Max materials with blinn shader, except for the water material which was a Brazil glass, which had been slightly modified (Fig.10).

Some other artists use Darktree's Simbiont procedural shaders, which can be really useful for very rusted, metallic surfaces (as can be seen on the front gate, for example) (Fig.11–13).

LIGHTING AND RENDERING

Although the animation was rendered in Scanline render (as was the whole project), the still was actually rendered in Brazil r/s 1.2.

Fig.12

The daylight scene uses one yellowish 3D Studio Max standard target direct light, which casts blueish shadow maps, a Brazil skylight, and an indirect illumination with one bounce. The complete rendering and lighting setup can be seen in Fig.14. The aliasing filter was the Catmull Rom type; I love the sharp and neat quality that it produces, although in some cases it can generate aliasing problems.

After the straight render in 3D Studio Max, which took more or less 45 minutes, the scene was then processed in Photoshop in order to fine-tune the hue and saturation of some areas, further increasing the sharpness of edges and adding a subtle fading depth effect and, of course, compositing with the sky and the background picture.

Fig.13

SCENES

CONCLUSION

The project allowed me to work on several aspects related to 3D work: the research of source material to understand which were the interesting elements that I wanted to focus upon; the interpretation of a design, and the practical realization; the problematics of modelizations and scene optimization (remember that this image was not created for a simple still); and, last but not least, the making of photo-realistic materials and textures.

It took me almost a month-and-a-half of my spare time to create, which proved to be a great and complete experience for me, and I hope that you will all be able to see the efforts of the whole work in the final image.

The Code Guardian was a short, full CG movie project which began in around 2002. For this project, four artists were involved in the production, who were basically working for their passion for CGI: Alessandro Briglia, Giovanni Bianchin, Iacopo Di Luigi, and I, Alessandro Baldasseroni...

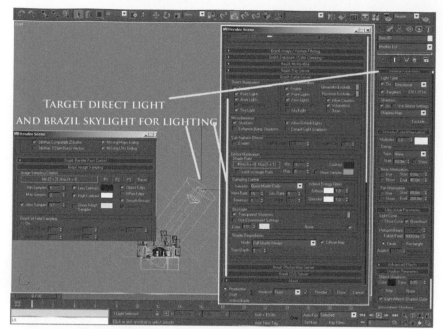

TARGET DIRECT LIGHT AND BRAZIL SKYLIGHT FOR LIGHTING

Fig.14

The story is about a battle fought during World War II, between giant robots during an attack against an American military harbor. The period setting required a lot of documentation, like photographs, footage and so on; the huge carrier dismantled in the drydock was one of the settings that was used for an attack sequence. The formation of P-51 Mustang fighters flew beside and throughout this set.

ARTIST PORTFOLIO

SELFILLUMINATION 2:
THE DARK SIDE OF SUCCESS
BY ANDRÉ KUTSCHERAUER

CONCEPT

This image was created as a follow-up to my artwork entitled *Selfillumination*. I wanted to create a picture that not only took the esthetic message from the first one, but also followed up on the story. The first work of this series was a light bulb that was trying to plug itself in (Fig.01). The message I was trying to convey, was that everybody should try to get the very best out of themselves. This message I aimed to communicate through the use of minimalist elements, and a sterile, cool-looking image. Through *Selfilllumination 2* I wanted to show the possible future of the light bulb, if he had achieved

his goal to "illuminate" himself. The little fellow succeeds with his plan to get out, but then faces other problems. As soon as he starts to illuminate himself, moths begin to annoy him – flying around him – suggesting he could go crazy. The initial idea came from a request by *3D World Magazine* (Jim Thacker and Shaun Weston) to create a picture within the *Selfillumination* universe that perfectly suited the cover of their magazine. I would like to thank them for this fantastic opportunity – to be on the cover of *3D World Magazine* was a great honor for me. I hoped to create a worthier follow-up to my first *Selfillumination* picture, and, who knows, perhaps it will become a trilogy…

Fig.01

MODELING

Most of the elements in this artwork were created by box modeling (Fig.02), except for the plug, the jack and the screws. I think that the modeling of such industrial shapes is much more effectively achieved with a Nurbs modeler. Sadly, 3D Studio Max does not have a good working Nurbs modeller itself, so you should use something external like Rhino, or use a plug-in like Power Nurbs, from Npower Software, to make up for this deficiency. In this case, I used Rhino 3D (Fig.03), which is a good and easy Nurbs modeler for Windows. Always remember that, when modeling, fillets are extremely important for real-looking objects (Fig.04). Even though your shader may be perfectly set up, it will not look real if there are unrealistic hard edges. A lot of "materiality" comes out on the edges of objects. On most of the edges of the models in this picture, I made a fillet – about 2 mm minimum – so that it could be clearly visible in the rendering, and so that the light could do its job properly. For this cover image, I took the model from my first work, *Selfillumination*, and modified it to adopt this new pose. Because I included a fully animatable biped structure under the first guy, I was now able to re-pose it very intuitively with the focus purely on the esthetic (Fig.05).

Fig.02

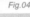

Fig.03

Fig.04

Fig.05

SHADING

The intention behind this picture was to create a sterile, cool atmosphere where the little guy is clearly in focus. Another purpose was to achieve a look of photographic realism. Although inorganic materials, like metal and glass (Fig.06), are easier to simulate in 3D than skin or hair, it takes skill to make them look absolutely photo-realistic. Most new 3D users often make the mistake of tweaking things, like shadow opacity, or such things to optimize the render time and to easily be able to correct the light. This often results in pictures that will not look photo-real, although it is hard to say why. Try to avoid such techniques. If your picture looks bad, think about your lighting and think about your materials. Don't tweak, just set up and wait...

Fig.06

LIGHTING

If you have a lot of materials like metal or glass in your scene, then keep in mind that they will reflect things that are indirectly visible in the scene. A light box is a good start to achieving reflections (Fig.07). The light box that I used consists of five simple planes with short distances between each other. The right and left ones are self-illuminated, whilst the others receive a diffuse white material. The light comes in from two huge Area lights on the left and the right. With Area lights, the picture will quickly lose its contrast, and, to correct this, the Level tool in Photoshop is great. Use it as a Correction layer, with the blending mode "luminosity", so that you will be able to perfectly correct the contrast without raising the saturation. Using this tool, press and hold the ALT Key and pull on the High or Low slider, and you will quickly find the Black and White points.

Fig.07

Fig.08

CONCLUSION

That's about it (Fig.08). This account is meant to show you one kind of working method that can bring you to the point at which you are able to fully realize your ideas. There are endless other ways to construct such pictures, but always remember that if your software doesn't have a button for the thing that you need, then it doesn't mean that it can't be done. You also need to be technically inventive within the creative process, whilst designing the picture itself. These packages are just like a hammer to a sculptor, and are dependent upon how you use them. The techniques provide us with powerful and new possibilities to create something really unique – we just have to use them...

ARTIST PORTFOLIO

HUSH
BY BENITA WINCKLER

INTRODUCTION

"Damp forest soil and the light of the evening sun… If you follow the old path to the mountains it will lead you to the caves of the Ylreen.. Stay silent for a while and you might get the chance to see one.."

This is one of the cuter, and more cheerful, concepts for my Eeanee project. The image shows a female shaman character and one of the ancient creatures that used to live in the woods around Aion – a Ylreen.

The artwork was created in the context of serving as a demonstration image for a basic tutorial on digital painting for *Art Scene International Magazine*.

LINE ART AND TEXTURES

I began the work with some simple sketches in Photoshop in order to find the right composition for the piece. Once I decided upon this, I took my time working on textures for the background. This was all done with Painter in a second file. I was simply looking for rich and interesting structures, and didn't worry too much about concrete forms or anything at such an early stage. Think of it as emulating a natural painting surface – the result shouldn't scream "Digital!" in our faces. Even if most parts of this basic texture were later covered with the other elements of the image, there would still be some spots where these first brush strokes will remain visible, suggesting all of those random little details that real material surfaces exhibit.

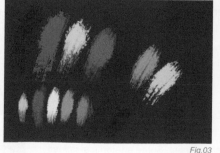

Fig.02

Fig.03

Fig.01

LAYERS

I took the new texture into Photoshop and made it my background layer (Fig.01). If you take a look at my layer palette (Fig.02) you can see that there were two layers, one for the line art and one for the textured background. I painted the new elements onto a third layer, which was then positioned between these two. This way my line art remained visible for as long as I needed it. Once I was happy with the results, I then merged the new layers with the background layer, so that there would be no more than four or five active layers present. Fig.03 shows the layer containing my color palette.

Tastes regarding the number of layers vary quite a bit, and every school has its own arguments – it really depends upon the occasion. If you are working for a client, it would be wise to keep your layer arrangement, as it would then be easier to change or replace major elements without affecting the entire work. Also, if the deadline starts closing in, you don't want to have repaint everything in your work just because the background color suddenly has to be orange, instead of blue.

Personally, if I am painting for my own pleasure, I tend to prefer to keep the number of layers low, as it has more of a painterly feeling to it, because your decisions are somewhat final and not that easy to undo. Furthermore, you can invite a vivid authenticity into your image by allowing for those happy accidents to occur – not everything can be planned consciously.

PAINTING PROCESS

I went on to paint with Photoshop's Standard Pen Opacity Flow, which has a nice hard-edge to it, this coming in very handy during the initial stages of an image when you want to define the forms with light and shade. Chance and coincidence are still on the VIP guestlist but, until they decided to show up, I stayed with the color scheme, as shown in Fig.03.

Looking at Fig.04, you can see the first phase of the image. Most of the important questions were solved by this point. The direction of the main light source was decided, the dominant color became clearly noticeable, and I had a precise feeling for the ensuing process.

Before I painted the Ylreen as the center of interest, I refined the face of the elven girl (Fig.05 – 11). Fig.07 reveals that I decided to change the design of her ritual headdress; a less spiky, yet more feminine and soft look, suited her character much better. Never underestimate the importance of such seemingly trivial and small decisions, as they can become the key to conveying something about the character that you are working on.

In Fig.09, you can see that the line art has now been merged down and has nearly vanished underneath the layers and layers of paint. Some anatomical issues were fixed and the form of her hand was repainted completely. Fig.10 shows that, in some places, her raven black hair was showing through the feathered headdress, giving the particular area a bit more depth. For the benefit of an overall smooth and unflustered look, I omitted the preconceived hair braids (Fig.04).

Fig.04

Fig.11

Fig.05

Fig.06

Fig.07

Fig.08

Fig.09

Fig.10

Fig.12 Fig.13 Fig.14 Fig.15 Fig.16

For the background of the image I chose to feature some willow branches reaching downwards. I couldn't be bothered painting every single leaf, so I took a shortcut by creating my very own willow branch texture. Fig.12–16 detail the steps of the work in progress. Firstly, I decided on the overall form of the leaves; then I added light and shaded areas. I went on to add some minor details and then the basic texture was complete. Later on I added more individual leaves and more detail to achieve a smoother result, more pleasing to the eye.

When painting a Ylreen, or painting the leaf of a willow, the technique was nearly the same (Fig.17–23). As you can see, the painting was done in several stages, the creature being refined step by step. After finishing the work on its feathers I decided that the position of the Ylreen in the image could be improved by moving it slightly to the left and bottom of the image. Fortunately, I hadn't merged the bird at this point, so it was easy to make adjustments. Working on a separate layer, I suggested a motion blur effect at the tips of his wings (Fig.23). Then the layer with the Ylreen was merged down.

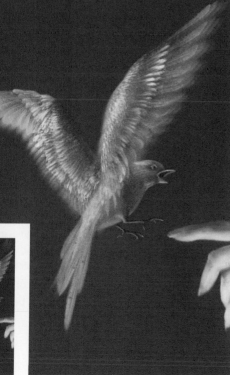

Fig.17 Fig.18 Fig.19 Fig.20 Fig.21 Fig.22 Fig.23

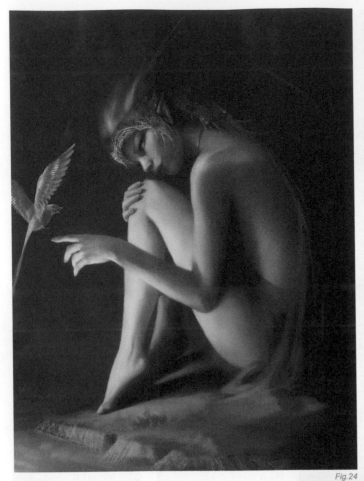

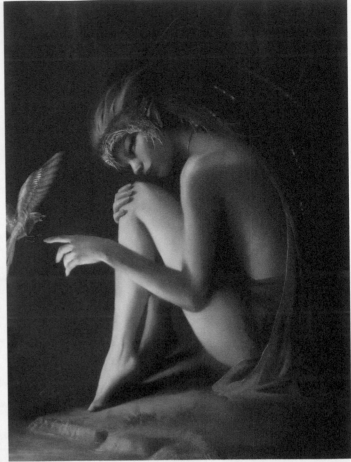

Fig.24

Fig.25

FINAL ADJUSTMENTS

As beautiful as immaculate, white, fay skin may be,
after a hike through the woods of Aion, tidiness is very
unlikely (Fig.24 and 25). On her search she had to
climb over rocks, walk through mire and mud up to the
mountainside behind the old city. Some traces of this
journey should be visible on her delicate body (Fig.26).
Whilst cautiously applying mud to her skin, I suddenly
noticed that her ankle looked a little too thin – even for
a slender elven girl. I made the necessary adjustments
and also decided to tear a hole into the precious
material of her veil. Some last brushstrokes added a
soft glow on the garment and the image was finished.

CONCLUSION

The expression on her face and the overall mood
turned out just how I had intended: warm, quiet and
peaceful – a happy little something. I noticed strange
marks appearing on her forearm, and knew there was
another, more important, mark on the nape of her neck
beneath all that silky black hair, but this will be the
subject for another image...

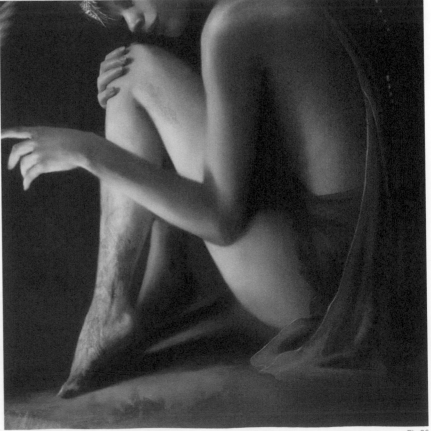

Fig.26

CHARACTERS

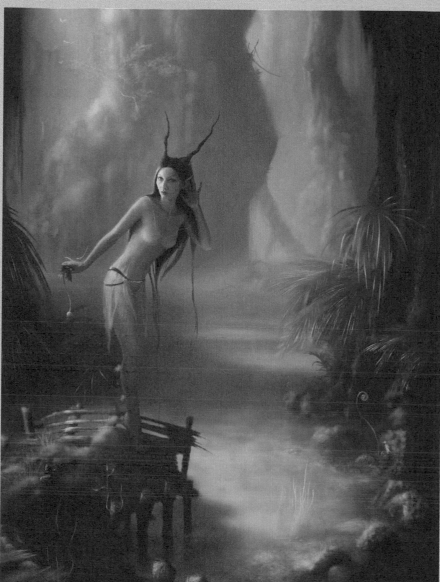

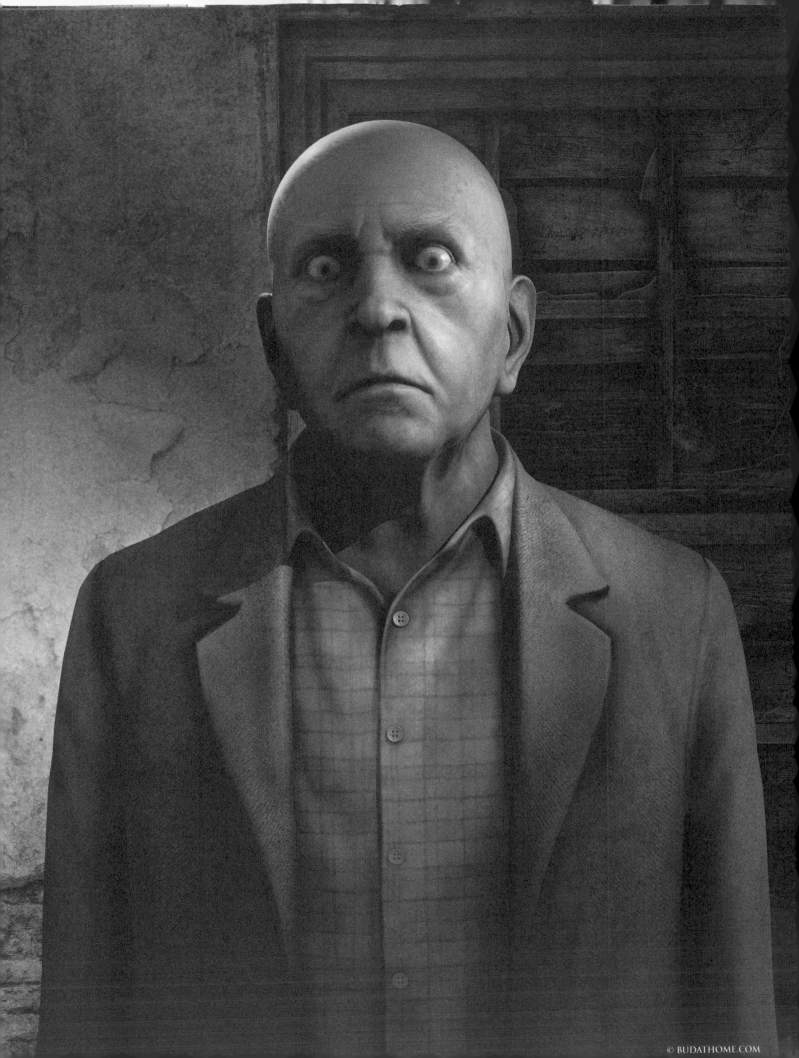

Mr Quixote
By Antonio José González Benítez

Introduction

The origin of this image comes from my particular interest in art, and especially in the work of *Old Masters*. I have always tried, in a way, to follow my artistic inheritance; that is to try to endow my personal work with something of what I have learnt in the study of Art History. I also try to bear in mind the number of artists that we have in my native country, Spain. My work is intended to hold a certain message, a certain artistic purpose which references historic sources and yet tries to go beyond the limits of the technical challenge, which means the creation of a digital artwork.

For this particular image, the works of Velázquez (color palette), Caravaggio (dramatic and tenebrism lighting) and El Greco have inspired me greatly. Regarding El Greco, I was thinking particularly of *The Gentleman of the Hand in the Chest*, to whose composition this image owes a lot. I have exercised some license naming my creation *Mister Quixote*, intending this to be a tribute to the famous personage. This contemporary Quixote is more of a Quixote for his lunatic behavior, than by any historical resemblance. We would think of a Quixote with a beard and a white moustache, wearing his armor. Nevertheless, the most important aspect in this image has been to achieve an expression of real insanity, keeping at the same time the dignity of an anonymous elder.

Regarding the composition of the image, it has been endowed with very little dynamics, and almost a hieratic pose. I intended to recall the inexpressive gesture of some sculptures of ancient Egypt, centering the attention in the look of the personage as the only expressive element. Finally, the tenebrism and neglected room in which he is standing, together with the claustrophobic effect caused by the blocked-in windows, seeks to emphasize the mental state of the character, and therefore increases the sensation of confinement.

MODELING

Regarding the technical concerns, and in order to shape the character, I used a wide range of reference material for this artwork. This helped in order to model the correct proportions of the figure, and in making a credible and anatomically correct human head. I always begin with the eyes: extruding the edges and taking special care in the disposition of the "loops". I consider it very important to have a good topology in the distribution of polygons, as well as avoiding too dense a mesh. Besides, I try to keep everything as quads, to avoid incompatibility issues with other programs, as well as for cleanliness reasons. In this case, I used Softimage XSI for the shaping of the low resolution mesh (Fig.01). I also used the new Pelt Mapping in 3D Studio Max 8 for the UV setup. This new tool allows a very fast and optimum UV setup. For the clothing, I simply used ZBrush 2´s AUV Tiles.

Before itemizing in ZBrush, I designed a pose for the model using a pair of bones and an envelope: a simple structure that allowed changes to the position of the head. Once the model was finished, I exported an .obj to work with in ZBrush 2. I added all of the possible subdivision levels (normally no more than six), which offered a result that flowed between one million and two million polygons. Therefore, I was able to reduce the level of detail in each stage of subdivision, going from minus to more, and finishing the details, such as the pores, facial imperfections, and so on (Fig.02).

Fig.01

TEXTURING

For the texturing, I used the new ZapLink tool belonging to ZBrush 2, which permitted the combination of ZBrush with Photoshop. This meant that changes carried out in Photoshop were brought up to date in ZBrush and stored in the texture automatically. In order to achieve a result with as much realism as possible, I used real photographs together with tools in ZBrush such as the Projection Master. Especially useful to me were the SingleLayerBrush and the SimpleBrush, including a Stroke in Colorized Spray to imitate the grainy skin texture.

Once I had finished working in ZBrush, I exported an .obj at the highest detail level and imported it into XSI. I then generated a normal map using the Ultimapper tool. This tool compares the two mesh types – high and low – and creates a normal map following specified instructions regarding quality and size. This was then applied to the low resolution mesh. A great advantage to applying normal maps this way is that the result can be shown in real time – with the Realtime Shader in DirectX or OpenGL.

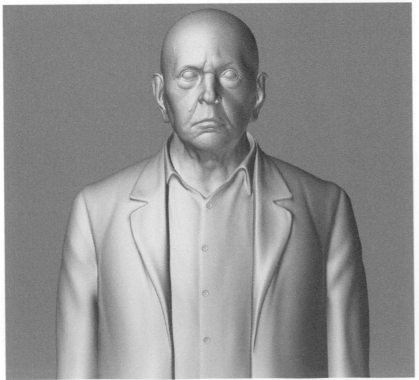

Fig.02

For the background, I shaped a simple structure with a fragment of a wall and part of a window. Then, I mapped them using the tools of the XSI Texture Editor and textured them with Photoshop, again with the support of real photographs. For the shaders, I used a Phong with a Bitmap connected to the Diffuse for the head, and a Normal Map connected to the material Bump. I used the same configuration of the shaders for all the other elements of the character (Fig.03).

LIGHTING AND RENDERING

For the lighting, I used an HDRI map connected to an Enviroment Shader in the render pass. For the direct lighting, I used a triangle of lights: two Spots and one Point. In order to preserve the quality of tenebrism, I ensured a very low intensity and didn't use any Global Illumination, only Final Gathering in the render options in Mental Ray. After that, two more passes were added: one for the Subsurface scattering and another for the Ambient Occlussion, all composed later in Photoshop (Fig.04).

Fig.03

Fig.04

ARTIST PORTFOLIO

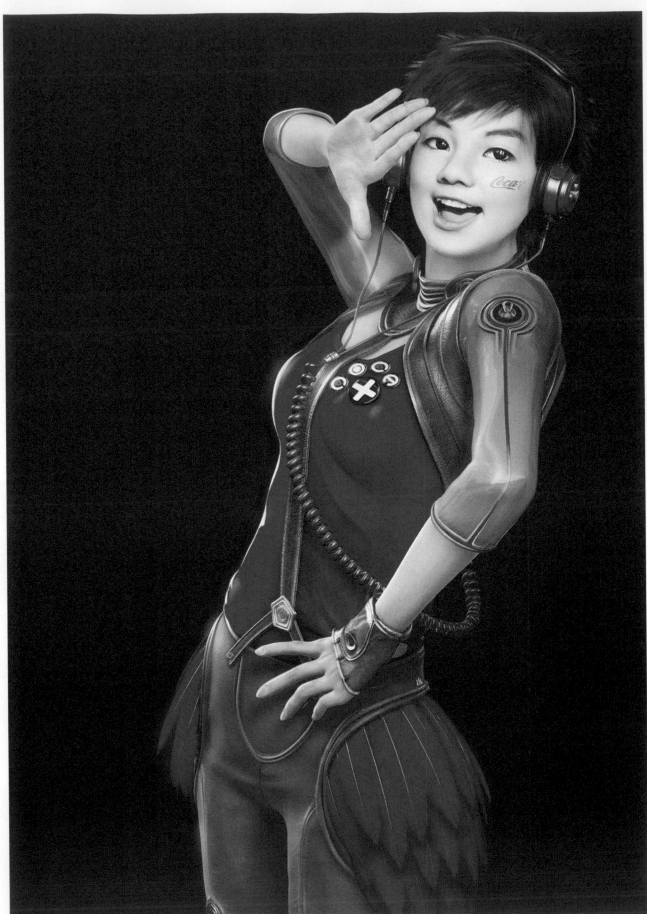

ELLA
BY BINGO-DIGITAL

INTRODUCTION

Ella is a 3-dimensional virtual doll that we made under the consigning of Coca-Cola and Tencent. As we know in China, *Ella* is a very popular pop singer, and because of this, It was very difficult to produce a character based upon such a well-known figure. At the beginning we analyzed many of her photographs, and at the same time Coca-Cola provided us with lots of high resolution photographs of her for reference. Our goal was not just in making everyone recognize *Ella*, but to achieve making the character more charming, and more vivid, in 3D. We hope that her fans will accept the character which has been produced by digital technology.

MODELING

Because *Ella* is a very famous pop singer in China, it is very easy to get detailed information about her for reference, and Coca-Cola was also helpful in providing a large number of large-scale reference photographs of her – all of which helped us greatly in attaining our goals.

Concerning the production of the model, we had to pay particular attention to the proportions, including the relative proportions of her body, head, clothing and so on (Fig.01). We also had to keep in mind that *Ella* would had to be in the correct proportion to other characters modeled for Coca-Cola. We therefore required a scale to assist us with our work. The tasks of producing the properties for *Ella* were divided, but we used the same proportions and aimed to produce more details based upon the accurate proportions.

The adjustments and similarities on the modeled head were related to the focus and angle of the camera (Fig.02). When we set out to make the model we needed to keep in mind that we would be adding special lighting effects. We therefore had to adjust the details of the model's face using a highly precise method (Fig.03).

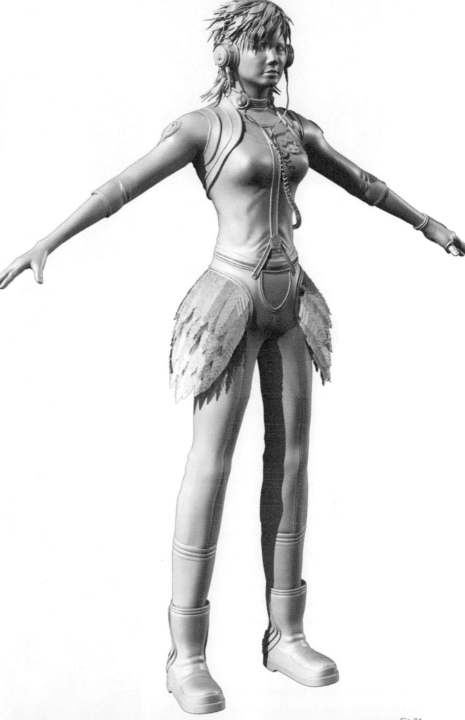

Fig.01

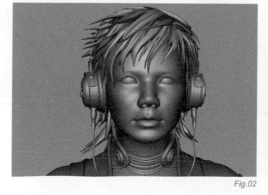

Fig.02

Fig.03

Fig.04a

Fig.04b

Fig.05

At the same time we also took into consideration the final, dressed-up effect when we were making the textures. The adjustment of the pose after the setup was done in the same way that we would make a sculpture. Only after we had confirmed the effect of the pose with our clients, Coca-Cola, could we then delete the history and continue with the necessary adjustments (Fig.04a and b).

Producing the expressions was another key process in the modeling of *Ella*. We had to understand how the muscles in the face move when people express their different emotions, before we could begin (Fig.05).

TEXTURE

Due to the size of the output image we rendered this time, it was very large, at 14 000x14 000 pixels. We went on and added some details, such as the feathers on the costume, the grains of the skin, and even the trace on the properties. The references helped us a lot with this task. We usually analyse a variety of excellent 3-dimensional and 2-dimensional pictures, and if possible we also tried to find large-scale, true photographs of our subjects. Only when you can see the real photographs are you able to understand what kinds of details are the most believable. A nice reference image can work wonders for your creations (Fig.06).

In order to achieve fine, textured effects, such as metal and leather, we used the render layer by layer so as to make the highlights and textures. We had a mixture of other pictures which were then easily and conveniently controlled and modified. This also made the details more abundant. When dealing with the highlights of the metal we used HDRI to render, to achieve only the most realistic effects.

RENDERING

We used both Maya and Mental Ray software during the rendering stage. The most difficult factor was that we needed to output very high resolution images, reaching

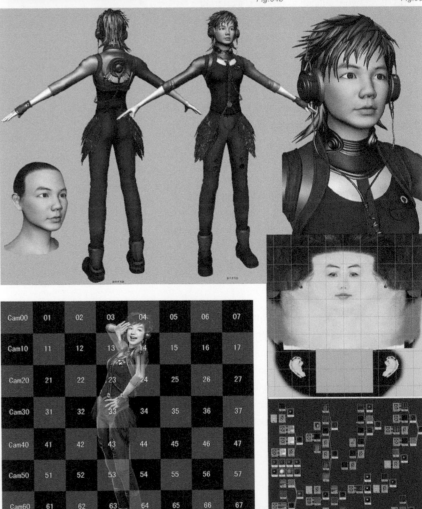

Fig.07

Fig.06

14 000x14 000 pixels through the whole rendering procedure. We made a script to solve this problem and rendered the image block by block (Fig.07). This is why we divided a large image into several smaller sections; each one of them being 2048x2048 pixels. After rendering we were then able to combine them all again. In order to get super-fine

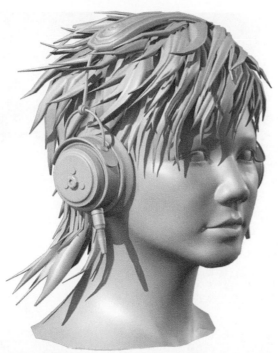

details, such as the texture of the metal and leather, we rendered the material layer by layer. In this way the highlights and textures became more easily controllable and were easier to modify, if necessary. At the same time we used HDRI to render whilst we were rendering the highlights of the metal to get the desired effect.

LIGHTING

During the lighting stage we tried to simulate a real environment to arrange and set the main light source and the subsidiary ones. We also added some reflectors, similar to what would be used in a real studio, to the software, as necessary. To distinguish the role of the lighting, we then added some fill lights. The light for the shadows was set individually, and then combined in the final stage (Fig.08).

CONCLUSION

It took us over one month to complete this entire project. It really was a great challenge to create representations of pop stars for all of us to admire in 3D. You can now see our work all across China, for example as large posters and billboards, and our images are even featured on Coca-Cola cans. Now that we have had our confidence boosted, we believe that we are able to vanquish any challenges that may arise for Bingo-Digital in the future.

Fig.08

ARTIST PORTFOLIO

SUMO
BY DANIEL MORENO DIAZ

INTRODUCTION AND CONCEPT

I've always been fascinated by the world of Sumo and its ancient traditions. The name Sumo comes from the Japanese word "Sumai", which means "struggle", and is one of the most ancient combat forms. The best fighters (Sumotori) had a privileged social status.

The reason I wanted to do this work, is that we are accustomed to seeing many 3D characters of beautiful women and handsome men with perfect bodies. For example, I had previously made two models of women with these characteristics, and so I wanted to do something different. I therefore decided to model a Sumo wrestler. It was a challenge for me to obtain a good sensation of weight and the fat under the skin, and I have continued studying ways of obtaining a good skin shader.

In the future, I would like to make a short animated film about a fight between two Sumo fighters. For this, I will have to learn a bit about montage, post-production and a few other things first. In animation, it would be a challenge to obtain the movement and the vibration of the skin. But for the moment, I have limited myself to making a video with the character rotating in the scene, in order to learn something of post-production and to gauge the technical limitations that a project like this might present (Fig.01).

Fig.01

© GUANNY

Fig.02

Fig.03

In my opinion, the most interesting things to discuss about this work may prove to be the skin shader and the post-production. Therefore I've focused upon these particular aspects in more detail.

Skin Shader

I think it's important to mention that, for this piece, I have used the V-Ray rendering engine for Autodesk 3D Studio Max, and the lighting was done entirely with only one HDRI map. The scene doesn't contain any other lights. The indirect illumination is set in order that it calculates the primary bounces with an Irradiance map and the secondary bounces with Light cache.

For a long time now, I have been lighting my scenes with V-Ray. It seems to me that V-Ray materials are very effective when trying to mimic reality (Fig.02 and 03).

The textures fulfill a crucial role in building a realistic skin shader. I think that if you want to obtain a good result, the best thing to do is to use photographic retouched textures, but you have to ensure that any lighting information in the photograph (light and shade), has been eliminated. Ideally you only want to keep the color information (Fig.04).

The color of skin has a variety of tones, as well as green, blue and purple hues, apart from the dominant skin color. I think it's more difficult and laborious to obtain the same result purely by painting it by hand. If we left the lighting information in the photograph, we would be simulating a non-existent volume on our model. Our aim must be that the entire volume of our model comes from the modeled details and from the bump and displacement maps (Fig.05 and 06).

Fig.04

Fig.05

Fig.06

CHARACTERS

For this model I used two different materials, one of which was a falloff (shadow/light) in the diffuse slot to mix two maps (Fig.07). One uses the normal skin color and the other uses the same map turned to orange by way of Color Balance in Photoshop. In this way you see the normal skin tone in the diffuse areas and the orange-colored tone in the shaded zones. This is a way of faking translucency, as it simulates a sub-surface scattering shader. This method is also very useful when doing an animation as it diminishes the render times by some margin.

Using this material I created the base render of the complete character (Fig.07 and 08). Material 2 is a material with translucency (sub-surface scattering).

Fig.07

Fig.08

Fig.09

Fig.10

Fig.11

I used this type of material to extract a layer of V-RayRefractionFilter, a gray scale layer which you can color using the Color Balance in Photoshop, to create a red-orange tone. Once you have this layer, you can add it to your Adobe After Effects composition. (Fig.09–12).

The reflection on the skin is also an important point to bear in mind for a sense of realism. The ideal thing is to control it with a gray scale map; this way we can control the extent in which the zones are reflective. However, in this work, I have not used it, because the camera is for a middle distance render and I needed to optimize the resources for a possible animation. If the work was a close-up of a face, it would be advisable to use this map. In this particular case, I used a falloff map (Perpendicular/Parallel) in the Reflection slot, changing the Mix Curve, and in this way obtained a light diffusion similar to that for real skin (Fig.13).

Fig.12 Fig.13

POST-PRODUCTION

For the post-production I used Adobe After Effects. In 3D Studio
Max, through the Render Elements window, I wanted to extract the
color layer (V-RayDiffuseFilter) and two layers of reflection (V-
RayReflection and V-RayReflectionFilter), but the V-RayDiffuseFilter
couldn't recognize the falloff between two textures that I used. As a
result, I made a single-layered render of the complete character with
the diffuse color and the reflections in one pass.

The following were the layers used for the final composition in After
Effects:
1: The background layer done in Photoshop (Fig.14).
2: The complete character layer done with material 1 (Fig.08).
3: The V-RayRefractionFilter colored from material (Fig.11).
4: The Light map for occlusion (this layer was made with a gray
material without reflections and speculars, and used the scene
illumination The HDRI Map) (Fig.15).
5: The Z-depth (for the depth of field) (Fig.16).
I used the .tga file extension with 32 bits to save the alpha channel of
all of these layers.

Fig.14 Fig.16

Fig.15

CHARACTERS

I went on and composed all of the elements in After Effects. Most of the post-production software works in a similar way to Photoshop, where you combine many layers. You need a background layer under the stack, and then you simply add different layers above, controlling the manner in which the layers are mixed (add, multiply, and so on). For this particular work I mixed them in the form as seen in Fig.17 and 18.

Fig.17

Fig.18

ARTIST PORTFOLIO

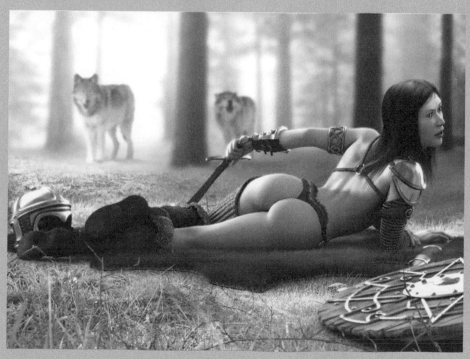

CHARACTERS 99

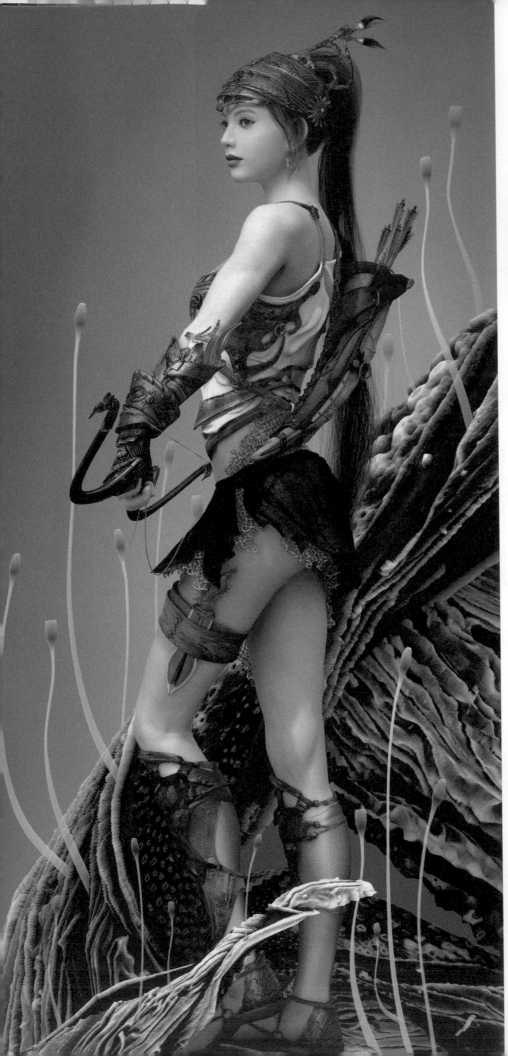

DIVINE PROTECTION
BY HYUNG-JUN KIM

IDEA ON THE PICTURE

Sometimes inspiration that I get from great artwork, performances or general culture, become the motive behind my pictures, but sometimes small things in everyday life are what motivate my pictures. I have a Nikon EOS camera and this is my treasure. When I found out that "EOS" meant Goddess of Dawn, I wanted to create a character by the same name. Thereafter, I began creating the world in which she would inhabit. Her parents named her after the Goddess of Dawn because she was born at dawn and she grows up to be a famous hunter in her village. One day, the god hears about her incredible archery skills and make her the guardian of a land, normally under their protection. Whenever she goes out hunting there is an eagle that flies over her head and follows her. The eagle is named Hoya, and in my initial drawings I thought about the composition of EOS and Hoya together (Fig.01).

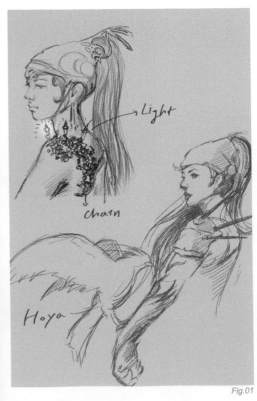

Fig.01

She also has an enemy, or a "nemesis", like other characters, and loses Hoya in a battle with the nemesis, Wax (the *Invader Commander* created later by my wife) (Fig.02), and therefore we do not see Hoya in the final picture. I wanted EOS to appear strong, overcoming the sadness of losing Hoya and enduring the long battle.

Of course, I knew that it would be difficult to include all of this character's background in just one single frame; however, attaching a story to the picture is one of my ways in which I develop images.

HOW I WORK

When designing a character, it is more important than anything else to continuously imagine the story behind the character and the world in which they exist. This is because you need to also create all the accessories that adorn them, such as their costume, gloves, weapons, and so on, from the world they live in (Fig.03a–c).

Some original ideas became crucial to structuring the picture, which remained until the end. In the past, I used to spend more time looking for various reference images, as opposed to drawing itself, in order to visualize the idea. However, nowadays, I frequently imagine the world that the character lives in. I based EOS design upon the fact that she is a hunter using a bow, as well as a warrior who has been in various battles. Not forgetting either that she lived in the time of the gods. Therefore, even though EOS is female,

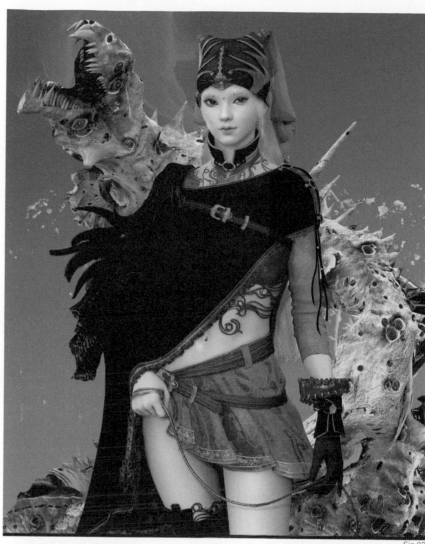

Fig.02

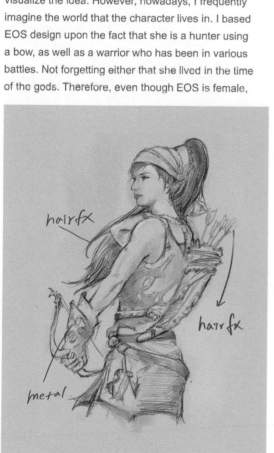

Fig.03a

Fig.03b

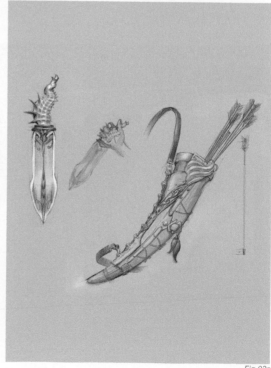

Fig.03c

she has well developed muscles and wears armor, although it is not made from heavy chain-mail. She also carries a small knife tied to her leg which she uses after catching her game. She is the heroine of a mysterious world and it followed that the environment had to also have mysterious plants and trees to match.

Creating good pictures means making good decisions. Deciding upon a suitable look and style is dependent on the world in which the character lives, and I believe that this determines the appropriate designs necessary for the picture (Fig.04).

LIGHT

Lighting is the most important tool in my artwork. I get tips for lighting from movies and the theater. Controlling lighting in 3D is not as straightforward as with drawing. In a drawing it is easy to emphasize or eliminate the light, but in 3D, one often gets unwanted results.

To combat this, I used various techniques to control the lighting. In places where there was too much light, I installed a plane to cover it or created an imaginative reflection. Also, I created reflective objects that radiated light to make reflective light (Fig.05). Sometimes, I also placed the diffuse and specular lights separately (Fig.06).

BEAUTY

One of my goals is to make my work look beautiful, whether it is in the form of illustration, game art, 3D animation, or film. This is one of the fundamental targets that I always aim for in my work. The definition of beauty differs, depending upon history and location, but there is more to it than it just being about prettiness. I believe that "beauty" is giving pleasure and satisfaction to someone via balanced and harmonized pictures, images or dance, which was certainly the intention behind this piece.

Fig.05

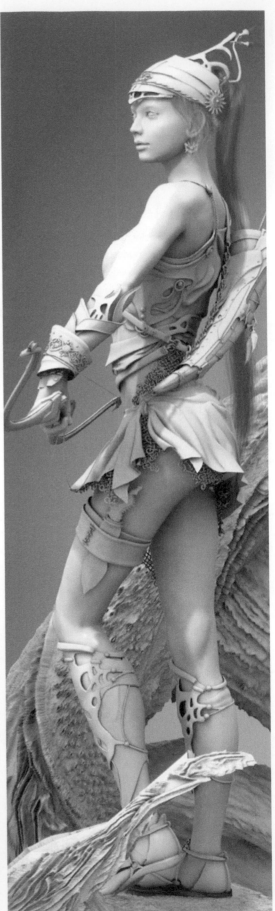

Fig.04

CHARACTERS

CONCLUSION

I made hundreds of renders and made a continual comparison between small differences. Sometimes, when I was unsure about the best solution, it was wise for me to listen to the advice of others.

Whilst working on this piece I felt, once again, that it can be very difficult to create a perfect balance and harmony which is capable of providing pleasure and satisfaction to another person.

Fig.06

ARTIST PORTFOLIO

JIMI HENDRIX: THE GUITAR LEGEND

BY MARCIN KLICKI

INTRODUCTION

My main goal in creating this piece was to show Jimi Hendrix playing his favorite song, one which he loves and which gives him a lot of pleasure to play, but also makes him seem sad, although I didn't want this mood to be too obvious. Why Jimi Hendrix? Because my friend convinced me to give it a try in the Max3d.

pl CG challenge, called *Myths and Legends*. The idea of showing the guitarist – undeniably a "legend" – was just brilliant, so it had to be Jimi. My inspiration was through Google, where I would advise people to search for reference images. My biggest motivation came from my friend, who constantly reminded me to work well, but quickly, for which I thank him now. I aimed to achieve a good, final effect and make the scene work

CHARACTERS

well as a whole, especially the colors, because they give depth and mood to this piece.

MODELING

The model of Jimi was done in Wings3D. I started with a quick sketch of an average human and proceeded to look at reference pictures of Jimi, aiming to make the sketch look like Hendrix by adding characteristic facial traits, accentuating his large lips, nose and cheek bones. I later decided to abandon the big nose, because proportions were so important for me and a smaller nose worked out perfectly.

The jacket detail was important for the work because, as everyone knows, Jimi's trademark is his jacket. I could have added a lot more detail, as I wanted the clothing to fit the character, but decided to make a simplified version. I didn't add creases or folds to the jacket because I wanted it to look stiff, to emphasize the head. Detail on the jacket was made by creating a box, and from it I created one part of the flourish. I copied it a few times and made interconnections using the bridge tool. I fitted the finished model to the jacket using the "tweak" utility, which is one of the most powerful features of Wings3D. I added little bells by creating a sphere and adding a bit of detail and cutting the insides. I then duplicated it along the surface of the jacket and rotated it in different directions to break up the symmetry. The next stage involved cloning everything to the other side of the jacket. The sleeves had little detail so I added two patches on every side and a spot to add hair to later on.

The guitar was done in a similar way, by finding good reference photos and using them to create a model that represented an original (Fig.01). I started with the body of the guitar by making an overall shape of both the body and the fret board and then placing little boxes

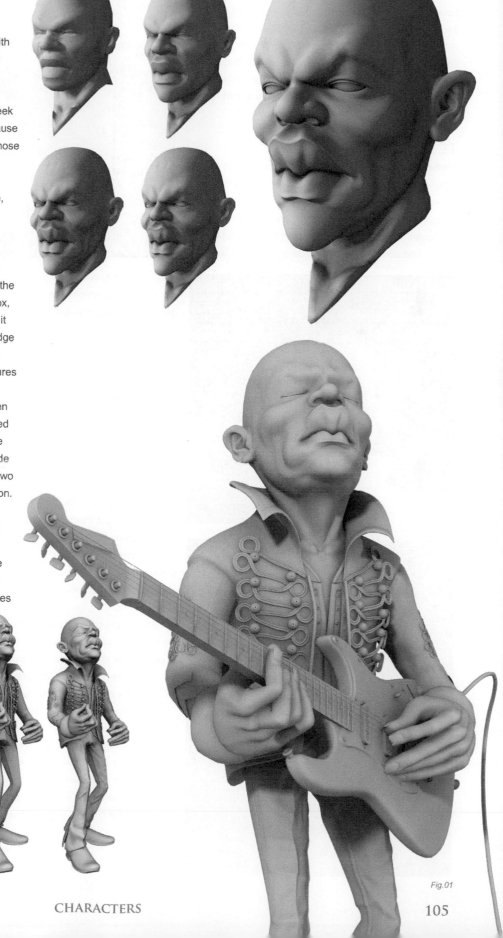

Fig.01

in spots where I knew I was going to add extra detail. When the main shape was similar to a guitar, I made boxes into more complex elements, keeping in mind the rule "work from big to small". I made everything (knob, frets, bridge) using primitives, adding detail where necessary. The pickguard was created in 3D Studio Max, using splines drawn along the guitar shape which were then extruded. Meshsmooth was only added to the main body and detailed areas which required it.

TEXTURES

Textures are one thing I hate to do, so I wanted to achieve a good effect using the simplest methods available. First I searched for nice photos at the highest possible resolution. After posing him properly and rigging the fingers I mapped the model using Wings3D's unfold option. The corrections were made in 3D Studio Max, in

Fig.02

places where textures had a tendency to stretch. I knew that the only spots which would be visible in the final image would be the hands and head, so I scaled up the rest of the body on the texture to gain more space for the visible geometry. I baked the UVmap using Unwrap and opened it in Photoshop. I established the skin tone and copied the detail from the photographs and added some extra detail by hand (Fig.02).

MAKING AND RENDERING THE HAIR

With previous experience in making hair I knew it was going to be hard to connect it to the head – it almost always looks artificial, so I wanted to avoid this. I added a band around his head to avoid texturing or correcting it by painting it in post-production. The Afro hairdo worked to my advantage because I didn't have to use splines; instead I was able to use one of the hair rendering systems, like Shag Fur.

I selected faces on which hair was to emerge, and then cloned the area and scaled it down so I could hide it inside the head. I could have assigned ID values to the faces to avoid cloning them, but I believe cloned areas give better results. I set the hair length, changing the "maximum" parameter from the Parameters rollout, and activated and set the curliness. To make the hair look more dense and fluffy I set the Radius parameter properly, but turned off the Random option.

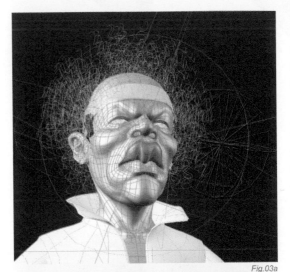

Fig.03a

I set the Turns parameter to add little curls, which fitted perfectly, and turned on the random parameter so every hair looked different. Another necessary option was clumping. I set Amount to maximum and tweaked "radius" to make it look good (doing a lot of test renders along the way). This option groups the hair together, which makes it look more realistic. Next I moved to the material editor and used a default Max material where I set the color and specularity. I used a gradient in the opacity slot to make the hair look more opaque at the end. The rest of the effect was achieved by altering the light settings, which is where it began to look real. A bluish light was set behind the head with an intensity of three; two lights were set on either side with colors that resembled the ones in the background: bluish-orange on the right side, and bluish-red on the left. Every light had an intensity of about 0.8 and had Hair Shadows option turned on. I rendered the hair as a tga. with an alpha channel so I could add it later in Photoshop (Fig.03a–b).

I then dealt with the hair on the sleeves. Why didn't I use Shag hair again? Well, I did this to compare Shag hair and HairF/X. I have to admit that HairF/X is as good as Shag

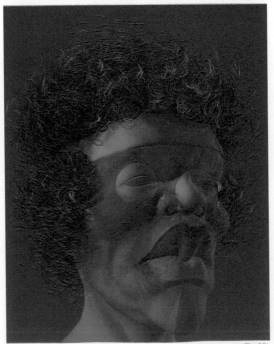

Fig.03b

hair, but this may be because I didn't have to worry too much about the complexity of the hair on the sleeves. I made two tubes and assigned the Hair and Fur modifier. I set the amount of hair to 10 000 and the length so that each of them differed. I then set the thickness of particular wisps by changing the Root thick and Tip thick parameters, paying particular attention to the "kink" and "frizz" ("kink" is responsible for producing the curls whereas "frizz" combines hair into groups). For the material, I went into the Material Parameters rollout and set "hue variation" and "value variation" to add a bit of randomness to the colors. I set the root color to dark blue and the Tip to a cooler light so that the earlier inserted tubes weren't visible. To render the hair I used the set of lights as I had done with the Shag hair (Fig.04).

Fig.04

THE BACKGROUND

Because I was very short on time I had to do something simple, but at the same time something good enough not to ruin the scene. My friend advised me to add fog and use volumetric effects, so I tried it out and hit the jackpot. I used three colors mixed together (Fig.05). To make the fog more convincing I used AfterBurn, since the basic fog available in 3D Studio Max wasn't good enough. With the AB plug-in, I was able to add additional mists and sparks.

MATERIALS, LIGHTING AND RENDERING.

Because all of these elements must work together effectively, I think it's good to discuss them as one. When I started this piece, I didn't have an exact plan on how to render the whole image, so decided to compose them in Photoshop from rendered elements. I made a few skin shader tests in different rendering engines, including Mental Ray, Brazil, FinalRender and V-Ray. I preferred those done in Mental Ray and V-Ray and decided to render final passes in those two renderers. Mental Ray was used to render the skin and ambient occlusion maps, and V-Ray helped in rendering the rest of the image.

The best way to achieve a fast, interesting skin shader is to use Mental Ray's Fast Skin Shader. I made a few option adjustments, for lighting purposes, and the final image was a combination of Mental Ray's render and skin rendered in V-Ray (Fig.06).

Global Illumination itself wasn't good enough, so I added a backlight to give more depth to the scene. I also added a few smaller lights with multiplier settings of about 0.2, which illuminated particular fragments of the model, for example on the back of the calf, on the shoulders, the hand holding the pick, cheeks, guitar, and so on (Fig.07a and b).

Fig.05

Fig.06

Fig.07a

Fig.07b

The rendering process was quite easy. Fig.08 shows the rendering settings used to render almost the entire scene. After setting the right values I hit F9 and went for a good night's sleep.

The second phase of rendering was to set the scene to render the Ambient Occlusion pass. I removed all the lights and the HDRI map and turned on the Mental Ray renderer. This map displayed some blackened spots which I could use to add a better sense of realism to the scene (Fig.09).

COMPOSITING AND ADJUSTING THE COLORS

I added more contrast to the renders so that colors appeared more convincing and made a copy of that layer – I always arrange it so I have the main picture at the bottom and make all alterations on copies. Next I added the rest of the layers – ambient occlusion, hair and fog – from AfterBurn. Layers were overlaid in different modes, mainly overlay and soft light, with different levels of saturation. I can't give you specific details on how to do this because it depends on what kind of effect you'd like to achieve. It's also good to have someone look at the work that you're doing, because it's helpful having a fresh eye from someone not directly related to your work (Fig.10).

Colors were very important to create the mood, so I made a few dozen tests, and max3d.pl forum users helped me to choose the best of them, and I then decided upon one with my friend, Jarek. I changed all of the tests using the starting point settings, using color balance in Photoshop (Fig.11a–d).

Fig.08

Fig.09

Fig.11a

Fig.10

CHARACTERS

Fig.11b

Fig.11d

Fig.11c

CONCLUSION

I think the final result has a good quality; the CG community has responded well to this piece, which is the most important factor. I'm very happy with the representation of the character, and the facial expression is exactly what I aimed for. There are perhaps some details that I would like to change, or redo. I wanted to also change the background by adding some amplifiers, reflectors and microphones – basically, everything that ought to be in the scene. Unfortunately, I just didn't have enough time to do it all, but thanks to the time restrictions of the project I avoided the problem of too much detail and achieved a simple, yet successful, composition.

ARTIST PORTFOLIO

© Marco Menco

Smoking Creature

By Marco Menco

Concept

I didn't have a precise idea of what I was going to do. I only knew that I was smoking a lot and I was really agitated by something that was happening in my life. I remember being really angry, but for reasons that I'm not going to go into now. As a base, I took the last human head I had created, Dante Alighieri, and started by experimenting with some different designs. In my imagination it was a creature trapped by something, which for me was a mere sensation, but for him was something physical, such as a straitjacket and captivity in a unknown place. The creature is seemingly a victim, with a light coming from above. He is possibly a victim of himself, but at the same time executioner of himself, and I wanted to underline that aspect

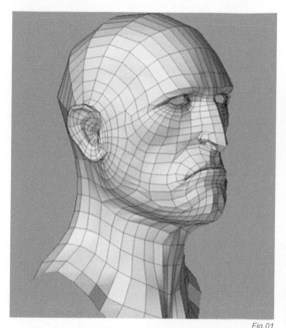

Fig.01

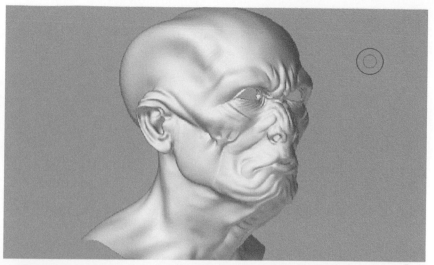

Fig.02

with the use of the smoke. Smoke is what is killing him. He is blind and he cannot see the damage that he is doing. Essentially, I used myself as a reference, looking at my outer appearance, namely the small wrinkles and facial muscles. I looked at myself in the mirror and I made the same expression that I wanted to create. It was odd, but really useful, because I could see which muscles I was using and how the skin reacted to their movement. The idea of smoke coming out of the head from the tubes obviously came from the fact that I was smoking, and also because I had visualized the anger seeping out of the head in the form of smoke.

MODELING

The modeling of the base mesh (Dante Alighieri) was done starting from the shape of the eye in XSI (Fig.01). Having the head ready, I started to do some experiments with ZBrush using the program as a sort of sketch pad (Fig.02). As you can see from the first design I did, the creature was not much different from the final result. But as I proceeded to modify the shape of the facial structure, I thought that to have an angry and desperate look, I had to extend the snout and open his mouth (Fig.03). I did this using ZBrush with the gray mask, selecting the eyes so that they were not involved in the movement of the shape of the face whilst modeling. When I had formed the face as I wanted it, the time then came to add the pipes and the straitjacket in XSI. I took a cylinder from the primitives and then made some extrusions by curve, to position them on the shoulders. I did the same with the little belts but using a cube this time, instead of a cylinder. The clothing of the straitjacket was done in ZBrush on a base mesh made in XSI. I followed the same operation for the teeth (Fig.04).

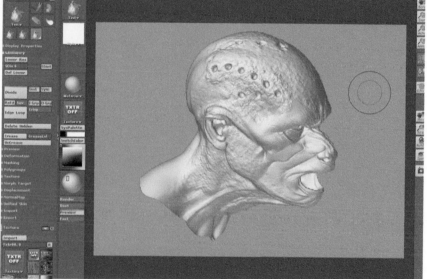

Fig.03

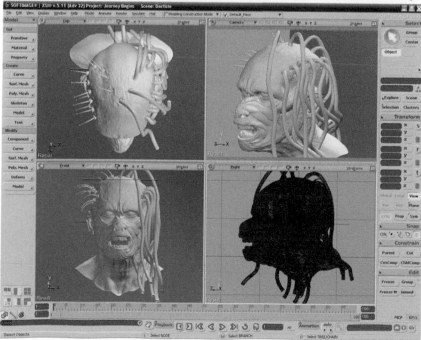

Fig.04

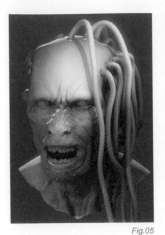

Fig.05 Fig.06

TEXTURING

I chose from the beginning to not have a color map, because I was interested only in modeling and rendering, but I did unwrap the back scatter map. Before starting the modeling in ZBrush, I did the mapping using Modo. I use this software for unwrapping because I feel very comfortable using the UV Unwrap tool, which helps the process. Following this, I went on to modeling, followed by painting the back scatter map, making it completely gray, but with some red on the ears (Fig.05).

LIGHTING AND RENDERING

The idea of creating an atmosphere engulfed in smoke and unbreathable air emerged after my girlfriend's mother came into my room and started coughing and complaining about the thick fog I had created whilst smoking cigarettes in a closed space (and yes, I know I should quit). She opened the window and the light spilled into the room revealing the extent of the smoke which filled the room – it was inspiring!

I decided to use volumetric lighting with a spot that shed light from above, which created the halo effect around the figure. There were also other lights in the scene: two point lights, the rim light and the fill light. The fill light was positioned against the key light so as to avoid the face becoming completely black, and also to make the shadows much softer. The rim light was positioned behind the head to have a more three-dimesional effect, and to give more volume to the creature. I also decided to put a gray "limbo" behind the character, and rendered the scene using final gathering (Fig.06). I used only two shaders, which was enough to achieve the desired effect. One was used for the skin and another one for all the other objects. After having positioned all the lights, I rendered three passes: an occlusion pass, a Z-depth pass and a beauty pass (Fig.07–09). The Z-depth pass was rendered to be used in Photoshop with the lens blur and the grain filter.

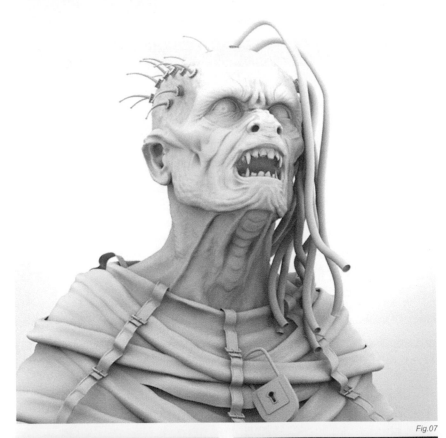

Fig.07

Fig.08 Fig.09

POST-PRODUCTION

I opened all the passes in Photoshop to do the compositing and create some smoke. I created a new alpha channel where I pasted the zpic and, using levels, I adjusted the blur that was done with the Lens blur filter (Fig.10). The ambient occlusion layer was multiplied over the beauty pass and then merged. I created the background smoke with the clouds filter and I created the light effects with the lighting effects filter, putting in a light from above as I had done in 3D (Fig.11). I then made a selection on this layer, using the alpha channel to delete the smoke on the model, and then left it on the background. I went on and painted more smoke onto the right shoulder to integrate the creature into the scene, with some more smoke escaping from the tubes. As a final touch, I finished off by making some color corrections (Fig.12).

CONCLUSION

At the end of all this, I can say that I was quite satisfied with the final result. I would have prefered to have had more detail on the face, and to have made it less symmetrical, but I was still able to create what I had originally envisioned. I even learnt how to paint smoke in Photoshop, which was fairly new to me. After this character, I decided to start work on my next creature, with the aim of making him less symmetrical, because I believe that this is the way to bring life to a 3D monster, and make it appear more realistic.

Fig.10

Fig.11

Fig.12

ARTIST PORTFOLIO

OLD DETECTIVE
BY JAMES BUSBY

INTRODUCTION

My fascination with computer graphics has been ongoing since the age of ten, back in the days when pausing *Street Fighter 2* to look up Chun Li's skirt was about the coolest thing you could do on a computer. It wasn't until I went to college, six years later, that I discovered the magic of 3D Studio and the satisfaction that came from creating a gigantic chessboard with a floating reflective cone. That's when I decided I wanted a career in computer graphics. I studied Film and Media at college, in Ireland, and went on to do a degree in Electronic Imaging and Media Communication at the University of Bradford. In 2002, I graduated from university and began work as a 3D artist for Argonaut Games, working on the hugely successful *Powerdrome*, which I believe has sold over thirty copies in the UK alone! In 2004, I left Argonaut, two weeks before it went into liquidation, and started work at Ark Vfx...which is where I am today.

I began making this image right off the back of a six month FMV project we did at Ark for the PS2 game, *Driver Parallel Lines*, during which time we created over thirty characters and thirty minutes of intros, outros and cut scenes. I spent most of that time modeling and texturing characters, so it made sense to put the new techniques I had learned to some use on a character of my very own creation.

I chose to make an old, gritty, evil Indiana Jones-type character, a guy with a real chip on his shoulder. I wanted this project to be primarily a texturing exercise, focusing upon creating realistic skin and fabric, opting for a more traditional approach to texturing, rather than going down the ZBrush route. Although, if I'm honest, this probably had a lot to do with Lightwave's inability to cope with displacement maps.

MODELING THE FACE

My head modeling techniques were nothing particularly ground-breaking, and as such I don't want to focus upon what is a very technical, and already very well documented, process. Instead, I want to look at the esthetic considerations that I had to take into account whilst modeling the head (Fig.01).

I discovered whilst working on the older Driver characters that the reason a person looks old is due to the loss of elasticity in the skin; as it sags and stretches the underlying bone structure in the upper face becomes more prominent, particularly the cheekbones

and the ridge of the orbit around the eye. The fat under the skin, which usually smoothes over bony surfaces in younger faces, slides down to form jowls around the jaw and neck, as well as fatty deposits under the eyes and around the mouth. These were the two main considerations I wanted to pay careful attention to during the modeling process, as they would also play a key roll in creating his sinister appearance; harsh cheekbones and deeply set eyes have a way of making a man look "evil".

MODELING THE JACKET

The jacket was modeled from scratch, using splines to rough out the shape and position of the seams. This process can be a real time saver as it allows you to quickly visualize how a garment is going to look, how it's going to hang and where all the major features are, before committing to a fiddly, polygon mesh.

Fig.01

Once I had the basic shape roughed out with splines, I used Lightwave's AutoPatcher to create a very low poly mesh. From there I subdivided, knifed and split the polygons, where it was necessary, to add details. To create the edging on the leather I used HDPumpit, a little plug-in that has proved invaluable over the past year or so (Fig.02).

TEXTURING THE FACE

I've always found high-resolution photographs are the key to creating photo-realistic texture maps. However, there's more to it than simply slapping a photograph on a model and pulling it around until it looks right. I used a fairly simple tried and tested method to texture this model, which I'm going to attempt to explain in the next few paragraphs.

THE PROJECTION SCENE: To texture the head I used a projection scene with three cameras and three lights (Fig.03). I used the cameras to project photographic textures onto the front, side and back of the model. These were then baked out into three separate UV maps. I then rendered out three baked illumination passes from each of the lights and used the resulting images as alpha masks to combine the front, side and back images into a single base color map.

COLOR MAP: Once the three projection images were successfully baked into a single color map I took the image into Photoshop and touched up the areas around the texture seams using the heal and clone tools. Next I painted out the eyelashes, shadows and any facial hair; basically anything that I wanted to recreate later in 3D was removed from the map. I touched up the lips and inner eyes, but apart from that I didn't fiddle too much with the map. I have found from experience that the more I do so, the less realistic it can look (Fig.04).

SPEC REMOVAL: The next step was to remove the specular highlights/reflections, by creating a new layer in Photoshop with its blend mode set to Darken. Then, using the eyedropper to pick a color closest to that of the skin next to the highlight that I wanted to remove, and using the paintbrush, I simply painted over the bright areas. It's a bit

Fig.02

Fig.03

Fig.05a Fig.05b

of a fiddly process and you must keep changing the brush color to that of the skin closest to the highlight you're working on, but as you become familiar with the process you soon learn how to speed things up. The results of this can be seen in Fig.05a and b.

BUMP MAP: I made the bump map by desaturating the original image, applying the high pass filter and adjusting the curves to increase the contrast. For areas like the lips and eyebrows I simply painted in a few hairs and wrinkles where it was needed (Fig.06).

SPEC AND GLOSS MAPS: Before I began painting the specular map I wanted to find out what shades of gray to use for the various areas of the face. Usually it's just a case of trial and error, but this time round I loaded the model into a scene with a single spotlight and a base specular value of 128 gray. Focusing specifically on the cheek area I tweaked the value until it looked correct, which gave me the gray value for the cheek. I did the same for the forehead, nose, chin, eyes and lips. When it came to painting the map in Photoshop I knew exactly what shade of gray to

Fig.04

Fig.06

Fig.07

CHARACTERS

use and where (Fig.07). I made a gloss map to tighten up the highlights in areas where the skin would be particularly oily or tightly stretched, such as the nose, forehead and inner eyes, and I used the same method as with the spec to get the correct gray scale values.

Skin Shading

For the skin shading I used Lightwave's G2 (which is good for rendering stills, but try animating lights or objects and it falls apart), which, for the purposes of this render, worked just fine. For me, the most important thing was being able to remove the diffuse from the bump. I've seen so many nice models ruined by plastic-looking bump maps, shiny on one side and dark on the other. I used to get around this by rendering a separate spec pass, but G2 solves this problem with the Diffuse Bump boost, and it even gives you a handy slider should you wish to add a little bit of diffuse to the bump. To control the amount of scattering I created a simple translucency map; applying the same technique as I used to get the gray values for the spec and gloss maps. Fatty, boneless areas, like the end of the nose, lips and ears, have a higher value as the light passes more freely through the skin, whereas the bridge of the nose, forehead and chin all have fairly low values as they are close to the bone and don't allow much light to pass through. I try really hard never to overdo the sub surface scattering on a face, as there's nothing worse than a waxy-looking skin shader (Fig.08).

Jacket and Shirt Texturing

As I said before, I wasn't overly concerned with the modeling of this character, as it was more the texturing that I wanted to show, and I put a lot of effort into making the jacket look like a real, old, worn-down leather. I studied lots of images of vintage leather jackets and tried out a lot of different techniques for painting the maps, and eventually I settled for a good, old-fashioned, hand-painted-in Photoshop map. I started with a dark brown color and used the leaf brush to slowly build up layers of dirt and scratches, using a lighter brown to show areas where the leather had been scuffed or worn. Perhaps the most crucial thing when rendering leather is to get the spec just right. As with the color map I spent a long time trying to figure out what it was that made leather look like leather. Eventually I concluded that it has similar specular properties to skin, so I applied the same G2 Spec settings as I had on the face, except with a darker blue tint. I used a gray scaled version of the dirty, leather texture to break up the spec so that it was shiny in the dark, oily patches and dull on the scuffed and scratched parts. The bump was a quick and dirty, leather texture which I grabbed off the Internet and applied as a test, which seemed to work so I left it there (Fig.09).

Lighting

The lighting rig is very simple, consisting of one key area light emitting only diffuse, and a simple spot fill light. I used a copy of the key light set to emit spec only, which allowed me to control the specular highlights independently of the intensity of the diffuse light. Lastly, some good, old background radiosity was used to lighten up the dark areas. I also added a quick reflection object in the shape of four windowpanes to give his corneas something to reflect.

Post-Processing

This is my favorite part of the process; I love fiddling for hours with the levels, curves and color settings in Photoshop. For this image I also used it to compose the sasquach beard hair and do some quick retouching to the jacket and hat texture. I added some grain and faked a bit of depth of field using the blur tool, as well as using a slightly yellow cast just to give it a bit more of a stylized look (Fig.10a and b).

Conclusion

Like everything I've ever made, I'm not happy with this image. I've spent so long looking at it that all I can see now are the flaws, particularly the eyes. No matter how much time I spent tweaking them they just never looked right. I wouldn't like to say that I was particularly happy with any part of the image that would imply that it's complete, but if I was forced to comment I would have to say that, for me, the skin and jacket textures look OK and he does have a bit of a nasty look to him, which I quite like.

Fig.08

Fig.09

Fig.10a

Fig.10b

BIRDHOUSE

BY SEBASTIEN SONET

CONCEPT AND INSPIRATION

What I intended when imagining this anonymous character, was to create a kind of subject that one could easily imagine in a horror museum, whilst at the same time emphasizing a main idea as part of the absurdity of the form: the man-cage appears more alive than the bird it contains. I love this sort of semantic opposition in my pictures – the first "disturbing" vision fades away to make room for questioning which goes far beyond the technique and the methods used to create it. I like to put content before form.

The character, initially human, has lost its whole identity. It has been confined to the rank of a silent object and is only there to perform the unnecessary task of birdkeeper. Initially this model was inspired by the *Tortured Souls* series of Clive Barker which consists of ten characters or so, all of them in situations of extreme suffering. For my image, I didn't want to keep the gore and down to earth aspect of drawings and figurines of Clive Barker. Instead, I wanted an image in which the loneliness of the character would be more obvious than the physical pain.

MODELING

The base for the character could not be simpler, composing it with ZBrush with the help of a few ZSpheres – a technique which is tremendously effective at very quickly establishing shapes as close as possible to the initial idea. They are then subdivided and modeled until a volume is obtained consistent with my intentions (Fig.01). Then based on this volume, the flesh tones are worked, stretched, flattened, and roughly handled until little by little the character comes "alive" (Fig.02).

The ZBrush Projection Master is used for this step, which allows work in very detailed areas of the model. I often use my own alpha brushes to paint details instead of standard ones. The other elements are modeled in 3D Studio Max around the imported middle resolution model. The bird was made from a very basic shape which was also worked in ZBrush.

TEXTURING

My skin textures are always hand-painted. To my way of thinking this gives more life and unpredictability. Whatever you do and whatever you try, when you are painting there is always a moment when a little accident happens – the feature goes adrift and takes with it the rhythm applied beforehand. This succession of imperfections actually makes the skin look more convincing and natural and less plastic. Next I add some marks and variations in hue so as to further accentuate the idea of imperfection (Fig.03).

The bump map – equally essential – is also painted by hand, with the help of ZBrush. By using the 'Bump' material, the intensity of the bump is visible in real time on the model, which allows for control and enormous time saving, compared with other solutions which result from blindly painting a map in a 2D program (Fig.04).

The normal map is generated from the high resolution model (more or less two million polygons) with the help of the ZMapper plugin (Fig.05).

Fig.01

Fig.02

Fig.03

Fig.04

It will be applied to the model later at render time.
Specular maps are also a key element to a realistic
render and allow control of the shininess of specific
areas across the skin of the model (Fig.06). It's
composed of a gray scale image, where black denotes
dry areas and white displays moisture and basically
determines the light incidence on the skin surface.
The presence and settings of these maps are essential
in determining in the realism and credibility of the final
image (Fig.07–11).

As far as the bird is concerned, I got its plumage by
placing a multitude of mapped outlines all around the
basic shape. Afterwards these different outlines were
turned and adjusted according to their position (small
for the body, longer for the tail…) (Fig.12).

POSING

To break the symmetry of the composition and give the
model more life, the head has been slightly tilted. For
this sort of very simple posing, and in an attempt to gain
time, I did not skin the model, but instead used FDD
box. Although this method does not allow for a great
deal of control on the mesh, it does have the advantage
of being implemented very rapidly, and afterwards it
can be adjusted, whilst still allowing modifications to be
made on the mesh afterwards without the pose being
lost or having to be readjusted. The bird, as well as all
the character's accessories, were also subjected to the
same FDD modifier.

Fig.12

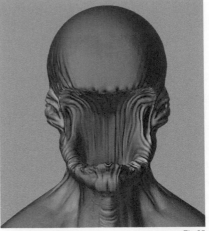

Fig.05

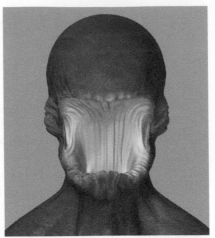

Fig.06

RENDERED WITHOUT TEXTURE

Fig.07

RENDERED ONLY WITH DIFFUSE

Fig.08

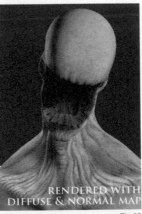

RENDERED WITH
DIFFUSE & NORMAL MAP

Fig.09

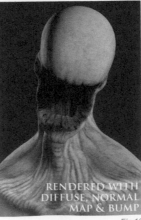

RENDERED WITH
DIFFUSE, NORMAL
MAP & BUMP

Fig.10

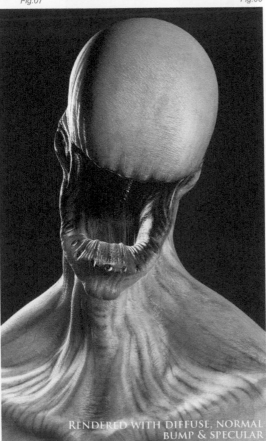

RENDERED WITH DIFFUSE, NORMAL
BUMP & SPECULAR

Fig.11

LIGHTING AND RENDERING

The presentation could not be simpler. The absence of real scenery means it is possible to make the presence of the character more intense, whilst still keeping to the raw spirit I wanted at the outset. On the other hand, the light required a lot of care and attention. There is lighting at three points: A pale yellow main source coming from the right, a faint source on the left to unblock the shadows, and a bluish rear light shape (Fig.13). The rendering is also very basic: an ordinary pass, an occlusion pass and a final pass for the depth, all with very high resolution. As I prefer to use a normal map on a "medium resolution" model, the rendering time was extremely short (less than two hours for a rendering of approximately 5000x4200 pixels). The different passes are composited using Photoshop, and the size of the final image is deliberately reduced by 15% to remove the rendering's last artefacts. Occlusion passes add contact shadows between the objects and tie together the entire composition (Fig.14). Final adjustments, essentially on the hue, brought out the important elements of my image, especially the bird.

CONCLUSION

Birdhouse is definitely one of the pictures that I am most satisfied with, both as far as the modeling is concerned and the concept that it conveys. Of course, it reveals certain technical weaknesses, certain

mistakes in its conception that I would no longer make today. From the beginning I was very determined about what I wanted to do, so I produced it very quickly – in three or four days. This picture is part of a complete series, inspired by Clive Barker's *Tortured Souls*, which was started at the beginning of 2006; the end goal was to produce a program – a guided tour of my horror museum. Moreover, this series is far from being finished; it includes several other characters, most of which are being prepared at the moment.

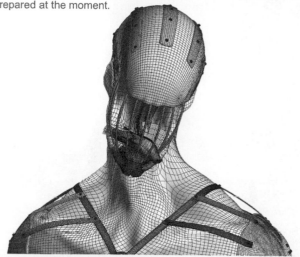

Fig.13

Fig.14

ARTIST PORTFOLIO

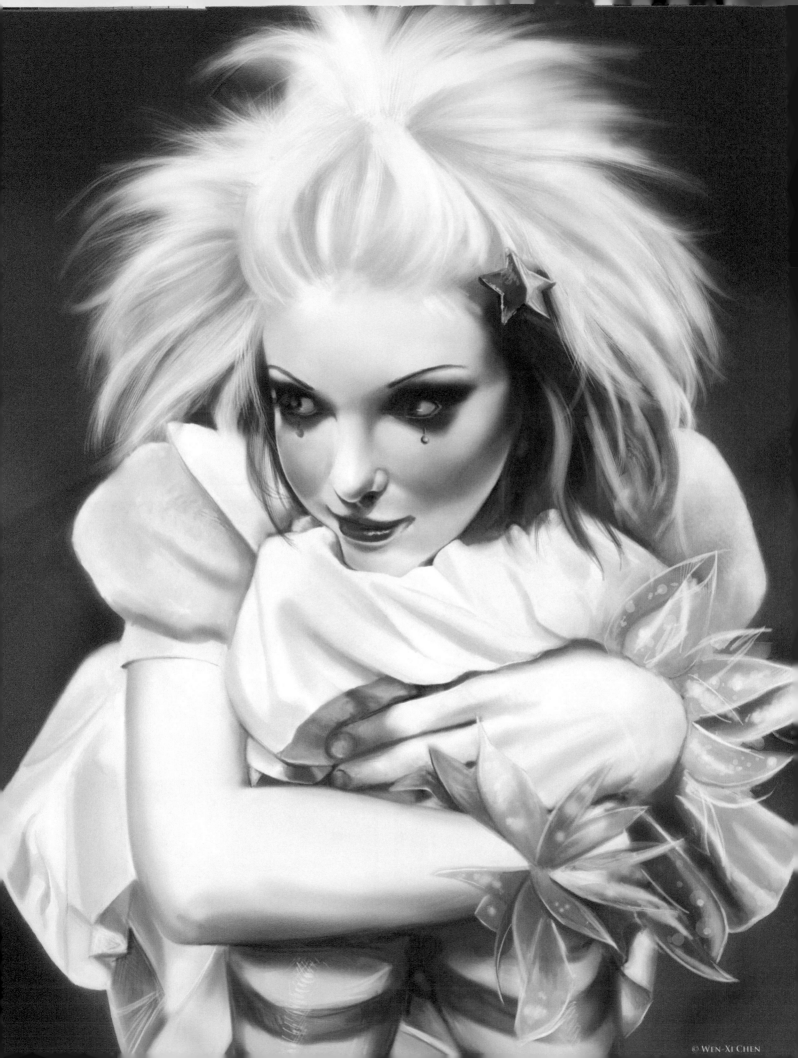

© WEN-XI CHEN

ROCKETBOX

By Wen-Xi Chen

INTRODUCTION

This picture all started some time ago, back in 2005, when I ran a "doodle" thread on my web blog where I offered to paint caricatures of my online friends. One of them, Ashley Ann, provided the most beautiful reference photographs of herself by the talented photographer William "ZAIDEN" Chrysler, and I was so taken by them that I set out to paint her in full...

The "doodle" I did for her can be seen in Fig.01.

I have always been fascinated by the "sweet, yet scary" feel, and I believe that this image captures it nicely. Yes, that is what you get for growing up with Tim Burton and Lolita-goths influencing your formative years! The reason that the title of the picture is *Rocketbox* is because Ashley sometimes goes by the alias Rocketbox, and that's how I always thought of her.

PROCESS

When I paint from my imagination I don't tend to have a very definitive outline, preferring to work with blobs of color, but since I used a photo reference for this painting, I decided that starting with a line sketch would help me to capture the likeness of my subject better.

As you can see, the line drawing is usually very rough, and I often cross-hatch to give some indication of shape and shadow. I did the line art in Painter Classic and then imported the image into Photoshop. I set the layer on top of a background layer and set the Layer Blending Mode to Multiply so that I could paint on the background layer under the lines (Fig.02).

Fig.01

Fig.02

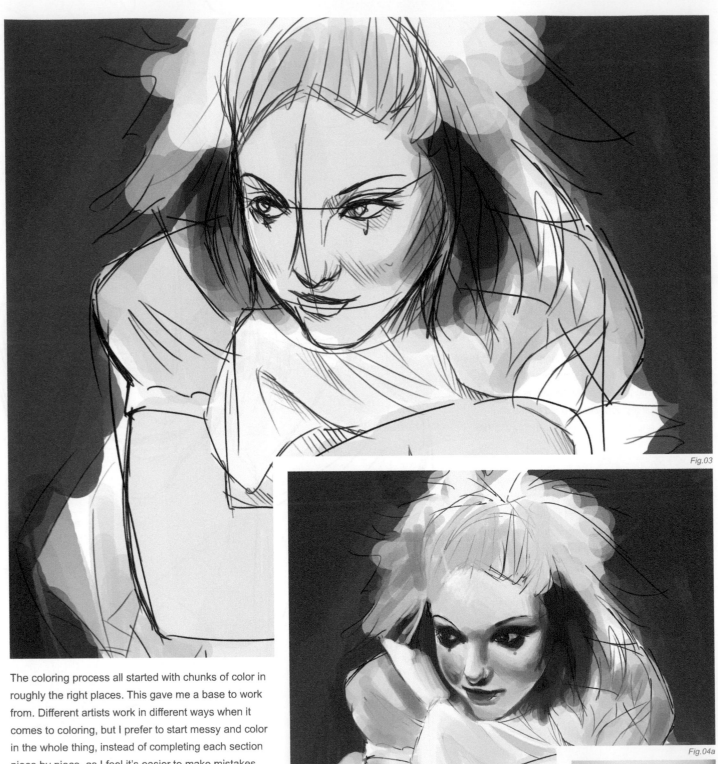

Fig.03

The coloring process all started with chunks of color in roughly the right places. This gave me a base to work from. Different artists work in different ways when it comes to coloring, but I prefer to start messy and color in the whole thing, instead of completing each section piece by piece, as I feel it's easier to make mistakes with color values that way (or at least I do) (Fig.03).

After the base colors were laid down, I almost always then start work on the face first. I love faces; I personally think they are the most interesting part of the body, and particularly like to paint eyes. All my works follow a similar pattern, where I work in detail from the eyes outwards (Fig.04a and b).

Fig.04a

Fig.04b

CHARACTERS

MAD, RAD HAIR

The hair in this picture was the most fun to paint. It took both Photoshop and Painter to achieve what I wanted. This was a challenge for me as I had never painted such big, fluffy hair before, but since it was such a significant part of the picture (it gives the character a clownish aura, and clowns and harlequins are another one of those themes that fascinate me) I felt that I had to use whatever was necessary (Fig.05). As many digital artists will tell you, use a speckled brush and go from there. I made several brushes that look something like what can be seen in Fig.06, and I did the basic detail work with them (Fig.07). I moved into Painter Classic to paint some individual strands for the sake of realism. For one reason or other I find Painter to be the perfect program to paint hair in with, as the lines just seem to come out smoother than in Photoshop. Perhaps I'm simply overlooking a software setting in Photoshop, but it has become habit that I almost always paint hair, fur and string in Painter now.

The method with which I paint hair has evolved a lot since I started experimenting with digital painting in 2003. At first I only had a mouse to work with, which meant that it was very difficult to paint convincing hair. At that time I used to use a flat brush and paint in a zigzag motion to create a hair texture. It was very effective for straight hair, but the method was limiting as to which hair styles I could paint. When I started to use a graphics tablet, I followed tutorials by digital artists, noticeably Katherine Dinger, who advised painting using dotted brushes, which remains the basis of how I paint today. Sometime in 2005, I realized that I could achieve higher detail by throwing Painter into the mix. In 2006

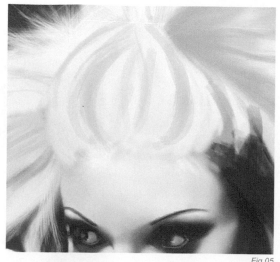
Fig.05

Fig.06

Fig.07

I often used Painter exclusively and worked strand by strand. It may seem like a strange regression of technique, but I've found that it creates some very realistic effects and doesn't take any longer for me than using a dotted brush in Photoshop.

CONCLUSION

First and foremost, I paint for the sake of creating beauty, and, in that respect, I think I was successful in this painting. It was a painting process that taught me many new techniques, and somehow I feel that it has also been a turning point in my art. This painting was, in a way, me proving to myself that I could paint realistically, but without the obsessive attention to smoothness or neatness that I showed in my earlier work. It was also a way of proving I could use digital painting software effectively and comfortably. From this point onwards, I have started to focus more on experimenting with different styles and to become bolder in my artistic decisions.

Oh, and as for the "sweet, yet scary" theme:

"She looks so sweet, but probably is very naughty..."

Well, almost.

ARTIST PORTFOLIO

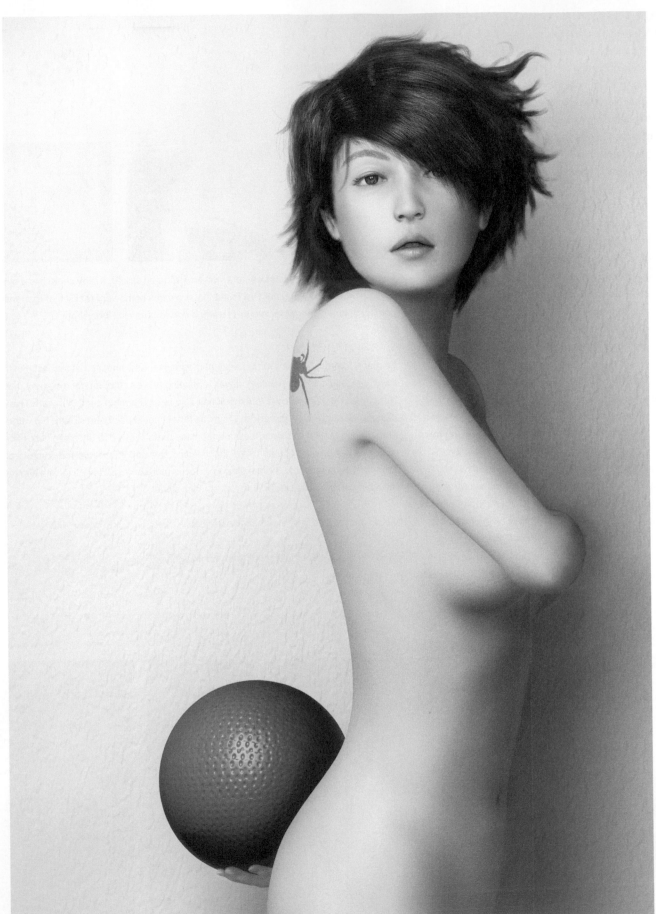

ZHANGYANG84

THE FAINT AROMA

BY YANG ZHANG

CONCEPT

I was watching a movie which depicted affairs in Shanghai in the 1980s and noticed that some women from that era in Shanghai were shown in such a way that I was moved. They were so mysterious and appealing: their hair-styles were very exquisite, and wore suitable cheong-sam over their shapely figures. They inspired me want to make this work without any hesitation in order to express their beauty.

I collected some old photos of Shanghai women, observing them carefully, finding that the photos lacked something, maybe some animation, or maybe a more modern feeling. Therefore, I consulted modern photographs, trying to find how to combine the modern feeling with an esthetic quality and mystery in my artwork. After that, I began to draw what I wanted to express. First I drew the sketch and then painted it in Photoshop. I experimented with various poses and expressions to find the one that most suited her temperament. Then I started to consider the color scheme and decided that purple and magenta were appropriate to highlight the sense of mystery and sex appeal. At this stage, I didn`t draw it in an exact manner, because I preferred there to be some creative room in the latter stages. Owing to this beautiful woman's body looking a little monotone, I added the tattoo which was placed on the shoulder, so as to not appear "head on". And in order to emphasize the girl's enchantment I chose a spider tattoo (Fig.01).

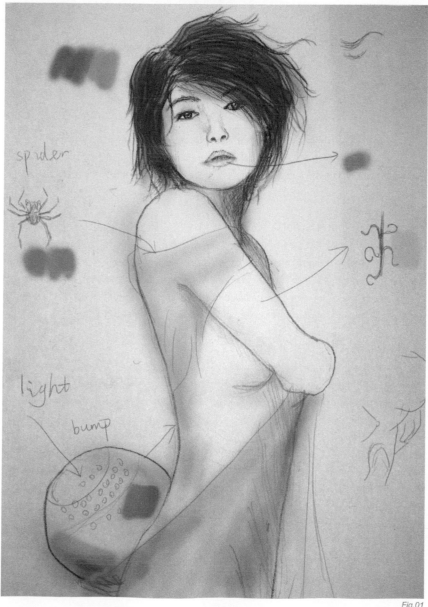

Fig.01

Fig.02

Fig.03

MODELING

Now, onto the low polygon modeling phase of the process, which was done in Maya. First I modeled a standard human body dedicating much time to her topology because I needed to pose her in a difficult position. I only hope that she has a comparatively real, anatomical appearance. I then went onto modeling teeth, eyes and hair, which required a good deal of patience (Fig.02). It was then time to move on to the UVs. This character was made for an illustration, so I didn't set up UVs according to the normal method. I decided to let the parts which can be seen take up more UV space, and in this way gained more detail (Fig.03).

TEXTURING

For this image, painting the texture was a complicated process with most textures for this character being around 4096x4096 in size. To construct the textures, to begin with, I used camera projection. I created three cameras which separately projected the map onto the head from the left, right and front. The said map was finished in Photoshop, making use of some reference photos (Fig.04). Then I texture baked the color map, which was aligned with the UVs in Maya. After this I took the basic color map, modified it in Photoshop using photos and also hand painted some details such as speckles and wrinkles. After completing the color map, I lowered the saturation to make the bump and specular maps. In Maya, zero represents no bump effect, whereas one is full bump, so adjustments were needed. Eye and mouth areas also needed some adjustment, which can be done using the Levels adjustment tool. After that, I changed the tone and detail of the color map to make the Epidermal Scatter Color and Subdermal Scatter Color maps and changing the specular map to create the reflection map. In my experience, Epidermal Scatter Color maps contain more yellow with Subdermal Scatter Color maps appearing more red, which demands some color balancing. I extracted a very detailed normal map from

Fig.04

Fig.05

Mudbox by using a high-res model. Then using Bodypaint I removed texture seams and added more details and blemishes – I love detail (Fig.05)! By just using a simple 3-point light rig, I could check the texture integrity, whether there were stretches and seams on the textures and whether the tone looked natural, etc.

BINDING, POSING AND REMODELING

It`s time to bind! I didn't want to spend much time on binding, so I used a simple skeleton and normal binding method, after which she was posed. I didn`t care much about whether the joints had unnatural deformation, because I would delete the skeleton shortly and begin remodeling. At this point I would also like to re-emphasize that this is an illustration. I only remodeled the parts where deformations appeared incorrect (Fig.06).

SKIN SHADE AND LIGHTING

Someone once asked me how to apply Mental Ray's Fast Skin shader. Everyone has their own way but, on the whole, I think it's best to control every parameter as much as possible. Therefore, I used around ten maps to control the more important parameters (such as Diffuse Color, Epidermal Scatter Color, Subdermal Scatter Color, Primary Weight, Secondary Weight and so on). My own experience is that the SSS effect of some areas like ears can`t be too high, which is to say they cannot appear too red. We need to show the skin being somewhere between plastic and wax (Fig.07), Because I used an HDRI, it was important to click Include Indirect Lighting in light map mode.

I used Mental Ray IBL with an HDRI picture and several other lights for special purposes. I wanted the light in this scene to be similar to studio photography: symmetrical and soft. The key light was an area light, with a few other lights added to help. The most important thing was simulating the reflective light of the purple ball as there was little purple on the area of body close to the ball (Fig.08).

Fig.06

CHARACTERS

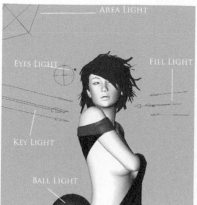

Fig.07

Fig.08

Fig.09

AREA LIGHT
EYES LIGHT
FILL LIGHT
KEY LIGHT
BALL LIGHT

EXPRESSION

Now is the most important stage – her expression, for which I devoted two whole days. In order to make her look mysterious and charming, I lifted her head upwards a little, half closed her eyes and made her look downward slightly. To complete the look I opened her mouth a little, giving her expression a relaxed and natural feel (Fig.09).

HAIR

I used a comparatively traditional method here. Firstly I made curves to draw the form of the hair, then lofted NURBS patches along these, duplicated them and adjusted the control vertices. Then I extracted curves to create hair by way of the Maya hair system.

RENDERING, COMPOSING AND FINAL RETOUCH

I rendered the image using multi-passes, which made it easy to modify and control them. The final image size is 4000x3500. I opened all the passes in Photoshop and made use of some of the tools to improve the image such as sharpen, noise and adjustment layers (Fig.10a and b).

Fig.10a

CONCLUSION

I gained a lot of knowledge of both traditional art as well as 3D/2D techniques during this process. The area I am perhaps most satisfied with is the character's expression, for which I must acknowledge and commend the book *The Artist`s Complete Guide to Facial Expression* by Gary Faigin. Thank you for reading my account of *The Faint Aroma*.

Fig.10b

ARTIST PORTFOLIO

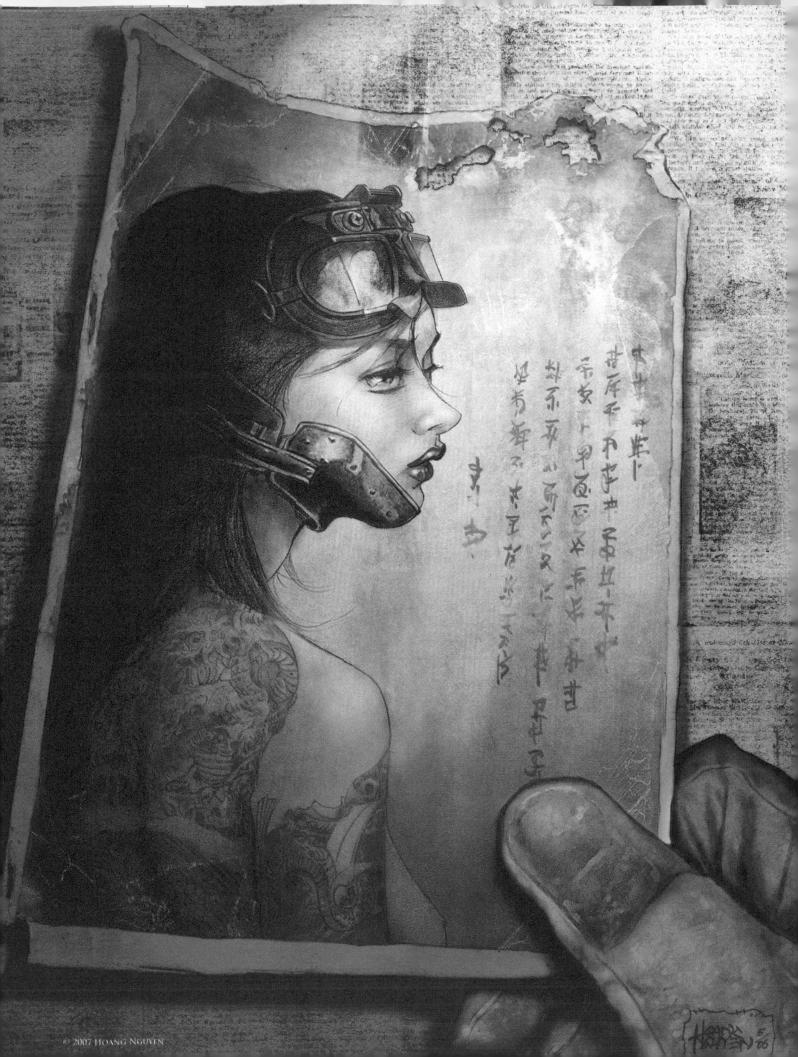

Memories Lost

By Hoang Nguyen

Concept/ Introduction

This piece was created for the Master and Servant challenge on CGTalks. When I heard about the contest, I thought long and hard and decided to create something different. Rather than going for the two characters interacting, I wanted to go with something more introspective, more of a personal demon. I have always been a slave to my past memories, always living in the past; and I think that sometimes it influences my decisions in life. So I set out to create an image that would reflect this. I decided to incorporate some of the things that interest me the most, namely girls, World War II and tattoos.

Sketches

My initial thought was to blend all of these elements and see what I could come up with. My first sketch didn't work out, since it didn't convey the pain and sadness that I wanted; so I abandoned it. I started to flesh out the second sketch and went with more of a profile; that way I could allow her to stare into space and allow room for the tattoos. I wanted some kind of harness or a head gear to denote constraint. So I started to play around with that and in the end decided with the goggles and chin straps. Being pretty satisfied with the sketch the next stage was to flesh out the details. I added tattoos and fixed her anatomy, made some refinements and it was complete (Fig.01a–c).

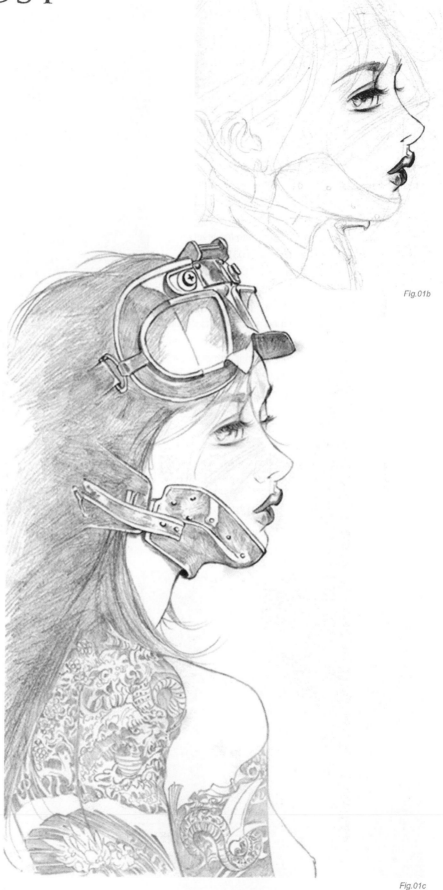

Fig.01b

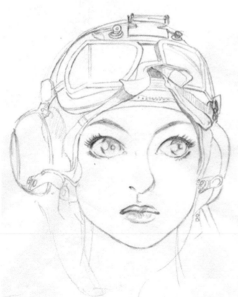

Fig.01a

Fig.01c

My approach to painting is a bit different: I create various layers separately and composite them in Photoshop. I wanted to capture those old photos from WW2 to create the background texture. I used a soft lead pencil and shaded in the background. I also used a grease pencil to get the grainy effect and added minimal colors to the piece in Photoshop. I applied noise and film grain filters to simulate that old feeling, which became background layer in Photoshop (Fig.02a and b).

This layer was used to mimic the aging and creased old photo. To create the scratch layer I took one of my old pictures and weathered it somewhat. I ripped the edge, tore it up a bit and burnt the edges too. I then scanned it into Photoshop and played around with the levels, finally applying it as a dodge layer (Fig.03).

Main Painting and Details

I started to lay down the color for the rest of the picture and flesh out her skin tones. I then proceeded to detail the various elements, primarily her face and chin guard at this stage. I also started to experiment with different hues, always bearing in mind that I wanted to have very minimal color palette, basically monochromatic (Fig.04a and b).

More detail and color were added to the tattoos. Here I'm fleshing it out a bit more, since the line drawing is a bit confusing. Once colors were added it helps to bring out the detail.

The tattoo was always a challenge; I started out wanting to design a serpent or a dragon, but in the end

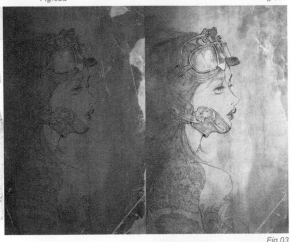

Fig.02a
Fig.02b

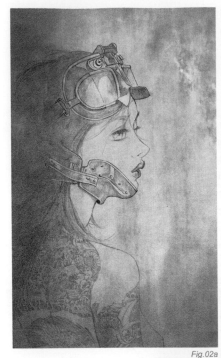

Fig.03

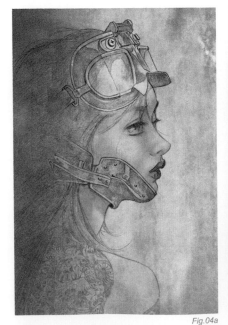
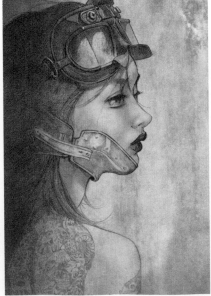
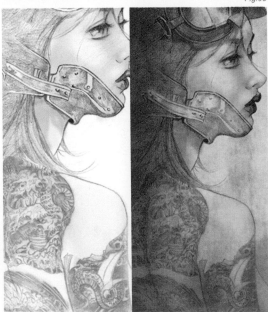

Fig.04a
Fig.04b
Fig.05

CHARACTERS

opted to go with something non-descript (Fig.05).
I then detailed in the face, adding highlights and eye
shadows. I paid a lot of attention to the eyes, because
of the emotion that they can express. You can tell if a
person is sad, happy, lost, lonely, depressed, etc... just
by looking into their eyes. They say that the eyes are
the reflections of one's soul (Fig.06).

At this point, all of the layers have been added and the
various details are refined and I'm feeling happy about
the progress. The next step was to tell a story... what
if someone was looking for their lost love, reminiscing
about time gone by, or what could have been. I wanted
to convey a sense of longing and the pain of a never-
ending love that would not die or be quenched (Fig.07).

Fig.06

Fig.07

Fig.08

I decided to go with the hand holding a picture and since photographs hold so many
memories, I went along with this idea. I did a quick thumbnail and distorted the image, but
it was too flat and stiff. I needed to warp the picture in order to uphold the idea of a worn-
out photo (Fig.08).

I was restricted by time constraints, so rather than model the image in a 3D package and
map, light and render it, I decided to cut it into little strips and paste it together. A rather
primitive approach admittedly but it worked. I had to do some cleaning-up and fix some of
the distortion, but overall I think it turned out OK (Fig.09 and 10).

Fig.09

CHARACTERS

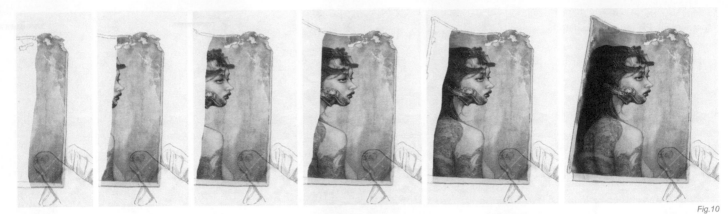

Fig.10

So now that the picture was nicely warped, I focused on the glove by painting in details and adding noise to weather it. At this point I really didn't know what I was going to do about the background – considering old newspaper clippings or letters – although this implied an unwanted distraction (Fig.11a and b).

I decided therefore to add some sort of writing to the photo, sort of creating the illusion of someone's love letter.

Since I don't really know how to write in Mandarin or Kanji, I decided to make up my own. The characters were created using a dry brush on paper and scanned into Photoshop (Fig.12).

If anyone can decipher them, let me know! I'm hoping that I didn't write anything bad. Anyway, I applied the characters on a different layer and faded them a bit.

Fig.11a *Fig.11b*

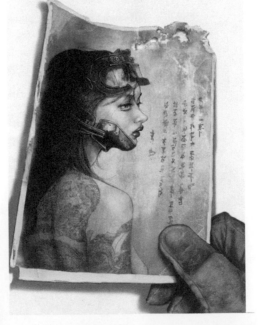

Fig.12

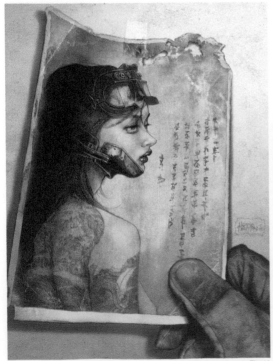

Fig.13

I remember the tragic 9/11 event, where people would post pictures of their loved ones on the side of the building or a sign post and I wanted to do something similar, as though the character is picking her picture off the wall (Fig.13).

Again, I went back to the grease pencil and shaded in the background. I wanted to used it as a backdrop to the newspaper clipping that I will overlay later on. I also added a concrete texture and set the opacity at 25%.

CHARACTERS

EFFECTS AND FINAL ADJUSTMENT
I scanned in old newspaper clippings and blurred them until they were illegible.

As for the background, I went with something cool to offset the warm color of the photo. I did experiment with the hues, but it seemed to overpower the main focal point. I also fleshed out more details and played around with various filters (Fig.14).

FINAL IMAGE
I added a worn-out tape to show that it was attached to the wall and added more scratch marks on her back and upper left corner. I also played around with the background color and started to introduce a warmer palette. I fixed a few things and did some more clean-up; most of which is just too subtle to even notice at this point. Lighting would be the next logical step; since the picture looks pretty flat I wanted to draw the viewer's eyes toward her face. On a soft light overlay, I painted in a warm light and adjusted the rest of the background. I felt that this was the final stage in the image for me (Fig.15).

Just to give you an insight into the process of how I came about the idea, here is a summary of my thoughts:

"You know that feeling when you look at an old photo, It brings back a lot of memories. Sometimes, don't you wish you could go back in time and change things? A lost love, missed opportunities, etc...

I wanted to capture that moment in time, so I used a female to represent that lost time. And to capture her essence: pain, sadness, elegance, and beauty.

I wanted her to represent all of these things, but also have her looking toward the future, with anticipation. Her blank stare represents the unknown; the goggles are to denote things we don't wish to see and the chin strap prevents us from speaking freely.

The glove (hand) represents us, and it was worn down to suggest the elpase of time gone by. The endless streaming of newspapers was to denote thoughts and memories passing by.

Sometimes memories have a way of coming back, beckoning and haunting us. Good or bad, they are always there.

Fig.14

Fig.15

ARTIST PORTFOLIO

AN EXACT AND FINAL MOMENT

BY MICHAEL ENGSTROM

INTRODUCTION

The intention with this piece was to try to capture an exact moment directly before death. I guess it is a reaction to my own personal fears and paranoia of living and working in Western capital cities under today's political climate. I felt it relevant to have the event happening to a middle class, stereotypical, Western office worker and to freeze-frame the instant he became aware of his demise. To get this effect I wanted to have a feeling of extreme movement and force but without the use of motion blur. That way the viewer can absorb the true horror and detail of such a situation. The exact cause of the blast is intentionally left unknown to provoke more intrigue. I hoped to make something a little off the beaten track but relevant to a situation which could happen, in a way that would never be caught on camera. This is one of the great assets of digital art today, giving the artist the tools to create realistic images from the depths of his imagination, or in my case paranoia.

Fig.01

CHARACTERS

To get the ball rolling, I roughly sketched out an example of what I had in mind in Photoshop (Fig.01). I knew that things would change from here but this is just to get the feel across. I liked that there was almost a humorous aspect to this sketch; it somehow makes the whole thing even more unsettling.

For the purposes of this creation, I will call him Arthur.

MODELING ARTHUR, THE HEAD

I decided to start the piece off by making a basic human from scratch which could later be rigged and manipulated to become the victim of the massive blast force. The first task was to get good reference for the right kind of male model. Once I was happy with my choice of model reference, the side, front and perspective views were set up to make following the contours of the head easier. Once happy with the basic proportions, i.e. he looked similar to the reference but different enough to be his own self (Fig.02), I unwrapped the model, applied a symmetry modifier and mirrored the new UVs ready for

Fig.02

Fig.03a

Fig.03b

texturing. This saved time having to fiddle with both sides of the head's UV coordinates.

MODELING ARTHUR, THE BODY

The body was made in exactly the same way as the head. I set up more reference photos and kept the geometry simple to get the proportions correct. At this point I just wanted basic shapes to work with. Most of the limbs started as cylinders which were manipulated to fit the reference. The fingers and toes started life as simple extrusions from basic hand and foot meshes. Once a fairly rough version of Arthur was taking shape I started on a medium detail pass. This means modeling all the major creases in the folds of skin and some of the more prominent wrinkles, lumps and bumps such as knuckles, ankle bones, muscle definition, etc. A quick meshsmooth was done to check if it was all going in the right direction (Fig.03a, and b). These days I would normally use ZBrush to do any details such as these but I didn't have it or know how to use it at the time. You may notice that I also dropped the jaw a little and modeled the mouth interior; this was to make life easier with rigging the mouth and jaw.

MATERIALS AND TEXTURING

Despite the obvious need for accurate mesh modeling, I feel that creating accurate textures and materials is essential towards a realistic end result. Seeing as this piece is all about Arthur, I needed to get his head looking convincing before I could tackle the rest of him. The reference photos I had for Arthur came in a fairly expansive set and were ideal for making these textures.

Fig.04

CHARACTERS

It is important to paint out all the shadows and heavy creases in the texture maps, but I think it's fine to keep all the pores of the skin and smaller creases. Once I had created the color map, I made only a specular and bump map to gain the extra realism. The skin needed to be quite clammy, so I increased the amount of specular more than usual. A tip for making a quick bump and specular map is to use the high pass filter in Photoshop on the color map; but make sure you don't lose any of the details! It was still necessary to exaggerate certain parts like brightening the white on the inside of the mouth and eyes for specular and exaggerating wrinkles

Fig.05

Fig.06

Fig.07

in certain places such as the lips for the bump. For the final render I chose to use Mental Ray; it has a great sub-surface skin material. I had to tweak a few values to get the desired effect but not too much from its default settings. An important tip here is to make sure the scale of your geometry is accurate. These physics-based materials simulate real world space, so if your SSS (Sub Surface Scattering) is looking way off, check the scale of the model! In this render I exaggerated the SSS slightly to make sure it was all working correctly (Fig.04). I then went on to texture the body in the same way. The SSS was reduced a little in intensity and as you can see we are starting to get a fairly close approximation to a realistic human (Fig.05). There are many glitches and seams in the texture at this point, but I was not worried as the clothes would be covering these. I think it is interesting to see what values an artist uses in a skin shader, so here are mine (Fig.06).

CREATING THE BLAST EFFECT

Arthur was taking shape now, but the real challenge came next. I have already spoken about the need for good reference. But, as you can imagine, reference for a situation like this is hard to come by. I found some images of fighter pilots experiencing heavy G-force and also some images of people in high wind conditions. Having a rough idea of what I needed to do, much trial and error was needed to get a convincing pose after rigging. Once happy with the pose, I cloned parts of his body as the starting point to model the clothes; using basic extrusion techniques I added the collars, lapels etc. I then moved on to the skin-modeling again. By adding more polygons and moving parts of his body and face around with soft selection I ended up with the look of extreme force I was hoping for. The final geometry details were brushed in using 3D Studio Max's paint deformation tool on a denser version of the mesh after applying the turbo smooth

modifier. This works in a similar way to ZBrush but is very cumbersome and slow in the view ports. A good technique to make the blood look like it was splattering in the direction of the blast was to use a particle spray with Meta particles. Finally, to enhance the blood effect, I added more droplets and streaks into the textures: this gives the appearance of the blood splattering on the skin. At this point all the modeling was complete (Fig.07).

SETTING UP THE SCENE, RENDERING AND POST-PRODUCTION

You may have noticed that I did not model any shoes. I realized that because it was better to crop the piece in such a way as to maximize visual impact, the lower half became redundant. The scene I set up was very basic: I used a sky light and ground plane, and added three area lights: one light for the blast, one for the direct sunlight and one very dim just to pick out any cool geometry I felt was getting lost in the shadows of the other two lights. Also, I put a few other objects in the scene which are out of view, but there to enhance the reflections in the eyes and skin. Once happy with this setup, I gave it the final render. From here I needed to add the missing details using Photoshop. The hair was mostly hand-drawn, and extra details were painted in like threads in the torn clothes, the dust clouds, the sky, etc. A second render was made without clothes and merged onto a new Photoshop layer. This was so I could get the shirt to appear see-through in particular places as it stretched across Arthur. Finally I tidied up, played with the levels, and added a little noise to get a more photo-realistic finish.

CONCLUSION

This was a really tough piece to make (Fig.08), but the image is pretty close to what I had imagined. I learned a great deal about how to evolve an idea into a convincing image from which there is little reference. Ideally I would have liked the hair to have been part of the 3D render but using Photoshop still yielded a reasonable result. The process I used was not necessarily correct or the most efficient but it certainly helped to hone my modeling skills and my understanding of materials. Overall I'm happy with the end result; I hope the viewer can sympathize with Arthur and get a feel for an aspect of the world which terrifies me.

Fig.08

ARTIST PORTFOLIO

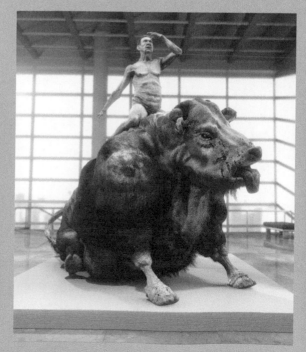

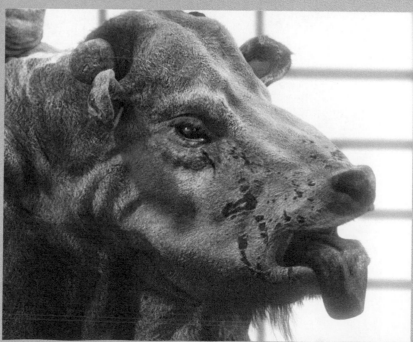

WILL
PROCESS
DATA FOR
ENERGY

© PAWEŁ HYNEK

OBSOLETE

BY PAWEŁ HYNEK

INTRODUCTION

The idea for this image was born a long time ago, but was in a form which is now very different from the production of my work. At the beginning, it was meant to be humorous and not very complicated in terms of rendering, showing a fairly broken robot collecting change on an unpleasant street corner. The way I originally meant to show my character and his environment was not realistic, because my idea was to add humor to the image and give it a funny look. I considered creating my hero in the style of one of the movie characters from the film *Robots*. At the same time I also decided to show my robot as a war veteran, using the appropriate textures with military ranks and additional objects.

When I had made some initial sketches and had planned the entire scene in my head, I felt that my work seemed to have become less funny, and much more serious. The robot became a self-aware machine, trying to preserve his existence in the world at all costs. Now, can that be a funny scenario? What is the difference between "him", the robot, and a human being: a real soldier harmed by war and left to fend for himself?

I also remembered many books and movies that in one way or another touched upon the problem of the relationship between humans and artificial forms of intelligence created by mankind. From *I, Robot*, through Robert Sheckley's short stories, to the recent *Battlestar Galactica* series, they all raise many similar questions. I knew that I had to change my project's basis and give it a more realistic look. I decided to give up the cartoon character and environment, and began work on a more realistic-looking scene, which had to reflect an essence of my thinking and encourage spectators to contemplate the message.

I didn't make any additional sketches, and went on to keep the original composition I had sketched out, and I used an old model of a battle droid which I had built quite some time ago. I must add at this point that, in despite of creating an image that contains some kind of message, I was also aiming to display my current abilities in creating high resolution imagery with a lot of mesh details and advanced materials. In my recent works I have always allowed less important elements to remain uncompleted, so with this image I decided to change my working style and really show what I can achieve.

MODELING

This stage was rather simple. The robot was rebuilt from an old mesh using polymodeling. For example, I started out with a single box as a base, and a cylinder for the arm hole. I then joined them together and made extrudes, cuts and vertex manipulations to achieve the basic block. Then I subdivided it and made panel holes (Fig.01). After I had finished the whole body, I made additional parts, like eyes, cables and skeleton parts (Fig.02). The tricycle was modeled in a slightly different way. Only a few parts were box and cylinder modeled, and most of the geometry was created using renderable splines. The hardest thing to do was the chain. It's hardly even visible on image, but I couldn't refrain from creating it properly. As you can see in Fig.03, the geometry wasn't too complicated, and some details were added later on by displacement mapping.

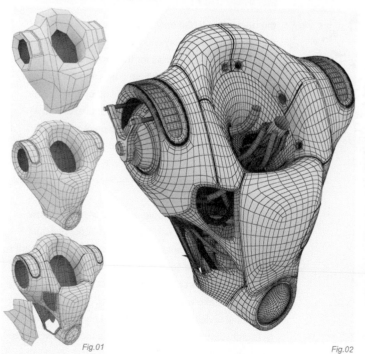

Fig.01

Fig.02

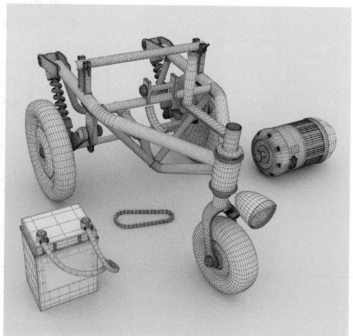

Fig.03

Lighting

After I had finished my model, it was then time to light it (Fig.04). Working with an untextured scene, allowed me to set up the lights properly and didn't cause me to grieve at excessive rendering times. As a main light source I used an HDRI type image, which allowed me to achieve a much better lighting environment simulation of results than if using standard bitmap files (Fig.05). It was also great as an environment reflections source. But this method also had its disadvantages. For example, because it is always good to simulate diffuse light and soft shadows created by large area lights, it didn't work very well for small light sources. A practical way for me to solve this problem was to use additional lights. In the scene I added one extra light to simulate a feeling of the "underground": artificial sodium-like lighting from the top, right corner. Following that I set values for the intensity, temperature and shadow sampling, and was really pleased with how my scene was looking (Fig.06).

Textures and Materials

Creating materials and painting textures is, in my opinion, the most important part of creating a 3D image. You can have a great model, and you can either ruin it, or make the surface of a simple box look wonderful – it's up to you.

For the robot, I started painting the textures after the basic material properties were stated. As you can see in Fig.07, the first (base) layer is a painted metal. At

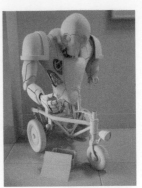

Fig.04 Fig.05 Fig.06

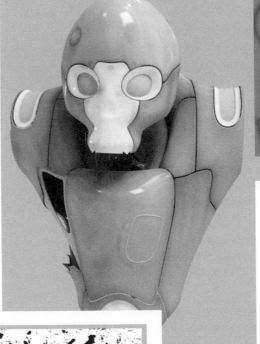

DIFFUSE COLOR

REFLECTIVITY CORRECTION

Fig.07

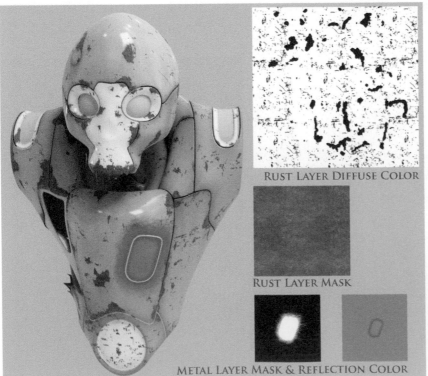

RUST LAYER DIFFUSE COLOR

RUST LAYER MASK

METAL LAYER MASK & REFLECTION COLOR

Fig.08

the beginning, it had only two color textures. When I had made extended layers, I decided to paint more details. The basic settings for the material were very simple: base texture for diffuse color, and some glossy reflections. Reflections were modified by the Fresnel curve to dim them on surfaces perpendicular to the camera axis. When I had the basic paint material, I started to add more layers, defined as independent materials. For every layer I used a texture or procedural map, and set the opacity and placement of the material.

The rust layer was a simple material with a very low reflection level, and I used a texture mask. The dust layer was also a simple material, just a standard shader with a gray, diffuse color. Far more important is the mask. I used a dirt procedural shader with low sampling values, to make my dust more "noisy". I must admit that it's almost invisible on the mesh, but I used it anyway to slightly dim the reflections. For the metal layer, there

were parts of the model where additional metal plates were welded to the body. I used a metal material to partially simulate scratched paint, and used a texture mask (Fig.08).

For geometry correction, after I had added all the extended materials, it was time to create two textures which controlled the geometry of the model through all of the layers. The first one was a displacement map which allowed me to move surfaces backwards and forwards. The second was a cutoff map, which made part of the geometry invisible (Fig.09).

For the tricycle, I tried a different approach. I had to set the material to look like paint applied with spray or a painting pistol. A little tired of recent texture works, I decided to use a very powerful, but often underestimated, tool: procedural mapping. Of course you can't use it to do everything, but in my case there was no need to paint another texture for most of the tricycle parts. I have shown the creation stages for the paint and metal materials in Fig.10. The first step was to define the basic paint material. It used Fresnel reflection

DISPLACEMENT MAP

CUTOFF MAP

Fig.09

Fig.10 Fig.11

Fig.12

and two noise maps to simulate multi-level bumps. This was my basic (base) layer. I then added a basic gray material with a dust mask as the second layer (Fig.11). It looked nice, but I needed to add more details to the mesh. In Fig.12 you can see the completed material, with noise, as the displacement map for weld joints and paint grazes on the mesh's edges. Grazes were created by adding a layer of simple metal material with a dust mask, but this time with the invert normal option enabled. The metal shader for the bolt was very similar to paint. There were just a few other minor changes: other diffuse colors for materials, glossy reflections.

CONCLUSION

It has been a little while since the moment that I first completed this image, and even now I am still happy whenever I see it. I think it carries a string message, and it proves that my efforts weren't wasted. Of course, from the perspective of time, I can now see that some of the elements could have been done in another, or an even better, way. The rendering time could have been shorter, and perhaps I could have also added some more details. This all goes to prove that I have learned something from the whole experience, and have improved my skills. In addition, despite the goals that I had originally set myself, I achieved an impressive, and unexpected, final effect. I am now convinced that everything you can imagine in your mind can be done in 3D. It's only a matter of the effort and the heart that you put into bringing your ideas to life.

ARTIST PORTFOLIO

BV-01
BY ALESSANDRO PACCIANI

INTRODUCTION

Since a teenager I have always been fascinated by sci-fi and industrial robotics. I wanted to create this image to realize a robot design focused on functions and applications, rather than simply appearance. I think that the sophistication of a robot is achieved through the symbiosis of art and science, and the role which design plays to enhance the beauty of the other. Thus the exterior design of technology must visually convey the information system within and allow the identity to become instantly recognizable. My inspiration for the design came directly from human dynamics; I wanted to create a sort of bio-inspired technology, something that man created in his own image (Fig.01).

CONCEPT

The final image is a still from my first movie, called *BV-01*. The main character is a robotic police enforcer from the twenty-first century; he's a synthetic human that can function on his own and make simple decisions, not remote controlled or programmed on predefined trajectories. He's unique in the world of human-substitution technologies. If we develop this kind of technology we can build a team of self-thinking, self-maintaining robots to take on the many tasks that humans cannot do, or would rather not do. After the urban fear of 9/11, and the terrorist menace, one of the main benefits of this robot unit would be that it could bring rescue, or attack, or participate in any dangerous situations with no risk for the human counterpart. We could have fewer body bags at home, and a more efficient and renewable army to preserve life, and to aid human suffering. I wanted to revive the idea of the bipedal robots that have been proclaimed for the past fifty years in sci-fi films and books: "with a soul without emotions, a skin without feelings and the heart of a hero" (Fig.02).

MODELING

For the modeling of the robot I started with the shape of the head – something that looked like a camera and a computer case merged

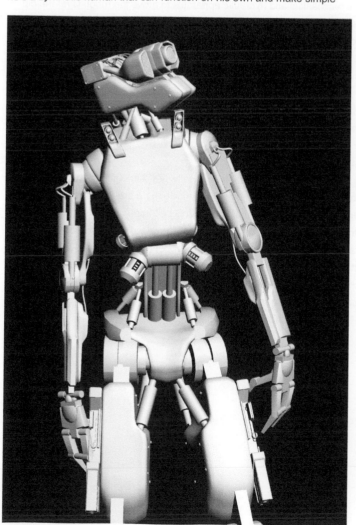

Fig.01

Fig.02

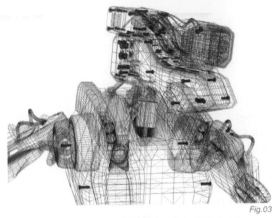

Fig.03

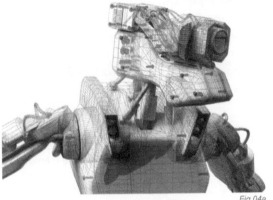

Fig.04a

Fig.05

together. At the borders of the head are two air tubes for cooling the central processing unit of the logical functions, located in the back of the head (Fig.03–05). Underneath are some hydraulic dampers which rotate the head on two axes at the same time. Four LED lamps are located on the shoulders, and the chest is simply a big, white case that contains all of the mechanical and hydraulic apparatus to move the robot. Over the hip are the dampers and the motion sensors which correct and calibrate the position of the spine and the posture of the robot.

I modeled the mesh using a Non Uniform Rational Basis Spline – non-organic modeling – so I extracted the shapes directly from the hand-drawn blueprints. In brief, I wanted to create a slim robot who would be able to move faster than a human, and who could run and jump in different kinds of terrain conditions.

TEXTURING

I made different shaders for all the materials; basically, the skin of the robot is white kevlar, with silver chrome for the dampers. In the movie there are a lot of action sequences where the robot shoots, jumps, repairs his self from bullet "wounds", and moves around in a dusty environment. So the textures needed to be dirty, and had to show how the rain had condensed the dust onto the robot (Fig.06a and b). To realize the materials, I started with some reference photographs of dirty plastics, onto which I added dust and scratches. Scratches are very important because he made a lot of dangerous actions in the movie, and scratches are like his "scars" from battle. The textures of the robot therefore tell the story of his past actions.

Fig.04b

Fig.06a

Fig.06b

SCI-FI

LIGHTING

For the source of the lighting I used an HDRI chrome ball to capture the real lighting of the live action footage behind the robot. After this I adjusted the exposure to create a brightened image, and made the edges of the materials look shinier. In Fig.07 you can see the robot in an alternative lighting environment.

RENDERING AND POST-PRODUCTION

After rendering the image, I used Photoshop to blur the background, and I added a little glow to the highlighted points on the surfaces to make them brighter. After all this I then desaturated the whole image to make it look more gloomy and poignant.

CONCLUSION

I'm pleased with the end result because I achieved what I set out to do. The character design of the robot was one of the most important things for me, for the realization of my movie, and I've realized exactly what I originally had in mind. Whilst working on this image I realized just how complex it is to transpose my ideas into a 3D scene. If I came back to the modeling part again in the future, maybe I would model something without the hull, and perhaps even focus more on all the small details, like the cables, screws, air holes and internal hardware devices...

Fig.07

ARTIST PORTFOLIO

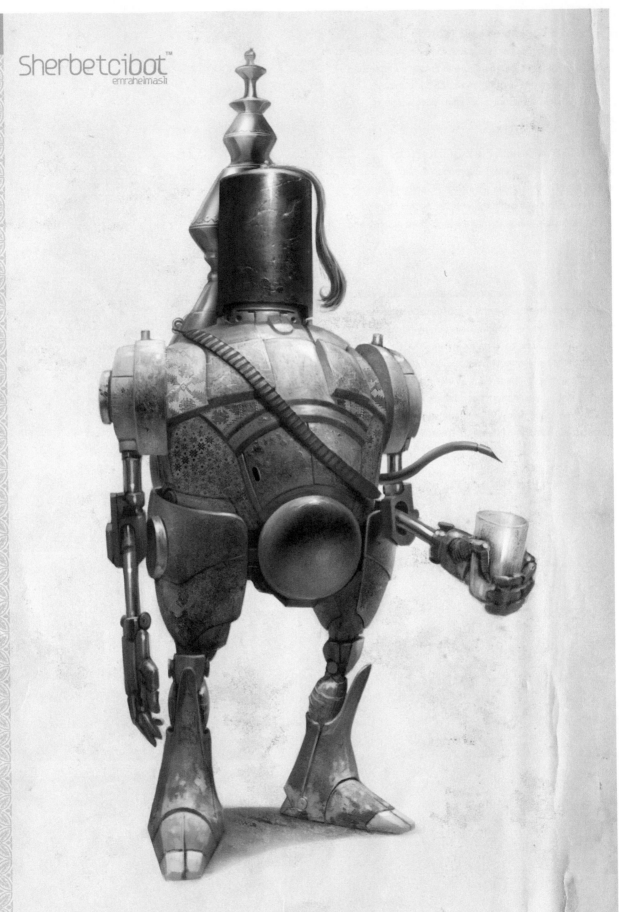

Sherbetcibot™
emraheimasli

SHERBETCIBOT

BY EMRAH ELMASLI

INTRODUCTION

In this making-of I will explain the drawing and painting of a robotic character, and will also touch upon character design in video games. My aim is to provide some information about concept design, and the character that I have designed is a sample of the process that I use. The character is part of the Oriental Science-Fiction Universe, which I've been working on for a long time now – just one of a dozen other robots, *Sherbetcibot*.

The story is simple: in the days of the Ottoman empire, a time overlap occurred. The worlds of a technologically improved robotic civilization in a parallel world, and the 1700's Ottoman empire, became "superimposed". A disaster occurred in which millions of lives were lost. With time, all wounds healed, and the two civilizations began living together in harmony. But, what kind of civilization is born after these two different worlds merge?

The concept of the story that I've been working on is completely built on this idea. The robot that I have designed is part of the robotic culture that has been affected by the Ottoman culture. It was good to consider a wide scope when I was designing the character, mainly because I needed to think about the character's past and future. I also had to bear in mind the historical facts of the time in which the character has been placed. The concept is complicated, but great fun to work with.

What kind of design elements should I use? Which colors and shapes? These were the key elements to clarify. If they were not good enough to convey the idea to the viewer, then my concept would be unsuccessful.

STARTING WORK

Firstly, I had to gather some information for the Ottoman *Sherbetcibot* character. The clothes worn and the instruments used were very important design elements for me. I collected some photographs and information for the character from various books and the Internet. The ornaments and engravings on their outfits were the things that I really wanted to see and use in my design. I also wanted additional Seljuk and Ottoman textures to use, so I searched and found some carpet designs from the Seljuks (one of the Turkish dynasties that ruled Asia Minor from the eleventh to the thirteenth centuries). It was important that all of the textures were tileable, so that I could overlay them on my character very easily.

After accumulating enough information about the character and digesting it, I could then begin sketching. I had to have some ideas and rough shapes in mind before starting to sketch. I started out with small thumbnails and firstly determined the silhouette of the character. I used my pencil and paper, and also drew digitally. The most important thing was the idea and getting the brainstorming done before I even started to paint – you need to discharge your mind on to paper. After putting the rough shapes in, I made them look like robots. It was important not to forget to use perspective lines when drawing the characters, to avoid them looking "odd".

After completing the preliminary sketches, I went to work digitally, using both Adobe Photoshop and Corel Painter. I love going back and forth between these two softwares. The biggest advantage of creating sketches digitally is the speed, as you can easily do a number of color and shape variations by just duplicating and editing them.

Fig.01

I continued by refining my rough sketches. The sketches had to resemble the final design as closely as possible (Fig.01), because I wanted to select one of them to develop. As a concept designer, I hoped to see the best design among these sketches, which could then be transformed into an oriental robotic design. As these were only the general shapes of the final characters, they needed much more refining.

I then selected my final sketch. I preferred the first sketch because it had the curved and balanced lines that I was aiming for. I also wanted to use the "Fez" idea, so this one made the most sense.

The next step required cropping the sketch that I had selected and pasting it into a new document. The resolution of the sketches was very low, so I had to increase it to 300 dpi, which resulted in a file more than 2000 pixels in size. I then lowered the opacity of the sketch to 25% (Fig.02). I used the sketch as a reference and drew the character over it once again.

I continued by drawing the lines with a basic thin brush. I didn't need to put in all the details whilst doing the linework because I was able to do this this later when applying the form. After finishing the lines I set the layer property to multiply and opened a new layer underneath. I then started forming my character. I prefer to work in black and white whilst first starting to

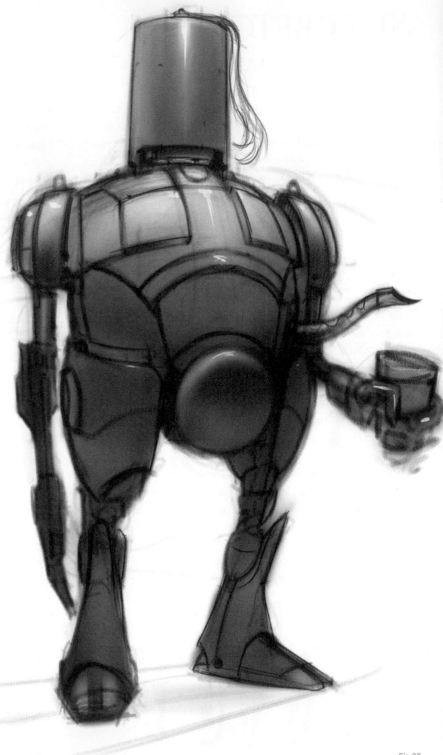

Fig.03

Fig.02

form the shapes, but you can start directly with colors too – it's a matter of preference. I determined the general form: hard and soft edges of the character, and so on (Fig.03). I also started to apply the textures and material information to the painting. This step was very important in the concept design because the material and texture information is very helpful in 3D modeling and texturing processes. 3D Modelers and Texture Artists will use your artwork as a referance for their own work, which is why we must determine all of the details very carefully. After this stage, I could then paint over the lines to give more shape to the character. One thing I had to do was to open a new layer and start painting directly with my own set of brushes, which varied from soft to hard-edged. You can also

use photographs to apply textures to your painting, but you would need to use the Stamp tool for this. Simply open a new layer and change the property of the layer to Overlay, then, using the stamp tool, select the area on the photo that you want to use with "ALT and apply it on your painting. That's all you have to do. You can also change the opacity of the Overlay layer to absorb the textures a little. Before starting to color, I added the instruments of the robot, such as the container on his back and the shoulder strap (Fig.04). To start the coloring, I opened a new layer and changed the blending mode to Color. That way I could apply the basic colors on to my character, which in this case is composed mainly of yellows and reds.

DETAILING

The final steps in finishing my character illustration was the detailing and further texturing process. I created new layers and put more detail on to my character, aiming for a more painterly look by absorbing the photographic textures. I tried to capture a more realistic look by detailing the container on his back and I aimed to achieve a chromatic effect.

In the final stages, I applied the textures to the robot and tried to portray a vest effect. I also used the Stamp tool to help, and to complete, the picture by painting a shadow under the robot (Fig.05).

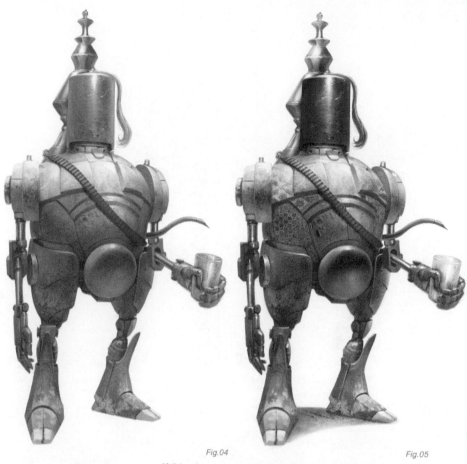

Fig.04 Fig.05

If this character were modeled, I would also have to draw a model sheet, which can also be called an Orthographic drawing (Fig.06), from which modelers can easily understand the shapes and forms.

CONCLUSION

This is the way I generally work when I'm designing a character and it can equally apply to a video game, an animation or a feature film, but the most important thing is the idea. It's your duty to try to make your ideas logical and useful.

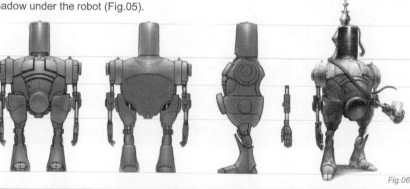

Fig.06

ARTIST PORTFOLIO

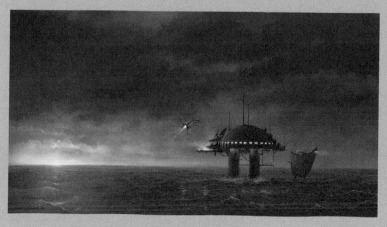

LOST TRINITY

BY BRIAN RECKTENWALD

INTRODUCTION

Whilst exploring in the park one sunny afternoon as a child I discovered the dying shimmer of a rusty, tin toy hidden in the grass and I was totally taken aback by the simplistic, elemental beauty amidst nature and man-made objects. Ever since then my personal artwork has been inspired by this dichotomy. My latest piece, *Lost Trinity*, is basically a reproduction of that childhood scene, but on a much larger stage.

While brainstorming for an idea to bring to life, I unearthed the concept of a cave. A cave represents all the complexity and beauty of nature but with the intimate, bounce-light atmosphere of an architectural interior. This concept also aligned with my aspiration to explore the environmental creation capabilities of ZBrush. By the end of this project I hoped to achieve a render that would stimulate feelings to explore further into the scene, whilst sparking the visual quality of a classical oil painting (Fig.01).

MODELING

The first step, before laying a pixel or polygon down, was gathering as much reference and inspiration as I could. Everything – from other artists' CG work to personal photos – was useful for this purpose. During

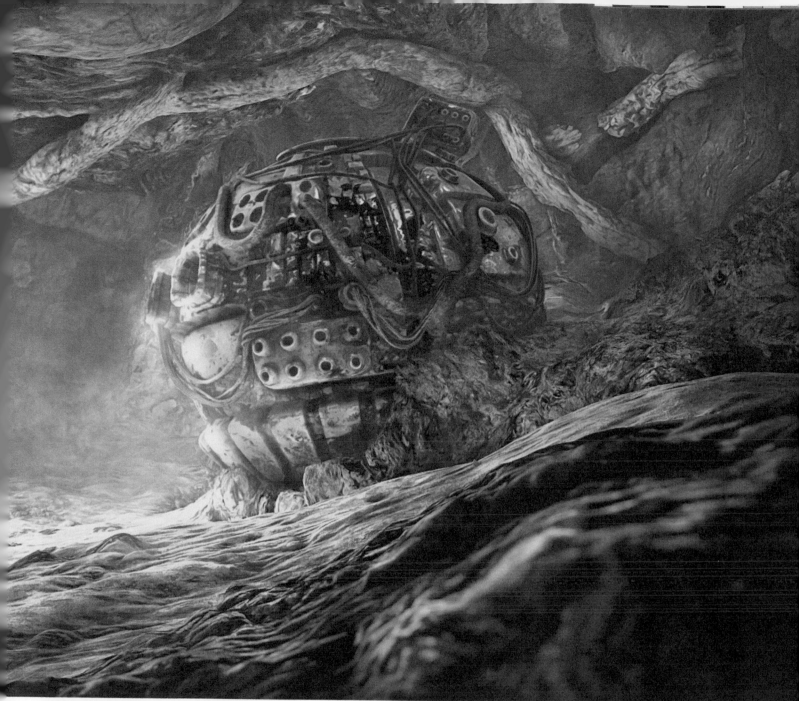

© Brian Recktenwald

Fig.01

SCI-FI

Fig.02

Fig.03b

this stage I also realized that a focal element was required. I knew it had to be mechanical and man-made and so I asked myself, what would be absolutely crazy, yet strangely provocative, to stumble upon whilst in a cave? The answer came in the form of the first nuclear explosive, code-named "The Gadget", which was tested at the Trinity test site, in 1945.

After gathering up all the appropriate references, I started the creation process by making a quick 3D scene in 3D Studio Max (Fig.02). By converting a sphere into an editable poly, I was able to rapidly sculpt the shape of the cave using paint deformation, and could fully carve out my composition with the bomb in place. I placed preliminary lighting to touch upon the mood and feeling of the final piece. Using the concept render as a visual guide, I then began modeling the cave using various polygonal primitives. This made things very easy to visualize and change, allowing me to focus even more on the composition. This technique also allowed me to experiment with getting the right lens and camera angle early on (Fig.03). Once my primitives were laid out, I had to decide how I was going to chunk the cave up. By building up the cave like a character, I was able to output the highest resolution textures and normal maps after sculpting in ZBrush. To hide any seams, I followed discrete crevices and roots. Using my 3D primitives like blueprints, I created proper topology on top of the geometry by using Snap to faces and splines. Once my spline cage was drawn, I converted them to editable polygons, attached the predefined chunks and then merged all the vertices together. The UVs were laid out using 3D Studio Max's pelt mapping tools, giving me exactly the layout needed for their organic shape in a very short amount of time.

Fig.03c

Fig.04

TEXTURING

The idea behind using ZBrush on the cave stemmed from wanting to create the most geometrically detailed terrain as possible, without having to rely upon procedural solutions or hand-painted displacement maps. Also, because I was using Brazil 1 for rendering, micropolygon displacements were not available whereas normal maps were. By using ZBrush I was able to extract highly accurate normal maps from my hi-resolution meshes using the free ZBrush plug-in, Zmapper. I also gained instant feedback – the ability to switch between sculpting and painting on the fly – and an overall speed boost throughout the entire creation process. The lined blurred between texturing and modeling when I used a few of the incredibly useful and high quality Total Textures images to "sculpt with my texture". This is a technique in ZBrush where you import a texture, apply it to your model at a very high subdivision, and pull a mask from your texture (Tool>Masking>Int). Then, using the deformation tools, one can pull detail similar to that of an interactive displacement map (Fig.04).

Once I had all my chunks textured and detailed in ZBrush, I brought each one back into 3D Studio Max at subdivision 3-4, replacing the previous low-poly versions. The next step was creating a generic rock/dirt material that I would instance for each chunk. I used the Brazil advanced material for each chunk consisting of a color, specular, normal, and falloff map. The falloff map was used for a slight fresnel effect to lightly simulate a thin layer of dust or dirt. The "gadget" was created with a simple sphere and then using basic polygonal modeling techniques, such as extruding, insetting, and beveling renderable splines and turbosmooth to finish it (Fig.05a–f). Once again, pelt mapping was used for

Fig.05p

Fig.05a

Fig.05b

Fig.05c

Fig.05d

Fig.05e

Fig.05f

Fig.05g

Fig.05h

Fig.05i

Fig.05j

Fig.05k

Fig.05l

Fig.05m

Fig.05n

Fig.05o

each element to make the UV process quick and pain free. Shading the bomb was a little more involved than the cave and required several mixed Brazil advanced materials with glossy reflections, mostly using falloff. My goal was to create a surface that still had some shine to it, but had a layer of dust/dirt along with a substantial amount of rust (Fig.05g–p). To aid in reflections, I used an HDR panoramic which I photographed from a probe and compiled using HDRshop.

LIGHTING AND RENDERING

My goal for lighting and rendering was to create a painterly image with depth and atmosphere in a sfumato flavor. I began lighting by using my concept piece as reference. Firstly, I had to place the direct light source. In this case, the sun was the direct light source, but most of the illumination from the scene has been caused by the sun's light bouncing off the sand/rock, resulting in many soft, diffuse shadows. My solution for tackling this was using area lights to fake the bounce (Fig.06a and b). Before lighting I

decided that for the final composition I would use a primary beauty pass along with other passes, including diffuse, z-depth, light rays, ambient occlusion, vegetation, and several custom masks to isolate and color correct sections in Photoshop. By saving my renders off in a floating point format, such as open EXR, I was able to re-expose and pull details that may have been blown out or too dark. Using passes and floating point images, I spent less time re-rendering and more time tweaking my image (Fig. 07).

Fig.06a

CONCLUSION

After many hours of fine-tuning and color correcting in Photoshop, I finished the render off with a slight bit of foreground Bokeh using Richard Rosenman's Depth of Field Generator Pro. This final step helped add just a touch more depth since the focal length I used was quite long. Looking back over the entire creation process, I believe I successfully learned how to harness ZBrush to create detailed and fully living environments without sacrificing complete artistic control. Since the scene is 3D, I would relish bringing it to life in a short animation or flythrough – perhaps in another project down the road. Until then, this render will continue to remind me of that little tin toy I found as a child and never to forget the beauty in the relationship between nature and machine.

Fig.06b

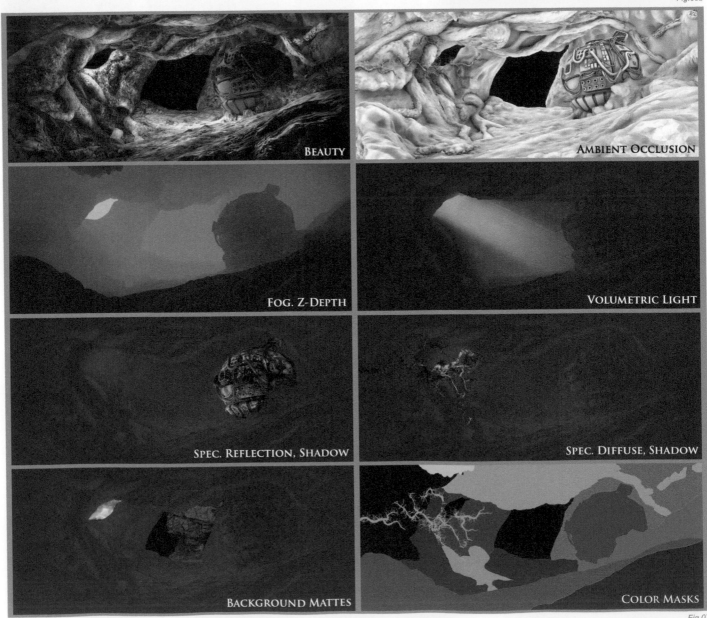
Fig.07

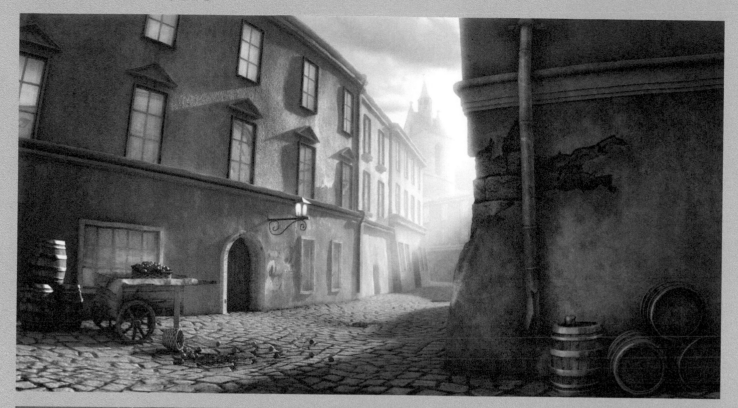

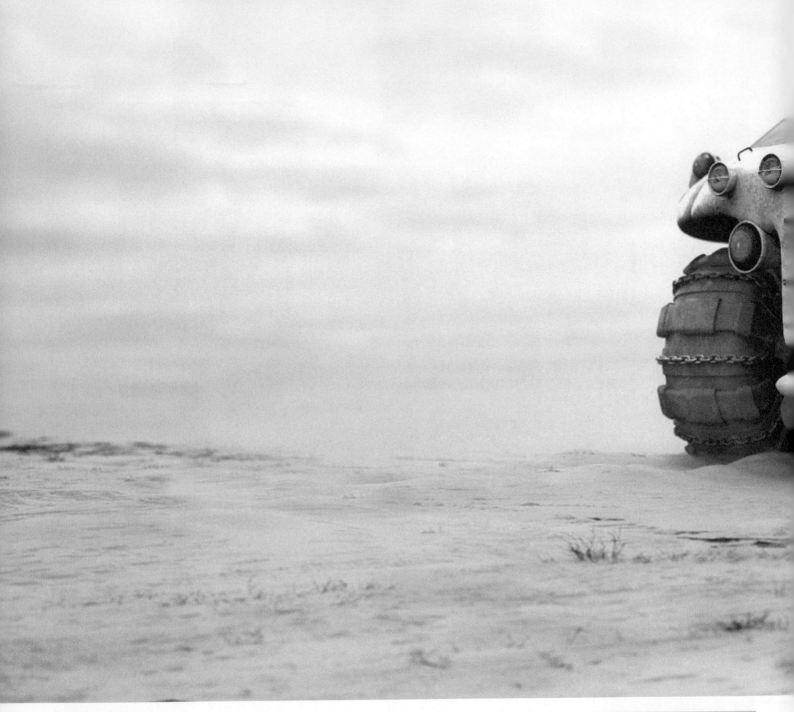

OVERLANDER

BY NEIL MACCORMACK

INTRODUCTION

The idea behind the concept originally came from an earlier model of an off-road vehicle that I had made. However, I wanted this vehicle to be much more rugged and realistic. I decided that it should be an all terrain off-roader, specializing in snowy, icy tundra. I also knew from the beginning that I didn't want this vehicle to be a clichéd military type vehicle, so there are no guns or anything like that: it was to be simply an exploration and support 4x4 – slightly futuristic, but defiantly recognizable as a design from current times.

Generally, the inspiration for the design of the vehicle came from the landscape it was to be used in, so the first step was to download some images from the Internet for the type of landscape, weather and general mood of the image.

Fig.01

Fig.02

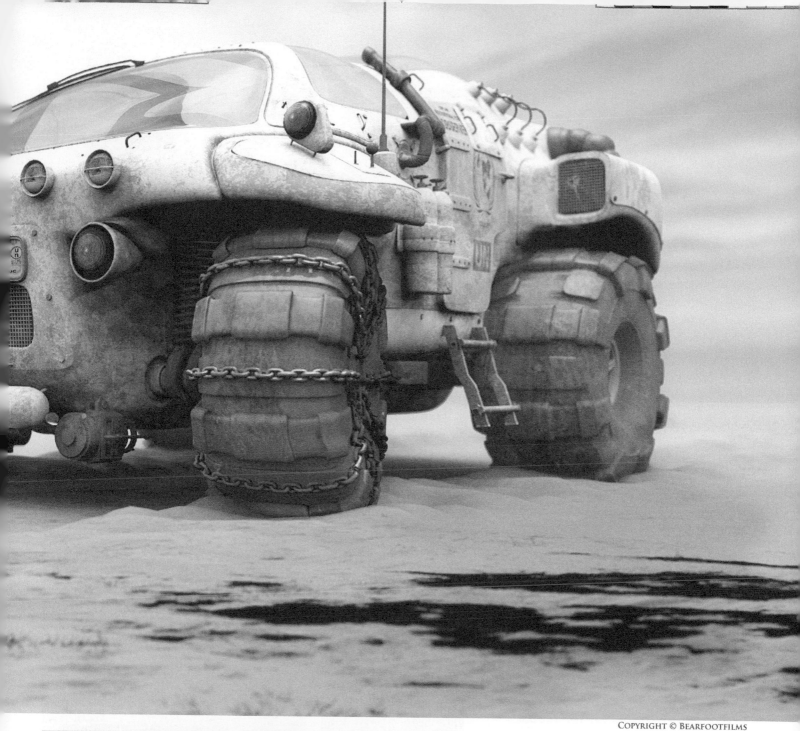

MODELING

I started the modeling process knowing that the size of the wheels would determine the shape and structure of the main body, and so, using a large off-road wheel size, I started to form the basic shape of the body (Fig.01 and 02).

I knew that if this model and final render was to be believable, then I would have to give the vehicle a real sense of weight and heaviness, which I think is missing in a lot of car renders that I see around today. Weight adds a lot to the realism of vehicles, so I added a heavy-duty suspension and then began to finalize the main body (Fig.03).

Fig.03

Fig.04

Fig.05

Fig.06

Once the main body of the vehicle was complete I started to add in the details, including snow chains on the tires, various machinery to the hull (including a winch on the front), radiators, grills, door handles, windscreen wipers, exhausts, steps, radio antenna and basically anything else I could think of which would be needed on a vehicle such as this. Please note that all of these things are functional and realistic – there were to be no lasers or weapons or anything that would detract from the realism of the object (Fig.04–06).

TEXTURING

With the modeling complete I could then move on to the texturing stage. This, I knew, wouldn't be quite the challenge that the modeling had been, and would be more about getting the basic materials correct rather then texturing every last nut and bolt. I knew that I wanted the vehicle to be white, which would provide an element of camouflage in the tundra environment, and I also knew it would be made of metal, so with these things in mind I created some white metal textures with plenty of scratch marks and wear-and-tear on them, to provide the base material (Fig.07 and 08).

Once the main hull and tires had their base textures, I used specific UV maps to add the details to the door, lights, and other areas which required more attention (Fig.09).

Fig.07

Fig.08

Fig.09

Fig.10

LIGHTING AND RENDERING

The backdrop for the render was 2-dimensional. I created a matte painting of the tundra environment using downloaded reference images and by hand-painting the rest. I chose this method simply because I was able to produce a higher level of realism than I would have been able to achieve using a 3D generated background. I then added an aligned ground plane on which to project the foreground of the matte painting and also to receive shadows, and then the creation of the environment was almost complete (Fig.10 and 11).

With the ground plane aligned and the background in place, I then had a reference for my lighting. I knew that

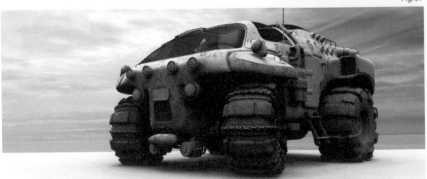

Fig.11

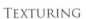

I had no direct light source, so the image would be lit using bounce light and radiosity. I created the shadows under the vehicle using an array of spinning distant lights, which create nice soft shadows to match the background image, and added an area light to produce some specularity on the metal surface and some slight refraction on the windscreen.

With the lighting complete, all that was left at this stage was to tweak the reflection of the windows and windscreen and to finalize the textures, with regard to their diffuse and specularity settings. I also wanted to convey the weight of the vehicle by displacing the ground slightly with tire tracks, which would have been left in the snowy surface. Again, adding these details helps to achieve the realism and adds to the believability of the piece. Fig.12 shows the final render before post-production work.

POST-PRODUCTION

As I knew this was never going to be animated, I decided to give myself a bit of freedom in post-production and used Photoshop to overlay some more textured elements and to tweak the colors and retouch the shadows under the vehicle. I used various metal textures to paint in some extra weathered elements to the render, especially on the front of the vehicle. The colors were lightened and the image was given a slight blue tint to add to the wintry feel. You can see the difference in the final render in Fig.13.

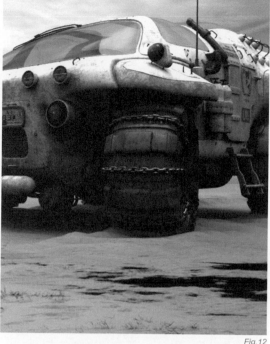
Fig.12

Fig.13

CONCLUSION

I certainly enjoyed making this piece and was really very pleased with the end result; however, it was also good from a learning perspective, and some changes should have been made that would have taken the image just a step further. To do this, I think the snow chains on the rear wheels would be first thing I would add, as you rarely see four wheel drive vehicles with only snow chains on the front tyres. I also would have added some snow onto the roof and windscreen, and given more time to the project as well as adding a driver – perhaps he would be standing against the vehicle or taking weather readings or setting up a camp?

ARTIST PORTFOLIO

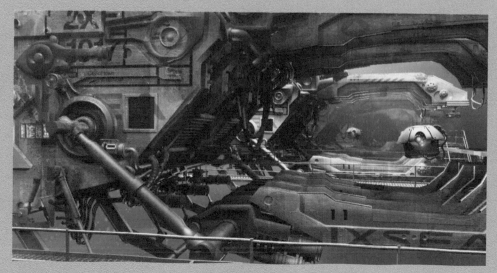

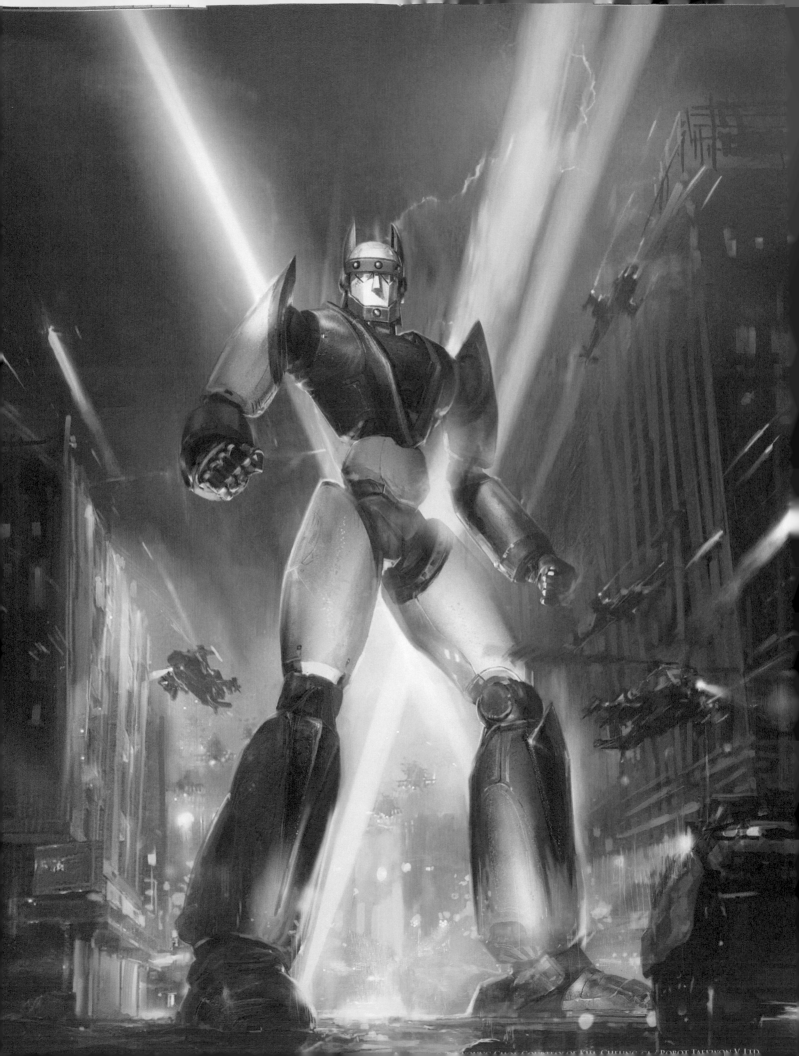

TAEKWON V
BY TAE YOUNG CHOI

INTRODUCTION

I have many different ways of creating images. For this project in particular, I used both 2D and 3D applications to create my image, *Taeknwon V*. My process involved building a low polygon model in 3D and the majority of the work was done by painting over it the 3D model in Photoshop and Painter. I then used the painting as a texture, and used a camera mapping tool in 3D Studio Max.

PAINTING

When I work on personal projects, I usually don't have a final detail sketch for modeling, just basic ideas and a style. This is because I don't want to rule out any possible new ideas that might arise as I'm working. Instead of relying on a final line drawing, I always write down simple themes and the story behind the image that I want to create. These initial ideas eventually become my motivation to finish up my creation. I believe that a good story leads to good art. The story for this painting was about creating a heroic robot image that is based on an old Korean robot character, called *Taekwon V* – which is why his body shape creates an overall 'V'-shape. I grew up watching the movies about him and drawing him in my sketchbook. I still love this character and this is a sort of "fan art" for the old robot.

Fig.01a–c shows my initial speed paintings, style guide, silhouette and color scheme sketches for the final painting. Based on those images, I started building a robot character in 3D applications, such as 3D Studio Max and Maya.

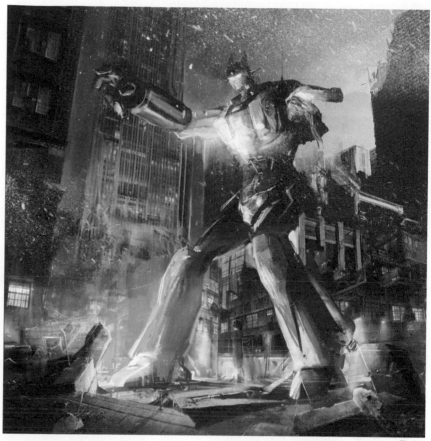

Fig.01a

Fig.01b

COLOR SCHEME

BASIC SILHOUETTE

Fig.01c

Based on the sketches, I built a very fundamental 3D mesh in a 3D application (Fig.02a). As you can see, the 3D model doesn't have a whole lot of detail; however, even though it is a very simple model, it was built to be animated so that I could create all the poses that I needed to use for the final image. Having a fully animatable model also gave me more freedom to choose different camera angles, and much more.

Although the poses that I wanted to work with were ready, the 3D was still in the beginning stages and needed texture and lighting attention. I took the image into 2D applications, such as Photoshop and/or Painter, in order to paint over the 3D mesh. Then I was able to start painting over it (Fig.02b).

Fig.03 shows the final model sheet for *Taekwon V*, with the final texture and lighting done entirely in Photoshop and Painter. The rendering was then projected over the early fundamental 3D model as a texture for the next illustration, using a camera mapping tool in 3D Studio Max (Fig.04).

BASIC 3D POSES

Fig.02a

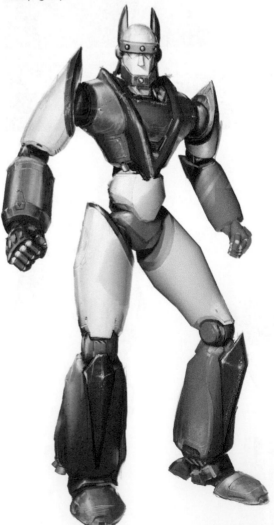

Fig.02b

Fig.03

Camera mapping is, basically, taking an image and recreating the geometry in the photo in a 3D space (so that it matches up with the still image) and then "projecting" that still image directly on to the geometry. Then, in your new projected 3D mesh, you can create a different camera and move around in the 3D space. Recently, lots of matte paintings have been created using this tool. However, it is a very limited tool, since textures are projected from one direction only. If you look at the texture from a different direction, you will see distorted or empty textures on the 3D model.

When all the projections were finished, I was able to create different poses with certain limitations. Because the poses and camera angles changed only slightly, the image wasn't greatly distorted. If I turned the model dramatically, I would have seen more indistinct and blank textures. However, this was good enough to create a more heroic pose for the robot.

SCI-FI

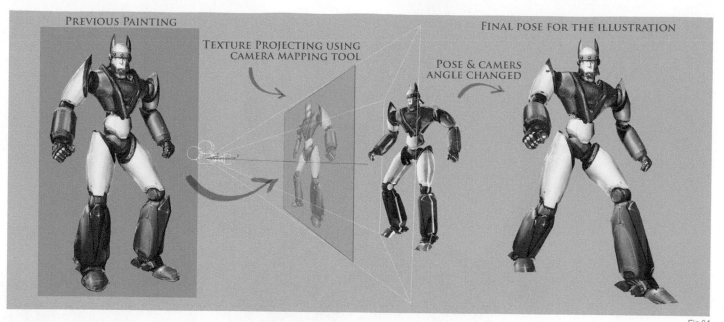

PREVIOUS PAINTING

TEXTURE PROJECTING USING
CAMERA MAPPING TOOL

POSE & CAMERS
ANGLE CHANGED

FINAL POSE FOR THE ILLUSTRATION

Fig.04

Fig.04 shows the final pose with the textures that basically came directly from my first 2D painting. You can still see distorted parts here and there and the 3D model is very simple and needs to be polished.

I then started building up the light, mood and a different background, using 2D applications. Perhaps I could have done it entirely in 3D, but sometimes I can paint more freely in a 2D application. In this case, it was much easier and faster for me to finish the illustration using 2D applications.

The final shows the valiant representation of *Taekwon V.* In order to bring a feeling of awe to the painting and to make the robot's pose more heroic, I lowered the camera angle and spread his legs further apart. I added lots of vehicles in small scale so that the size comparison between the robot and the vehicles made the painting more interesting and gives the effect that *Taekwon V.* is really big and empowering. Finally, I added the searchlights behind the robot to emphasize the 'V' shape of *Taekwon V's* body.

CONCLUSION

For me, I believe that a digital painting is an endless piece of work; I can always find ways to add more detail and to bring it to a higher resolution. Personally, I find that finishing a digital painting is more about finding and fixing the worst parts of it, until I can be happy with my painting.

ARTIST PORTFOLIO

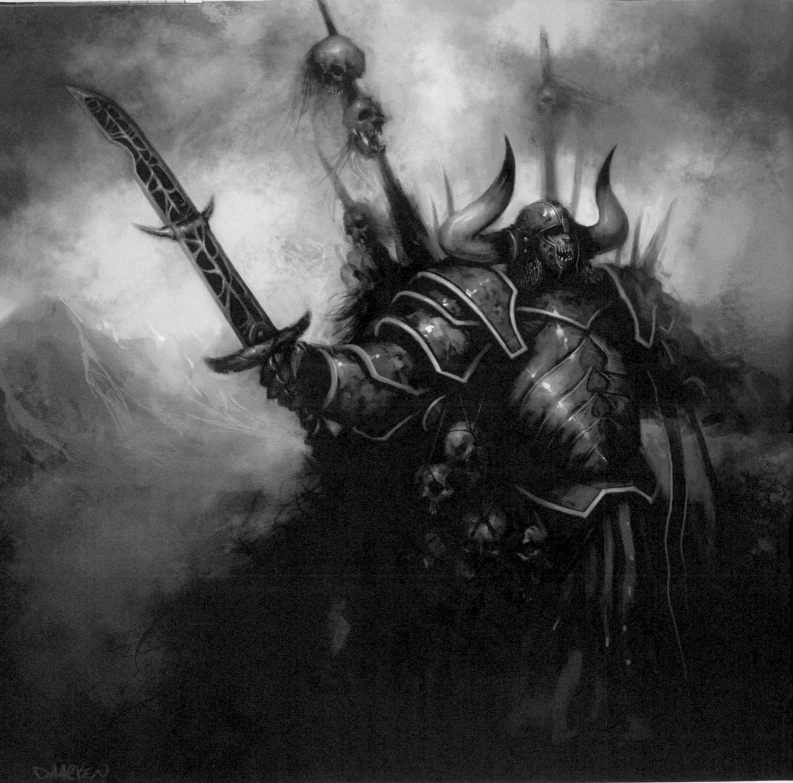

KORLASH, HEIR TO BLACKBLADE

BY DAARKEN

CONCEPT

I received a commission from Wizards of the Coast to create an illustration of *Korlash, Heir to Blackblade*, for the tenth Edition set of *Magic: The Gathering*. They were looking for a character that looked evil enough to be able to succeed Dakkon Blackblade and take his sword. Other than keeping the same look of the sword, I pretty much had free reign as to what the actual character looked like. Since there was already an original Dakkon Blackblade, I wanted to make something that would live up to the fans' expectations and excite them about the new heir. I already had an idea of what I wanted Korlash to look like. I wanted something that looked like he could have come from Warhammer, so I knew I wanted a lot of

skulls hanging from him, mementos from his previous victims. The idea behind Korlash is that he is like a dark paladin, so I wanted him to be in some dark armor with gold trim. I intended for the armor to be big, and yet feel light, almost like robes.

THE BLOCK-IN

Whenever I get a commission I always get right into it without any preliminary sketches or line work. For me it is easier to think in terms of large shapes and colors, as opposed to line. This illustration is going to be for a black Magic card, so I knew that the border was going to be black and that black cards are more evil and sinister. Sometimes I start out in black and white and add in the colors as I go along, but this time I figured I would begin with a bluish color as the main theme for the base of the painting (Fig.01).

Fig.01

After I had established some sort of background – usually just abstract shapes – I laid down an initial silhouette (Fig.02). In the early stages I try not to really think about the details too much and hold from putting in any details for as long as possible. That way I can focus on composition and getting the shapes right before thinking about the detail. If you can get your basic shapes correct you will have a good-looking illustration, regardless of the details. One way to help you with this is to paint zoomed out. I usually paint at 25% of the actual size. which helps me to see the entire composition and to not get bogged down in the details. I also try not to zoom in until the end of the process, if at all. Painting zoomed out also allows you to paint more loosely, yet it will look tight zoomed out. A lot of times if you zoom in and paint something very tightly, when you zoom out it will look weird because a lot of the detail you put in will get lost since your eye cannot resolve the detail. It also helps to know the print size of the illustration. Since this illustration was intended for a Magic card, I knew that the print size would be around two inches wide, so I could paint more loosely due to the fact that it would tighten up when shrunk down to size.

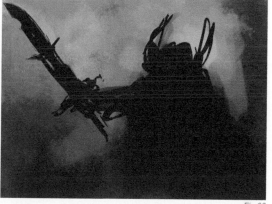

Fig.02

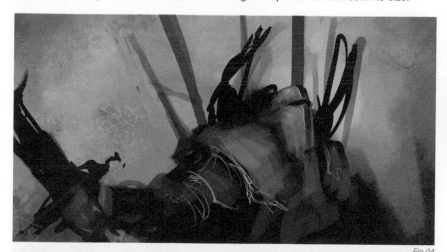

Fig.04

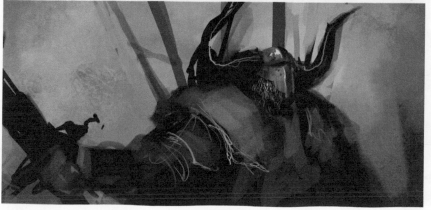

Fig.03

Even if I start with a basic color scheme, it is always just a start, never a finish. I usually change my colors several times throughout the painting process. I wasn't really feeling the blue colors, so I changed my illustration back to black and white so that I could focus some more upon the illustration, without worrying too much about the colors at this point (Fig.03).

With the basic silhouette in place I could begin putting down the basic shapes of the armor (Fig.04–05). I knew that I could be very basic with these shapes at the beginning because I would be refining them as I went along. For the helmet I was thinking of something like a crusader's great helm with some chain-mail underneath. I felt that this kind of helmet would give him the feeling of being a holy knight.

Fig.05

FANTASY

167

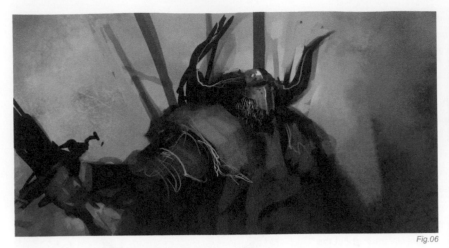

Fig.06

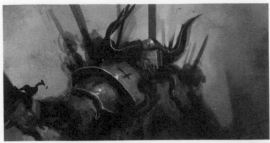

Fig.07

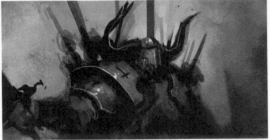

Fig.08

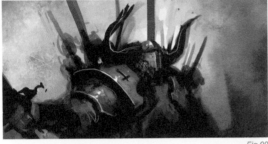

Fig.09

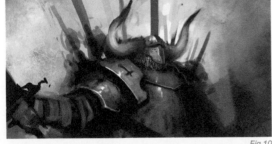

Fig.10

PUTTING IN THE DETAILS

I started feeling more confident about the piece, and so got back to thinking about color (Fig.06–07). An easy way to put color into a black and white illustration is to add the color on a separate layer. Just add a layer on top of your black and white layer, and change the layer mode to something like "color" or "overlay". In this case I used "color" as the mode (Fig.08–09). This was just the base color for the illustration and was then built upon throughout the process. Many times I added several "color" or "overlay" layers on top and changed them by hitting Ctrl+B to open the color balance dialog box. With this box you can change the colors very easily. All illustrations go through what I call an "ugly stage." You can't just add one layer of color and think it is done. You have to build upon the layer, not just by adding more overlays, but by actually painting opaquely on top of it. Even if I know where I am going with color, many times I will switch back and forth between color and black and white to make sure that my values are correct (Fig.10). If your values are correct, your illustration will work no matter what colors you use.

I also constantly flipped my image horizontally throughout the painting process (Fig.11). Flipping an image allowed me to see my errors more easily, as well as to look at the illustration from a different point of view. It also allowed me to better evaluate the composition to see if any areas were weighted too heavily. Usually, I will paint for a few minutes, flip the image, and paint on the flipped version for a few minutes, and then flip back again.

At this point I moved back to working on the colored version and added the gold trim on the armor (Fig.12–13). I hadn't yet resolved what his left arm was doing, and I felt like

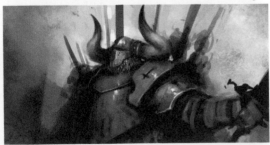

Fig.11

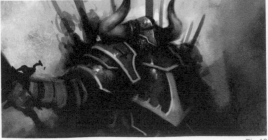

Fig.13

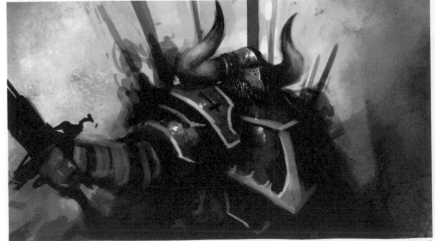

Fig.12

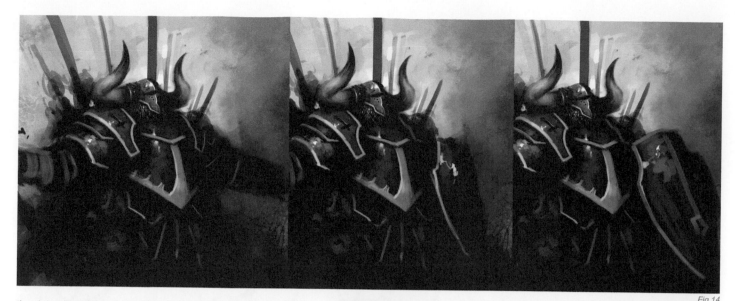

Fig.14

the right side of the image needed something, since there was so much weight on the side with the sword. I tried out several versions: one with his left arm raised like his right, and two different ones with him holding a shield (Fig.14). The shield felt a bit awkward, so I decided to go with his arm held up. I think this pose also worked better because it is like he is holding up his arms and roaring in triumph.

UP FOR REVIEW

With his pose resolved and his armor design blocked in, I could then send it to the Art Director as my sketch (Fig.15). Most of the time I send my sketches as black and white images, but if I am confident about where I am heading with the color then I would send a color version. The good thing about sending black and white sketches is that the Art Director can better focus upon your values and composition without being distracted by color. Also, if you tend to do really refined sketches, it would be better to send them in black and white. That way when you send the colored version he/she can better see a difference between the two versions. Several times I have submitted very refined color roughs, and then when I sent the final they could not tell the difference between the two versions.

One of the major problems with my sketch was that I had misread the aspect ratio, and thus I had to change my illustration to more of a square composition. Luckily this kind of change was very easy and fast when working digitally. Another problem with my sketch was that the sword was a bit too large, and I needed to size it down a bit. On his pauldrons I had a symbol that was like an upside-down cross, so I had to remove that since there could be no "real world" symbols in the world of Magic. The final change to be made was that his helmet needed to be open faced instead of closed. The viewer had to be able to connect to the character more and for Korlash to be able to show some kind of emotion, rather than being an anonymous warrior.

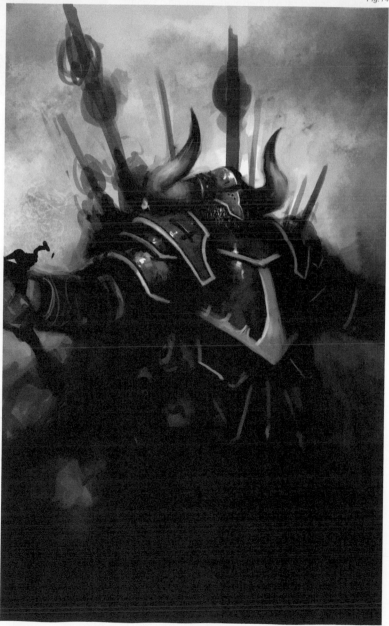

Fig.15

Fig.16 Fig.17 Fig.18 Fig.19

BACK TO THE DRAWING BOARD

Knowing what changes needed to be made, it was time to start fixing my illustration. The first thing I did was to change the aspect ratio. I then started working on what his face and helmet should look like, since that was one of the main focal points of the illustration (Fig.16–19). After opening the helmet and putting in a face, I wasn't really sure if this was what I wanted, so I tried out some different faces. Because the first face was more of a demon face, I wanted to try something more human here (Fig.20). The face on the left didn't seem to have enough emotion, and the one in the middle didn't seem like it was a believable expression. It just looked like he had his mouth hanging open. In the end I opted for the undead/demon face. I also wanted to try out different designs with the horns on the helmet (Fig.21), and changed the animal horns to something that was more like it was made out of metal. This version was sent back to the Art Director for further review. My Art Director, Jeremy Jarvis, told me that he preferred the original horns better, so I switched them back.

Fig.20

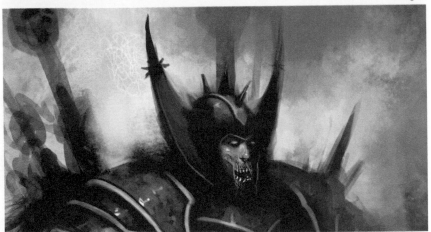

Fig.21

Fig.22 Fig.23

THE FINISHING TOUCHES

At this stage of the illustration I had the approval to take it to final stage (Fig.22 and 23). I had all of my major shapes in and the colors set, so all I needed to do was to refine, refine, refine. Finishing a painting is always the hardest part. How do you know when the painting is finished? How much should you refine things? I am still unsure of the answers to some of these questions. Most of the time you can just feel when a painting is finished. My teachers always said that when you think an illustration is finished, it is actually only 95% finished. I find this to be true. Put your illustration away for a while and then come back to it and look at it with fresh eyes. Usually you will see things that need to be fixed or changed, that you just hadn't even noticed before.

I continued trying out different things with the horns (Fig.24). I felt like the ones I had were a little too clichéd. I really liked the new horns that I had done, but something didn't feel right for this character. The new horns made him feel more like a caster type class, as opposed to a melee class. In the end I went back to the original horns.

The first step when painting the sword (or any other part for that matter) was to lay down the base color (Fig.25). With the base color down I could then start pushing and pulling with the lights and darks. In order to give the sword some extra texture I dropped in a texture layer and set it to "overlay".

The painting was then nearing the final stages (Fig.26). Pretty much all I needed to work on now was finishing up his hand and a few areas of his armor. One thing I did notice was that the blade of his sword did not match the same perspective of the sword's hilt.

Fig.24

Fig.25

Fig.26

All I had to do was select the hilt, and then go to Edit – Transform – Distort. The distort tool is one of those golden Photoshop secrets. After fixing the hilt I had to use the Distort tool on the blade as well, since it was a bit skewed.

For the finishing touch I changed the color balance of the illustration to add some more blues to balance out all of the oranges. I felt like this gave the illustration a greater color range and didn't look so monochromatic.

CONCLUSION

In the end I felt like I was able to create something that was dark and evil, and would live up to being the heir of Dakkon Blackblade. Looking back I feel that I could have improved on the composition more. Perhaps I could have added some elements in the middleground and background, like some more poles with skulls, or flags, or maybe some dead bodies. Composition is still something that I really need to work on as an artist. I think my downfall in that department is due to the fact that I don't do preliminary drawings or compositional sketches. Still, I feel that this was a successful illustration and a fairly good debut piece for *Magic: The Gathering*.

ARTIST PORTFOLIO

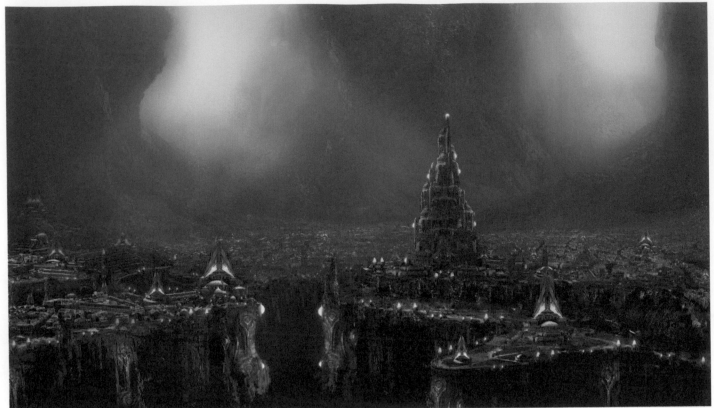

ATLANTIS

BY ALEXANDRU POPESCU

INTRODUCTION: BUILDING THE CONCEPT

The legend of Atlantis is one of the greatest legends in the history of mankind: a story so beautiful, filled with questions and mystery that one cannot help but to think and dream. So imagining the city of Atlantis must be something that each and every one of us has done perhaps just once. The concept is amazing and the possibilities are endless…

When I began thinking about making this image, all I had in mind was that I wanted to create the city in all of its glory – filled with life. I wanted to create a mysterious civilization, with charming architecture, ancient-looking buildings, but I wanted to show it as being technologically advanced, with a touch of science-fiction.

The idea was of a colossal underwater city, so the first thing I thought about was setting the mood, choosing a starting color palette, and creating a basic environment sketch to help me to better visualize the whole concept (Fig.01). As you can see, the original sketch isn't immensely detailed, but it was a good basis upon which to start the work.

MATTE PAINTING BASICS: CHOOSING THE STOCK PHOTOGRAPHS

Reading this making-of, the first thing you need to bear in mind is that my image is a digital matte painting. This is a genre which involves so many techniques that are all so different from one another, but all work together towards the purpose of building a realistic end result.

In pursuit of this "realism" in matte painting, we use a lot of stock photography, but choosing photographs is not straightforward. They have to work for you, not you for them. Always aim to be creative and use photographic elements in an original manner. If you just stitch them together, you won't get anything more than a photographic collage. Instead, research photos that will help you to achieve the concept you

Fig.01

COURTESY OF CARLOS PAES

COURTESY OF E. MENASHRI

COURTESY OF
WWW.B-GRAPHIC.CO.UK

COURTESY OF DIETER JOEL JAGNOW

Fig.02

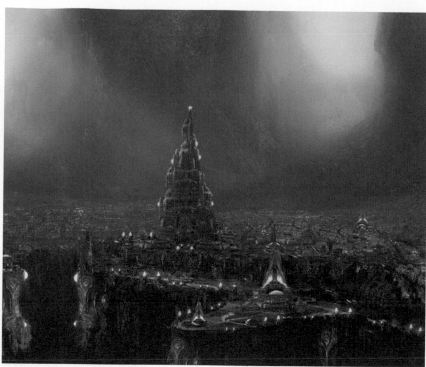

Fig.03

have in mind. If you try to be original, you'll always reap some unexpected results. Fig.02 shows some of the photographs used in the making of *Atlantis*.

MATTE PAINTING BASICS: THE PRINCIPLES

In matte painting there are several things you have to be very careful with. There are basic principles, but perhaps the most important thing – and the first that

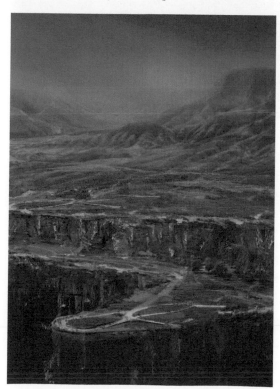

Fig.04

you must keep in mind – is that the result must be realistic. In order to achieve this there are some very simple, yet very important – and sometimes hard to implement – rules:

DEPTH: Your images need to have depth, especially when working with environments. It has to be clear what is in the foreground, what is in the middle ground and what is in the background. For that you need to watch the levels and the colors. The foreground elements should have high contrast and more powerful colors. Towards the back, the contrast fades; black turns to gray and the colors become much less saturated. You must keep this in mind when combining your photographs.

LIGHTING: Another important factor is choosing the appropriate lighting. It depends upon whether you want it to be dramatic or not, but you have to be very careful to ensure that everything looks correct. When adding a light source, think about the consequences, about the highlights and the shadows that you'll have to add. Always be careful when matching the lighting of the main image when adding a new stock photograph.

SCALE: This is something you could run into when working with a lot of stock photos: be very careful not to destroy the scale of your image. This is something that's very important, especially in very dramatic matte paintings which depict large environments.

CREATING THE CIVILIZATION

The city concept that I had in mind was very environment-dependent, so I started by building the setting of the city first. The idea was to create steep cliffs in the foreground, and in the distance would be a great valley surrounded by hills. As you can see in the final image (Fig.03), things changed a little from my original concept.

Firstly, I detailed the foreground cliffs, to get into the feel that I wanted for the environment. I started working on the right part of the image first and built the canyon-like type of cliff, with that very nice terrace (Fig.04). For the left part, I tried out different settings because I was also thinking about the city. I wasn't quite sure about the architectural style at this point, so I was simply trying out different kinds of photographs

to see which worked best. I wasn't sure if I wanted the left cliff at the same distance as the right one, or if it would be better to bring it in closer. Eventually, I chose to make it similar to the right one, and then started on the details. My main concern was to create shapes with the right volumes, to make everything seem enormous (Fig.05).

One thing I would like to point out is that, even though the landscape I have created is very complicated, the viewer still has to understand very easily what is going on within the image. This is why I enhanced all my edges with small portions of sand, and later on I added all of those light pillars. This way the eye couldn't be fooled, and the environment was easier to depict.

The background was intended to be a valley surrounded by hills; however, sometime later on came the idea of a cave. I tried it out and absolutely loved it, and consequently began building giant stone pillars in the background, and then added in the powerful light sources. This was perhaps the most important step in building the environment, because it gave the image the original and impressive touch that it required (Fig.06).

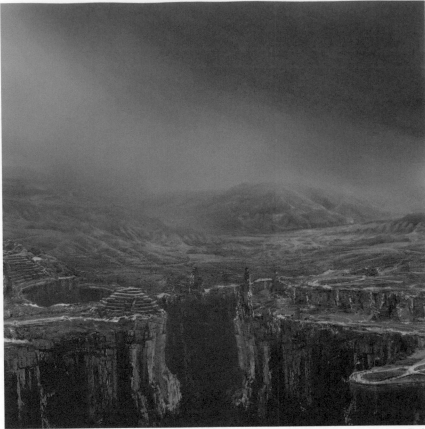

Fig.05

Fig.06

BUILDING THE CITY

The city was one of the most difficult parts of this image. I wanted to create a monumental city, with very stylish and unique architecture, but this wasn't easy. I had a pretty clear concept in mind, but it was hard to illustrate. The idea was to divide the city into three parts. In the foreground I wanted an area with big structures, with a lot of space between them, filled with temples and special buildings. The second part was to be the very crowded far site in the valley. It had to evoke the feeling of scale and of a megalopolis, with a large density of buildings, illustrating civilization. The last part to add was the big castle – the point of interest in the image. It also contributed to the feeling of scale in the artwork.

I started with the right part of the image, where I experimented with several versions of basic architecture: Greek, Turkish, modern Mediterranean, and even Aztec (Fig.07). The look I achieved wasn't what I was originally looking for, so I tried another solution: 3D. I rendered some buildings which I had previously modeled, and started to place

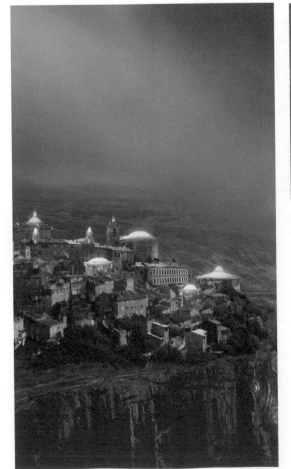

Fig.07

FANTASY

everything into the scene. Things started looking much better at this point. Then several stock photographs were included, and I started to get the right feeling I wanted. Now I had achieved an ancient civilization I wanted to also add the feeling of technology, so this came when I added the triangular shapes to the tops of my temples. These were made out of a modern skyscraper photograph. It was a great example for what I said previously about using photographs in an original manner (Fig.08).

After all this struggle, I finally achieved the style I was aiming for. For the middle ground and background I used photo references of Paris, and other big cities, to create the feeling of scale that I was going for. I paid a lot of attention to placing the elements in the scene, because the streets and avenues had to work well with the composition (Fig.09).

For the temple I used a 3D render of a big castle that I had modeled, but it wasn't textured and it didn't have the detail I was going for in my image. So, I added more architectural elements, for it fitted in with the mood and style of the overall image. Fig.10 reveals the results.

Fig.08

Fig.09

Fig.10

CONCLUSION

Building the city of Atlantis was a very interesting experience for me. From developing the concept to getting everything the way I wanted was a lot of work, but also very rewarding. I believe I managed to create an original image, one that takes the viewer to another world and asks him to think about how it may have felt to live in the great city of Atlantis.

ARTIST PORTFOLIO

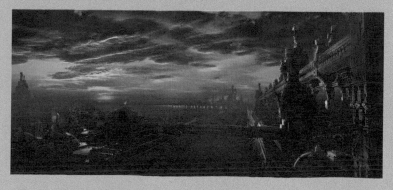

MONUMENT
BY MIKKO KINNUNEN

INTRODUCTION

This painting started as a result of my curiosity for trying new artistic approaches. I was planning to do a painting derived from an abstract composition. Usually I would start a new image with a clear vision of what I wanted to do in terms of subject matter, mood, color palette and so on. This one started much more vaguely, with spontaneous brush marks and very little idea of where I would be going with the piece as it progressed. This is an interesting yet risky approach, and something that may need to be reserved for personal works. I'm going to write a bit about my thought processes and how I approach a digital painting in general.

ABSTRACT SHAPES

As I start to lay down the first few strokes, I'm thinking that I might be doing something that's grounded in science-fiction. I begin with black brush strokes on a bright background, trying to find interesting shapes. This is probably the most important part of the sketching process, to try to nail the basic composition as well as possible. It helps to squint your eyes, or step back from the monitor screen to get a better idea of how your shapes are working. Important things to consider when designing an abstract composition are the relative sizes of the shapes, their position in relation to each other, and their placement within the whole frame. You should be looking for some repetition in the shapes, be it curves, boxes or maybe even spherical elements.

Repetition can unify the design, and having something that contradicts the major elements can play a vital part in laying down the focal point. For example, if you mainly use cubic shapes, you could add a sphere where you wish to have your center of interest. People often use contrasting values (brightness/darkness) to enhance the focal point, but you should also try to lead the eye with curves which can act as "driving instructions" for the viewer. Every now and then I flip the canvas horizontally to freshen my eyes. I'm not afraid of mistakes at this point, since every stroke can always be erased or changed later on (Fig.01).

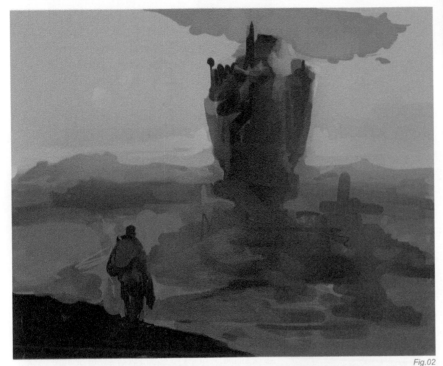

Fig.01

UNDERPAINTING

There are several options available when starting to add color on top of the intial sketch. Painting "alla prima", with hand-picked colors, will give vibrant results, but is by far the most difficult way to add color to your painting. That's why many successful artists start with an underpainting, which is essentially a monochromatic rendering of the values (Fig.02). Some people prefer to use complementary colors in the underpainting, which means if you plan to do an image that has a lot of red colors, you would start with a green underpainting. I usually try to pick a tone that would represent the final mood of the image instead. I'm going for a sunset scene with a strong light behind the background structure.

I don't want to make the image orange or red though, so I'll try to find an interesting mixture of warmth and coolness using a warm magenta as my main color. Be careful not to use too much backlighting in your paintings, as it has its limitations. You may get a strong graphic silhouette that works, but this lighting condition has its downsides. For example, you can't easily do this and use a dark sky. That would, in most cases, require objects to receive more light from the sides or front. Since this is a rather abstract piece, I'll go for a strong backlight anyway. At this stage it's a good idea to use a black frame around the image, to see how your overall values work. This also reduces the temptation of adding too much black in your shadow areas when doing the underpainting.

DEFINING THE FORMS

I gradually add more three dimensional volumes to the piece (Fig.03). The idea is to find the planes that are facing upwards, and make them brighter than the planes facing away from the light. Note that the sun doesn't reach the shaded areas, which are lit with a cool ambient light to simulate the light coming from the sky. I'm also adding some photo textures at this stage. I'm not using a part of a photo to directly depict an

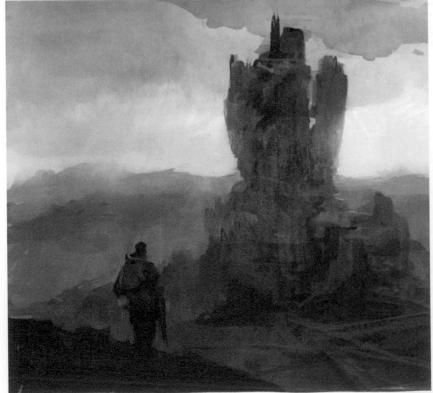

Fig.02

Fig.03

element in my painting, but I'm trying to find interesting variations and so-called happy accidents. You can always paint everything using brushes, but sometimes it's much quicker to just whack in some photo textures and see what you get. This time I used parts of a photo I took in Hull, England, to create some variation to the sky (Fig.04). Many artists copy elements from someone else's photography – there are too many examples of this and I wouldn't recommend it. But using your own photos for interesting surfaces is really useful in a production environment. You can put an interesting texture on top of your painting and play around with it, erase areas and see what happens. I'm always experimenting with different techniques, but I'm also careful not to let these experiments dictate my artistic decisions.

Fig.04

Fig.05

At this stage, I'm not afraid of using too much saturation or contrast, since these can always be reduced at a later stage. I prefer painting very boldly, and subtle adjustments can be done once I'm sure of how the finished piece will look. At this stage it's better to scale up the image to a minimum of 3000 pixels wide or high. This allows you to paint without using overly complex custom brushes. Most of my painting work is done using standard Photoshop brushes. I have included an example of some scanned acrylic paint daubs to give some idea of what you can use as brushes to get rid of that "digital look" (Fig.05).

FINISHING TOUCHES

Many people tend to overwork their digital paintings as there are no physical restrictions as to the amount of detail that can be added to a piece. I try to leave some room for the viewer's imagination, and all I'm doing here is adding a bit more texture and edge variation to make this more suitable for print (Fig.06). A good idea is to keep the edges in shadow less sharp than in brightly lit areas. Be careful not to make everything too sharp or too blurry! Many successful paintings use different types of edges, ranging from sharp edges in highlights

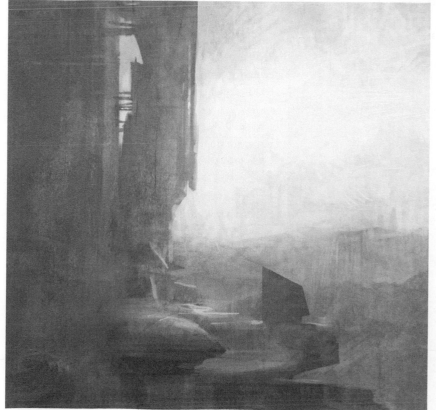

Fig.06

to indistinct, gradient-like edges in the darkest shadows. While I usually paint as opaquely as possible, I finished this painting with a watercolor-type technique. I added transparent strokes of saturated color to create areas where intense and dull hues lie next to each other (Fig.07). This subtle crosshatch technique makes the paint "come alive" in a way. Your brain will try to define the color of an area that's comprised of many different tones, resulting in a vibrant effect. Some people like to call it optical mixing. As a final step, I also add a bit of grainy canvas texture to the piece, to make it look less clean and artificial.

Fig.07

CONCLUSION

My finished work has a resolution of 5000 pixels wide, but there's not always the need to work this large. A good tip is to start small, and re-size when you need more detail. This allows your computer to run more smoothly but it also depends on the kind of brushes you use. If you rely heavily on Dual Brush settings in Photoshop, you may need to keep your image resolution reasonable to ensure a smooth workflow. Then again, with standard round brushes and only a couple of layers, you could work somewhere around 8000–10 000 pixels without too much slow-down.

I always think that my works can be improved in many ways, but I'm happy with the result. I didn't have a clear battle plan when I started and yet the outcome is, in my opinion, one of my better paintings so far. It's important to be your own critic, but it's much more important to see success in some aspects of each of your images. In the commercial world, I think one can easily lose the enjoyment of the creative process. Doing small personal works on the side allows you to experiment and "find your own voice" – something that may not be easy to accomplish under tight deadlines. When I started out a few years back, I had no clue how to approach a digital painting. I hope some of these thoughts prove helpful to other people who are going down the self-taught route. Just remember, there's no one right way for doing things; there's usually more than one good solution to every problem (Fig.08)!

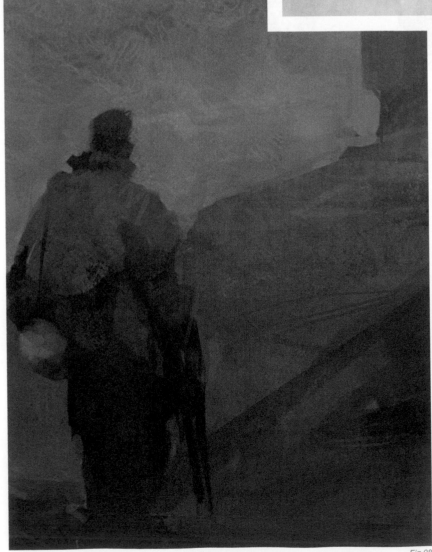

Fig.08

FANTASY

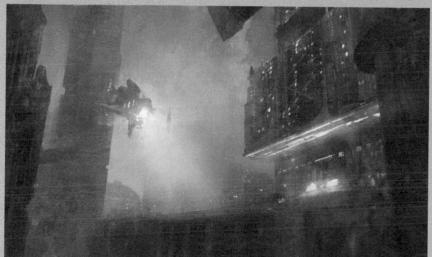

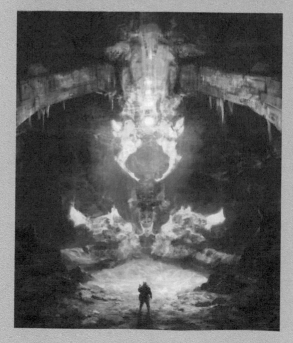

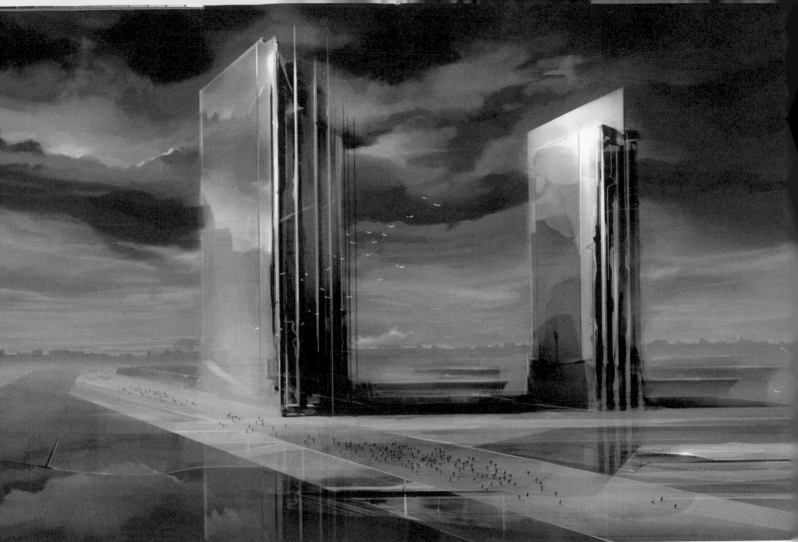

OF SUN AND STEEL

BY GERHARD MOZSI

INTRODUCTION

I had the desire to create an image that evoked a sense of scale and grandeur. Having always been greatly impressed by the work of Syd Mead and John Harris, I attempted in this image to get a similar sense of awe and mass that the above-mentioned artists consistently achieve in their own artwork.

PAINTING

Initially, there was no real theme as such; whether it was to be a sci-fi or fantasy image didn't really concern me. I simply wanted to achieve something bold and grand. *Of Sun and Steel*, as it has become to be known, started as an abstract series of shapes and textures, all created in Photoshop 7. I played with shapes and textures until I found something interesting, and then proceeded to exploit them. Really, I was just doodling with my Wacom tablet, quickly and loosely waiting to see what would appear. The only real formal element was the establishment of a horizon line, which is a fundamental element in the genesis of any landscape painting. Once a pleasing series of shapes had appeared, I then pushed and

Fig.01

FANTASY

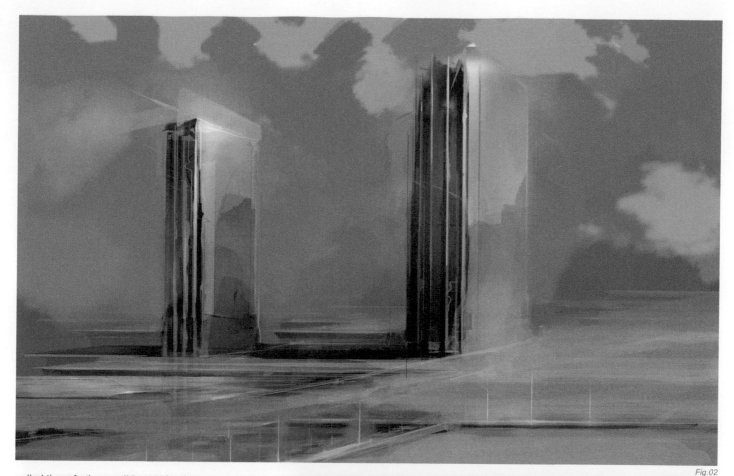

Fig.02

pulled them further, until I could begin to see a hint of the narrative in the seemingly random shapes, lines and textures (Fig.01).

Once I had decided upon a satisfactory composition, I then began to develop the palette. Defining the palette is important as it helps to unify the image and establish the nature and color of the light. It's really a part of the overall composition, because once the basic shapes are established, you then decide how the shapes will look, and how they will be rendered. The palette is simply another visual element that allows you to articulate your image. To do this, I firstly established the time of day, which then determined the source of the light. I went for an afternoon light, so this meant a warm palette, with a low sun and rich shadows (Fig.02).

Setting the palette I generally started with the sky, which created the mood of the piece. Unfortunately, my previous files had been flattened and so the layer content was lost, which meant that I was then actually working backwards, having to mask out the buildings. Once that was resolved I could then paint the sky without worrying about the foreground elements being painted over (Fig.03).

Fig.03

FANTASY

183

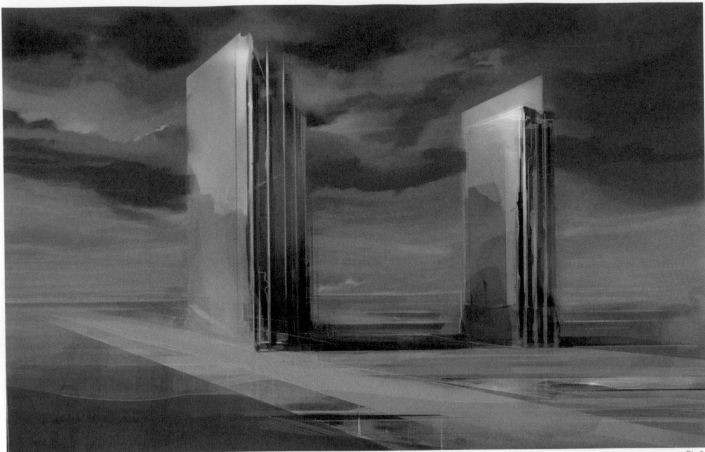

Fig.04

A dramatic sky was required, so I went for a high contrast – an other-worldly feel – with a high saturation. Realism, in its purest sense, wasn't the objective, so I painted quick, broad strokes until I had achieved the level of tension that I wanted to express. Generally speaking, when painting skies the trick is to keep the sky darker at the top and lighter at the horizon, especially where clouds are concerned. In addition, the clouds generally appear larger at the top of the sky than on the horizon. Furthermore, the introduction of diagonals helps to "link" the various bands of clouds together. By offsetting, or alternating, warm and cool colors next to one another in the sky, the colors appear richer and the tension in the sky is increased. I often flipped the canvas, both horizontally and vertically, which both served in highlighting any inconsistencies in the image, and giving me a fresh point of view, enabling a greater clarity when making critical decisions about the artwork (Fig.04).

Once the sky was in place, I felt really inspired, as it crystallized the mood of the piece. I could then start work on the reflections and horizon and on building up the detail. I started moving into finalizing the image and working on the grandeur that I had originally planned to evoke through the imagery (Fig.05).

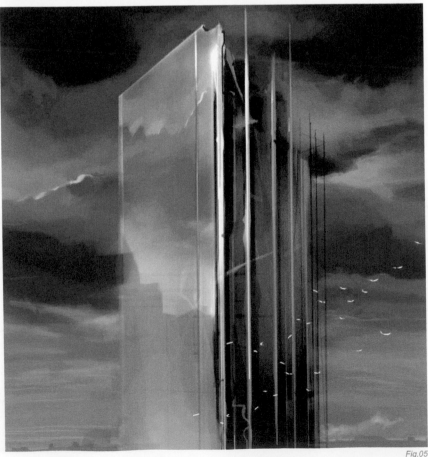

Fig.05

184 FANTASY

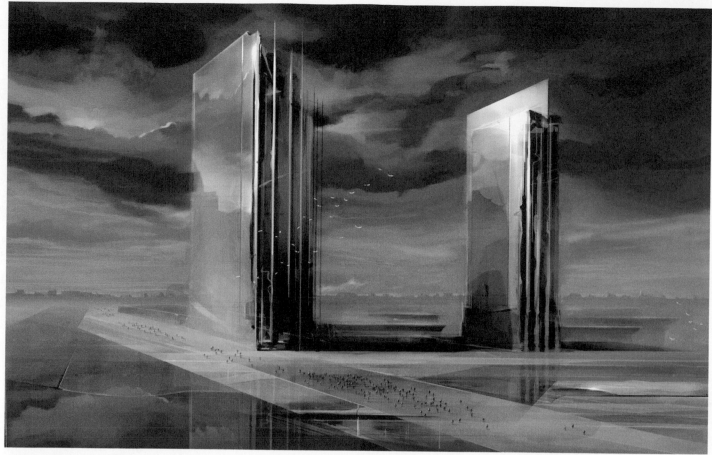

Fig.06

Having determined that the image was to be a modern, and perhaps even futuristic, city, the image in my mind's eye was already taking shape, and so I played with the palette, defining it more, as well as clarifying the lighting. With all these elements slowly starting to develop I began to play with buildings' details, fleshing out the scene and developing the narrative. The introduction of a road in the distance helped with the perspective, as well as providing a very convenient path for the people that I was to introduce later on.

The reflections were quite simple: I took the sky layer, duplicated it and then applied the Free transform tool, flipping it upside down, and setting it to Soft Light mode. Finally, I knocked back the opacity and placed it on the buildings and on the ground. The important thing was to position it properly and to know how much opacity to kill. With a little trial and error I ended up with a result I was pleased with.

After playing around with the content of the image, the basic composition and palette were established. I could then start unifying the image and introducing more detail. The highlights were added with just a couple of key hot spots to give the image a little more of a "pop" feel. These also helped the reflections to appear more realistic, and clarified the various plains in the picture. The most notable ones are evident on the buildings themselves, which served to make them more reflective. I added people for scale and birds were added to direct the eye and introduce more noise into the image.

To complete the piece I played with the Levels and the Color Balance to increase the contrast. The color balance was very helpful as it allowed me to further balance the warm and cool hues, thus introducing a bit more drama into the image. Last of all came the hardest trick with any artwork: walking away and not fiddling with it anymore (Fig.06).

ARTIST PORTFOLIO

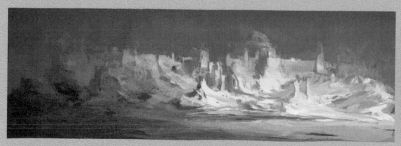
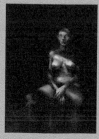

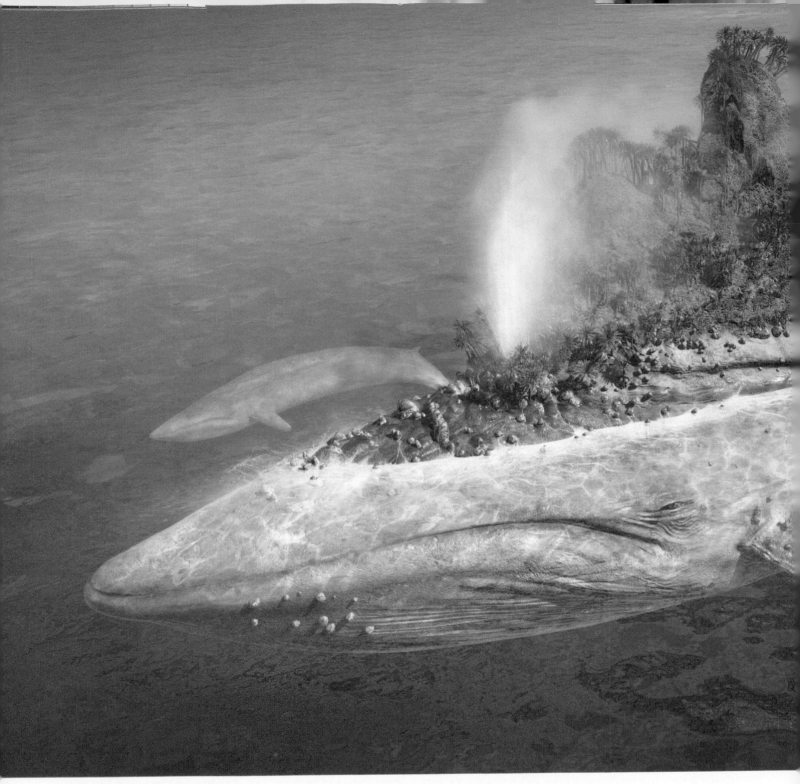

MYTH OF THE FLOATING ISLANDS

BY KHALID ABDULLA AL-MUHARRAQI

CONCEPT

I have always been excited by stories of Sinbad, and in particular the story of the island on the back of a whale. It just seems such a fantastic concept that I had to try it out. I have always been inspired by the old Japanese Sinbad animations from the early 1980s and I hoped to achieve a vision of this story that would inspire others in the same way.

WORKFLOW

Modo > ZBrush > LightWave > Photoshop. Having a smooth workflow is very important in creating an artwork. I do not think that art should be restricted to any particular platform, software or system. In the old days, I used whatever medium was available to get the best results required. Today, the tools that are available interact with each other seamlessly, but even that requires a lot of pre-planning, before getting heavily involved, to minimize the complications that will inevitably arise.

FANTASY

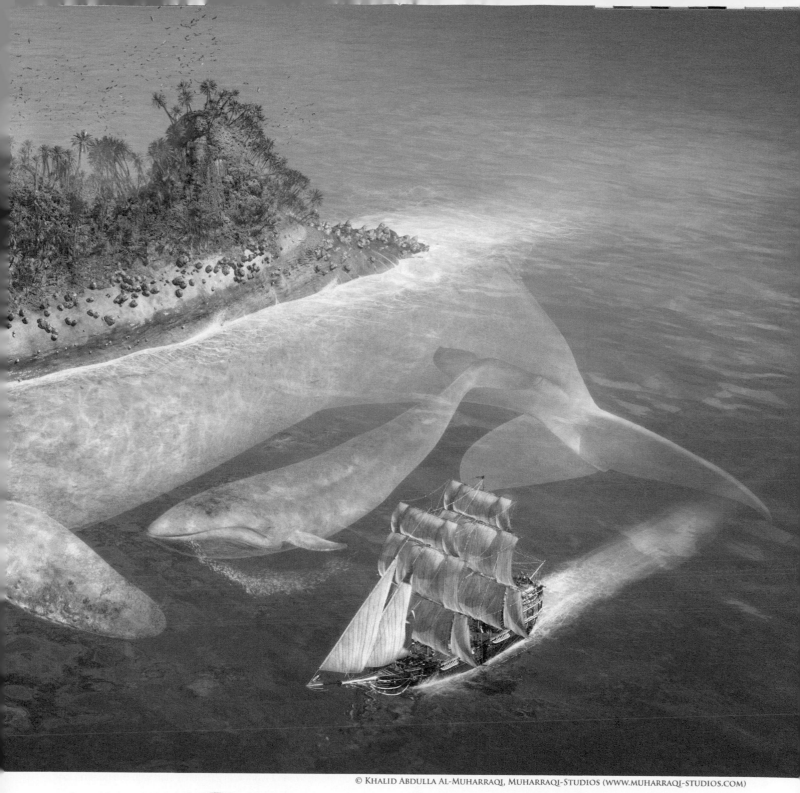

Fig.01

Before I even turn on the computer, I create a sketch of what I want to do, or draw the "map", as I call it. Once I have made up my mind on the items needed, and maybe the general pose, I then go into a research frenzy, looking for books, sites or artistic impressions of what I need to have in the image. The more I can relate it to reality, the more convincing the piece will be (Fig.01 and 02).

FANTASY

Modeling

I started modeling in Modo and went back and forth with Lightwave (Fig.03). It was important that I had a "back and forth" workflow, because both applications have different strengths that helped me to attack the subject to get it to where I wanted it to be. I made sure that the model was smooth, and without too many complications, and this was when I then began designing UVs in Modo.

It is important to find the right formula to make images sit smoothly, reflecting the feel of the skin. The UVs were to be used in many ways, especially because I had planned to create displacements and details once I got into the sculpting tools in ZBrush, so I was very careful during

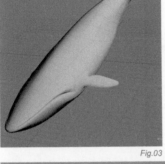 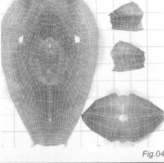

Fig.03 Fig.04

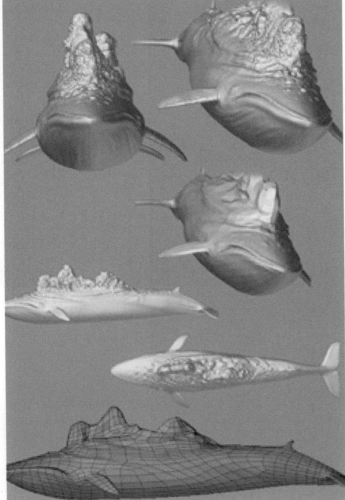

Fig.05

Fig.02

this stage. Again, I cannot stress enough the importance of the artist having a clear path from A to Z so that you don't end up trying to "ding" things into place later on (Fig.04).

Sculpting

This is where I really got to enjoy the process because I got into the fun part. It is very relaxing to sculpt, and I feel that it really pushes the subject to the next level. This is a purely intuitive process, since it is where technical approaches are reduced and artistic hands kick in. When I finished the original model, my poly count was about 2000, and after finishing it rendered at about 2 300 000 polys. I use a Cintiq monitor which connected me even more with objects, as I could feel the geometry building up more. When I work with ZBrush, I start with the general look and then get into the details, so that I can fix the sizes of things, add muscular mass and then get into the feel of the skin and its bumps, grooves and scratches (Fig.05).

Texturing

I was then prepared for the texturing, where I started off with the general color scheme, followed by all the details. On this model, I had five layers of painted textures between ZBrush and Modo for color painting: color+bump+specular+reflection+diffused area. There were also other texturing methods achieved in LightWave, using Fprime, like procedural and gradient texturing, which are long processes, but very important. I then added other details, like the stones and trees, whilst I was painting the

texture: building the trees and rocks with their own UV textures and using the Mesh spray tool in Modo to spray the objects onto the surface of the whale. This helped to speed up the process, plus gave a more random look which helped everyting look more natural. In total, the images in the scene were applied on to 62 areas on the model, and exceeded 630 MBs in size (Fig.06).

Fig.06 *Fig.07*

SCENE SETUP AND LIGHTING

These two, in my opinion, cannot be separated, and it reminds me of the days when I used to do photography, where one considered the subject, lights and camera. I set up the camera first and posed the subject, but needed to create a few bones that were in areas that would help me get the right feel from the character. I then put in the sea water and positioned the ship, adjusting the camera type and lens, and then moved onto the lighting. Lighting is the most crucial aspect in transforming the image into a final render. I used three lights, with one dominant light and other lights that helped increase the drama in the scene (Fig.07–08).

Fig.08

RENDERING AND POST-PRODUCTION

Rendering is the last stage in 3D, so it is the last point of return or "going to print", as I say! I got into all the details, like the degree of anti-aliasing, final file sizes, and optimizing render times, even splitting the final image into difference components and rendering each of them on different passes before post-production. Finally, I was at a stage that allowed me to adjust colors, do some re-touching if need be, and position the layers to create the final product (Fig.09).

Fig.09

CONCLUSION

At the end of all of this, I was very happy with the result and feel that I have fulfilled my desires by creating my own version of this story that I have had in my mind since my youth. Also, I would like to thank all the developers for creating platforms that are unique in many ways, but which all interact easily with each other to allow the artist to utilize their products as tools that help to achieve the vision.

ARTIST PORTFOLIO

SKY OF KALUOLO

BY JIAN GUO

"This world was once a part of the heaven, but after the chaotic battle of the old Gods, it was splashed apart from the sky, and all the cities and the land were left swirling around the empty space; only the giant birds – Kaloulo – can cross through the border to the new heaven…"

The above is from an ancient Chinese and Indian Buddhist mythology, in which heaven has many levels, and every level is named as a kind of "sky". An exalted soul will be able to enter the higher level of heaven, and that progress is named "lunhuo". The sky of Kaluolo is a cracked part of heaven, so the people in there want to "lunhuo" to the new heaven, and so they ride on the birds and flying carpets, rushing towards the portal door.

When I first decided that I wanted to draw this picture, I began by searching for material on the Buddhist temple and figures of Buddha that could all be used to represent the ancient mythology. I felt that birds and flying carpets may be the best tools for these people who want to "lunhuo" (Fig.01), and so I made my decision to create a painted world that was mixed with the ancient. Indian and Chinese Buddhist culture.

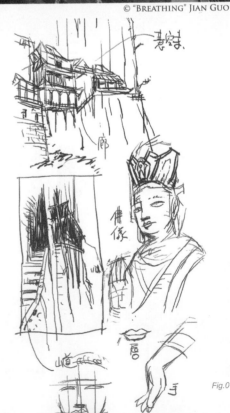

Fig.01

FANTASY

CREATING THE CHARACTER

To begin, I painted a couple of figures on a canvas in Painter to be the main characters; a beautiful Indian girl and the navigator of the flying carpet (Fig.02). With the Painter tool – 2B pencil – it was easy to make the girl appear to be squatting on the carpet, looking back in anguish and so revealing her feelings of sadness and unwillingness to leave her home.

PLANNING

To show a chaotic traffic scene and the broken world, I added a much larger Kaluolo bird, just flying over the little carpet in the middle ground. The cliffs on the side, housing a temple and many giant figures of Buddha, look as though they have been abandoned for some time. Far below the flying people is the unrestrained rocky ocean, where the remains of the world lie, and the tearing forces break the continent apart. All the rocks started as molten lava and flowed into the ocean, and after solidifying changed the surface of the land forever. In the front of the stream of traffic there is a floating city, which is the patrolled door to heaven.

After the planning stage I checked the whole picture and used the digital watercolor tool to add a simple color level to confirm the relationship between the elements (Fig.03).

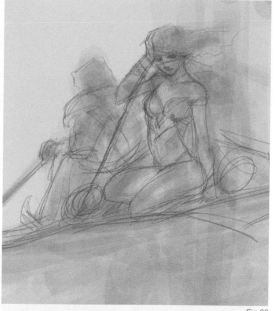

Fig.02

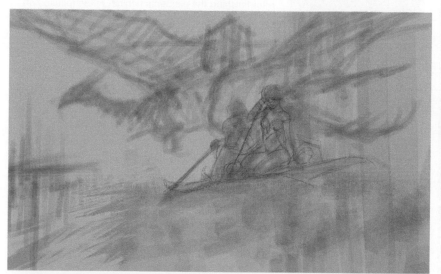

Fig.03

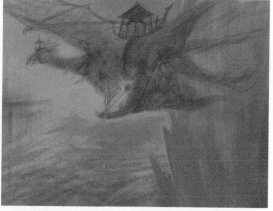

Fig.04

COLORING AND DETAILING

I placed the sunlight coming in from the back of the mountains to suggest sunset and evoke the feeling that there is much sadness, with all hope being almost lost.

For the sunset, I used oranges and yellows to show the highlighted surface, and used a purple-blue color for the shaded areas. The burning, fiery sky and the cool, "unconcerned" mountains seem well-balanced. After drying the watercolor, I used the pencil, of just a small size, to give more detail to the elements (Fig.04 and 05).

In my concept, the Kaluolo bird is a transportation device, just like a large ship, but how would people handle such a giant creature? The navigator must control the head of the bird, so I added a Chinese-style pavilion as the control cabin on the head of bird, and there are also cabins that can hold passagers, so I added a more pavilion-like structure to the bird's back. Following the light, I made out the feather and wings of the bird. The Chinese-style lanterns and guard express

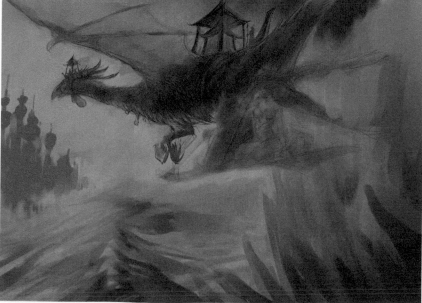

Fig.05

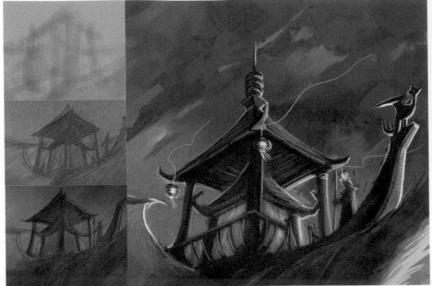

the noble authority of the master in the control cabin, meaning that whatever the kind of person, they are all afraid of being buried within the dying world (Fig.06).

Setting the eyes upon the background, the mountains occupy a large section of the canvas. Following my concept, the mountains climb with the temple and the Buddhist statues. I began with the rough sketch of the structures – a bridge-like corridor – making contact between the two palace halls, and positioned it just over the cave of the figure of Buddha. Adding more handrails and columns, I then used a darkened watercolor tool to sculpt a temple leaning against the cliff, using a little light color to draw the outline of the border closest to the sun (Fig.07a–c).

FINISHING THE MAIN CHARACTER AND BACKGROUND

After finishing the elements behind, I then focused on the main figures; the sketch of the girl was done at the very beginning and I added the watercolor in the planning stage, after which I noticed that the color of the girl's skin was just in the right state, and so the only work I needed to do was to use more accurate lines to tighten up the shape of her body. In this process, I also added some details here and there for the cloth, belts and necklaces – more brush strokes gave light to the bodyline, and brought life to it. Particularly on the face of the girl, the sunlight and the reflections of light were adjusted very carefully to perfect them (Fig.08).

I used a large chalk tool to paint the rough stone ocean. The faraway city was also filled with pavilions and palaces – a kind of crowded and busy scene – but I did not spent more time detailing the city, for this was not the main point of the picture. I only gave the city buildings some light to make them seem much more complex in their shape and form (Fig.09).

Fig.06

Fig.07a

Fig.07b

Fig.07c

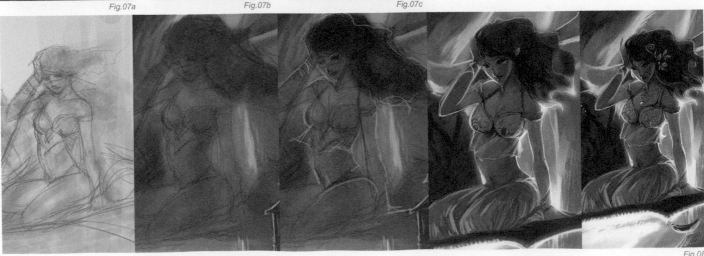

Fig.08

FANTASY

Adding Texture and Making Final Adjustments

I saved the file in Painter, and then opened it up in Photoshop. I searched for some texture files and used the "paste into" tool to add textures to the selected areas of the picture, to the mountains and to the stony ocean surface, which made the stone quite crude-looking, so I adjusted the scale of the texture to make sure that it appeared to be the right size in the far distance (Fig.10).

In this step, I had to get an overall view of the whole picture, and I also turned the canvas around to check that everything looked fitting on the right side, because sometimes, after a long time painting, you will start to consider the wrong direction to be nice-looking. To prevent this, at the end of painting, I always flip the canvas to see it in its reverse, to check the picture from a fresh perspective.

By doing this, I found the faraway city to be too close to the border of the canvas, and so I increased the size of the canvas to make it seem more relaxed (Fig.11). To complete the picture, I adjusted the color in Photoshop to make it look much more theatrical.

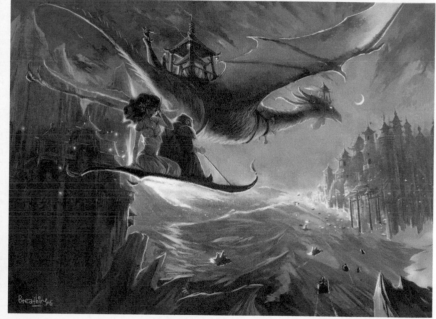

Fig.09

Fig.10

Fig.11

Artist Portfolio

CITY ON THE ROCKS

BY OLGA ANTONENKO

INTRODUCTION

This picture is a concept piece for a new game by Sibilant interactive – W.E.L.L. – online. The premise of the game is set in a fantasy world, with all the social and state life influenced by magic. Eight different races live in cohabitation within this world and each of them exists in a unique environment, a separate place on the map. For example some live in a swamp or on lakes, and others in a forest but each race builds its own towns, with characteristic architecture. One of the races is Tenki – proud, independent man-birds. They could fly a long time ago, and have since lost the ability but still have a longing for the sky in their blood (Fig.01). My goal was to picture how they should look and to create them with two towns: one town in the mountains and another one on a steppe.

The image *City on the rocks* is one view of the steppe town, built on the sharp cliffs located on a wide prairie. Tenki always settle on rocks or mountains, because they are attracted to the sky and they want to live closer to it. They climbed onto the mountains, built high houses with balconies and galleries with passages from one house to another at a great height.

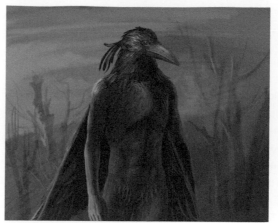
Fig.01

Fig.02

The architecture should be light, simple, and at the same time aimed skyward. So I decided that it shouldn't be too massive and the houses shouldn't be built on the ground or rock and so elected to paint them built on wooden supports, which makes them appear visually lighter. Also I decided they should have a cylindrical shape, laconic from my point of view, and showing the character of the Tenki – simple and independent, but inclined to thinking and self-contemplation. Maybe this directed me to add some Asian aspects to the architecture: stepped roofs, torches and little gardens on the rocks displaying a Japanese influence. To create even lighter buildings I decided to make the roofs from a light material – something like leather stretched across a frame, and some roofs made of straw. I added rope bridges, also very light and precarious, but attracting Tenki because they can appreciate the height while moving between houses and feel a sensation of flight and being almost airborne.

I wanted to show that everything exists in another world and not on earth, so I decided to place several suns in the sky simultaneously. It also helped me to create an interesting light.

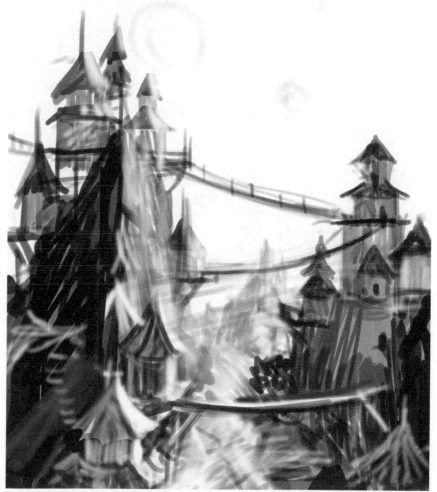
Fig.03

Fig.04

I did not create any special brushes to paint this image but used only Photoshop default brushes. I have a Wacom tablet (intuos), so it was very easy to add different gradations of a single color using pen pressure to define transparency of mixing colors (Fig.02).

First of all I tried different compositions – painted some quick black and white sketches with an approximate location of the rocks, houses and bridges. I decided that a picture should have a rich atmosphere, so there should be a lot of empty space between the different rocks and houses in the foreground and background. The first sketch looked too overloaded (Fig.03), so I removed some houses while painting a second one, leaving just a few of them in the foreground (Fig.04).

I then used this second sketch and added some color to the picture. As soon as I began to paint with color I noticed that the borders of the picture were too tight for the rocks, and there was not enough air, so I added some space to the edges, especially to the left. At first I used dilute pastel colors, to add some softness to the picture (Fig.05).

The next day I looked at it and didn't like what I had done. The front rock blocked the entrance to the image, not allowing a view beyond, and it was also too dark, drawing too much attention. Also I realized that the point of view was very low, which detracted from the sense of height and flight. I forced myself to redesign the sketch and came up with something that I followed till the end. First of all I removed a rock in the foreground, then lifted the viewpoint, in order that the horizon moved downward. This meant the viewer could see everything from above, as though flying or standing on a neighboring rock, so we could see a vast landscape. Then I extended the entire space, shrinking the central rocks almost by almost half and adding some ground at the bottom and finally adding a new foreground.

Fig.05

I decided to show multiple levels of the town where we see the top buildings from below, and some other buildings from above. Also I added a rope bridge connecting the spectator to a top left house, and so emphasizing the perspective and helping lead the spectator into the image. At this stage I had created a composition that remained practically unchanged (Fig.06).

However, I did alter the color as the scheme in the sketch looked too faded in the new composition. I added some brightness little by little while working on details. I added saturation to all layers except the sky and then added even more brightness to some areas, for example greenish trees, grass and roofs. I wanted the roofs to be made of some strange, light, thin material, so I added a little translucency to them as they looked like thick plastic without it. Step by step I added details to the houses – balconies, windows, torches, and textured the rocks and placed vegetation on them. So bit by bit I painted the entire image, assembling it like a mosaic. The picture became much warmer, with brighter suns, and the entire mood got more positive (Fig.07).

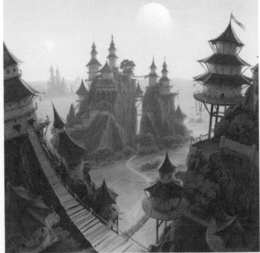

Fig.06

Fig.07

I added simple and laconic ornaments to the roofs to add variety, with one roof covered with a sort of bush (also I didn't want them to look similar). In this manner I managed to add enough level of detail to the houses and rocks but the sky now looked flat and empty by comparison. To compensate I painted some cumulus clouds. The next step was to create a transparent layer of haze between near and distant rocks, which added some atmosphere to the image (Fig.08).

Fig.08

FANTASY

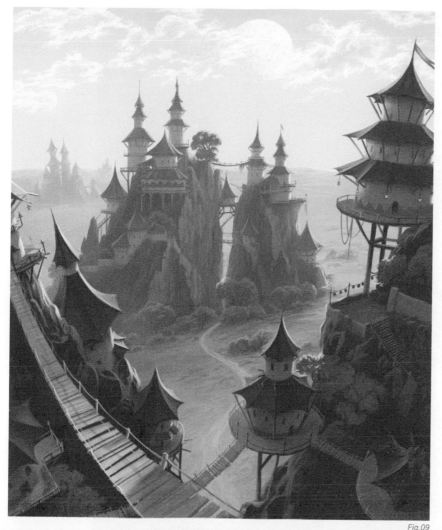

At this stage of the piece I felt that something was missing: a kind of sharpness perhaps but I didn't want to add contrast because I was afraid of losing the atmosphere and softness of entire landscape. I decided that if this place was not located on earth, I could go further beyond realistic light conditions and add even more natural light sources. I therefore included one more, even brighter than any of the suns in the image. This light source cannot be seen on the picture but it creates an intensive backlight. I painted a separate overlay layer, with beams of light falling on the roofs and rocks, and cutting across the tree foliage. I think these bright spots add some life to the scene and helped me to separate foreground from background as well as create a nice sunny mood. The last thing I changed were clouds; I totally replaced them with new ones because the old clouds looked out of place with the new light. This is how I arrived at the finished picture (Fig.09).

Working on these concept sketches proved useful, as I had to create an entire environment, characterizing the inhabitants of the place. I was given rather tight constraints by way of the game plot, but on the other hand, I had complete freedom from a creative point of view. A bonus was that I like mountainous scenes, which made the task even more pleasant and inspiring for me.

All Images are courtesy of Sibilant Interactive.

Fig.09

ARTIST PORTFOLIO

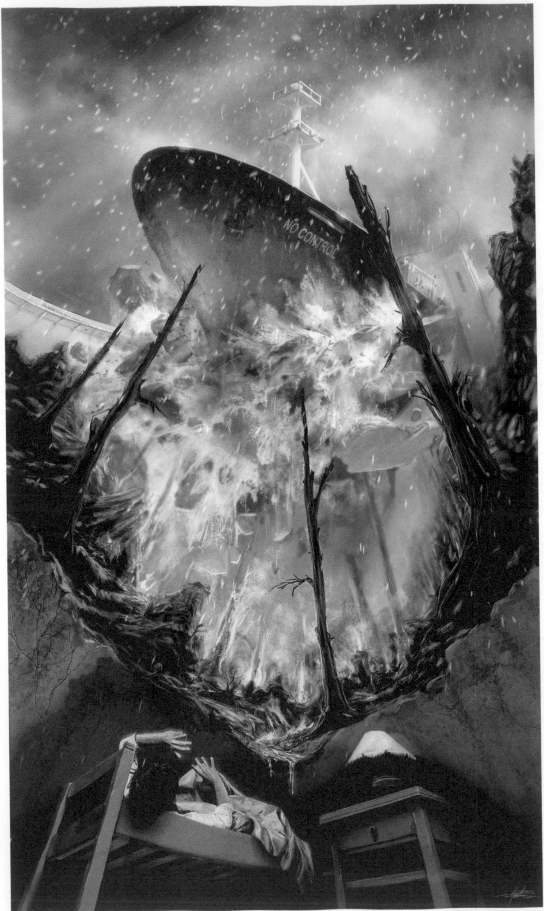

No Control

By Marcel Baumann

Concept

Have you ever been in a situation where you weren't sure if it was real or just a dream? The character – in this case a boy – is finding himself in an extreme situation: a deep gorge, from where there seems no escape. In the picture he is caught at the moment where he is trying to break out of his dream, but at the same time he is still covering his face from the heat and brightness of the fire.

The oil tanker that breaks through the dam moves the character into a surreal world. He stops to believe that he can survive, but at the same time does not accept that what he is seeing is real. Most importantly, he refuses to accept that he will die, because there is still the possibility that it is a nightmare. He tries to break out of the dream with all of his mental will and is caught between the two worlds. He finds himself in the bed of reality but simultaneously the fire of his nightmare is still surrounding him. The painting captures this very short moment of just a few seconds.

I chose *No Control* as the title and as the name of the ship. Firstly it explains that we normally don't have control over what we are dreaming, like the captain who has lost control over his tanker and crashes. It's like the earth is a plate and the tanker in this moment is reaching the edge. This may be associated with the character's feelings, who is afraid of having reached the end of his world. In this complex moment he is the captain and the boy lying in the bed, all at the same time. This last point is just my interpretation of how I see my own work.

The feelings and experience in that very short moment of switching between these two worlds are the spectacular parts that I wanted to capture in the picture. I tried to integrate this idea into a spectacular visual impression of a dream to support the story and help the viewer feel the same anxieties as the character.

The concept image (Fig.01) shows how I developed the story and composition for *No Control*. The viewpoint should be to one side and convey the drama in an abstract way. I tried to capture different levels of consciousness and it ended up quite convoluted, blurring the viewer's understanding of what is actually happening. I liked the rough style of this concept painting but tried to find something more spectacular, and something that the viewer could understand intuitively. Other concept pictures I made ended up too bizarre, but I didn't want to leave the main idea. I kept the bed but changed the camera angle, which is placed beneath the floor to create a dramatic and exaggerated feeling of space. I had other spectacular scenes in mind, including a ship crashing into a rock, but this was another concept altogether. I remembered a picture from a Disney comic, made some very rough pencil sketches, and then connected all of the ideas into one composition that supported the story successfully.

3D Model

The next step was to build a rough 3D scene to find the correct perspective and to test the scale of the ship and the dam. I used the rendering as the background layer in Photoshop and started to paint over it (Fig.02).

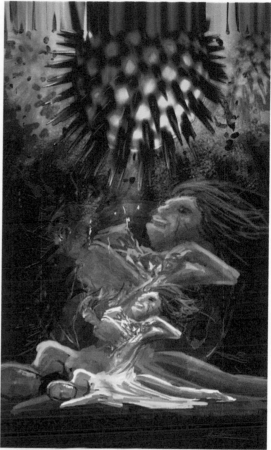

Fig.01

Fig.02

PAINTING

I started blocking in the gorge with the rocks, changing the size of the dam, flipping the bed to the other side, and then began to work again on the main composition and established the correct scale (Fig.03).

I then created some simple custom brushes, with different particle sizes and different blur levels, to block in some preliminary water effects. I added further fragments of the breaking dam onto different layers and placed a photo of myself inside the bed. For the foreground I needed a more realistic quality than in the background, in order to separate the real world from the dream world. I wanted to keep the foreground monochromatic, in contrast to the background.

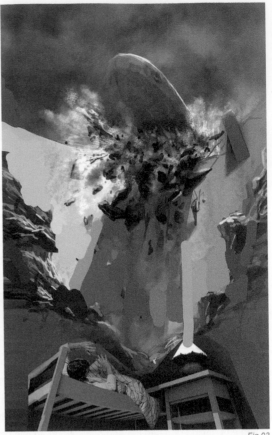

Fig.03

To save time, I painted over the photo and added new textures. I later added some new light, shadows and hair to better blend it in with the painted elements. The way that the bed linen looks metallic was unintentional, but the heavier appearance works well with the concept in an interesting way. The blue background of the sky is a photograph with some added details in the form of clouds that were painted with a customized cloud brush. I drew little details and shadows on the rough 3D bed and the 3D table to match the realism of the character, and then replaced the ship with a huge oil tanker strong enough to break the wall of the dam (Fig.04). More

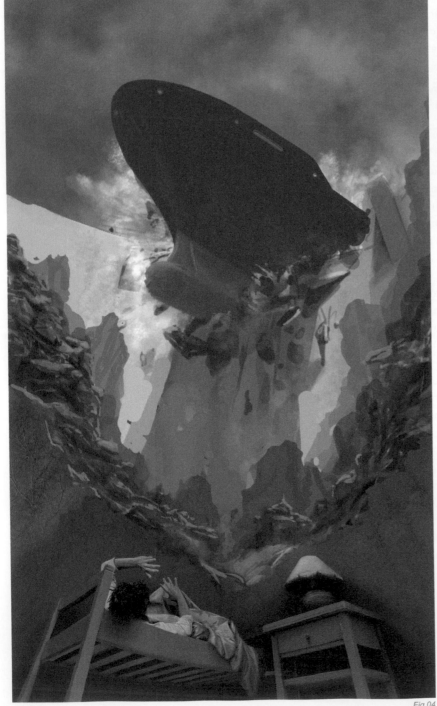

Fig.04

Fig.05

FANTASY

rocks with different brightness levels were then needed to create a sense of depth and distance.

On different layers I added more fragments and different water effects to get the feeling that the oil tanker was still moving forward (Fig.05). The water shouldn't be the only nightmare; it should be followed by an oil-filled tanker which would inevitably fall into the gorge. To make the crazy nightmare complete, I surrounded the character with a burning forest, to make escape absolutely impossible (Fig.06), which also serves in increasing the surreal nature of the picture. To make the fire more threatening I let it flow like lava onto the bed, which was something that I stumbled upon whilst playing around with the water effects. The hope that the water may kill the fire and the possibility of surviving is destroyed by the appearance of the oil tanker and ensuing disaster. Oil and fire would be a nice mix if the dream was crazy enough to prevent the water extinguishing the fire. I used the same brushes for the fire as I used for the water.

For the final version I added lighting to the rocks, character, ship, and trees, and followed with some blur effects in the water to portray different degrees of motion. I used more detail, such as the two inconspicuous cars in the water and details on the ship, to emphasize the scale. The trees in the foreground create the feeling of protection, but like the hands of the character, they are too weak to stop anything. A darker sky, 3D particle snow and rain add a further contrast to the heat of the fire and make the thrill of the whole scene more dynamic.

CONCLUSION

After finishing this piece, I was happy that I had tried to describe a more complex situation than in my other environment pictures. I learned that the concept is the part of the painting which is the most interesting and important part of creating a picture. Following this I strove to find a rougher and faster style of painting for my work.

Fig.06

ARTIST PORTFOLIO

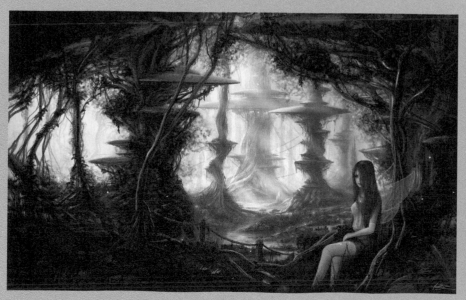

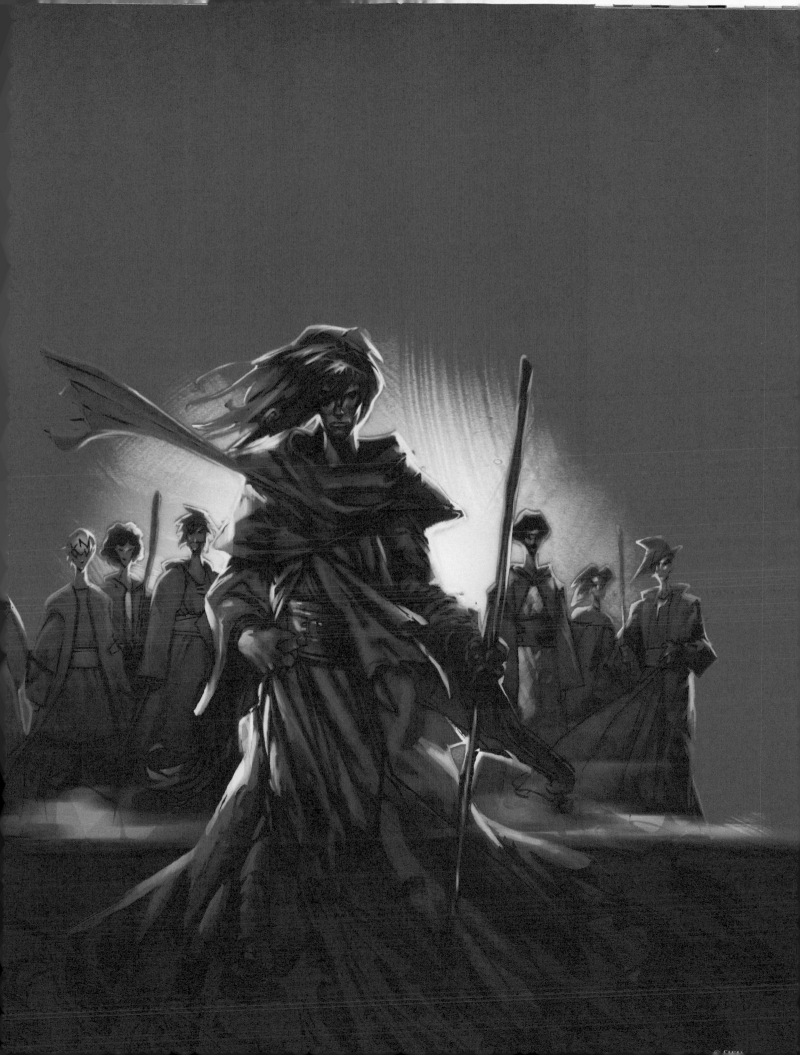

THE MANGA CHRIST

BY SIKU

CONCEPT

I was commissioned by Hodder and Stoughton book publishers to develop a Manga graphic novel adaptation of the New and Old Testament Bible. I also had to do four covers for four different versions of the project. Here, we have some character development for the first of the four covers (Fig.01a).

I needed to develop Manga hero archetypes. The first was Jesus. This was only an initial first step. Fig.01b–d are cover ideas. My clients settled for Fig.01d. I could now move to the next stage: fleshing out the detail.

Fig.01e shows how far I had developed the lead character Jesus Christ. His crew were also being developed at this time (see Fig.01f and g – Judas and Peter respectively). Peter's curly hair hints at his fiery temperament while Judas' hood-like hair and slender features represent duplicity and slyness.

In the books of the gospel, Jesus called some religious leaders who exploited the people "vipers and sons of vipers"; one of my final preparatory drawings; reflecting this is Fig.02a.

Fig.01b

Fig.01c

Fig.01d

Fig.01e

Fig.01a

Fig.01f

Fig.01g

Fig.02a

TO PAINT OR NOT TO PAINT?

My publishers wanted painted covers for a deluxe look. We were under pressure to churn out the work quite quickly with just two months to produce the entire graphic novel. So I suggested a fast and flexible alternative to paintings on paper or canvas: a digital painting with painterly effects.

For this job I would use the familiar Photoshop. It is possible to acquire painterly effects but it never convincingly simulates oil, acrylic, watercolor or impasto effects. I wanted to achieve these effects.

A friend had e-mailed me details on new software called Artrage. I had tested it a few weeks before the commission. The severe time constraints meant there was little time to get to grips with Artrage so learning to use it on the job (as we all do) would have to do.

There were certain certainties about Photoshop; I knew it well and it is great for editing and doing precise work, so I decided to work both in Photoshop and Artrage. For the first cover I used Photoshop, for the second cover (Fig.02b), I used Artrage .

Fig.02c

Fig.03a

Fig.02b

PREPPING WITHIN PHOTOSHOP

Once approved, I went on to develop Fig.02c. I usually scan at 300 dpi, even when producing content for none print material. You never know when an image might be required for print. Working in Photoshop, I tend to work in RGB because of its larger palette gamut. This is perfect for video or digital output but may be problematic for print material. For print you would need to transfer to CMYK mode.

Fig.03a is a roughed-out using Photoshop's polygonal selection and gradient tools. This is the fastest way to construct a palette – call it a digital sketch. Much of what I have in my "digital sketch" will be used in the final work.

While working on a painting, there is the tendency to get sucked in; a rudimentary sketch that captures the required mood of what you want is essential. You may require a mood board with references from several sources. I have a resource of references on my hard drive which I consult for inspiration.

BUILDING THE FOUNDATION

Fig.03b and c are my basic elements of the final work. I like working up from dark hues to lighter hues. It creates a heavier and more painterly look. Blacks in paintings don't always work well (although a few fantasy artists like Simon Bisely like to use black). In Fig.04a I begin to break down the black with red hues using the lasso tool (Fig.04b). I work really quickly to create a sense of urgency at every step and layer of color.

Fig.04c shows how I use the lasso tool. I use it like a pencil, drawing quickly and marking out sections for lighter colors.

Fig.03b

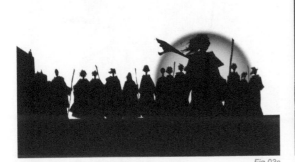

Fig.03c

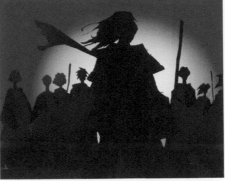

Fig.04a *Fig.04b*

Fig.04c

Fig.04d

Fig.05b

HOW I PAINT IN MY COLORS

In my tutorials of the past I demonstrated a novel technique where "motion bur" is used to break up a section of colour like that seen here in Fig.04d and Fig.05a. For this work I work differently, Fig.05b shows how I relied more on wet edge brushes to fill in the sections. The lasso selections allow me to use my brush quite quickly across the canvas. I keep building up the colors from dark to light.

One way of keeping your colors fresh is to use white as a last resort. For example, I use yellow to lighten my reds and greens. For brown hues I progressively use yellow then some red to warm it up. Eventually you have to use white, for example when your greens approach lime or if you have to brighten up your blues.

Fig.05a

FANTASY

Organizing layers in Photoshop

Some digital artists advise keeping your layers as simple as possibly by regularly merging and flattening layers. It helps to making the document size smaller, hence making your computer purr smoothly. While this is true, I tend not to work this way. I would rather keep my layers as separate as possible for future editing possibilities. I believe that when we work in the digital domain we should keep whatever advantages result from such a method. In this case keeping separate layers for sections of the work means it is easier to make corrections. Artists who work for book publishers understand how shifting requirements may mean making many corrections to a work of art. Fig.06 shows how I organize my layers. It's a payoff between keeping the file size small but yet retaining as much flexibility as possible.

Getting that painterly feel

Fig.07–09 is my painting worked up. Now I intended to mix things up a bit. See Fig.10a. The sky looks like it was painted with a real brush… well it was!

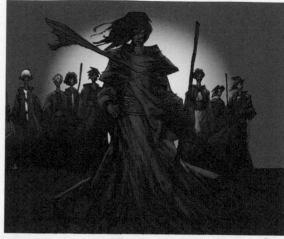

Fig.06

Fig.07

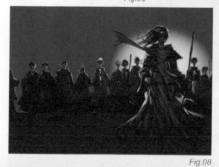

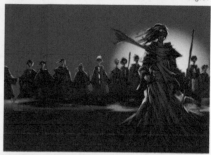

Fig.08

Fig.09

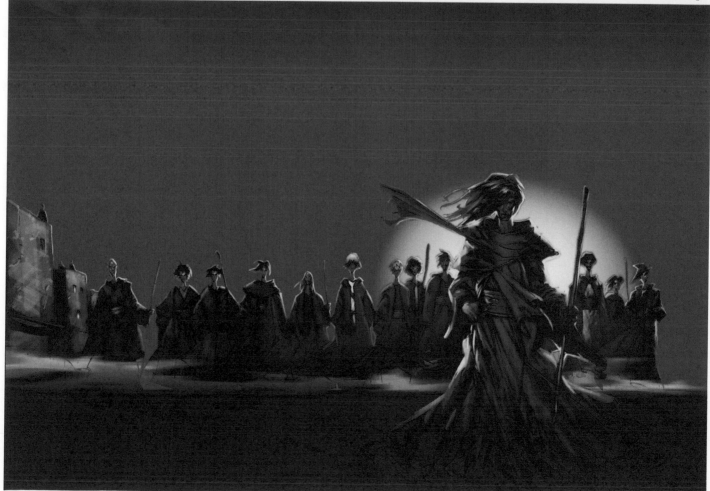

Fig.10a

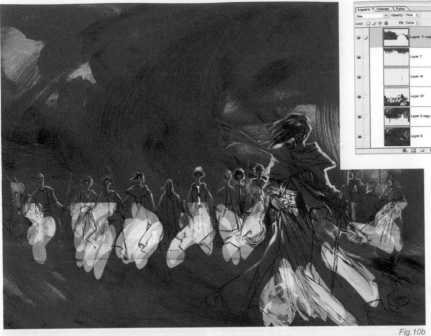

Fig.10b

Fig.10c Fig.10d Fig.10e

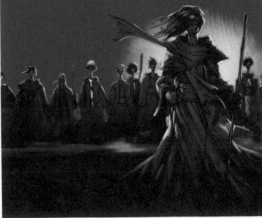

Fig.11

Fig.10b–e reveals how this was done. I had painted a white board in sienna, scanned it and imported it into Photoshop, and had manipulated several copied layers using wet edge erasers and blenders. I used the scan like a paint brush to finally achieve Fig.11.

For an alternative painting see Fig.12. Because I keep my layers separate it's possible to "rejig" this easily in Photoshop.

CONCLUSION

I needed to achieve a fresh but studious painting. It needed to belong to the Manga genre. The characters had to fulfill Manga archetypes and I judged that we needed a cover with mood in the tradition of "Seven Samurai".

I think I achieved this.

To know more about this project, please visit:
www.themangabible.com

Fig.12

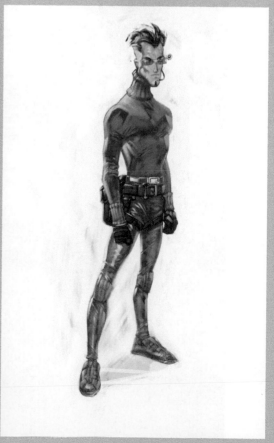

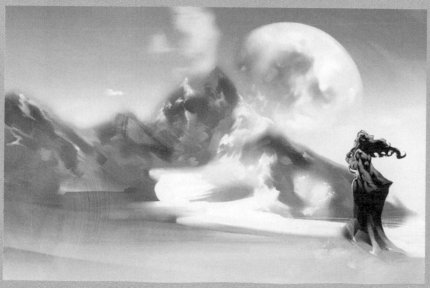

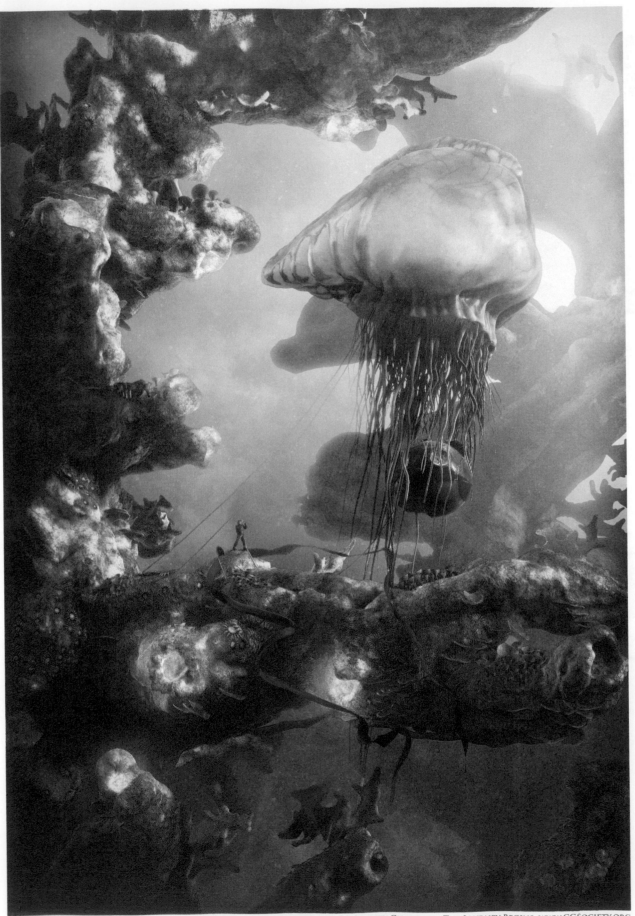

Journey Begins

By Adrzej Sykut

Introduction and concept: part 1

I made this image as an entry for a competition. The theme to be illustrated was entitled *Journey Begins*, which I liked, as it was open to various interpretations. Apart from this, I like a good challenge from time to time. The deadline was set for three months, which sounds like a lot of time for a still image, but, in the end, it was just enough. The concept phase took some time and I spent a few days thinking, imagining, daydreaming, and doing lots of quick thumbnail sketches. At the same time, I was undertaking some "visual research", which meant looking at various pretty images, photos, etc, searching for inspiration. Slowly some images started to emerge in my mind. Big, coral reef-like structures, teeming with life and rich in detail and color. Everything was immersed in a dense atmosphere, with lots of "junk" floating around. Included were some angled sun rays and maybe some nice, dappled shadows here and there... I wanted a world that felt alien, but still somewhat familiar. I certainly wanted to mess around with the sense of scale and, for some reason, I wanted to have airships and jellyfish in there too. So far all my ideas orientated around the setting with no attention to the story but as I was forming the alien world, it led to the idea of "exploration". Usually, it's good to work the other way round: first have a story to tell and then place it in a context; but as I was happy with the images I was dreaming up, I didn't let it bother me too much.

Fig.01 was the first "presentable" sketch with everything up until now being just loose scribbles, quick, messy, and shortlived. Still not much of a story as yet, but I managed to merge the jellyfish and an airship into one being... Fig.02 and 03 show some more sketches,

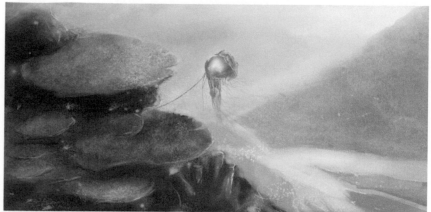

Fig.01

Fig.02

Fig.03

exploring the details. Since the story part was giving me some problems, I decided to do some 3D for a change, and wait for new ideas to form in the meantime.

MODELING: PART I

The general modeling workflow was really quite simple. I started by making basic, simple shapes using Wings 3D, or, in some cases, using ZSpheres inside ZBrush which I then sculpted further to enhance the form. I like the sculpting approach not only for detailing, but also for working out bigger shapes – it certainly works well for organic shapes like the jellyfish, and can be an effective and swift method. Fig.04 shows the jellyfish body in two stages – basic mesh and final, detailed model. I then imported the detailed, high-res objects into Cinema 4D for scene layout and rendering. I did generate some displacement and cavity maps, but they were used mostly as texture guides – there were no displacements in the scene.

Fig.05

Fig.06

Fig.07

Fig.08

Fig.04

Of course, not everything received the same treatment. The tentacles were made using 3D Studio Max's hair, and converted to polygons. The ship was just built in Wings 3D, with no ZBrush needed as it's definitely not an organic shape (Fig.05).

CONCEPT: PART II

Having modeled the jelly-ship and some terrain (the coral-like terraced mountainside from the first sketch), I threw them together into Cinema 4D, and tried to find some nice composition... but it didn't really work. The composition proved uninteresting: the airship was too small with no reference to set the correct scale. Any human figure I would include would be ant-sized at best, so I returned to the drawing board, making a few sketches on paper and even over the rendered image. Fig.06 shows one of the sketches (OK, sketch is too much of a word here), that looked promising. Changing to the vertical format worked and felt more dynamic, allowing for better cropping. Just to be sure, I mocked up some simple tree-like shapes, loaded them into a scene, and played with the camera and colors a bit. Seemed to work nicely.

I think it's time to mention some more sources of inspiration here: stories by Arthur C. Clarke, Peter F. Hamilton, Dan Simmons and, of course, by Frank Herbert. All the visually intense, imaginative science fiction stuff – the kind I like most.

MODELING: PART II

In accordance with the new concept, I built some detailed, coral-like "trees". Base geometry was made from ZSpheres, further detailed using ZBrush sculpting tools (Fig.07). Next in line were various smaller coral life forms (Fig.08). Some were placed manually; for others I used a script for 3D Studio Max, which allowed me to "paint" them over the surface of the big "trees". It made the job of populating the scene with vegetation quite easy.

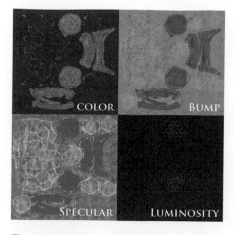

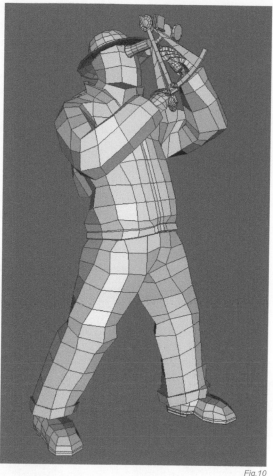

Fig.09

Fig.10

TEXTURING

For some objects, I used good old painted textures. Fig.09 shows an example – the ship. The body of the jellyfish also uses a hand-painted texture, although it may not be that visible due to the refraction. It may be worth pointing out that I didn't render the jelly as a transparent object; refractions were rendered separately, mostly to save time and allow for more control in post-production. Most of the other objects used a combination of multiple procedural textures, and some simple bitmaps, used mostly as masks. Cavity maps rendered from ZBrush were used to add some dirt here and there, while "displacement" maps provided some larger-scale detail. That way, I didn't have to worry about texture resolution, and the sometimes uniform/repetitive look of procedurals was reduced by the bitmap masks or overlays. As a bonus this also meant it was faster to blend some fractal noise layers to get a rock-like texture, compared with manually painting in all the cracks and bumps. The big "trees" have some sub-surface scattering, to add some life to the surface but that, too, was rendered separately.

LIGHTING

Light setup was simpler than it actually looks: just a "fake" skylight made up from multiple spotlights, one directional light acting as the sun, and some more directionals here and there, to highlight some edges. Pointlights provided the local light from the glowing parts of the coral. Some objects were placed in front of the sunlight, to cast the shadows across the whole scene to give the impression of more "trees" just out of view, and to add bit more complexity to the light. Simple, isn't it?

CONCEPT: PART III

At that stage I thought it would be good to add the main and only character to the scene: an explorer, taking last navigational measurements before setting off into the uncharted teritory. Just for fun I gave him an old school sextant. And here is our hero in his full, low-polygon glory (Fig.10). I also added two ribbon–like flags; maybe some kind of a beacon, or simply the border of known space? Who knows; I think I just liked the way they looked.

RENDERING

With the deadline approaching, it was time to render the

Fig.11

Fig.12

scene. Since I like to have a lot of room to play with during the post-production stages, I rendered the foreground, middleground, background, and the character separately, with a lot of additional passes. Fig.11 shows main passes. Fig.12 shows the flat color passes. Fig.13 represents fresnel passes, and Fig.14 shows a normal direction pass – both useful for subtle lighting touch-ups. There were also miscellaneous passes, like fog and volumetrics and sub-surface scattering passes (Fig.15), jellyfish refractions and reflections (Fig.16), and some separate shadows – just in case. Since the scene was quite polygon-heavy, and used a lot of procedurals, it took a while to render.

POST-PROCESSING

With all the passes rendered, I was able to start working on the final image, finding the right "look", atmosphere, colors, etc. alongside the things that are not really practical to do in the 3D package, but are vitally important. First off, I combined all the passes together in Photoshop and looked like Fig.17. I used the normal direction pass, combined with fresnel and flat color passes to add a bit of light along some edges: to simulate the light reflected from the sky, or to separate the foreground from the background. From now

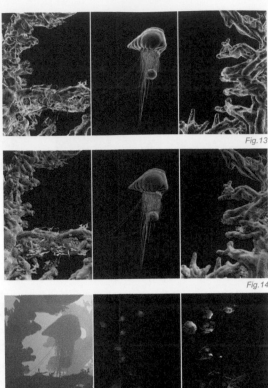

Fig.13

Fig.14

Fig.15

Fig.16

Fig.17

on, there are really no rules, anything goes. Add a glow here, deepen the shadows there, exaggerate the highlight somewhere else, add a texture overlay, blur, adjust colors, levels etc. until it feels right. I made the background slightly fuzzy and foggy, and added some particles floating around. After a few days of playing with it I ended up with a tonne of layers making up the final image. This is my favorite part and what defines how the image will really look like.

CONCLUSION

I'm really happy with the way it all turned out. It was a bit of a journey in itself, with an unclearly defined concept, abundant breaks to do some "real", payed work, and life generally getting in the way. But it was definitely fun – lots of fun and satisfying, and I learned some new tricks in the process, too. And as icing on the cake, it turned out that I won the competition.

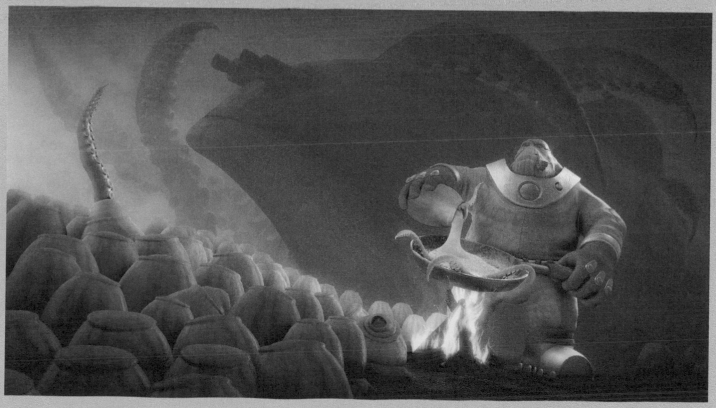

RECKONING DAY

BY PHILIP STRAUB

MEMORABLE MOMENT CONCEPT DESIGN

Every Concept Designer in the entertainment industry must be able to successfully stage and visually describe a key or "memorable moment" that occurs in a game or film. With this type of Concept painting, staging, dramatic camera angle, and camera focal length should all be considerations when you begin planning out your scene. The goal here is to create the most dramatic and visually exciting scene possible from the tools you've been given. Usually a Concept Artist will be given a scene to illustrate or pivotal moment in a storyline to describe visually but, you can apply this approach to your own personal work by getting in the habit of developing a back story to illustrate from. I've been meaning to get started on a piece that focuses on a memorable moment in a story where a civilization is nearly destroyed by a "natural" or, in this case, a somewhat unnatural disaster. I know I want to depict a lot of destruction and chaos, with plenty of smoke, fire and dramatic lighting. This scene is going to require quite a bit of reference gathering for the many different subjects I'm going to be dealing with in the scene. So, I start digging and gathering all that I need to get inspired and to gain a better understanding of what actually happens to buildings and the landscapes around them when a catastrophe occurs.

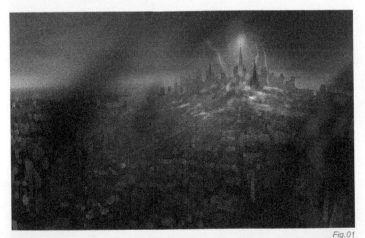

Fig.01

Fig.01

BASIC COMPOSITION, LIGHTING, AND VALUE STRUCTURE

The first thing I always do before beginning a new piece is to try to visualize the final painting completed. I imagine the scene is actually occurring in my head, moving the camera around, searching for the most interesting angle, looking for the most interesting subject matter, or character to focus on. With this painting, I know the focal point and dramatic lighting is really going to sell the piece so identifying where the highest point of contrast and main point of action becomes my first priority. At this point it's time for me to begin working out the overall shapes that will define the positive/negative shapes and overall composition. Before I begin defining the composition, I need to pick an aspect ratio or overall size for my canvas. Confident I want the painting to represent a fairly cinematic moment in the story, I choose a "landscape" type layout that will allow me to cover a lot of ground along the horizon line.

I almost always begin with a gray scale canvas and since I know the piece I'm going for is going to be on the darker side of the value spectrum, I fill the canvas with approx. 50% gray and build up from there. This process is a carryover from the way I used to work traditionally and allows me to focus on the simple value composition of an image before I begin even thinking about details. Really, all an image is, regardless of style, is a series of abstract shapes that are put together in such a way that they are representative of something familiar to the human eye. Nothing fancy here; I like to do my sketching with a few different brushes in Photoshop. Again, my focus is on creating positive and negative shapes that are pleasing to the human eye, keeping in mind what the most interesting lighting solution will be for my subject matter. I keep all of the reference I've gathered close at hand so I can be sure to be accurate with my depiction of the scene.

Next, I begin to define the lighting solution further as well as the focal point of the image, focusing on leading the viewer's eye across the canvas. To add additional interest to the scene I add some other smaller areas of interest in the composition to balance the main focal point and further lead the viewer's eye (Fig.01).

POSITIVE/NEGATIVE SPACE, AND SCALE

Positive space is usually defined by the areas of a painting or drawing that are occupied by a form or forms. Negative space is those areas of the painting or drawing which are not occupied by forms, i.e., "empty" or negative space. Simply put, there is no such thing as background. In other words, all areas of the work are equally important – there is not a background area which can be left unconsidered. Now my focus is on finding a balance between what I call "the hide and go seek" of the foreground, middle ground, and background that define the positive/negative shapes.

Depending on the type of image I'm creating I may spend more time in the sketch stage then I am with this painting but, since I have a wealth of reference and building blocks to draw from, I'm going to move straight to defining my basic scale and details now. I actually have a few cityscapes created with simple 3D geometry… so I grab a few renders as well as some of the photo references I gathered earlier and begin to lay out the scale of the city as well as further refine the perspective. The technique I use here is very basic, just lots of skewing, scaling, and distorting until the overall perspective feels pretty good (Fig.02).

COLOR

The Concept Artist or illustrator can and should use color to affect his/her audience. Just like you would use composition, camera angle, lighting, and perspective to create a mood or environment that helps to tell a visual story, color is just another tool at your disposal. As you begin constructing a palette for a painting it's important to keep in mind what

you are trying to accomplish with your piece. If you want an area in your painting to "pop out", then you might want to place a "warm against a cool" or complements next to each other. Conversely, if you are trying to create a serene mood in a painting you probably wouldn't want adjacent complements.

The first thing to establish here is the sky! In a landscape image the sky is your most important component; it defines the color and temperature of your light, the color and temperature of your reflective light, and the color of your shadows. I grab a few different sky references I think will fit the scene I'm developing well and begin placing them carefully into the scene. Using a variety of layering techniques I erase and paint where needed (Fig.03).

MORE DESTRUCTION

With my basic color palette established I begin to push the destruction element that I want to depict in the scene. First, since I've created a few paintings like this before, I go to one of my brush sets and load up some smoke and fire brushes. As I add these elements I need to be careful to maintain a pleasing value and color composition. First, I create a new layer and begin painting in the fire around the focal point, experimenting with scale and layer modes until I get the desired effect.

Next, I begin to add some dramatic plumes smoke to further accentuate the destruction occurring in the city. Again, drawing from my custom brush set, and photographs I gathered in the beginning of the process, I begin painting in, first the smoke around the focal point, and then around the middle ground and foreground areas of the city. Establishing the middle ground and foreground smoke will help to define my scale by overlapping and layering one plum of smoke in front of the other (Fig.04).

Fig.03

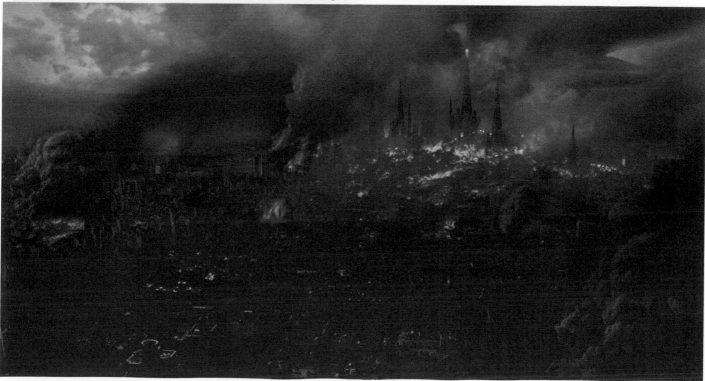

Fig.04

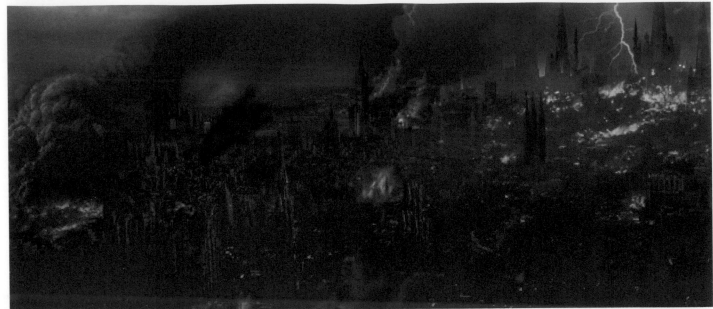

Fig.05

DERELECT BUILDINGS AND GOTHIC ARCHITECTURE

The city I pieced together from leftover 3D renders and photos was really just a stand-in for the final execution. Since I feel the overall mood of the piece is coming together, I switch my focus from the big picture of the image to defining some of the smaller details. Obviously, the buildings that I originally put into the scene were there just to define scale and clutter; now I'm going to begin to create the character of the city. With the amount of destruction that's actually occurring in the city I need to paint in some buildings that reflect this. I create a layer set that sits below all of the "post effect" layers and begin painting in destroyed buildings in key locations to help enhance the composition and further

lead the eye to the focal point of the image. I've always had an affinity towards gothic architecture; it just has so much character and amazing craftsmanship. Since the basic subject matter here has some religious overtones, it makes sense for me to begin to draw from the architecture of cathedrals and churches to further sell the "end of the world" setting. Since I had always planned on adding this element to the scene, I simply go back to all the references I gathered earlier as well as some photos I have in my archives and begin to carefully place the "gothic architecture" throughout the city. Again, I'm very careful not to disturb the balance of the composition and try to find little areas to "hide and seek" the architecture, creating overlapping elements to enhance my "back, middle, and foreground" (Fig.05).

Fig.06

FOREGROUND OBJECTS

A little trick I've picked up over the course of my career that helps enhance scale and frame your composition is the correct placement of foreground objects. In keeping with this concept, I make a new layer, set it to multiply, and paint in, using a semi-hard brush, a destroyed building in the left foreground (Fig.06).

FINISHING TOUCHES

At this point the painting is 90% complete but there is still quite a bit of finessing that I need to do to call the image finished. After some reflection, I realize that the image is a still not as warm as I'd like it, so I duplicate one of my atmosphere layers and pull down the opacity of the layer to 75% to get the temperature I'm looking for. Next, I spend some time refining all of the crazy stuff in the painting; I add little touches like more glowing windows and additional smoke. Finally, like I always do, I flatten the image and play with the levels to accentuate the focal point...annnndddd we're done!

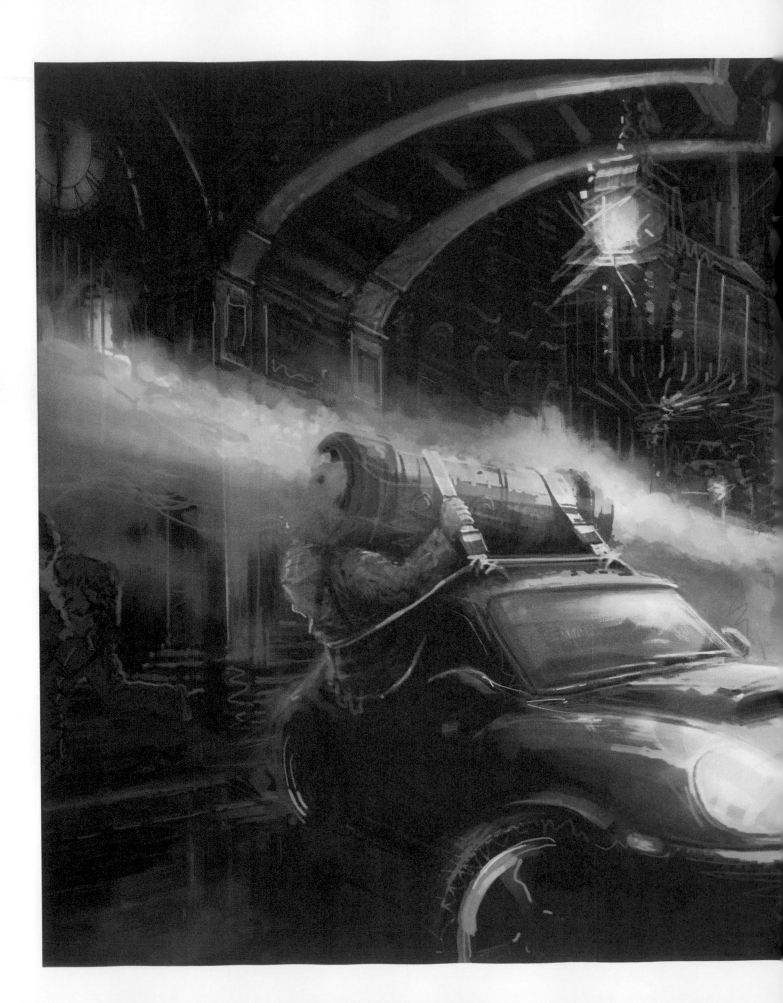

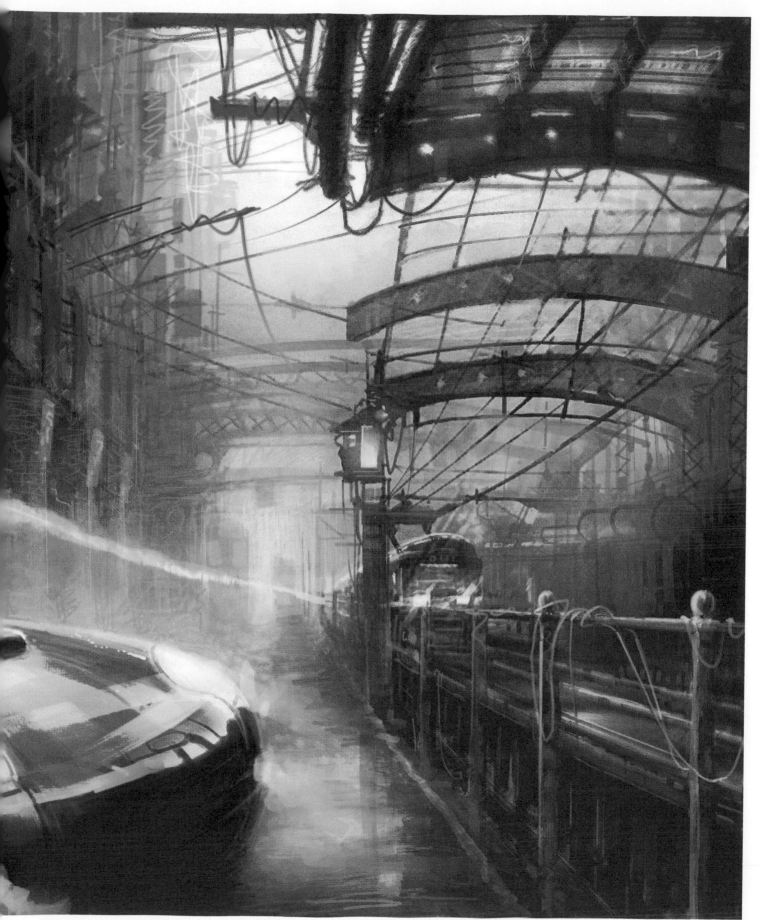

© Mike R Smith

BANG ON TIME

BY MICHAEL SMITH

CONCEPT

For this scenario I wanted to create something which emphasized movement set in a raw/gritty atmospheric environment. I chose a fairly loose abstract style, adding details where necessary to achieve the overall dynamic effect.

The theme, a freeze frame painting of a punctual train arriving at the station under attack from a terrorist's missile, was inspired by a fascination with action movies, such as those of the Bond genre.

Accordingly, the scene is stylized fiction using very little reference, effectively eliminating the need for extensive research and instead relying on pure imagination and visual interpretation techniques.

INITIAL SKETCH DRAWING

I began by sketching out some quick thumbnails of the scenario I had in mind to help devise the overall composition. I wanted the eye to focus firstly on the car and the figure, moving onto the clock, and then finally to the train via the missile smoke trail, creating a clockwise journey for the eye throughout the whole image (Fig.01).

PERSPECTIVE

When happy with the rough sketched scenario I prepared my page in Photoshop; I usually start with around 1280x800 pixels, then "res" the image up to around 4000 pixels when going into final detail. After transferring my thumbnail sketch onto the page I figured out roughly where the horizon line should sit; everything should originate from this point. A simple 2-point perspective was used. It's useful to apply your perspective lines to a new layer, which you can turn on and off throughout the whole process of creating your piece. It's also quite good to keep your line work loose as you work, referring to your perspective layer as you go.

Tip: A good tip is to regularly flip your page horizontally back and forth to determine whether the perspective looks correct. It's amazing how often when you think something looks right, flipping it shows how wrong you were.

I now had my sketch and perspective laid down. However, I'm not too concerned at this stage if buildings do not follow the correct perspective. I work by painting in multiple layers. I rarely draw something out 100% before applying lighting and color. At the beginning I find that it's best

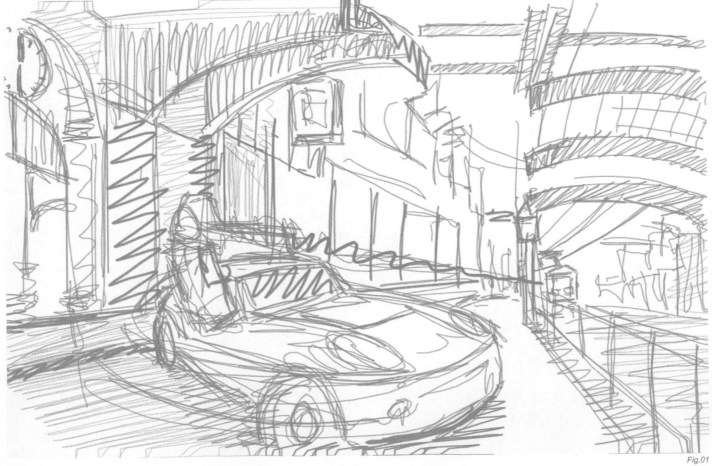

Fig.01

Fig.02

to stay as loose as possible using quick, bold and confident brush strokes. I tried not to narrow myself, or tighten up too much, especially in the early stages of painting (Fig.02).

LIGHTING

I next figured out light direction and the mood I wanted to portray. Here I wanted the main light source to be coming from the top right side, shining down at about 45 degrees onto the street and car (Fig.03). I added a new layer, fill it with black and knock the opacity down to around 40%, since it's good to get rid of the white space as early on as possible. I find it a lot easier to add mid-tones and highlights to a darker background rather than add darks and mid-tones to a light background.

To help get the overall lighting effect the way I want it, and properly conform to the direction of the light source, I proceed in black and white. Personally I find this an easier way to work out the strength of light bouncing around the environment and ambience of the light casting shadowed areas. Here I created a new layer, knocked the opacity down to about 50%, then, using bold, confident strokes painted in the initial shadowed areas to bring out the more dominant shapes to give the overall definition (Fig.04).

Fig.03

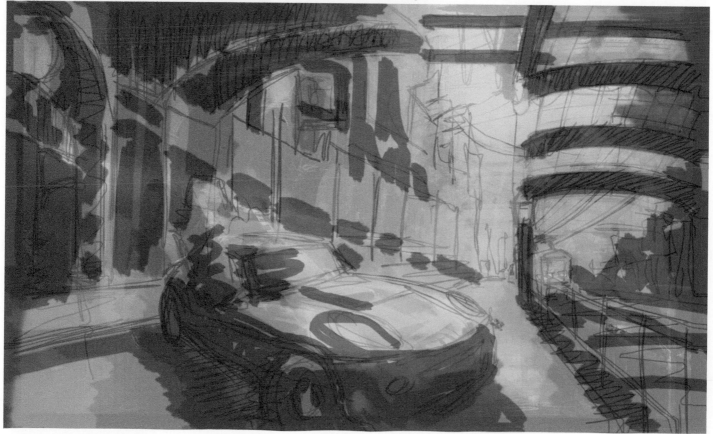

Fig.04

I then proceeded to fill in the mid-tones and areas of light with the most ambience; i.e. sky, road, car bonnet, at the same time laying down soft shadows that would be cast by overhead structures.

Tip: When blocking in shape and lighting it's a good idea to squint at your painting to see where the light is more prominent and less prominent. This helps to achieve an overall balance, making sure the light is where it should be.

Once I am happy with the overall lighting effect in black and white, I progress to painting in color and adding detail.

The mood and color of the piece depends on the time of day I choose and its environmental location. Intending to portray a gritty downtown backstreet sort of place, I decided to use greens and oranges for my overall color palette. I started by creating a new layer, filling it

Fig.05

Fig.06

with the desired green, and setting the layer to overlay (Fig.05).

From here I worked up the light and color values. As I progressed I adjusted the levels of brightness/contrast to the shadows/mid-tones and highlights to help give the overall impression of depth in the environment (Fig.06).

Once the lighting and initial color is laid down, it's time to start adding details, additional color and more definition to the shapes. This is where I usually enlarge my page size. I generally begin painting in the background details first; e.g. here, see the train, working around the image towards the foreground, refining details to a point that I feel happy with, frequently squinting and flipping the page throughout the process. I often take my pieces into Corel Painter, simply to use different brushes; a couple of my favorites are the pallete knife and oil brush (Fig.07 and 08).

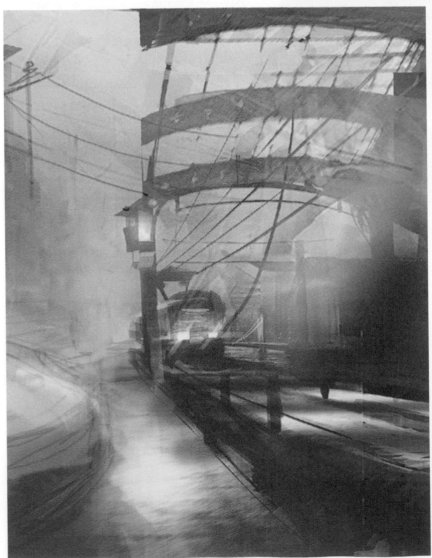
Fig.07

FANTASY

CONCLUSION

Creating mood in a painting is probably one of the hardest things to communicate effectively to the observer. When reviewing the finished piece it is my hope that the original objective to put across a dynamic scene in a raw/gritty atmospheric environment has been achieved. Initially I set out using a loose abstract style suggesting forms and shape. On reflection, it is apparent to me now, having taken the design to a much tighter style, which by its very nature had to incorporate authentic images familiar to us all, I might have undertaken more research into the design to make sure proportion and perspective were true (Fig.09), rather than rely solely on my own judgement. Had it been in the genre of sci-fi or fantasy art where the artist can create his or her own interpretation of desired images without fixed form, here the eye is more forgiving.

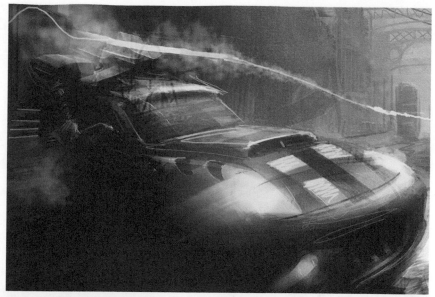

Fig.08

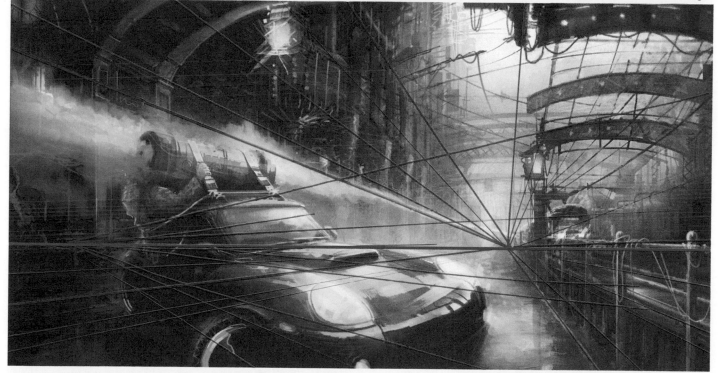

Fig.09

ARTIST PORTFOLIO

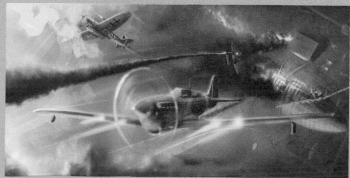

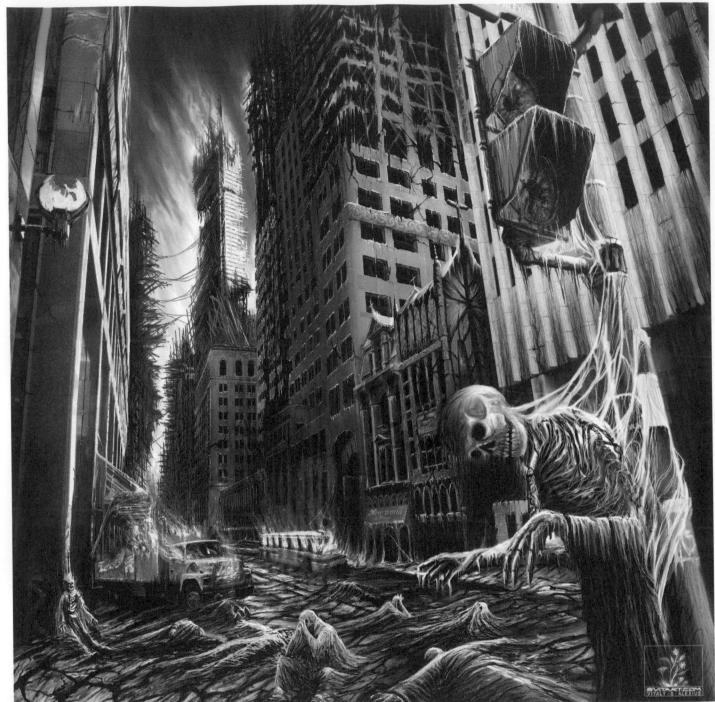

ABUROD TERRA

BY VITALY S ALEXIUS

CONCEPT

Aburod Terra (Uninhabited Earth) came about as a commission by Daniel Jeppsson as a cover for his music *Hardcore/Gabber* CD album/vinyl cover for his band *Recall;* I was hired to illustrate it back in November 2005. On 23 November, 2005 after finding my artwork on the Internet, he contacted me with

a request for an album cover. His exact words were "For my record, that I want you to design, I need something DARK. The record will be called "DAY OF EVIL" so something like destroyed houses, after war, burning buildings, dead bodies in a city landscape would look great. It needs to be minimum 30x30cm at 300 dpi." He also provided me with links of my paintings, which he liked, requesting a similar style, colors

and composition (Fig.01a–c). This painting fits into my series/style of work entitled *Dreaminism* – romantically apocalyptic dreams of the twenty-first hour at the dawn of the twenty-second century, depicting visions of the future that will inevitably come to pass if mankind's planet-wide industrial and war machine isn't stopped in time. This theme is inspired by my travels through the world and my life in Soviet Russia. I have stood witness to a fall of a nation and great noble ideals. I have seen Russian cities ravaged by human carelessness, industrialization, depression, oppression, crime and war. I have seen science fail and unleash death in the dark cases of Chernobyl and the Aral Sea "accidents". My vision is that of a romantic artist, with one exception – to showcase not just the destructive power of nature, but also the destructive power of science and human kind.

 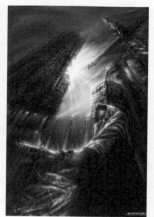

Fig.01a Fig.01b Fig.01c

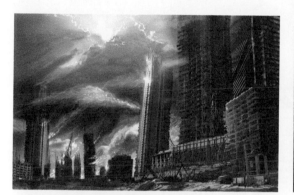

Fig.02a

Fig.02b

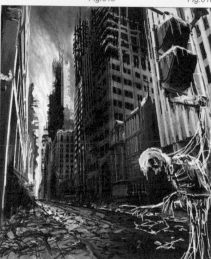

Fig.02c

This painting is one of my most morbid works, portraying decay, doom, fire and little hope. The architecture in the painting is inspired by my travels through Toronto downtown. It represents architecture of any modern North American mega-city. The "dead" people on the street are inspired by the catastrophe at Pompey, in which people were covered and encased in ash from the exploding volcano. I quickly created three sketches for the client to give him some options. (Fig.02a–c)

He decided to go with the second sketch, and so I worked on it, until both I and the client were satisfied with it.

PROCESS

Just like with many of my other paintings, I love to do research before starting a piece. For this one, I went out all around Toronto downtown, photographing everything that I witnessed that day. One of the streets I passed through was interesting and detailed and so I decided to use it as my main reference for this painting. Fig.03 shows one of the street photos. Fig.04 shows some detail that inspired the architecture in the piece and as used as textures in some places.

Fig.03

Fig.04

I usually start off with a gray canvas – that way the contrast values of the painting come out best, as I easily create lights and shadows. At this stage the painting is completely black and white, to better capture contrast values, a simple practice known way back in the Renaissance. Sometimes I start sketching things on paper and then scan or photograph them, but here I started off sketching straight in Photoshop.

First things first – I developed the perspective, by looking at my photo-references and by creating a vanishing point (Fig.05). From this point, I created perspective lines of reference for all my buildings in the piece. Then two more vanishing points came into play, creating a realistic 3D scene. Fig.06 illustrates how three vanishing points are

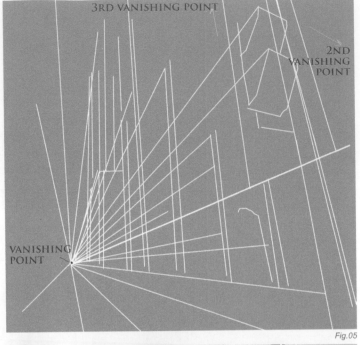

Fig.05

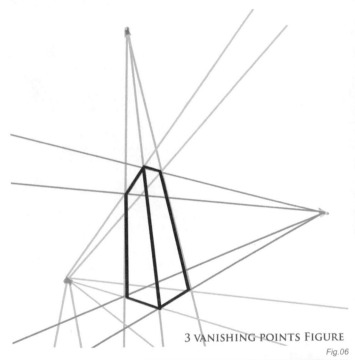

3 VANISHING POINTS FIGURE

Fig.06

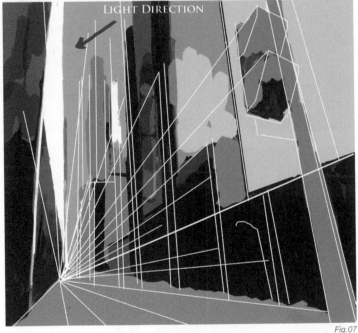

Fig.07

BRUSH TOOL

SMUDGE TOOL

Fig.08

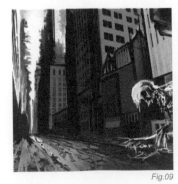

Fig.09

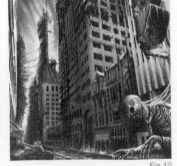

Fig.10

used for this piece. In my next step, I leave the perspective lines and vanishing point alone, and create a new layer, on which I start to block in the overall shapes, using a large square brush (Fig.07). Next, I make a copy of the vanishing point and perspective lines layer and set it above all my layers, set at Overlay so I can always look at it in case I need to, by playing with its opacity and remove it once I'm done with the perspective. At this point I decide where my light falls from (Fig.07). For this piece, I used the following tools: Default Photoshop brushes and the Smudge tool. Fig.08 shows the effects one can produce with just default Photoshop brushes, set at 10% opacity and the smudge tool set at 90% strength. I'm pretty much using Photoshop brushes/Smudge tool and a tablet just as I would use acrylic/oil paints with a brush. Dab and smudge method predominates. Sometimes, when I wish to save time, I insert textures from

FANTASY

my photographs into the piece as separate layers set to overlay/multiply/lighten/screen/darken, etc. The key is to just experiment with these layer settings for various effects. Fig.09 shows further development of the painting: windows are set in place, detail start appearing. Using the same methods I put around forty or more hours of work into the piece, until satisfied with the resulting black and white painting (Fig.10). I constantly zoom in and out to create big and small detail.

Next step is the coloring. I create a new layer, set it to "color", and start applying various colors to this layer, experimenting, looking for the perfect color combo/look (Fig.11 and 12). When I was pleased with the colors, composition and detail, the piece was sent off to the client. However, the client wasn't satisfied with the "tank" and suggested that I should instead add some burning cars to the scene. Following his direction, I removed the tank, and put a burning bus and a burning truck into the painting (Fig.13).

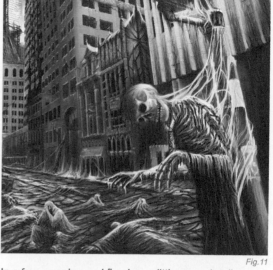
Fig.11

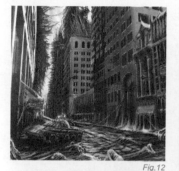
Fig.12

Fig.14

Fig.15

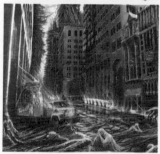

Fig.16

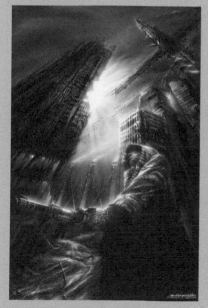
Fig.13

In a few more hours, I fixed up a little more detail, adjusted the perspective on the burning bus, and added my signature, finally finishing the painting after several weeks and more than sixty hours of work. The final PSD file is 123 MB, has no layers (as I don't tend to use a lot of layers during painting and constantly merge them to slow down loading time), and is sized at 45x45cm at 300 dpi. Fig.14–16 show intricate detail shots of the painting, which are invisible unless the painting is printed at its true 45x45cm resolution.

CONCLUSION

The piece was finished in time for the CD release. The client and I were happy with how it turned out. The key to any painting is to put hard work and effort into it and it will turn out marvelously.

ARTIST PORTFOLIO

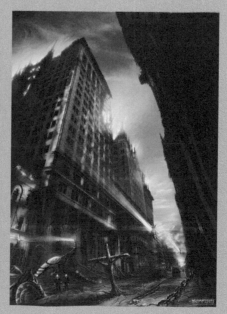

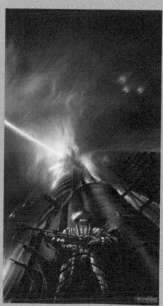

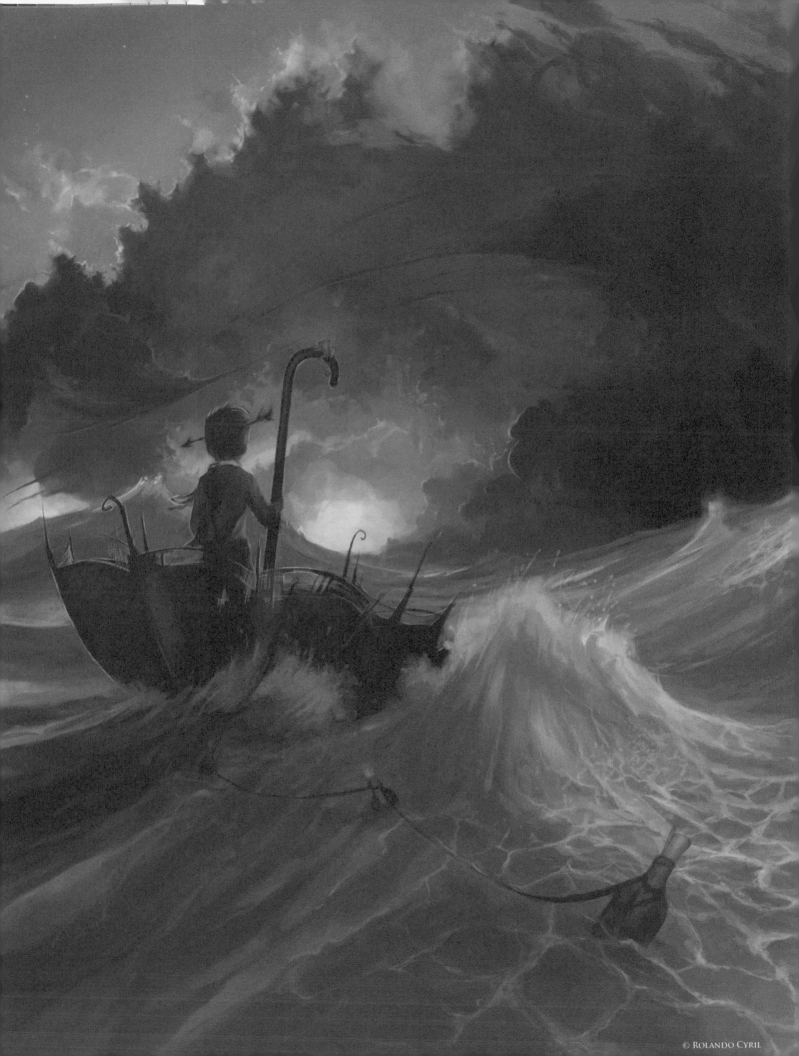

© ROLANDO CYRIL

SAVE OUR SOULS

BY ROLANDO CYRIL

INTRODUCTION

It's strange how an insignificant drawing can bring about so many meanings when you look at it attentively. The roots of this artwork come from an old oekaki that I drew as a gift for the birthday of some of my oekaki board friends (Fig.01). Two months later, a Canadian metal group, called *The Dooks,* asked me if I could illustrate one of their songs called *Archaic*. I decided to work on my oekaki, but this time using Photoshop 7. I had the feeling there was a great hidden potential behind this ugly drawing, first drawn with Paint BBS. Moreover, I wanted to introduce the character, who is also named like my pseudo, Sixio, through a serious and meaningful picture. This piece had to tell the story of Sixio in the twinkling of an eye, by which I mean a child with an arrow in the head, roaming in an upset and dangerous world, but, at the same time, a very attractive world, like the flame of a candle that we want to take in our hands, even though it hurts…

ROUGHING OUT

Everything was drawn in my mind, and then I had to put it onto the canvas before forgetting my ideas. I increased the size of the drawing, from 400x500 pixels to

Fig.01

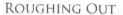

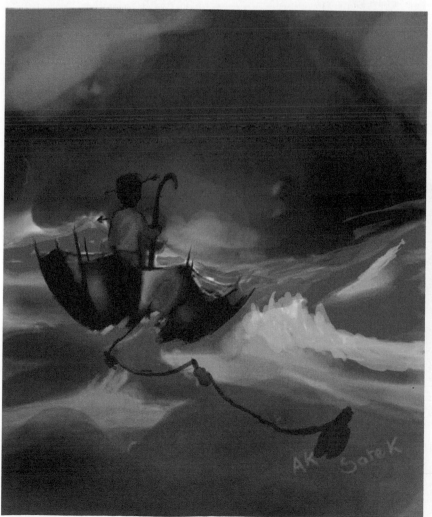

Fig.03

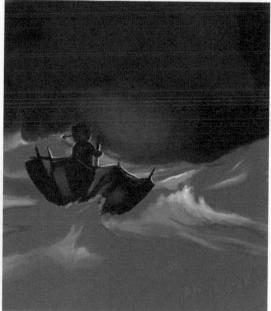

Fig.02

1200x1500 pixels, to work with more possibilities. If the canvas is bigger, you are able to work the details better. The first task was to choose a good color scheme, because the contrast between the blue and red troubled me. I wanted to erase the old sky (Fig.02), using a brush with a large size, and to "rise" a brilliant sun. In Fig.03, I changed the size of the picture, again, to 4500x6000 pixels, because the main composition was built: the orange sea, the umbrella dragging some linked bottles, Sixio's pose, and the rough structure of the sky.

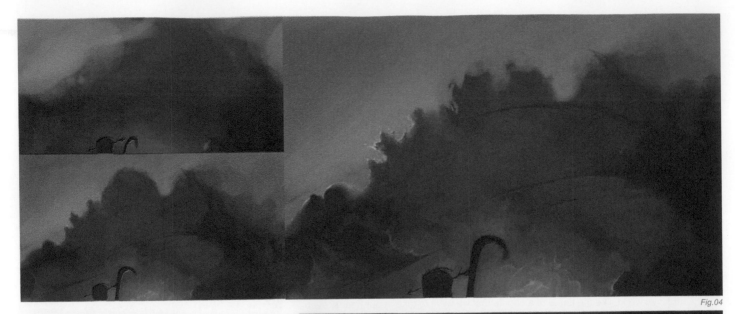

Fig.04

DRESSING THE CLOUDS

You may be thinking that drawing red clouds is harder than white clouds, but you'd be wrong. Playing with the different gradients of the red, then adding some strokes of orange for the light – like petals of a rose revealing the brilliant heart – is really enjoyable. That's why I wish to show you the main evolution of the clouds' structure (Fig.04). In the top close-up, you can see that I started with an abstract cloud formation. The advantage is to let your imagination work without being contaminated by social conventions (form, color and composition). In the middle close-up, you can see that I wanted to play with the contrast between the blue and red, and so I added a yellow outline to increase the separation. I desired to draw "living" clouds, as if they were hugging the sun.

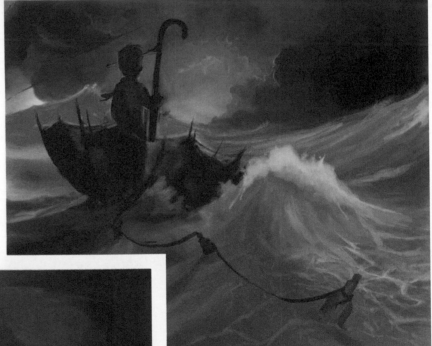

Fig.05

FLOATING ON HIS UMBRELLA

It was then time to draw the character, with details. Sixio has two main features, an arrow in the head and a dinner suit, but in this drawing I introduced him on an umbrella, because I liked the idea of this fragile – yet fantastic – boat (Fig.05). The work of the water was the most technical, because I didn't know how the ocean should look when it's upset in this way. I called on my best friend for help, Google Images, and, luckily, he showed me some examples. With regard to the character, my problems with the anatomic notions, and my fear of useless effort, drove me to not change the pose of the character and to work only on the details (Fig.06).

Fig.06

CARTOON

LIGHTING

The important thing to keep in mind is the influence of the light. I had to choose between a point of view; "against the light" (Fig.07), or to have two sources of light (the sun more behind Sixio). I chose the first option, even if the picture ended up a bit dark, because I decided this was the best way to increase the contrast between the orange and black. This effect was improved by the subtle nuances of yellow strokes for the outline of the umbrella, the character, the waves, and the clouds, as you can see in Fig.08.

Fig.07

Fig.08

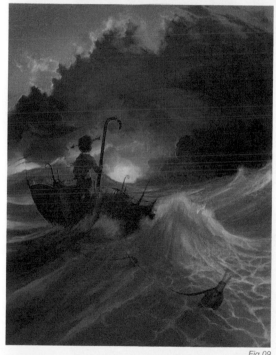

Fig.09

FINAL POINT

Twenty-five hours later, I decided to consider it as finished (Fig.09). This was time for me to write the description text that I was thinking about whilst I painted. The following is the text which completes the drawing of Sixio, in order to open it to your own interpretations, because this is not the end but a real beginning. Moreover, not only did *The Dooks* enjoy my illustration of their song, but also they chose to make it as their cover album. I am really proud of this picture, because this is a good introduction for my character (who is called Sixio, like me), and finally this picture becomes a metaphor of my life:

> Many are floating on the ocean
> But who is sure to know about them?
> Many are calling for help in the silence
> Who shall receive their message?
> I found some bottles, but there is a problem
> Who can help me now?
> S.O.S.

That's what I wanted; a meaningful picture, and after many comments from viewers I see that I am not alone in drawing a parallel between Sixio and our troubled lives. Finally, who can save our souls?

ARTIST PORTFOLIO

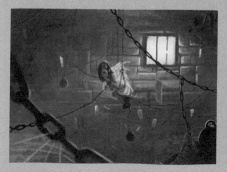
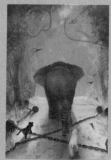
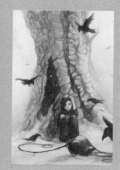
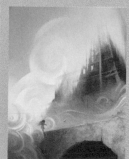
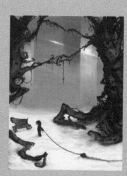

WHITE TEETH

BY JONATHAN SIMARD

INTRODUCTION

White Teeth was created in a very short time – the quickest of all my pictures in fact. The basic concept was very simple: to make a character with a very large smile occupying more than half of the character's head. I also had an image in mind of Tetsuo's chair in Akira, where you see him hung on a stone chair. This is what I was after: a character hanging himself on an object, where you could imagine that he had literally just escaped from a mental institution. So it really came about from a mixture of different ideas. The only thing I didn't want to do was to design a character with muscles and a too human-like face.

Before I started modeling, I had this criteria set in my mind, knowing that I would follow it through until the end. I also used some picture references by the 2D artist, Brom (www.bromart.com), to keep me inspired during the project. All I wanted for the end result, was an original character with a unique style, and big, white teeth...

COMPOSITION

Before I explain all of the 3D stuff, I would like to talk a little about the composition of the piece, because a bad composition can completely ruin a picture, even with the most beautiful character, or it can equally enhance an ordinary one. It's always wise to have an idea of the composition before starting to model. There are a tonne of rules concerned with composing an image, and although I don't call myself an expert in this field, I feel I have learnt much in this area. For this picture, I tried to respect the rule of thirds, and also tried to prevent the composition taking the viewer's eye out of the picture, by using a center of interest. Rules were made to be broken, so sometimes it's better just to break them!

The character's middle body is in one third of the picture, but the body's curve, head and tentacles are not. You don't feel that the character is in the middle, and it's not exactly placed one third across the picture, but rather it falls to the right. A very dull composition will show a character in the middle. Trying to not lead the eye out of the picture is really simple. In this case, I avoided strong lines on the character that abruptly led the eye out of the picture frame. For example, you can see that the the hat is near the edge of the picture, but it then curves 180 degrees to the other side, helping the eye to return into the picture and also back to the focal point: the face. If the side of the hat did not curve, but instead were a straight line, then it would more than likely lead the eye out of the picture. The tentacles could also do this, but I darkened the bottom of the picture a little in Photoshop to avoid that happening.

The center of interest is very important and helps to strengthen the image. You can have many of them, but not all in the same area. The two major points of interest here are the face and the tentacles. With the white teeth, it's very easy to bring the eyes to the face. The second one – the tentacle – is quite far from the face, so it does not become confused with the focal points. The white parts on the tentacles are also smaller than the teeth, and so do not detract from the main center of interest: the face.

There are two things I changed after doing an initial test render. First of all I added the silver collar below the chin, because it helped separate the head and the body. By placing your finger over the collar it feels as though the head is not separate from the body. Secondly, I offset the texture of the candy because it appeared too white, and stuck to the picture's edge, which I felt was too distracting and led the eye out of the picture. Another thing I wanted in this picture was a nice pose. As an animator, I'm always working on posing characters in order to animate them. It's the same thing with a still; I like to add curvature to them and avoid using straight lines as it gives more "movement" to the character.

MODELING

Modeling is the part I enjoy the most during the creative process, because you can witness the character taking form. Even though it may be for a still, I always prefer to model my characters with a clean mesh. This way I get to practice my modeling skills, and it's easier not to get too lost in the mesh. If you're exporting your model into ZBrush, or Mudbox, you need to have a clean mesh for better results. For this making-of, I divided the modeling process into three parts: the head, body and tentacles. I have assigned an image for each section that shows the basic modeling steps.

HEAD

I always start my characters in the same way: I create a sphere and start modeling around it with a plane, extruding the faces along the muscle lines, and then fill the "in-between" sections. I did the same thing with this character (Fig.01a).

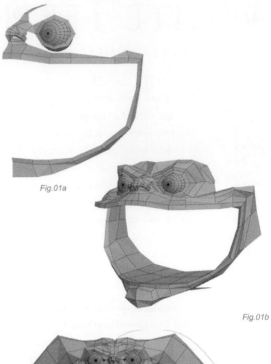

Fig.01a

Getting the edges in the correct places to begin with was not as important as it was to get the correct proportion for the face with lines that followed the muscles. The trick here was to model a low polygon head and then starting to refine this, which is easier than getting lost in the details and helps to maintain the right proportions. Once done, I used the Symmetry modifier and started filling in-between (Fig.01b).

Fig.01b

You can see that all the new polygons added follow the initial line (or muscle). There is no secret here; you just need to experiment. Before adding lots of polygons, you must have a clean mesh for the whole face with the correct proportion, as it's difficult to re-arrange the proportions with too much detail. I then began modeling the hat, and also made a place holder for the teeth, which helped me get an idea of the final result and a feel for the character in general (Fig.01c).

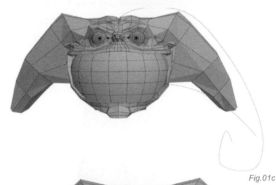

Fig.01c

For the hat, I made a spline which served as a guide and represented the path it would follow. This was just for a reference because, as you can see, I didn't follow it exactly. I started by extruding edges from the cranium, and also extruded along the path in a cylindrical fashion – nothing too complex. The mesh for the teeth was nothing complex, and the model followed the place holder exactly (Fig.01d).

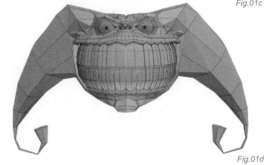

Fig.01d

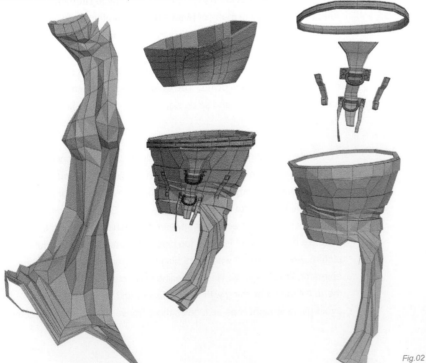

BODY

All the clothing was basically created with the help of a cylinder and some cutting, but when you see the final result it looks good and quite detailed (Fig.02). One thing I learned (but I don't use everytime), from a former modeling teacher, was that detail enhances a character. You don't need to add too much detail, but try to balance it. As you can see in the final image of *White Teeth*, I added detail on the body with straps and buckles (which are easy to model) and more on the tentacle. I think it was just enough detail and it creates the right feel. You can also look at your detail as a part of your composition – it helps to balance your character.

Fig.02

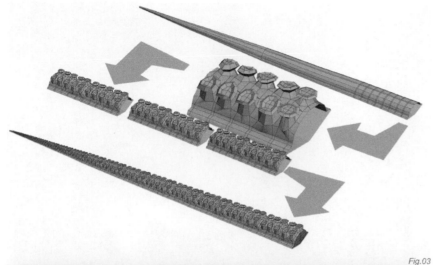

Fig.03

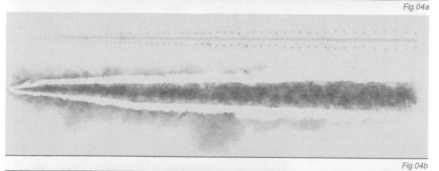

Fig.04a

Fig.04b

Fig.04c

Fig.05

Fig.06

TENTACLES

The tentacles were also easy to model. You just need a step-by-step process, which you need to think about before starting. I knew at the start that I was going to deal with a lot of polygons where the tentacles were concerned and didn't want to model each and every detail, and therefore attempted to re-use meshes. Firstly, I needed a basic box model of the entire tentacle in order to have an idea of the necessary proportions and dimensions. From there, I added edges extra edges and arranged them to form the correct mesh in order to start extruding the little, "sticky" suction pads. I then started modeling all of the detail for this single section and then copied it to the end of the tentacle. Next, I used an FFD box modifier for each section, to make each part smaller than the last one. Finally, I just needed to weld them altogether and my tentacles would be complete (Fig.03).

TEXTURING AND SHADER

I won't talk too much about the texturing process, because I do not consider myself to be a great texture artist, and I didn't honestly enjoy the texturing stage very much. For this piece, the only texture I used was for the candy cane and the tentacle (Fig.04a–c). I knew how my character would appear in the picture along with the tentacle and I didn't feel it necessary to spend days working on the textures. I simply researched some squid colors and then began texturing my tentacle. I also wanted to give them a "wet look", and so I created a specular map. The rest was all done with a Mental Ray skin shader (Fig.05). At first, I wasn't able to get the wet look that I wanted, and the only solution was to boost the RGB level to 1.7 (Fig.06) in order for me to achieve the results that I was aiming for.

PHOTOSHOP

Photoshop was the tool I used to make color corrections, to work on the atmosphere, and finish the composition. I never finish a still with just one final render; I always need to work on the picture further in Photoshop. The results of the final render can be seen in Fig.07a. You can see that the final render doesn't look as good as the final version. I needed three passes to composite in Photoshop: the Diffuse pass (Fig.07a), Ambient Occlusion

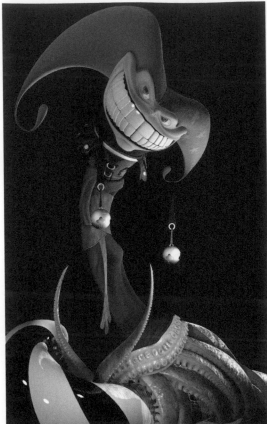

Fig.08

Fig.07b

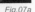
Fig.07c

(Fig.07b) pass and a Selection pass (Fig.07c) (this one will help me to select different parts of the character with the help of Colour Range in Photoshop). The first thing I did in Photoshop was adjust the saturation of the Diffuse pass. Following that, I added the Ambient Occlusion Map on top of the Diffuse, and then set this layer to Multiply.

The next step is a little harder for me to explain, because it always varies. The basic idea was to try different things to enhance the picture. For example, I duplicated the diffuse layer, put it on top, and then tried different layer properties (mostly Overlay and Soft Light), and tried adjusting the Opacity, Hue/Saturation and the lightness of the layer. Another thing was to duplicate the Diffuse layer, desaturate it, change the contrast and brightness, add some blurring (Fig.08), and then set the layer property to Color Dodge. This way, I added more contrast to the

lighting and put more depth into the picture. It's really a trial and error process, and I'm constantly trying out new techniques, and developing old ones.

CONCLUSION

I'm very happy with the final result, mostly because with this image I didn't create any detailed concept designs or drawings beforehand, and I think I achieved something really original. I haven't yet mentioned this, but during the modeling process, my character did have an arm and a hand, but I deleted them, which I believe resulted in a more interesting and intriguing image. The only thing I would have perhaps done differently, I think; is the lighting setup, because right now I'm learning a great deal about this topic, and so perhaps could have made something a little better.

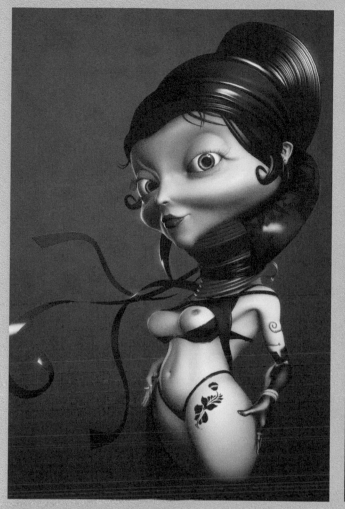

I JUST NEEDED A NEW BODY
BY DANIELA UHLIG

CONCEPT

Some time ago I painted my first rabbit, which was a kind of prototype bunny (Fig.01). I really enjoyed drawing this and a lot of people really liked it, so much so that I considered maybe drawing some more and to create a calendar with them. Painting the rabbits in different situations always gave me a pleasant and simple break from ordinary work. Meanwhile I have since drawn twelve bunnies in total. The calendar design offers the basis for many ideas, such as different seasons and events, as each picture shows the bunny's different traits and even mimics normal day to day situations. The Halloween picture had to differ from all other standard Halloween clichés.

The idea came to me as I was watching television and I saw a talking pumpkin. Upon seeing this I immediately started jotting down my ideas in my sketchbook (Fig.02). The basic concept was a fairly headstrong, bloodthirsty pumpkin, who is always trying to get up to mischief, and who, due to an acute lack of arms and legs, was somewhat restricted. In order to achieve mobility, regardless of the consequences, he pieced together his body from the limbs of a defenceless stuffed toy rabbit, who happened to be in the wrong place at the wrong time.

As the main focus of the rabbit illustrations lies in the personality, I tried to paint the background simply and in accordance with the theme. The whole illustration was centered around the rabbit so that the graphical value of the character wasn't swayed, but was supported. This has also been achieved through archetypical elements, such as the grave, moon and the graveyard atmosphere.

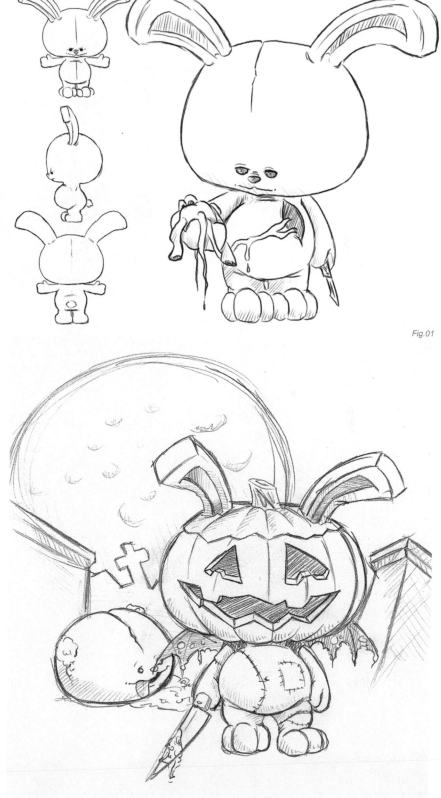

Fig.01

Fig.02

WORK STEPS

I immediately scanned the sketch and began to consider what atmosphere I wanted to get across. Since Halloween is dark and gloomy, the choice of the complementary colors purple and orange seemed to be the obvious one. Through the addition of different shades and contrasting colors that harmonized with the base colors, I created a basic color scheme which I kept to throughout the coloration. Based on this scheme I filled the different surfaces in Photoshop CS with base colors to create a feeling of harmony between the motive and colors (Fig.03).

Due to the moon, the background has a cooler coloring in blue and purple tones compared with the glowing eyes of the foreground which generally receives warmer yellow and purple hues. Through this a strong contrast emerges between the background and character. Following from this, I began detailing the color of the character to create a three-dimensional effect (Fig.04). I occasionally changed the colors a little more towards a purple/dark blue hue, so that the whole composition obtained more depth.

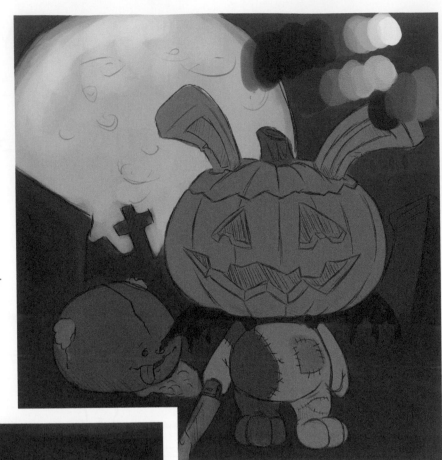

Fig.03

I used the same brush constantly (normal round), with pen pressure, to maintain the consistent style of the earlier bunny illustrations. The standard brush is my favorite brush, as its hard edge and various settings offer a large variety of possibilities and achieve a simple manual effect when drawing rougher textures. In order to create a finer texture for the pumpkin on an extra layer, I used the scatter option (Fig.05a and b). It was only a minimal effect, but it prevented the pumpkin's surface from being completely flat.

Next I drew the shine/glow in the pumpkin's eyes with a bright yellow and a warm orange, in order to

Fig.04

Fig.05a Fig.05b

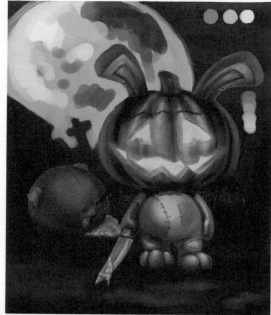

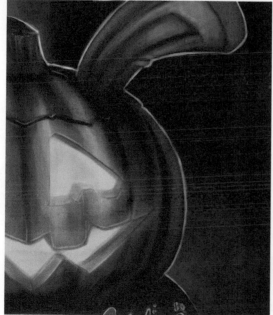

Fig.06

Fig.07

achieve the typical Halloween pumpkin glow (Fig.06). I also added the same colors on a separate layer to illuminate the other body parts, and increase the character's three-dimensionality. After I had roughly colored the background, I traced around the character and background elements with a bright outline as the moon in the background works as a back light and thus illuminates the character with a blue glow (Fig.07 and 08). This color contrast of yellow and violet serves to intensify the warm atmosphere in the foreground, which increases the overall color intensity.

During the coloring there was an accumulation of layers. As I drew the lighting and additional structures on a separate layer for safety and testing reasons, I reduced the number of layers little by little and continued working. Through the constant changing of new elements on single layers and the reduction, it was possible to work without having to make a large number of corrections, as I could easily delete elements that I found unsuitable.

CONCLUSION

This was to some extent a small challenge for me, because I had never worked with such dark colors and such strong contrasts before. As every picture tells a small story, it was an additional challenge to ensure that the story was recognizable and the calibration of subjective interpretation and the viewer's interpretation was somewhat aligned, which I feel is important (what does the other person see? Is it the same as what I see?). But I think on the whole I have I achieved the atmosphere in the picture that I intended. From the beginning, my primary goal was that the Halloween feeling was visually recognizable and I created a picture that is generally fun to look at.

Fig.08

ARTIST PORTFOLIO

Spacegirl

By André Holzmeister

Introduction

I've always been impressed by graffiti art in the streets of Rio de Janeiro, where I have lived for the past three years. One of the most active and great graffiti groups here is the "Fleshbeckcrew", and the artist, Toz, always designs a very cute and expressive little girl on the gigantic panels they paint everywhere. I was so inspired by his art that I decided to design my *Spacegirl*. I was also heavily influenced by Junko Mizuno, a great character designer from Japan. I guess I mixed their styles together and added my own style to it to create the image you see here.

Firstly, I designed some sketches that would guide me during the modeling phase. I do not like to restrict the idea too much in the drawing stage, to allow me more freedom to create when it comes to modeling. I usually use sketches more as a guide than as a goal. I think it is nice to always leave room to be creative wherever possible, so I always leave space for late changes. This work for example was not designed to have a carnivorous plant right from the beginning, I just found that she needed a scary "thing" in the scene with her, and the plant appeared to be a little less obvious than a little, nasty alien. I created the plant close to the end of the project, and I believe it fits really well into the final picture, as if it were planned from the very beginning (Fig.01a–c).

I designed a few different types of gun, so that I could decide which one would fit the project the best. I had some more complex sketches but decided on the cleaner version; a look closer to the Jetsons style seemed like the best. I wanted to give it a retro look, like the old futuristic designs. When I came up with the final design for the gun, it was then time to have a go at the ship's design, and I went into it with the previous thought on my mind: a clean, retro, futuristic design, using the style of the gun as a guide. I also used a book as a reference – which is fantastic – called *TASCHEN Icons Series: Robots and Spaceships*. If you like those old futuristic robots and ships, you should definitely buy this book – it's a must. This also helped me to go back and improve upon the gun.

The clouds show a clear reference to *Mario World*, from Nintendo, which I have noticed to be a great inspiration for so many graffiti artists and designers, all over the world – there are so many references to this game in so many places today.

The planet and small moon were designed so that it would look like a small world, like in the *Little Prince* tale, and I aimed for it to look like a small piece of Swiss cheese. If you remember *Monkey Island 3* game from Lucas Arts you should remember a similar design for the moon. This game has always inspired me in my art – one of the most beautiful games ever, and a real pity that they no longer make those kinds of game. I have seen a great rebirth of 2D art over the past few years, and

I personally hope that the 3D hype does not last forever. I would love to see new movies appearing, like *Les Triplets de Belleville*, or games like *Monkey Island 3*. There is room for both 3D and 2D – we just have to do it right.

I started by modeling her head, followed by the hair. For the head, I started with a smoothed box and turned it into a more rounded form, but I wanted to make the head slightly square to avoid it seeming like a perfect sphere. You can see that the drawing has a squared, smoothed silhouette for the head. The hair was made from simple planes that I adjusted to stay in place around her head. This geometry was later

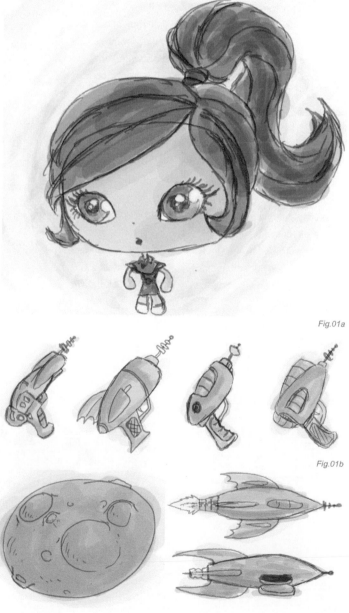

Fig.01a

Fig.01b

Fig.01c

Fig.02

extruded to give the hair more volume. I created a basic plane and extruded the edges, almost poly by poly. When modeling, I love to use "screen" as the reference coordinate system for the transform gizmo. It gives me a loose feeling for the modeling process that I cannot get with any other coordinate system.

MODELING

The modeling task was very basic, and not a challenge at all, but still, I love clean and soft cartoons – it's a style that I personally really like (Fig.02). It's not about how hard it is to create, but rather the final look and the simple, solid design. You can see in the wireframes (Fig.03 and Fig.04a and b) that the models were kept quite simple, and I intended for them to be very smooth. I tried to keep my meshes all as quads, but I was not constrained by this. If the area did not need to be deformed, I left a tri or an Ngon there.

SHADING AND LIGHTING

I usually receive lots of e-mails asking about the shading and lighting of my cartoons; but it is really quite simple and very easy to set up. In this case, I used a direct light to simulate the sun, set the multiplier to 0.7 and created a sky light (slightly orange) with a multiplier of 0.8. I used Mental Ray with final gather set to 500 samples and the bounce set to one, with global

Fig.03

Fig.04a

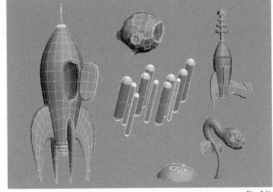
Fig.04b

illumination turned off. It was not complex at all; the real trick was the shading and the post-production.

In this project I used a plain color for almost every object. Other than that, there was a bump texture for the space ship and a bump texture for the ground, which is the splat procedural material in 3D Studio Max. The only painted texture was the girl's eyes.

The shading for everything else was a simple falloff in the diffuse channel (Fig.05), with usually a darker color inside and a lighter, similar color in the border. I did not use any self-illumination. The diffuse falloff worked very nicely with the global illumination, and gave a cool, velvet-like effect.

With the final image rendered, I then rendered an ambient occlusion pass (Fig.06a–c), set to multiply in

Fig.05

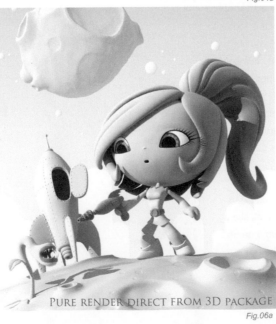
PURE RENDER DIRECT FROM 3D PACKAGE

Fig.06a

CARTOON

Photoshop. In this case I changed the lightness and hue of the occlusion pass to turn the black into a dark orange, which gave color to the black shadows and produced a nice effect.

I usually create the ambient occlusion by setting all shaders to pure white, by creating a skylight (if you do not already have it), also set to pure white. I turned on final gather in Mental Ray and set the bounce to one. It was also good to turn on the sunlight and set it very low on multiplier so that there was not any dark shadows where it was supposed to be lit by a backlight or sunlight. I prefer this approach to working with the ambient occlusion shader, because this technique is much quicker than with the shader method. Still, the shader solution can be more precise and give finer details, whereas the final gather approach is slightly harder to master for animation because of the final gather flickering, but once you get used to working with final gather and understand the engine, you become much more efficient.

I then played around with the color correction tool in Photoshop, called Curves. You can see the final result in Fig.06c, and the setup has been detailed in Fig.07. This tool makes a lot of difference. If you have never played with this fantastic color correction tool then give it a try; you can achieve several diferent looks other than the direct output from your 3D package.

CONCLUSION

Upon starting this project, I was working on a realistic and complex character, with complex problems that needed solving. I was really stressed out and decided to do something that I could have fun with, and so started to create this image. I guess I just can't stay away from the cartoon world for too long. The end result is a cartoon which fits the style that I have been evolving for myself for quite some time, which is the most important thing in my opinion – a style which you are recognized for doing. Some artists have a very strong identity and it becomes easy to recognize new work by a given artist, which is what I intend to achieve for myself, someday.

I like many aproaches to CG. At first, I preferred creating realistic stuff, but later – when reality did not represent an impossible achievement and I got bored with the technical process – I decided to work more with my imagination and have never had more fun than when creating cartoons. Cartoons are a field of CG that have no boundaries, because everything is possible; every shape is correct, you have freedom to design the way you like, and it is a fertile ground for creativity.

I find reality an achievement, but to create a realistic head or a realistic scene, just trying to make things look real, is not very creative. I prefer to see work where the creative part is what really stands out – it doesn't need to be a complex model or a difficult render, it just needs to have a great concept behind it. I tend to prefer the ideas more so than many photorealistic heads with no expressions that we can find everyday in the Internet. Of course, this is my personal opinion on the kind of work that I am used to doing. I believe that, if you are a special-effects artist, reality is your business.

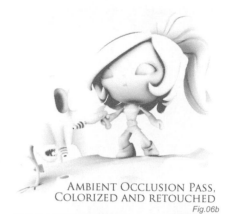

AMBIENT OCCLUSION PASS,
COLORIZED AND RETOUCHED
Fig.06b

FINAL COMPOSITE &
COLOR CORRECTION
Fig.06c

Fig.07

ARTIST PORTFOLIO

SUPERPIG

BY FRAN FERRIZ BLANQUER

INTRODUCTION.

This image was created for the cover of a children's book. The idea was born from our very own history, where, on a planet populated by pigs, a war breaks out and a pig must flee with her piglets to a safer country. Of course, it was a very attractive project on a creative level. I began with pencil sketches, firstly to obtain a clear design for the piggies and thus help in the modeling phase (Fig.01). I did many tests before arriving at the final result. Perhaps the most problematic thing was choosing the design of the eyes. I liked both versions and I decided that the mother pig would have different eyes to the piggies'. Once I had decided on the story the first thing was to do was to choose the type of illustration. At the outset it was going to be a colored illustration by hand, but eventually I decided to do it in 3D to enable the possibility of creating new scenes with the 3D pigs. The final result was something that I was very happy with (Fig.02)

Fig.02

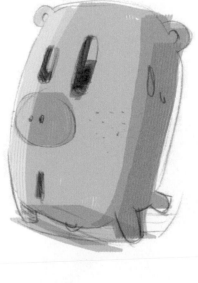

Fig.01

DEVELOPMENT OF THE IDEA

In a children's illustration the characters must demonstrate a tender and rounded quality. Using the finished sketches I began to model the scene. The first step was to model to the mother pig. From the initial mother pig I then made the children and scaled each one and made small anatomical variations. The initial idea for the scene was that the piggies were holding on to the body of the mother, but this just seemed too dangerous.

For this reason I placed them in a wooden box tied with cords to the legs of the mother. Another preliminary idea was that the mother had wings and was flying, but the final decision was to use two rockets tied to the body to transmit a greater sensation of dynamism and force to the scene (Fig.03).

One of the most problematic elements was making the smoke. I did not want realistic smoke, but rather a cartoon style. I tried to make it in 3D Studio Max, but could not obtain the effect, partly because I had never made smoke in 3D Studio Max and did not know how to achieve it. I tried to draw it directly in Photoshop, but it also seemed unconvincing. Finally, I used a combination of Freehand MX and Photoshop. The smoke was made up of vectorial circles (Fig.04) that I exported as *.eps files into Photoshop, where they were duplicated several times and blurred until I obtained the desired effect.

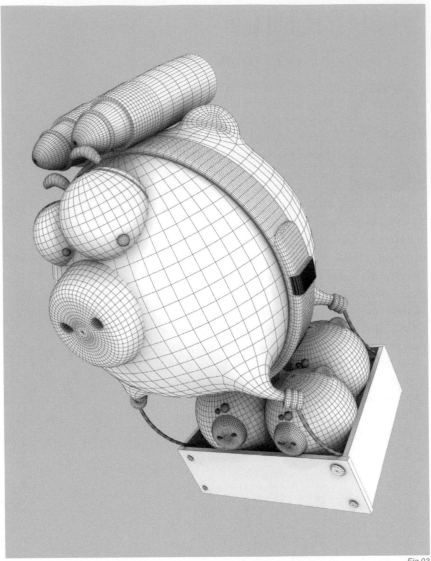

Fig.03

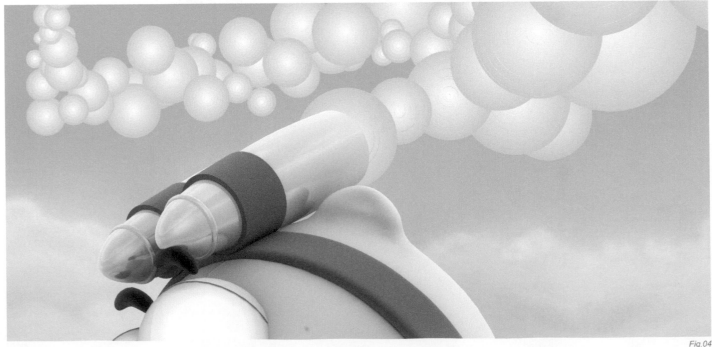

Fig.04

CARTOON

TEXTURING

For the textures I combined some of my own, such as the one used on the piggies, whilst others I grabbed from the *Total Textures Vol.15: Toon Textures*, by 3DTotal.com, such as the sky and wood. My main objective was to avoid any sense of realism. In terms of lighting I used the Lightracer in 3D Studio Max with two lights, a Skylight and an Omni, but the colors in the render were far too saturated (Fig.05). In order to solve this I corrected the levels in Photoshop and almost by chance I discovered that, by desaturating them, the image worked better (Fig.06).

CONCLUSION

I consider the final image to be an important step in my evolution and in my persistence in becoming a good digital artist. I believe that it marks the end of one stage and the beginning of a new one, which is very important to me. After this I created other images with a similar esthetic, which I am also very happy with. Finally, I would like to say that, without a doubt, my ideas and inspiration have come from tens, and probably even hundreds, of wonderful artists from all around the world, from whom I feel I have learnt a great deal as a result of studying their work. I believe that, thanks to the Internet, we are a growing "newspaper" to new and great artists, and it is a joy and a motivation to someday be able to be included among them.

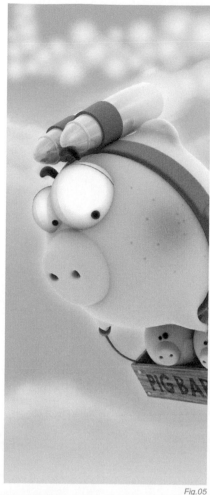

Fig.05

Fig.06

ARTIST PORTFOLIO

MONSTREUSIEN – COLD MEAT

BY FRED BASTIDE

CONCEPT

The term "Monstreusien" is a compression of the words "Monster" and "Montreusien", which is the name of the inhabitants of my native city, Montreux, in Switzerland. The idea was to manifest a kind of Clive Barkeresque alternate reality, where all the nice and friendly Montreux citizens turn themselves into ugly, drooling monsters. I've basically planned to make a series of images based upon this principle, with *Cold Meat* being the first that I've done based on a butcher's shop.

MODELING

Firstly, as always, I made some sketches to define the morphology of the monster and the general ambience of the image. The creature was very simple, so I didn't make a plasticine model or draw a front and profile view, as I would usually do (Fig.01).

I built a rough mesh in 3D Studio Max that I imported into ZBrush to make corrections and weight adjustments. When I was satisfied with the overall appearance, I re-imported the mesh into 3D Studio Max to unwrap the UVs and subdivide it. I then re-imported the whole thing back into ZBrush to refine the second level of subdivisions. Of course, this may not be the best way to do things, but I was a beginner with the Pixologic application, and this work was experimental.

Fig.01

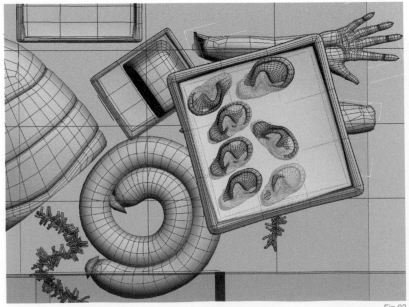

Fig.02

Fig.03

Most of the delicatessen featured started from primitives: spheres for the meat balls, chamfer boxes for the block of foie gras, capsules for the salamis, and helixes converted to meshes for the big sausages. I recycled ears, arms and eyes from a human mesh to add some disturbing elements to the composition (Fig.02 and 03). The green seaweed in the display was generated from a spline and then covered with some fur (Shagfur), and converted to an editable mesh. They do not look very realistic, but It doesn't really matter when considering they could be plastic ornaments.

The eye jar was made from a cylinder and a shell modifier with the scatter tool used to make the bubbles in the liquid (Fig.03). As a final touch, I added some elements in the background, such as the grinder (Fig.04), some butcher's knives, and a huge white rolled sausage. I like to add picturesque elements which are important to the narrative.

Fig.04

TEXTURING

For the creature, I made the color map on a high-resolution square, base bitmap (4096x4096 pixels) covered with small dots taken from a close-up picture of a ceramic plate. I combined it with numerous other images from different sources to obtain a convincing skin, and the tongue texture was made from a toad's back (Fig.05a and b).

I used ZBrush to create a grayscale map of thin lines around the mouth, cracks on the teeth and other skin details. This map was then used twice: as a bump map, and combined with the color channel to add some contrast. I also used the Zmapper plugin to add color variations, skin details and spots on the arms. The Zmapper often produces artefacts during the projection process, but they were easily corrected with the Photoshop Stamp tool.

All of the meat elements were textured using pictures of real food, found using Google Images, and then mixed

Fig.05a

Fig.05b

Fig.06a

Fig.06b

Fig.06c

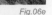

Fig.06d

Fig.06e

Fig.09

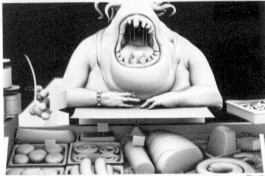

Fig.07

Fig.08

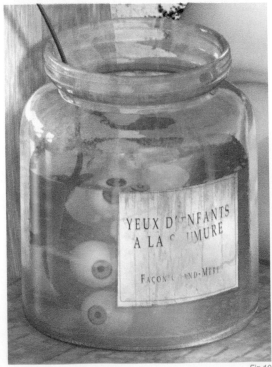

YEUX D'ENFANTS
A LA SAUMURE

FAÇON GRAND-MÈRE

Fig.10

with procedurals (procedurals are especially useful for high-resolution renders). As usual, the same maps were then varied and adapted for the other slot shaders (Fig.06a–e).

LIGHTING

The goal was to obtain an unusual type of visual for a monster character: a nice and bright environnment which felt very pleasant and familiar. The image does not only feature a monster, but was intended to convey the feeling that the spectator is a monster too.

I needed a very bright light to suggest a sunny afternoon, which would look almost saturated on the brightest elements. This demanded a very bright principal yellow light above the set as the main light source. The ambient light was provided by a skylight, used in conjunction with final gather. I also added a cold neon light inside the fridge to project some cold light onto the meat elements.

RENDERING

I usually prefer using V-Ray, but this time I chose to use Mental Ray, taking advantage of the great SSS shader, and using the opportunity to learn about a render engine, which was unfamiliar to me. I had previously planned to render the image using Global illumination, but finally gave up, principally due to CPU and memory restrictions, and so opted to use occlusion passes instead.

I separated my scene into four different render passes, all mounted in Photoshop: the background, the foreground and the two related occlusion passes (Fig.07–09). Unfortunately, I had to lower some settings on the glass materials, which clearly looked better in the initial attempts (Fig.10).

The mouth and tongue shader wasn't slimy enough in early render tests, so I cloned the teeth, gum and tongue meshes, added a push modifier with a very small value, and used them as a fine varnish coat. I also used a combination of two HDRI maps to show a maximum array of very bright details.

CARTOON

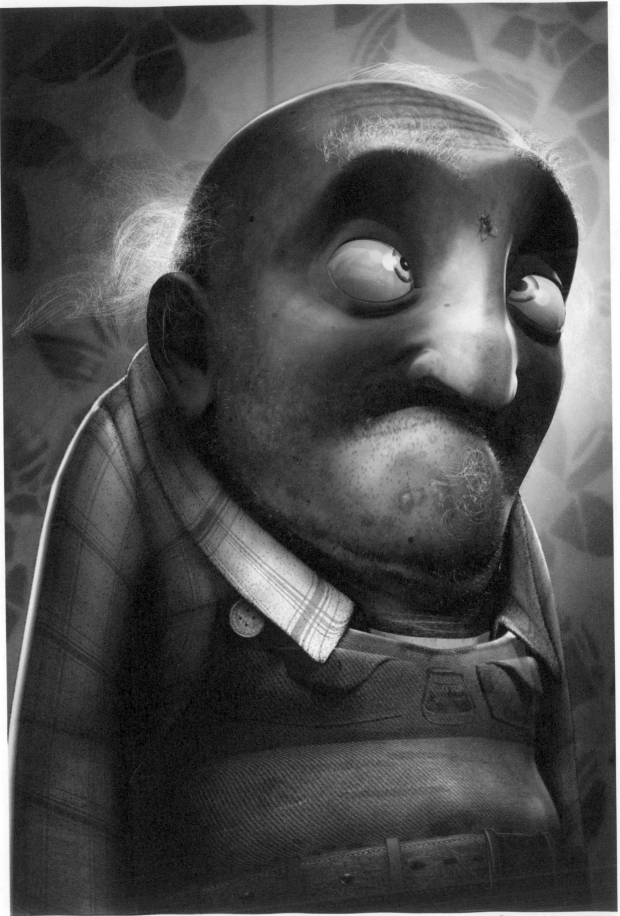

FERN 1903–1996

BY PATRICK BEAULIEU

INTRODUCTION

Here is the making of my last character, named *Fern 1903–1996*. I will describe to you (even bellow!), what methods, tools and tricks of the trade that I used. The main idea for Fern came from a man that lives near my house. He's a caricatural person and someone special in real life, which is why he inspired me to create a 3D model. I preserved his main features like his pale skin, baldness, his aging silhouette and his expressions (less exaggerated) (Fig.01a and b). I had never before approached the theme of an elderly person, so the subject was really interesting for me. My first intention with Fern was to create something different but keeping the style simple, cartoon-like and expressive. I used 3D Studio Max 8, Photoshop for textures and Shag Hair, for hair, beard and other details.

MODELING

For the modeling of the character (Fig.02) I always work the same way by using edge modeling. This consists of extruding the edges and creating guide lines to produce a mesh showing the main shape of the character (Fig.03) It's a fast way of making a rough shape, and enables you to make easy loop edges. I always work in quads because by minimizing the number of triangles, one results in a better turbosmoothed version. Once the wire frame is finished, I compare my sketches with the 3D and make the necessary adjustments. Since I only have the wire frame, I'm able to make modifications quickly because I have fewer vertices to move than if I had modeled the whole head. Once the first set of adjustments have been made, I start sealing the model and often make the whole character. Then I use my turbosmooth and adjust the edges so that I can determine which parts will be hard and which will be soft. I did not want my modeling to appear real but wanted to keep it stylized.

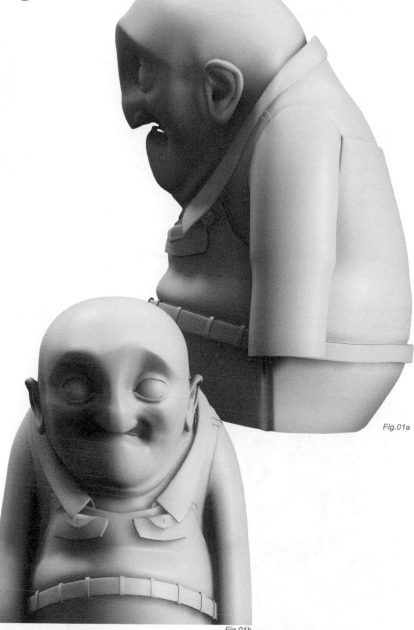

Fig.01a

Fig.01b

Fig.03

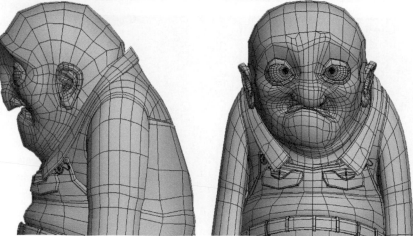

Fig.02

Texturing

Fern's texture was a challenge for me because all my other characters were all covered in fur, so texture was not a problem; but with Fern, the texture needed more detail to obtain a good result. I unrolled all the UVs using a checker (Fig.04) to reduce the distortion while keeping a good pixel ratio. I also used pelt mapping in 3D Studio Max as an unwrapper for the organic parts of the character. Once the UVs were done, it was time for the texturing.

I made most of my texture with Photoshop. I used a tissue tile for the overalls, then added some dirt and weathering to add interest. I used the same technique for the shirt texture. For the face I wanted more detail without losing my initial style so added a skin color, some wrinkles, and pustules, and other skin anomalies.

Shag and Fur

I used Hair FX to do the hair, beard, eyebrow and tissue layer on his shirt. For his hair, I started by creating splines which acted as paths for the hair to follow. These splines are added at the root of the hair and the orientation, curve and length are the parameters that determine the look. Each spline needs a modifier called Model Hair so you can add shag to the character. I used two types of hair, eyebrows and beards to make everything look more random and finally used filters during post-production (Fig.05).

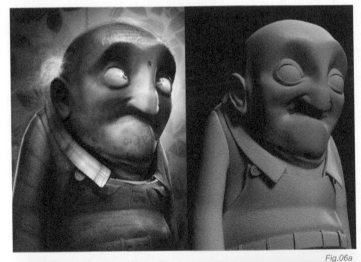

Fig.06a

Fig.06b

Fig.04

Fig.05

Lighting

For lighting, I used V-Ray for the Global Illumination pass coupled with several light passes for the back light and the left and right lights. For the final picture, I directed my light to illuminate the face since it's the focal point and put the rest of the body in shadow. For the eyes I used HDRI, which I made into a pass. Some passes are less important than others so it needed a more standard light, for which I used the Scanline in 3D Studio Max.

Post-Production

The image for the final setting needed more passes. I used them mainly to save time and to have full control of my image regarding color adjustment, contrast etc... (Fig.06a–d). I approached the filters in a simple way: I took out several lighting filters (B&W) with different lights placed differently in my scene. This gave me the opportunity to create my lighting with Photoshop. Lots of filters were made using texturing procedures such as falloff and noise, etc. I used them at a low frequency in softlight mode on my character. To control my passes and also have options to edit certain aspects, I created different alpha channels for separate layers. This enabled me to choose my selections for color adjustment, contrast and others more easily and more precisely. For the hair pass, I created each element separately, i.e. hair, beard and eyebrows. I made a lot of hair tests separately and mixed several hair passes together to get the final result for Fern.

Fig.06c

Fig.07

Passes require a lot of preparation but the final control is worthwhile. To be able to alter each layer in an independent fashion helps a great deal in getting the final result. To composite all my passes I used Photoshop. I began with the background and then layered each pass one on top of the other to make a .psd file with layers containing all the information (Fig.07). I used Photoshop techniques to combine all my renders together. Blending modes such as multiply, overlay, soft light and hard light, helped me in tying the layers together. With some tests made for each mode, I was able to get my results quickly.

CONCLUSION

I was able to learn new things during the creation of Fern. The passes were a new experience for me and I enjoyed the utility and freedom that they gave me to perfect my final image. It's a method I will continue developing and I hope you enjoyed the making of Fern!

Fig.06d

ARTIST PORTFOLIO

MOON GIRL
BY VINCENT GUIBERT

CONCEPT

The *Moon Girl* was part of a bigger project: a children's book. It was a little story inserted between two longer ones. The idea behind the three stories concerned French expressions used out of context. For the *Moon Girl* the idea was based upon the expression "être dans la lune" (to be in the moon). In France, we use this term to describe people who are daydreamers, or who have their head in the clouds. You can tell when they are very alert, as it seems you have to wake them up when you want to talk to them.

The *Moon Girl* was a sort of double page poem that takes you to another place in time ready for the last story. On the first page the girl thinks: "I'm here, but not really. Someone talks to me, I hear, but it seems that the words slip away. It's like I am sleeping even though I'm awake". And you can see her on the moon on the second page, "I think I'm in the clouds (moon in French)" (Fig.01a and b).

There was an overall idea for the three stories in terms of design. The main character had to be a sort of puppet with a big head. To be coherent, the environment could incorporate real objects but needed to be relative to a puppet's size. For this picture the main purpose was to represent the moon. I decided to replace it with a sort of Chinese paper lantern. Regarding the girl, I had some ideas but I wasn't really confident with my own designs, so I asked my friend Francois Bouclet, a great 2D artist, to create a concept sketch for inspiration (Fig.02).

Fig.02

Je suis ici et ailleurs en meme temps,
On me parle, j'entends mais les paroles s'évadent,
C'est comme si je dormais en étant éveillée...

Fig.01a

Je crois que je suis dans la lune...

Fig.01b

Fig.03

My friends were a big help to me as many of them are really good CG artists with great advice to offer. The CG community is also an invaluable source and provides inspiration. All the various 2D and 3D work on show across the various websites are just really amazing.

So…there was this little poem which had to be illustrated. What I wanted was something really poetic and nostalgic. It was the greatest challenge in creating this picture – having something with emotion but also something understandable.

Fig.04

SETTING QUICKLY THE 3D SCENE

I will quickly go through the process of modeling and texturing for this picture because it is nothing outstanding unless you consider simplicity as an artform in itself (Fig.03). Something interesting to consider was that the character was built as a puppet. She is made of different objects just like a puppet: head, arms, legs, hands and eyes are all individual components that combine to make her into a whole, living body (Fig.04). The only difficult aspect to model was her ponytail. One often tries to cheat with such problems, perhaps achieving it through simulation but sometimes the only way to make something believable is to manually replicate it. I decided to create the head by way of a loft. I found this to be the best way to avoid having to unwrap UVs for hours. Nothing special to mention on texturing except that Darktree was used to achieve the crumpled effect on the lamp.

It took me a long time to adjust the pose of the character. As the proportions of the girl were unusual, I had to pay attention to the idea behind the picture. The way she was sitting on the moon, with her arms beside her, was the most expressive pose I could think of to suggest the idea of a daydreamer. I work a lot with silhouettes to improve the posing

Fig.05

CARTOON

Fig.06

Fig.07

and I noticed that the initial size of the ponytail was in conflict the underlying concept (Fig.05), so I had to adjust it accordingly (Fig.06).

It's not simple to represent someone daydreaming and absorbed in thought, especially when the character has no real mouth or eyes to speak of. For the mouth I used the junction of the socks to define the lips, making her smile but not to enough to detract from her day-dreaming state. For the star eyes, the absence of a pupil heightened the sensation of a daydreaming person and suited the puppet style. The expression was mainly adjusted on the close-up picture (Fig.07).

A 2D/3D RENDERING

3D rendering...Now when I'm doing an illustration I often know what tones and colors I want to work with. It was really different for this picture. I was a little undecided on what color to use and the style of render and so decided to make a quick 3D test to help choose the colors.

For the lighting, there was of course a source in the middle of the moon lamp, but it couldn't be the only light otherwise the moon girl wouldn't be the focus of the picture. A spotlight was added coming from her facing direction to help emphasize the pose. Finally, I just added a little dome light to add more volume in the picture as a whole.

Then I quickly set up some colors in the 3D scene to have something close to a final illustration (Fig.08), but I decided to adjust the colors in Photoshop. In preparation I started by rendering a certain number of passes: the girl, the holes, the moon….Most are black and white just to be used as masks in Photoshop (Fig.09). 2D Photoshop rendering…There were three steps in Photoshop. The first one was to composite all the color passes and add some details to see the whole structure of the picture. I spent time adjusting the

Fig.08

Fig.09

light inside the moon, playing with different blending modes…I also added the stylish stars and drew the thin line which seems to attach the lamp to a ceiling. (If you look attentively at the picture you can see that this line never ends on the moon because of the position of the girl…) Finally, I arrived at a satisfactory illustration with interesting areas, but devoid of any real emotion or feelings (Fig.10a and b).

It was time for the second step: color experimentation. I started to make use of my different masks and color-correct different parts of the picture one at a time. Then I just played with variations: levels, hues, etc. Once I was happy with the colors I tried to put more focus on the girl within the picture as a whole and consequently decided to darken the surrounding environment. This was mainly painted with brushes to have a sort of 2D-like gradient (some may consider this as color degradation). I think this re-focus of the picture was crucial in suggesting the right feel of the picture. Moreover it added some depth to the background, a sort of fog across the picture. At that current time, I was working with a low-resolution picture. In order to be able to re-apply the very complicated color corrections to the larger version, I saved the entire process as a long Photoshop action.

Once happy with all the preceding steps, I added some fine details to the full-size picture. With the help of the masks, I adjusted the lighting by adding black in the hole at the end of the sock ponytail. I also darkened the holes in the moon to give it more volume. Some deformations were used to give a more "clothy" style to the head (Fig.11a and b) along with ironing out all the ugly 3D mistakes.

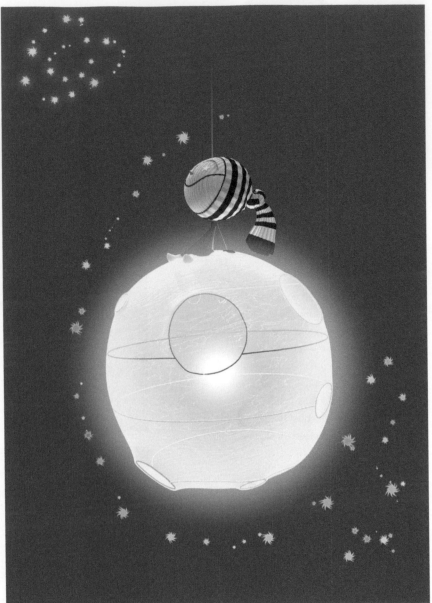

Fig.10a

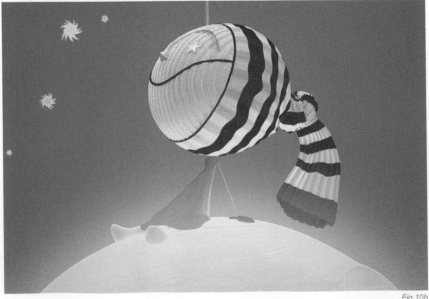

Fig.10b

CARTOON

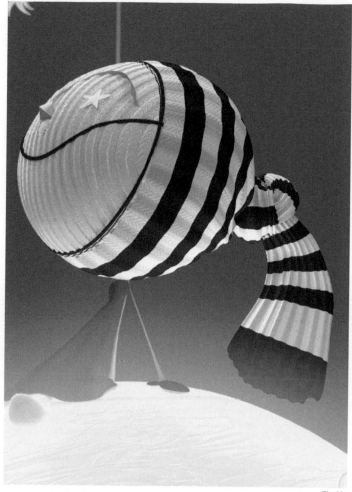

Fig.11a

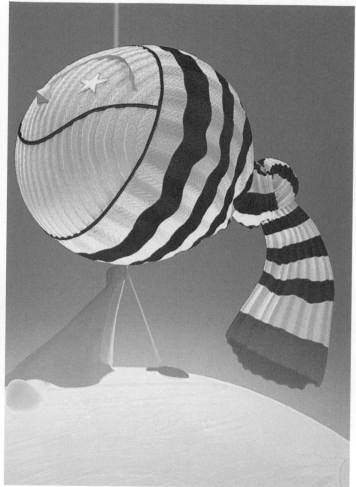

Fig.11b

CONCLUSION

I submitted five illustrations to the *Digital Art Masters book*, many of which are more recent than the *Moon Girl* and technically better but the one chosen was the moon. I believe it's the one with more feeling and mood. And if this is the messiest picture I have made in terms of organization and technique, the final result is at least successful even if it could have been refined. The star could have been more detailed, the color more contrasted and the rendering more precise. But this picture has its own style and that's what made the difference, I think.

If I had to give a title to this "making-of", I would call it "Once Upon a Time", because the picture tells a story. A story that was never published but has found another way to be discovered through this book. Not only this, but because the work is now three years old and seems to come from another time, a time when my characters were made of multiple objects and came to life like puppets. If I was remaking this picture now, I would add some final gathering and ambient occlusion; the dress would have been made with ZBrush. Would it be really better (and faster?). Cleaner, surely; better I don't know; and would I lose all the emotion and special style with a new approach? Well, perhaps as I'm talking about a nostalgic picture, it makes me, also, nostalgic, and not really objective.

ARTIST PORTFOLIO

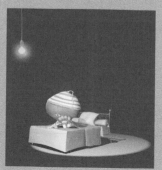

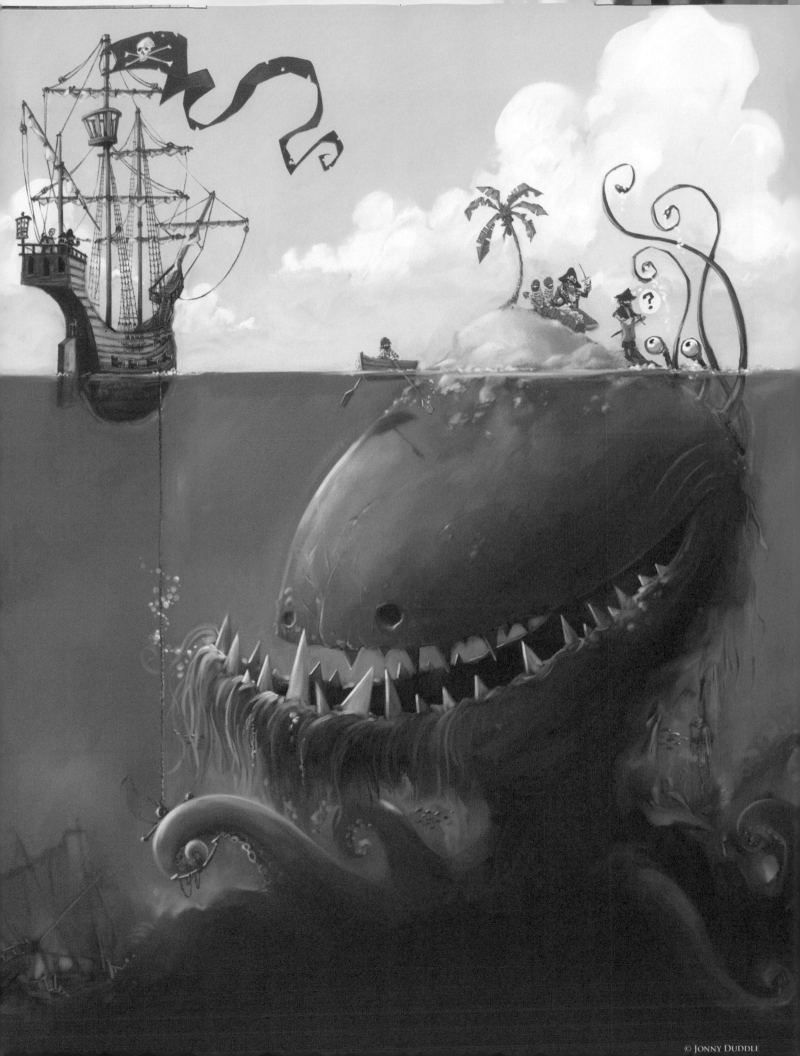

© JONNY DUDDLE

Ye Pirate Muncher

By Jonny Duddle

Introduction

Ye Monstrous Pirate Muncher was an image I originally painted for an online creature contest. It was done over a few lunch hours in Photoshop CS and was always meant to be a quick concept (Fig.01). It's had some great feedback since it has been displayed on my website, so I decided it was time to develop it into a more "finished" illustration. My aim was to give the illustration a more professional finish, without losing any of the concept's appeal.

I've worked as a Concept Artist in the computer games industry for eight years, and the software of my choice has always been Photoshop, but over the last six months, I've started to seriously dabble with Painter IX. In that time, it has become an important tool in my workflow, and it's even making an impact on my style and approach to digital painting. I wanted a more traditional painterly look for the Pirate Muncher illustration, and so Painter seemed the obvious choice.

The Painting

I do most of my sketching directly in Photoshop. I have a couple of custom brushes that I feel comfortable with,

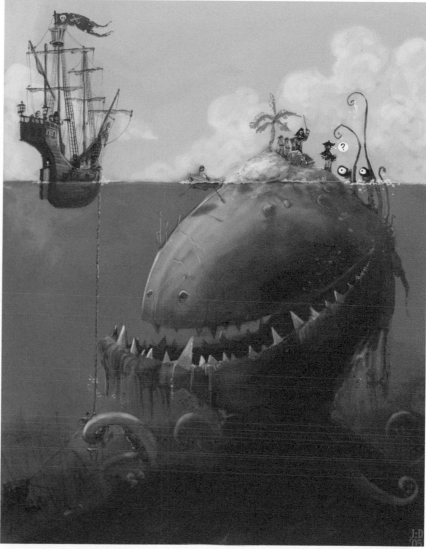

Fig.01

Fig.03

Fig.02

and whilst composing an illustration I find Photoshop's layers more flexible than the layers in Painter. I'm also a big fan of Photoshop's transform tools, and constantly play around with the scale and proportions of my sketches until I'm happy. I took the original pencil sketch from the first Pirate Muncher concept and made some modifications in Photoshop (Fig.02).

The sketch was pretty rough, but had enough information for me to begin painting, so I switched to Painter. The first task was to block in some base colors and establish the overall palette. In this case, I had the original illustration as reference. I used the color picker and sampled colors in the existing palette to form the basis of the new version. The drawing was on a separate "multiply" layer above the gray background, which enabled me to paint beneath the lines at this stage. I tend to work from dark to light colors, so the base colors were kept fairly subdued (Fig.03).

With the base colors in place, I dropped the opacity of the sketch layer and flattened the image. Then I scaled up the image. Because the Pirate Muncher is such a big sea monster and the pirates are very small, a larger canvas meant that the detailed areas would be less fiddly to paint. But before I started painting in the pirates, the ship and the other fun details, I needed to render the sky and clouds.

I try to work with a limited number of layers in Painter, because I'm aiming to mimic a more traditional painted illustration and it's the limitations of painting directly on a piece of paper with no layers and no "undo" that often give a traditional painting many of its more

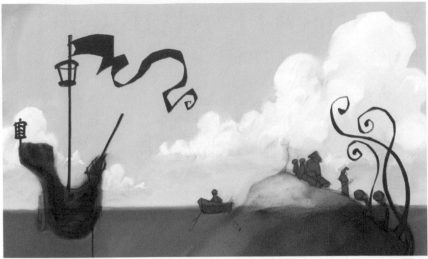

Fig.04

appealing qualities. But layers can be useful, and I created a separate layer to paint in the silhouettes of the surface details that I would paint over with the clouds, such as the ship mast and the rising tentacles.

The clouds in the original concept were one of the elements that I most disliked, so I took some digital photographic references from my attic window and painted in some more realistic clouds. I used the "Smeary Bristle Spray" from Painter's "Oils", which blends and swirls with paint on the canvas to great effect. It was perfect for the clouds, which I finished off with some edge details and some grainy blenders to establish the strong shapes (Fig.04).

With the clouds in place I decided to consolidate the detail above sea level, and made a beeline for the pirate ship. I used to work as a square-rig sailor, so I unearthed a pack of photos and used them as reference. I loved painting the stylized rigging and exaggerated hull. It took far too long and I got quite carried away painting individual ropes that will be almost invisible on the printed page, but it was great fun and brought back fond memories of climbing up and down the rigging in my sailing days! As with the rest of the painting, I tend to work by painting lighter colors over a dark base. I gave the ship a strong silhouette and built up the hull and rigging with layers of color and detail (Fig.05a–c).

Fig.05a Fig.05b

Fig.05c

The ship's trailing flag led me across the canvas to the pirates. These figures are tiny at the output resolution and were just blobs of color in the original concept. I didn't want to get absorbed in detailing a series of figures, but aimed to give them just a little bit more form and an indication of body language. I kept the costumes quite stereotypically pirate-like, whilst hopefully providing some indication of rank. The captain has the big hat and the sword and his minions are dressed in the red and blue uniforms of the lowly pirate crew. The attentive pirate who's spotted the peering eyes of the Pirate Muncher is in a costume that ranks him somewhere in-between. In fantasy illustrations such as this, it can make the whole job much more interesting for me (and potentially the audience) if I create a story and relationships for the characters in my paintings (Fig.06).

The Pirate Muncher takes up by far the largest area of the canvas, but the viewer needs to be drawn to the events on the fake island that sits upon his head. With this in mind, the painting is almost monotone below sea level and most of the detail is only hinted at. The tentacles and ships around the base of the Pirate Muncher are painted with fairly subtle variations of color that pick out important shapes in the murky deep. The details, such as shoals of fish and bubbles, are painted with quick blobs of color and bold highlights that

Fig.06

hopefully fool the viewer into seeing more detail than is actually there. The most detailed area underwater is the mouth. I painted an array of fangs which were inspired by sharks' jaws (Fig.07).

Along with being brimful of glistening teeth, the curve of the mouth is also a compositional element that tries to lead the eye to the island. The island is encircled by various details, including the swirling flag, the rising tentacles, the grinning mouth and the taut anchor chain, and these all aim to manipulate the viewer's focus. The composition of bold shapes within a painting can be a useful trick for establishing focal points.

Most of the painting was complete, but I needed to add in the final details and ensure the image worked well as a whole. This is obviously a consideration throughout the painting process, but it's easy to become absorbed by distinct areas within an illustration. In some cases I apply adjustment layers in Photoshop and tweak levels and colors to create a more unified whole, but this was unnecessary because I'd been using the original Pirate Muncher concept as color reference. I painted in more surface detail on the Pirate Muncher's nose, using Internet references of humpback whales, and using the eyedropper to pick local colors as I painted. By picking the existing colors on the canvas and tweaking them slightly in Painter's color wheel, I could keep within the existing palette and ensure the finishing touches didn't jar with what was already painted (Fig.08).

CONCLUSION

The final illustration is an improvement on the concept, yet retains the humor and freshness of the original. I rarely return to make improvements to existing works, but in this case its popularity called out for a more professional and deserving finish. I'm happier with the new version and, whether presenting work on my website or to potential clients, I'd rather show off an image that I'm proud of which is thoroughly finished.

Fig.07

Fig.08

ARTIST PORTFOLIO

CITY ESCAPE

BY ROSE FRITH

CONCEPT

What I wanted to achieve with this particular picture was to create a familiar urban setting with a surreal edge. Usually images of cities are cold and mechanical, and I wanted to give this particular project a more personal and warm tone, but still hold a hint of fantasy about it. I begin most of my projects by mapping out my ideas with pencil sketches, and this project in particular began with fairly personal sketches that gradually built up into larger scale ideas with more detail and focus on what I wanted to portray (Fig.01a).

PAINTING

What I'm going to focus on primarily is the painting process. Once I had the composition arranged to my liking, I recreated the final sketch in Photoshop CS (Fig.01b). A good tip when you have an image with a lot of straight vertical and horizontal lines is to use the Guides tool under the View menu. These guides are highly visible lines that you can place over your picture to help you draw in straight lines, or to keep certain objects lined up, and can be deleted once you no longer need them. I find them particularly useful in pictures when there's a lot of buildings where the perspective needs to be as accurate as possible. The slightest skewed building can unbalance an entire picture very easily.

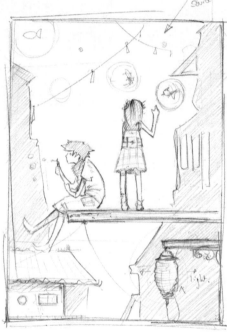

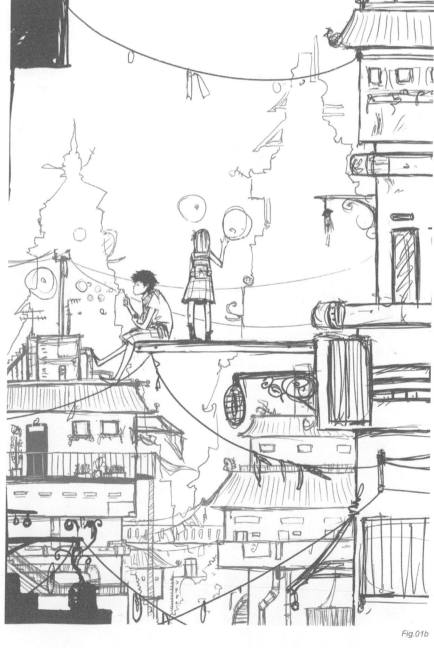

Fig.01a

Fig.01b

I often paint directly over the lines I've sketched in Photoshop, so my method relies on splitting up the sketch into three different layers – such as one layer for objects in the background (the two silhouettes of distant buildings), another for objects in the middle ground (the two distinct buildings behind the characters), and another for objects in the foreground (the nearest building on the right, as well as the characters and other immediate details). The painted layers go in between these sketched layers, working from the back to the front. This way I can concentrate on building up the picture by layers.

But before I start painting over the lines, I lay down the base colors on the very bottom layer beneath the sketch (Fig.02). This is probably one of the most important parts of the painting process, as this is where I decide my overall color scheme. Colors can be tweaked later on with layer adjustments, but it's a good idea to begin with a strong idea of the overall tone and color you wish to achieve. This base color layer doesn't have to be particularly neat, as it's simply where I'll be selecting most of my colors from as I paint. I wanted a warm, tranquil-like feel to the picture, so I picked mostly browns, oranges, and reds.

Once I'm satisfied with the general color scheme, I move on to painting over the top of the sketches. To speed-select the eyedropper tool to pick colors from the base color layer, you can hold down the ALT key, and with the [and] keys, the size of the brush can be adjusted as you work. My favored brush to use in Photoshop is the Airbrush Pen Opacity Flow brush. With a tablet, this brush is wonderful for the control it gives over the opacity, which varies depending on pen pressure. I also used some custom brushes

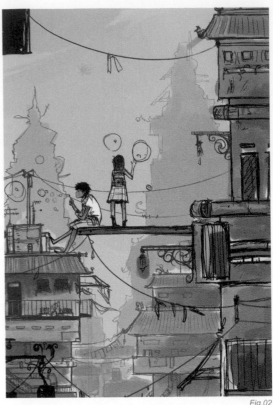

Fig.02

with textures, but all basically held the same principles and set-up as this particular brush. The first painted layer goes over the top of the background sketch objects and underneath the layer with the sketch of the middle ground objects. The second painted layer goes between the sketch of the mid-ground objects and the foreground objects, while the final painted layer is situated at the very top, above the foreground sketch (Fig.03a–d).

It's very difficult to explain the technique of actual painting. A lot of how your painting job turns out is based on your experience with color and familiarity with the tools you're working with. It also depends a lot on your personal style. Practise always helps to further your personal preferences and ultimately develop your own unique style. The way I work is to pick the colors from the surrounding area to paint with and keep adjusting the tone or hue ever so slightly to avoid plain, lifeless blocks of color. I find that keeping the tone varied even on flat surfaces gives an object a much more dynamic and interesting appearance. It can take dozens or more brush strokes over the same area before I'm satisfied with the result, and it requires a lot of patience. Paying attention to the effects of shadow and light is also a very important part of the painting process.

Fig.03a

Fig.03b

Fig.03c

Fig.03d

CARTOON

One way to illuminate part of the picture to give the effect of strong light is to use Color Dodge. Above the portion of the picture you wish to brighten, create a new layer and using the drop down menu in the layer palette and set the layer blend mode to Color Dodge". Anything painted on this layer brightens and saturates the work beneath it. I chose a medium gray color with a slightly red hue to give the light a warmer tone and picked out the areas I wanted the light to fall on (Fig.04a and b). I find this works better than directly using the dodge or burn tools over painted areas, since those tools tend to give an uneven, glaring effect that disrupts the colors. Using layer blend modes gives far more control over special effects and can always be deleted later if they're found unsuitable.

The fish were painted a slightly different way from the rest of the image (Fig.05a–c). Their lines were sketched by hand from references of real fish and scanned in to be painted separately from the main project so I could concentrate on their details. The glossy surface of the bubble was painted on a layer above the sketch using a low opacity brush to get a translucent-like quality. After the fish were painted the sketch was deleted and the

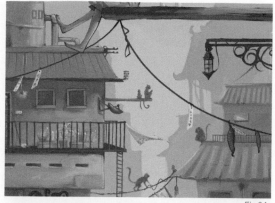

Fig.04a

Fig.04b

whole image was moved over into the main project to be placed in the appropriate places.

CONCLUSION

Overall, I'm happy with the finished piece. Once a project starts, it often takes on a life of its own and sometimes the end result can be completely different from what one starts with. This turned out to have a much larger scale than I originally planned, but usually it's just best to go with the flow and see where it takes you.

Fig.05a

Fig.05b

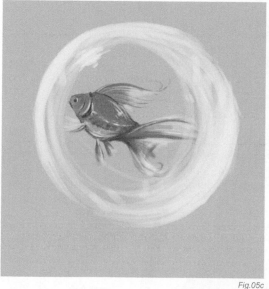

Fig.05c

ARTIST PORTFOLIO

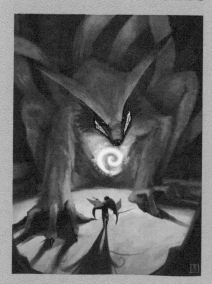

BAD TO THE BONE
BY KOSTA ATANASOV

INTRODUCTION

This is Bad - the main character for my upcoming short 3D movie, named *Bad to the Bone.* I needed a movie project for my graduation at the university, and I needed something short and easily done – I was amazed when I found out that the idea was under my very nose, because it was something I've always wanted to say. The idea behind the movie-to-be is that bikers, though looking mean with all the metal skulls, dusty black leathers and spikes, are actually nice, normal people – that not everything that is gold glitters, and vice versa. My favorite rock band – Bon Jovi – has put the same thing brilliantly in a song, named "Good guys don't always wear white" – it basically says that you should not judge a book by its cover. I've been a biker myself for quite a while, and I have a lot of biker friends that look exactly like Bad – when you meet them on the street, they might look all scary and mean – which is the total opposite of what they actually are; it's just that this is the lifestyle that fits them. The mean looks are just a mask, a protection from the other people, who more often than not don't approve anyone else's right to be different, unique, and are not free from prejudice. We live in an outdated world conditioning us with a lot of dogmas that are not necessarily true – so we have to rely on ourselves to find the truth behind it, about what's good and what's bad. So here's some more info about who I think Bad is: "Bad is a true old school biker. A lone wolf, he loves to ride alone – he doesn't need anyone else. On his scarred face you can rarely see emotion – the one thing that changes in his stone expression is the slow, threatening movement of the heavy eyebrows, as they drop even lower over his squeezing eyes. He has the ultimate hardcore macho aura, and never, ever smiles. His passion for motorcycles and the smell of gasoline and burning tire can only be compared to the love of leather clothes and skulls, with which he decorates every possible thing – starting from his bike, the belt, the boots, the tattoos, to the rings on his hands; he LOVES skulls. Looking mean, acting tough, inside he is truly a nice guy – but he never allows others to know that. He is content with the world thinking that he is the "Bad and mean biker". He doesn't show that he cares about anything, and doesn't let anything crack his stone-cold attitude. He is the personification of the word "Badass" – if there is a "Badass Biker Association", Bad is its president".

I spent quite a bit of time sketching and refining the character, the props, while thinking on the script in detail. When finally I came closest to what I was looking for, it was sketched with a ball pan on a piece of old yellowish paper, which I've used later as a reference point (Fig.01–04).

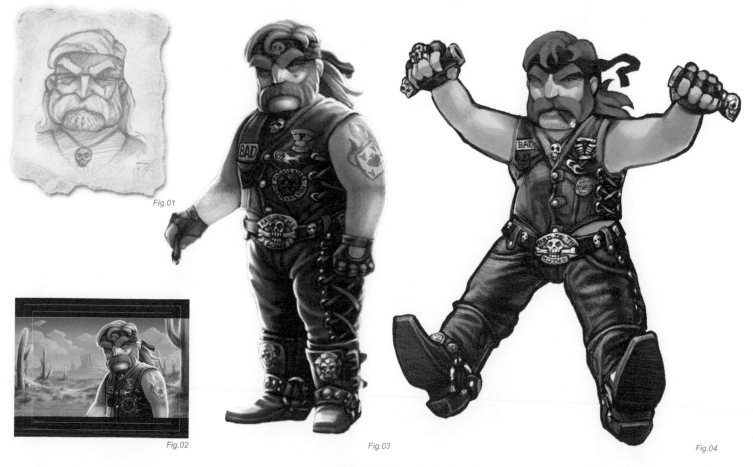

Fig.01

Fig.02

Fig.03

Fig.04

The "Live fast – die young" tattoo I think is a nice touch, since Bad is obviously not young and just as obviously still alive. From all the concept designs I drew, the other tattoos I chose to use were "Old Skull" and the classic "Mum" heart. I also like how the "Badass Biker Association" patch turned out – a black ass (the donkey kind of) with evil red eyes riding a bicycle makes a nice pun; stuff like that is rarely noticed, but I really love to add detail of this kind in all my works (Fig.05).

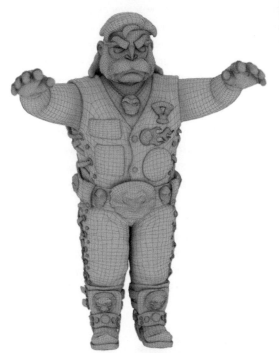

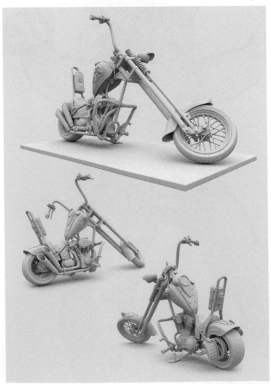

Fig.06

Fig.07

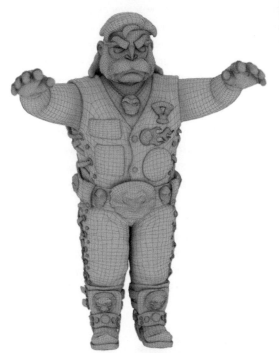

Fig.05

MODELING AND TEXTURING

When I began the actual work, I used my standard pipeline: I model a low poly in 3D Studio Max, using simple poly modeling. Working on the cage, I actually keep track of how it looks when subdivided. Then I UVW unwrap the subdivided version (it's really easy on characters like that using pelt mapping), import it into ZBrush and detail it. The final textures I apply in Photoshop, and, also creating a bump map, use them to render the normal map. I import the mesh back into 3D Studio Max, and add a quick biped to put it into pose. To achieve the realistic look I render it with V-Ray, using HDRI lighting. To make it look like a small toy, I simply keep in mind that there should be no small details; all of them must get a little exaggerated. Same goes for the textures, and the camera DOF (rendered in Photoshop using an external plug-in). Stronger camera depth of field at shorter distances makes objects appear smaller (Fig.06).

RENDERING

This version of the bike was face-lifted to look good exclusively for this render, initially planned for the cover of V-Ray Render 1.5. I had limited time to do it, so I mapped the bike's textures in camera projection mode, and actually used the full exported ZBrush geometry for the skulls. Since it would only be viewed from this angle and not in animation, no one would ever know the difference: it's hard to make compromises like this when you've been a perfectionist all your life, but this particular sacrifice is actually something you gain rather then lose. When you learn how to get past the unnecessary work you do for your own satisfaction and no one else will ever know about, you win the freedom to use your time for more stuff, bigger stuff, or both. As a whole, I really like how Bad's bike turned out; it fits perfectly the vision of the film I have – slightly exaggerated lines, scaled-up detail so stuff looks smaller, and realistic materials, render and lighting. Though I ride my motorcycle quite a lot, I do not know major things about how the engine works, which parts do what and so on. I know which hole the benzene should go into, I can bypass my gas pump on occasion, but that about does it. I wanted the motorcycle to look simplified, but convincing, so I had to put quite a bit of research to get the engine details right and get rid of the smaller ones. For the sake of clarity and easy animation I had to remove the cables of the front brake and the clutch – though they would look good on it and would certainly add dynamics, they would be extremely hard to animate and prove realistic in close-ups (Fig.07–09).

"Bad's bike is just like him – gotten over its mid age, with a classic, old school appearance. A little dusty, with slightly darkened chrome – a true biker's motorcycle, not the kind of bike a poser would ride on, but one for true riding, one who has seen lots

Fig.08

Fig.09

and lots of miles and will see many more. The bike is kept in a condition to work flawlessly, and about the outer look – well, Bad doesn't care about that stuff. All covered with his favorite skulls, the bike is distinct and unique" (Fig.10–12).

CONCLUSION

If I have learned something from this movie project, it's not how to model, texture or render a cartoon character, but that if you aim for something really good and something serious, you have to learn to rely on other people as well rather than on yourself alone. Yeah, sometimes it can be hard, because other people are neither clones nor extensions of you and have different vision, take different decisions – they are themselves. That's why you have to learn to trust others and let yourself become a part of a bigger, more creative whole that will produce greater results which will further on have a greater effect. From the beginning of the project I discussed the script with friends and colleagues, professors at the university, and, offering their different points of view, I believe they helped me greatly improve it. I really hope to finish this movie some day, despite the lack of time, more serious ambitions and all. I believe I will, because there are no boundaries but those we set for ourselves. Best of luck to you all; I hope you find the spring of your artistic creativity and inspiration.

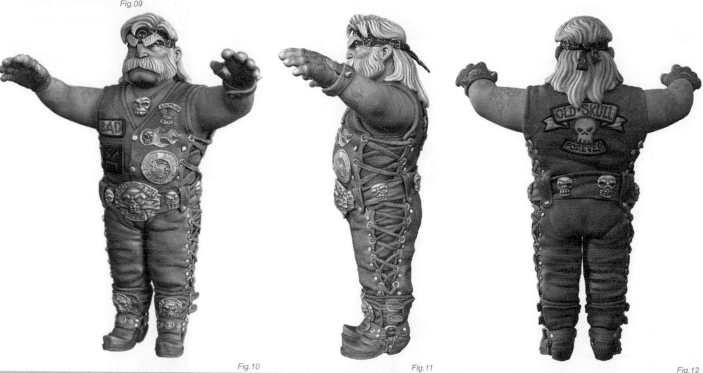

Fig.10 Fig.11 Fig.12

ARTIST PORTFOLIO

THE DIGITAL ART MASTERS

 ADRZEJ SYKUT
azazel@platige.com
www.azazel.carbonmade.com

 BINGO-DIGITAL
bingo@bingo-digital.com
http://www.bingo-digital.com

 HAO AI QIANG
metalcraer@hotmail.com
http://metalcraer.cgsociety.org

 ALESSANDRO BALDASSERONI
baldasseroni@gmail.com
http://www.eklettica.com

 BRIAN RECKTENWALD
breckten@gmail.com
http://www.brianrecktenwald.com

 HOANG NGUYEN
hoang@liquidbrush.com
http://www.liquidbrush.com

 ALESSANDRO PACCIANI
info@pacciani.com
http://www.pacciani.com

 DAARKEN
daarkenart@daarken.com
http://www.daarken.com

 HRVOJE RAFAEL
136dof@gmail.com
http://rafh.cgsociety.org/

 ALEXANDRU POPESCU
aksu00@gmail.com
http://alexandrupopescu.lx.ro

 DANIEL MORENO DIAZ
guanny@pyrostudios.com
http://www.guanny.com

 HYUNG-JUN KIM
kjunorg@gmail.com
http://www.kjun.org

 ANDRÉ HOLZMEISTER
andrevh@gmail.com
http://www.animation.art.br

 DANIELA UHLIG
libita@hotmail.de
http://www.du-artwork.de

 JAMES BUSBY
jabusby@cardboarddog.com
www.cardboarddog.com

 ANDRÉ KUTSCHERAUER
info@ak3d.de
http://www.ak3d.de

 EMRAH ELMASLI
emrah@partycule.com
http://www.partycule.com

 JIAN GUO
Beathing2004@yahoo.com.cn
http://blog.sina.com.cn/m/breathing

 ANDREA BERTACCINI
andrea.bertaccini@tredistudio.com
http://www.tredistudio.com

 FRAN FERRIZ BLANQUER
fran@frriz.com
http://www.frriz.com/fran

 JONATHAN SIMARD
capitaine_star@hotmail.com
http://pikmin.cgsociety.org/gallery/

 ANDREY YAMKOVOY
sheff.fp@gmail.com
http://www.cg.4mg.com

 FRED BASTIDE
tex@texwelt.net
http://www.texwelt.net

 JONNY DUDDLE
jonny@duddlebug.co.uk
www.duddlebug.co.uk

 ANTONIO JOSÉ GONZÁLEZ BENÍTEZ
mail@budathome.com
http://www.budathome.com

 GERHARD MOZSI
contact@gerhardmozsi.com
http://www.mozsi.com

 KHALID ABDULLA AL-MUHARRAQI
khalid@muharraqi-studios.com
http://www.muharraqi-studios.com

 BENITA WINCKLER
benita@eeanee.com
http://www.eeanee.com

GLEN ANGUS
gangus@ravensoft.com
http://www.gangus.net

 KORNÉL RAVADITS
kornel@formak.hu
http://www.graphitelight.hu

The Digital Art Masters

Kosta Atanasov

kosta@kostaatanasov.com

http://www.kostaatanasov.com

Marcel Baumann

marcelbaumann@gmx.ch

http://www.marcelbaumann.ch

Marcin Klicki

klicek@o2.pl

http://www.klicek3d.com

Marco Menco

drummermenco@yahoo.it

http://drummer.cgsociety.org

Marek Denko

marek.denko@gmail.com

http://www.marekdenko.net

Massimo Righi

info@massimorighi.com

http://www.massimorighi.com

Maurício Santos

mauricio@hypestudio.com.br

http://www.hype-studio.com

Michael Engstrom

engyorg@hotmail.com

http://www.engy.org/

Michael Smith

m100smith@gmail.com

http://www.msarts.co.uk

Mikko Kinnunen

mikko@artbymikko.com

http://www.artbymikko.com

Neil Maccormack

neil@bearfootfilms.com

http://www.bearfootfilms.com

Olga Antonenko

info@cgpolis.com

http://www.cgpolis.com

Patrick Beaulieu

squeezestudio@hotmail.com

http://www.squeezestudio.com

Paweł Hynek

hynol@op.pl

http://hynol.cgsociety.org/gallery/

Philip Straub

straubart@aol.com

http://www.philipstraub.com

Raymond Yang

bignanfer@hotmail.com

Rolando Cyril

sixio@free.fr

http://sixio.free.fr/

Rose Frith

rose.frith@btopenworld.com

http://www.rozefire.deviantart.com

Sebastien Sonet

contact@xxeb.net

http://www.xxeb.net

Siku

mutantbox@aol.com

http:// www.theartofsiku.com

http:// www.themangabible.com

Stefan Morrell

3dsmorrell@gmail.com

http://stefan-morrell.cgsociety.org

Tae young Choi

taeyoung1004@hotmail.com

http://www.tychoi.com

Torsten J. Postolka

torsten.postolka@web.de

http://protecta.deviantart.com/

Vincent Guibert

guibertv@free.fr

http://www.vincentguibert.fr

Vitaly S Alexius

svitart@gmail.com

http://www.svitart.com

Wen-Xi Chen

acid_lullaby@hotmail.com

http://www.acidlullaby.net

Wiek Luijken

wiek@luijken.com

http://www.luijken.com

Yang Zhang

zhangyangshaoyu99520@hotmail.com

http://zhangyang84.cgsociety.org

INDEX

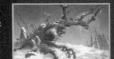

Printed and bound by CPI Group (UK) Ltd, Croydon, CR0 4YY

21/10/2024

01777094-0019